MW01010302

please
return to

Christina
Amri

BETWEEN GRACE AND FEAR

THE ROLE OF THE ARTS IN A TIME OF CHANGE

WILLIAM CLEVELAND AND PATRICIA SHIFFERD

BETWEEN GRACE AND FEAR

THE ROLE OF THE ARTS IN A TIME OF CHANGE

WILLIAM CLEVELAND AND PATRICIA SHIFFERD

Common Ground

First published in Champaign, Illinois in 2010
by Common Ground Publishing LLC
at The Arts in Society
a series imprint of The University Press

Library of Congress Cataloging-in-Publication Data

Cleveland, William, 1947-
Between grace and fear : the role of the arts in a time of change / William Cleveland and
Patricia Shifferd.
 p. cm.
Includes bibliographical references and index
ISBN 978-1-86335-737-1 (pbk : alk. paper) -- ISBN 978-1-86335-738-8 (pdf : alk. paper)
1. Arts and society. I. Shifferd, Patricia Allen. II. Title.

NX180.S6C54 2010
700.1'03--dc22

2010006543

Cover art: William Cleveland, Collage, 2010, Barbed wire image copyright Art
For Humanity, Durban South Africa, used by permission.

**Our profound thanks to American Composers Forum
for supporting the creation of this book.**

It is dedicated to the many community cultural workers who are helping to bring a just and
sustainable society into being and to two creative people in our lives:
Carla Cleveland and Kent Drummond Shifferd.

Thanks to Patrick Slevin for his stellar copy-editing.

Table of Contents

Part III : The Persistent Thread

The Role of the Arts in Society

Part IV : Other Voices

Reflections From Philanthropy, Religion, Education, Politics

Part V : Slow Culture

Local Initiatives in the Arts and Community Development

About the Authors

William Cleveland is a pioneer in the community arts movement and one of its most poetic documenters. His books *Art In Other Places* and *Making Exact Change* and *Art and Upheaval: Artists on the World's Frontlines* are considered seminal works in the field of arts-based community development. An activist, teacher, lecturer and musician, he also directs the **Center for the Study of Art and Community**, located on Bainbridge Island, in Washington state in the U.S.

Patricia A. Shifferd is an independent consultant in research and evaluation to arts groups and communities. Formerly the Vice President for community and education programs at American Composers Forum, she directed the community-based music commissioning project, Continental Harmony, a model of arts-based community development. Trained in Sociology and Anthropology, she received her Ph.D. degree from the University of Wisconsin-Madison; her research and teaching interests have centered on community development, the role of the arts in society, sense of place, and the social aspects of environmental affairs.

About the Artist

Gabisile Nkosi (1974 -2008) Born in Umlazi, Durban, Gabisile built a significant career as an artist in her short life. In 1996, in her early 20's she attended art classes at the African Art Centre. She received her degree in Fine Art from the Durban University of Technology in 2002, whereafter she was based at the Caversham Centre for Artists and Writers in the KwaZulu-Natal Midlands, facilitating printmaking workshops with well-known artists and local communities. She was actively involved in various community educational projects and was particularly interested in the therapeutic effects of art making. Gabisile was involved with Art for Humanity (AFH) for almost 10 years with her participation in two of AFH's print portfolios. She participated in numerous solo and group exhibitions including the 'Biennale – Jabulisa 2000' at the Tatham Art Gallery, Pietermaritzburg, South Africa, 'Warm Wind from South Africa' at the Durban Art Gallery, Durban, and the DLM Museum in England. Her work is represented in both private and corporate collections in South Africa and abroad.

Introduction

Early in its second term, the Clinton administration began to plan how it would commemorate the dawn of the Third Millennium of the Modern Era. Here is how the President described it:

> Our economy is measured in numbers and statistics...But the enduring worth of our nation lies in our shared values and our soaring spirit...We should make the year 2000 a national celebration of our spirit in every community - a celebration of our common culture in the century that has passed, and in the new one to come in a new millennium, so that we can remain the world's beacon not only of liberty, but of creativity, long after the fireworks have faded.

Given President Clinton's sentiments, it is not surprising that the millennial role played by the National Endowment for the Arts (NEA) was significant. The defining element of the NEA's participation was its investment in long-term creative partnerships between artists and communities across the country. By far the most unique of these was a program called Continental Harmony that placed composers in residence in American towns and cities.

Developed by the American Composers Forum (www.composersforum.org), Continental Harmony was a country-wide expression of the burgeoning community arts movement that had been establishing itself in American neighborhoods and cities over the previous two decades. Visiting composers worked with the participating communities to create musical works that explored local history and identity. The resulting 58 compositions were performed by local musicians at community-wide millennium celebrations in all fifty states. The success of the program led the NEA and other funders to extend the program, culminating in over 100 community celebrations through the end of 2005.

As researchers working to assess the program's impact, we had a ringside seat for all of the Continental Harmony proceedings. Although the project more than fulfilled expectations, much of what we found was unexpected. For many of the sites, involvement in Continental Harmony had provided a crucible for building new, and often unanticipated creative community partnerships. Many of the participating community members we talked to were truly surprised by the vitality and rigor of their collective effort. As a result, they came away with a different view of their community's future capacity and potential both within and beyond the cultural realm.

Of particular interest was the fact that many of those in the arts, business, educational, human service, and public sectors who had worked so hard to make Continental Harmony happen in their communities were first-time arts partners. In site after site we found that, while people actively involved in civic affairs perceived the arts as a valuable asset, they did not see them as relevant to their core concerns as community activists, be they business interests, sustainability issues or environmental concerns. Reflective of our own views about culture as a core element in sustainable community development, we began to refer to this separation as "the disconnect." Rather than see it as a problem, though, we regarded it as an interesting opportunity.

In the spring of 2006, we concluded our work with Continental Harmony with a two-day gathering of key representatives from the host communities, some of the resident composers, and leaders from the larger field of arts-based community development. Participants were asked to consider the question: *How can the arts help build caring and capable communities?* The day's discussions exhibited both urgency and passion, in part, because of their common experience via Continental Harmony, but also, because of a shared sense that the world was on the cusp of social and environmental changes that would likely alter the very foundations of the modern age. As such, the conversation moved rapidly from local updates and stories to questions about how these broader currents would manifest and the need for artists to be integrated into the emerging global movement for a sustainable and just future. The need for alliance between the community arts sector and individuals and groups whose goals are similar—organizers, community builders, environmentalists, forward-thinking researchers, etc.—was also expressed, as was a wish for on-going conversation and connection among like-minded others.

In our final session the questions raised by this challenge loomed large. If culture is indeed a critical element in the alchemy of change, how will the needed cross-sector, cross-discipline amalgam form? If the opportunity for arts-based community partnerships that we perceived in our research was lying fallow, then what kinds of support and stimuli are needed to make them grow? Most importantly, what barriers constitute the "the disconnect" between progressives and cultural activists working on parallel paths for change, and how might they be bridged?

We left our Continental Harmony retreat with these questions left largely unanswered. We also came away with a sense of obligation to contin-

ue addressing the ideas and issues that had surfaced there. In the weeks that followed it became patently clear that our path had already been set for us by our colleagues. We would do our part as researchers and writers by taking on the questions they had posed and seeing where they led.

This book is the product of that effort. It seeks to both explore the questions discussed above and contribute to the growing discussion among historians and social/political theorists about what some see as an historic shift or "turn" in how the world's systems and institutions function and are viewed. It is interesting to note that the "disconnect" we observed in the Continental Harmony communities was also evident in our review of recent writing reflecting on the current era as a time of widespread global transformation. As we reviewed the literature, we were struck that there was little or no mention of how arts and culture figure in these "turning" scenarios. As before, we were concerned about this apparent disconnect, because of our strong belief that the engagement of all of society's creative resources will be necessary if a just and sustainable society is to be created. Accordingly, this book is the result of our engagement with thoughtful people from various backgrounds—artists, politicians, scientists, community leaders, theologians and social theorists—in consideration of a question which we consider peculiarly significant at this time in our history:

If a major shift in worldview is taking place, what role might society's arts and cultural resources (artists, arts institutions, and cultural creatives) play?

Throughout 2007 we interviewed and collected the thoughts of around thirty individuals, asking each to contribute their reflections on this question. The selection of our interviewees, while deliberate, was certainly not scientific. All can be considered activists and change-makers in their respective fields. As such, although they represent a wide range of expertise and experience, they share dissatisfaction with the status quo and a hope for a more equitable and sustainable society. Their work, whether in the academy or civil society, is spent in serving and learning from the people, communities, and circumstances that inform their thinking. After getting to know these people individually, it has become obvious that the convenient labels (e.g., environmentalist, artist, philanthropic executive) that often appear next to their names do not adequately portray the breadth and diversity of their experience and skills. In fact, a quick inventory of occupational titles for the group totaled over 150; among these are biologist, sculptor, social theorist, psychologist, urban planner, economist, theologian, composer, and community organizer. The majority are active as teachers and writers on a wide range of subjects. And, although only four would self-identify principally as "artists," most are practitioners of one or more art forms. Another common characteristic is an abiding sense of responsibility to engage issues and circumstances beyond their immediate sphere of interest and action. They are global citizens in the best sense of the word.

The question we posed to this diverse community of colleagues was, of course, stated in the classic if-then form, and implies two distinct areas of reflection. The first invites input about whether there is, in fact, a paradigm shift underway which is altering the way people view their work, communit-

ies, and relationships to each other and to nature. The second requests that the interviewees consider the contributions that a major locus of creativity—the arts—might play in the years to come as individuals and communities grapple with the central issues of our time: globalization, political and economic insecurity, conflicting worldviews, and the ecological crises that appear immanent because of resource depletion and climate change.

As noted, we embarked on this exploration because we were struck by the seeming disconnect among the spheres of thought and action which have been the focus of our professional lives: sustainable social structures and arts-based community development. Sustainable development work, an outgrowth of the environmental movement, aims to harmonize human and natural systems so that both can thrive for the long term. Often, sustainable development advocates emphasize quality of life issues and intangible satisfactions. Since they find it easier to establish such harmony at the local level, the movement is often called the sustainable community development movement. However, people active in this field have not seen the arts as central to the work, except perhaps peripherally in the area of design.

The cultural work we refer to as arts-based community development is a worldwide phenomenon that has been practiced for many years, in both urban and rural contexts. In the U.S. it has roots in the WPA (Works Progress Administration) arts programs of the New Deal and the CETA Federal jobs program of the late 1970's. Though short-lived, CETA's legacy influenced multiple generations of artists who have produced a remarkable record of innovation and success working for social change in thousands of communities across the country. Over the past three decades many of this country's finest artists and arts organizations have established community/arts partnerships in factories, jails, condominiums, probation departments, senior centers, special schools and the like. Their aims have been equally diverse, ranging from educational reform, to economic development, to crime prevention. This work has challenged traditional ideas about the arts in America. It has also created successful models from which those concerned with the health and vitality of American communities can learn a great deal.

In an earlier paper, "Art for Life's Sake: the Role of Aesthetic Experience in Sustainable Community Development," one of us (Shifferd) argued that aesthetic experience will be key to develop the worldview and institutions necessary to overcome the mental fragmentation that divides us from the natural world and in the process from each other—to think the world whole again. Similarly, in a recent paper, "Converging Streams: the Community Arts and Sustainable Community Movements," Lagerroos and Shifferd used framework documents from the two movements to demonstrate that they are based on a similar set of underlying values and assumptions: equity and social justice, diversity, democracy, spirituality, and learning. They argued that a convergence of action would enhance the impact of both movements.

Modern society tends toward fragmentation of thought and action among its various sectors. But this fragmentation is no longer tenable, given the interrelated issues which face the planet and her people. This book, therefore, is our attempt to build bridges of conversation among those who

are working, each in their own way, for that just and sustainable society we envision.

A New Worldview?

Since the turn of the millennium there have been many major publications which engage the first part of our if-then question: is our culture at some kind of turning point in worldview and socio-cultural organization?

In the year 2000, philosopher Loyal Rue called for the emergence of a new narrative which will allow the world's peoples to cope with the interrelated set of problems facing us today: "global warming, ozone depletion, the extinction of species, soil erosion, toxic waste, air and water pollution, mineral and fossil fuel depletion, poverty, crime, injustice, terrorism, exploitation." (p. 3) This new narrative, which he called "Everybody's Story," would be one to advance global solidarity and cooperation, provide an integrated cosmology and morality, and be reflected throughout the socio-cultural order—in the intellectual, institutional, aesthetic, experiential, and ritual domains. (p. 26)

Rue finds the basis for this new story in the "epic of evolution" and argues that conditions in the world today are such that older worldviews will not be sufficient to master the situation. However, at this point in time, it seems to us unlikely that the "epic of evolution" will be able to provide the needed unified worldview, given the widespread rejection of the evidence and methods of the evolutionary sciences.

The conversation about changing worldviews continued in 2001 with the publication of *The Cultural Creatives* by Ray and Anderson. The thesis of the work, based both on interviews and survey data, is that a third worldview has emerged between the secular, materialist ideas of modernism and the traditionalists, who look longingly at an imagined past. The bearers of this belief system, the Cultural Creatives, are characterized by a concern for authenticity and holism, rejection of materialism and social inequality, interest in the arts, story, and spirituality, and a global ecological consciousness. A major point of the work is that this belief system has been emerging "beneath the radar," since the cultural creatives, at least at the time Ray and Anderson collected their data, do not recognize themselves as a social movement.

Interestingly, there is now reason to believe that such a social movement is coalescing. Internet-based progressive political groups (MoveOn, True Majority, etc.) have emerged to attempt to affect the outcomes of elections and policy debates. Moreover, a huge number of civil society organizations continue to emerge around issues of social justice and environmental protection. This is compellingly documented by Paul Hawken in his latest book. He notes that over the years as an itinerant lecturer on the environment he gradually became aware that manifold numbers of small organizations, mainly local, have emerged all around the world.

> Over the course of years . . .I came back to one question: Did anyone truly appreciate how many groups and organizations are engaged in progressive causes? At first, this was a matter of curiosity on my part, but it slowly grew

into a hunch that something larger was afoot, a significant social movement that was eluding the radar of mainstream culture. . . I initially estimated a total of 30,000 environmental organizations around the globe; when I added social justice and indigenous peoples' rights organizations, the number exceeded 100,000. . .I soon realized that my initial estimate of 100,000 organizations was off by at least a factor of ten, and I now believe there are over one—and maybe even two—million organizations working toward ecological sustainability and social justice. (p.2)

An open source, on-line catalog of these organizations may be found at www.wiserearth.org.

Daniel Pink and Thomas Friedman have each argued that, given the inexorable development of global forces in technology and economy, people in the West need to emphasize mental skills which are holistic, creative, and synthesizing. Friedman's in-depth analysis of the forces of globalization ends with this advice:

> The flattening of the world . . . has presented us with new opportunities, challenges, partners, but also new dangers. . . It is imperative that we find the right balance among all of these. It is imperative that we be the best global citizens we can be. . . And it is imperative that while we remain vigilant to the new threats, we do not let them paralyze us. Most of all it is imperative that we nurture more people with imaginations.
>
> To put it another way, the two greatest dangers we Americans face are . . . excessive fears of another 9/11 that prompt us to wall ourselves in, in search of personal security—and excessive fears of competing in a world of 11/9 [collapse of the Berlin Wall, 1989] that prompt us to wall ourselves in, in search of economic security. . . On such a flat earth, the most important attribute you can have is creative imagination." (pp. 570-1).

By creative imagination, Friedman seems primarily to mean scientific and technological innovation, not the arts. While he does make an occasional reference to the arts, the index to the book contains no reference to arts disciplines.

Daniel Pink, on the other hand, is explicit about the increasing importance of aesthetic factors to future success in the world. The attributes of right-brain thinking—the "simultaneous, metaphorical, aesthetic, contextual, and synthetic"—will, he argues, need to be emphasized to counterbalance the bias of our culture toward the attributes associated with the brain's left hemisphere—the "sequential, literal, functional, textural, and analytic." (p. 26) He labels these attributes design, story, symphony, empathy, play, and meaning.

> The future belongs to a very different kind of person with a very different kind of mind—creators and empathizers, pattern recognizers, and meaning makers. These people—artists, inventors, designers, storytellers, caregivers, consolers, big picture thinkers—will now reap society's richest rewards and share its greatest joys. (p. 1)

Finally, in *The Great Turning: from Empire to Earth Community*, David Korten makes an impassioned plea for a new values narrative, a new set of stories, to counteract the crises of environmental destruction, rampant materialism, growing inequality, and degradation of democratic institutions. He calls on people to work together in local communities and in networks

of congruence globally to bring a new structure to society based on several principles:

> The *cultural* principles of Earth Community affirm the spiritual unity and interconnectedness of Creation. They favor respect for all beings, nonviolence, service to community, and the stewardship of common resources for the benefit of generations to come. The *economic* principles of Earth Community affirm the basic right of every person to a means of livelihood and the responsibility of each person to live in a balanced relationship with their place on Earth without expropriating the resources of others. The *political* principles of Earth Community affirm the inherent worth and potential of all individuals and their right to a voice in the decisions that shape their lives, thereby favoring inclusive citizen engagement, cooperative problem solving, and restorative justice. (pp. 37-8)

To realize a society based on these principles, Korten argues that we need to recognize that our relationships to each other and to nature are matters of choice, not inevitability. But it often seems that these choices are not possible. Why? Our sense of powerlessness stems from the fact that we have been taught to believe a series of stories about how prosperity, security, and meaning are created. These stories, the imperial stories, favor concentration of power and wealth over more equitable forms of living. New stories are needed to provide the foundation for new beliefs about prosperity, security and meaning—stories based on the principles of Earth Community. For example, the belief that prosperity results from an ever-enlarging pie, part of which will trickle down, needs to be replaced by the recognition that "true prosperity depends on life-serving economies that satisfy our basic material needs, maintain a sustainable balance with Earth's natural systems, strengthen the bonds of caring communities, and support all persons in the full realization of their humanity." (p. 203)

Since the mainstream media most often convey the imperial stories and encourage materialism and over-consumption, the new stories will have to come from other centers of social life—churches, community groups, gatherings of neighbors and family, etc. The basis for Korten's belief that this is possible stems from his conviction that an evolution of human consciousness is occurring, providing the attitudinal foundation for creation of a new paradigm. Dr. Korten's interview, in which he expands on these ideas, is the lead interview in this book.

While each of these thinkers emphasizes the importance of creativity and imagination to our ability to deal with the difficult challenges the world faces, their purpose was not to specifically describe how arts institutions and artists should be involved in the emergence of a new paradigm. The interviews we collected will perhaps provide this guidance.

Why the arts?

As we have seen and because of the inherent ambiguity clouding the task ahead, the growth of a sustainable culture will require persons who are skilled in problem-solving, critical analysis, holistic and systematic thinking, and who have the ability to suspend judgment while seeking solutions.

These cultivators of the new world must also be adaptive, able to work co-operatively with others, and possess personal balance and internal grace. They must be able to identify with a particular place, a region, and to help preserve the unique cultural traditions and natural landscape of that place; without retreating into parochialism, they must not allow their communities to become the everyplace that is no place. They must be empowered to create economic and political institutions which are respectful of each other and of nature. The task, in short, is one that will require a strong dose of the most powerful of human capacities—our creativity.

We and others in the book assert that one important and often over-looked source for this needed creativity are the community artists and arts organizations living and working in our own neighborhoods and towns. These are creative workers and institutions who understand the intrinsic link between the development of caring and capable communities and the presence of a vital and democratic cultural life. The activist artists in our midst know that experiencing the products of human creativity gives us access to the most basic expressions of meaning; and being able to see the meaning of things is, after all, a uniquely human ability. Their dances, plays, literature, and painting help to sensitize us to the natural and social environment through creative reflection; this sensitivity and our experience of these creations allow us to endow the world with meaning, and to see our place in nature.

Indeed, artistic creation is the most basic, fundamental way that our species has of expressing our connection to the earth and to each other. We compose, we sing, we dance, we paint, we sculpt, we dramatize our understanding of our world. We always have and we always will, because it is our nature to do so. Thus, the performance and visual arts are both uniquely human and completely natural. The pursuit of truth, meaning, and the longing for beauty are universal human traits. So it is that participation in the aesthetic realm of experience forms a vital component of an ecological frame of reference.

Per Raborg forcefully makes this argument in his essay "The Culture of Nature":

The view of aesthetic culture as a superimposition on the material culture is in fact false. From an evolutionary viewpoint, technical society may be seen as a superstructure, while aesthetic culture is the more fundamental and indispensable sector. It seems, rather, to represent a deep level of our human constitution which is close to our central value system. It is through the system of values that our qualitative requirements of life are met, and that we obtain motivation for renewed vital efforts. The aesthetic sphere is perhaps linked to the sensory core of our consciousness, which lies far deeper down than the technical and rational level with which evolution has rewarded us. It may be within this sphere that the whole creative cosmos of sensory impressions, emotional expressions, and aesthetic nuances has its beginning. It may also be from here that we draw the zest for life and the inspiration which allow us to submit to the strain of everyday life, and find its routines worth the trouble. A culture which cuts off this vital nerve rapidly may find itself sunk in barbarity. Its life-force becomes significantly reduced and soon it is caught in a downward spiral of development. (p. 213)

The arts, like many activities, can serve to either modify or intensify the problems of estrangement from nature and from each other; but they always pointedly draw our attention to basic cultural assumptions because they concentrate sensation and emotion so vividly. Moreover, the artist's creation becomes a part of the environment; this is most clearly seen in the built environment, but it also applies to all the arts.

In *The Social Construction of Nature*, Klaus Eder argues that in modern society there are three basic arenas in which knowledge is sought—empirical objectivity, moral responsibility, and aesthetic judgment. He also notes that one of the problems of the modern age is that these have become separate spheres, fragmenting our knowledge. To fully comprehend nature, our approach to understanding the environment must consist of all three arenas. Moreover, when we contemplate the relationship of humanity with nature, the arts have a special place. They are, according to Eder:

> . . .the locus of an expressive relationship. The history of the European relationship with nature is characterized by the fact that nature is seen not only as something to be dominated, but also as something to be cared for, as an object of sensibility. Art has been the medium of communicating the expressive aspect of man's relation to nature, both in popular and high culture variants. The aesthetic use of nature and the communication of aesthetic judgments of man's relationship with nature have become a central feature in environmentalism. Thus aesthetic judgment gains in importance the more public communication of nature increases. The aesthetic relationship between man and nature is no longer the privilege of literary circles or of art as an *avant-garde* institution. Rather, its effects re-couple art with the everyday social world. (p. 175)

In other words, the more pressing the public debate over the social and ecological issues becomes, the more we must turn to the arts to provide a focus for the development of central cultural values to overcome the fragmentation of modernity. These themes will emerge again and again in the interviews.

Organization of the interviews:

All of the participants in these conversations were asked to consider both parts of our framing question: *If a major shift in worldview is taking place, what role might society's arts and cultural resources (artists, arts institutions, and cultural creatives) play?* So, each person provided input to both. However, since each interview subject brought their own particular experience and background to the conversation, significant differences in emphasis emerged. We, therefore, have grouped the interviews according to these differences as follows:

1. General formulations of the social situation and of the nature of change upon us
2. Environmental and community activist perceptions
3. Reflections on the historic role of the arts
4. Reflections from other institutional spheres: philanthropy, religion, education, politics

5. Local community initiatives in the arts and community development
6. The responsibility of artists in a time of social change

Readers are encouraged to pick and choose the interviews and the reading order which meet their particular interests.

Between Grace and Fear?

The title of this collection of interviews comes from the final interview in the group, that of Milenko Matanovic, Executive Director of the Pomegranate Center in Issaquah, Washington. Noting, as many of our other subjects did, the pressing social and environmental issues faced by the global community, Mr. Matanovic points out that we can learn how to live through grace or through fear:

> Change will happen, whether we want it or not. The choice is between being a constructive and willing participant in the change process or being a victim. Can we adjust, learning and adapting with grace, or do we wait until 4 x 4s start falling on our heads, subsequently allowing fear to spur us into action? The trouble is that learning by fear doesn't work because our creativity is constricted, our imagination is compressed, and we become reactionary only. Fear is like a black hole sucking energy, reducing the large field of possibilities to a singular point of view. Human beings have the capacity to be very creative and imaginative under the right conditions. . . We need to create an exciting, inspiring and joyful image of the future that pulls us forward. It requires a deep re-imagination of what human existence and culture is about. Being pushed from behind works only to get us started. The long journey requires purpose and courage only made possible by a compelling, living vision of the possible.

This book is our attempt to encourage people concerned about the future to engage their creativity and to learn through grace.

Bibliography

Cleveland, William T. and Patricia A. Shifferd. *Continental Harmony: A Study in Community-Based Arts*. St. Paul, MN: American Composers Forum, 2001.

Friedman, Thomas L. *The World Is Flat: A Brief History of the Twenty-first Century*. Rev. Ed. New York: Farrar, Strauss, and Giroux, 2006.

Hawken, Paul. *Blessed Unrest: How the Largest Movement in the World Came into Being and Why No One Saw it Coming*. New York: Viking, 2007. A database of non-profit organizations working for the environment, indigenous rights, and social justice is available at www.wiserearth.org.

Korten, David. *The Great Turning: From Empire to Earth Community*. San Francisco: Berrett-Koehler Publishers, Inc., 2006.

Lagerroos, Dorothy and Patricia Shifferd, "Converging Streams: The Community Arts and Sustainable Community Movements," presented to the Society for Human Ecology Conference, Bar Harbor, Maine, October, 2006. Subsequently published by the Community Arts Network.

Pink, Daniel. *A Whole New Mind: Why Right-Brainers will Rule the Future*. New York: The Berkeley Publishing Group, 2005.

Ray, Paul and Sherry Anderson. *The Cultural Creatives: How 50 Million People are Changing the World*. New York: Crown Publishing Group of Random House, 2001.

Rue, Loyal. *Everybody's Story: Wising Up to the Epic of Evolution*. Albany, NY: State University of New York Press, 2000.

Shifferd, Patricia, "Art for Life's Sake: The Role of Aesthetic Experience in Sustainable Community Development," presented to the North American Interdisciplinary Conference on Environment and Community, Ogden, Utah, February, 1999.

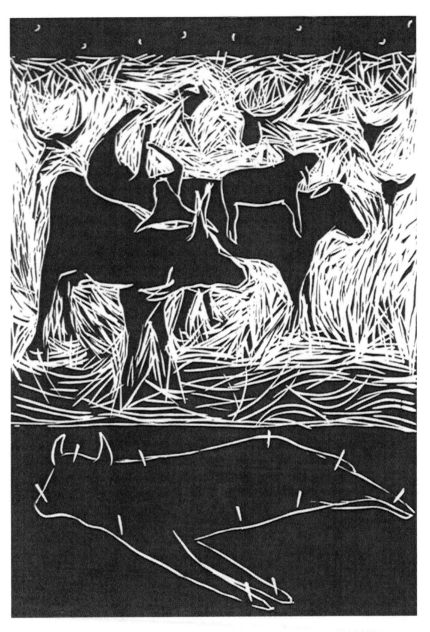

Gabisile Nkosi: *Ongaphansi nongaphezulu* (Ups and Downs), Linocut, 2007 from the Healing Portfolio commemorating the 200th Anniversary of the Abolition of Slavery in the United Kingdom.

Part I

Where We Are & Where We Are Going

General Formulations of the Social Situation & of the Nature of Change Upon Us

Where We Are & Where We Are Going

General Formulations of the Social Situation & of the Nature of Change Upon Us

David Korten, Lily Yeh, Dorothy Lagerroos,
Jennifer Williams, R. Carlos Nakai, Arlene Goldbard

The contributors to this first section speak about the social trends they see emerging that signify a shift in how people in Western culture have viewed themselves in relation to each other and to nature. These developments include the embrace of non-hierarchical ways thinking and working and an appreciation for the powerful human "stories" emanating from society's many cultures and peoples. There is also discussion of the growing recognition of the importance of spirituality in the creation of meaning, and the need for a new and inclusive balance among genders and generations as we navigate the change-constant landscape ahead. While each is cognizant of the perils of the modern world, these six people share the belief that human imagination and creativity may very well be equal to the task of confronting these dangers and contributing to the birthing of a new consciousness. The emergence of the new stories which will lead to this new consciousness is the central theme of this section.

Chapter 1

David Korten

"Change the Stories"

Dr. David C. Korten is the author of *The Great Turning: From Empire to Earth Community*. His previous books include the international best-seller *When Corporations Rule the World* and *The Post-Corporate World: Life after Capitalism*. Korten is co-founder and board chair of the Positive Futures Network, which publishes *YES! A Journal of Positive Futures*, and is founder and president of the People-Centered Development Forum, a board member of the Business Alliance for Local Living Economies (BALLE), a member of the Social Ventures Network, and a member of the Club of Rome. He is also a founding associate of the International Forum on Globalization (IFG) and a major contributor to its report on Alternatives to Economic Globalization.

Dr. Korten holds MBA and Ph.D. degrees from the Stanford Business School, has thirty years experience as a development professional in Asia, Africa, and Latin America, and has served as a Harvard Business School professor, a captain in the U.S. Air Force, a Ford Foundation Project Specialist, and a regional advisor to the U.S. Agency for International Development. He is known internationally through his writing and lectures as a leading critic of corporate globalization and conventional economic development models. He is a visionary proponent of a planetary system of local living economies based on the organizing principles of healthy eco-systems and properly regulated market economies.

WC: Could we begin with you framing the thesis of your book, *The Great Turning?*

DK: The basic message is that we humans have come to the end of a very destructive 5,000 year era of empire characterized by organizing human relations by a dominator hierarchy at all levels—from those among states to those among family members. That accounts for 5,000 years of exploitation of people and planet to support a privileged elite. We have now come to a defining moment in the human experience in which we have reached the limits of exploitation and domination that Earth's social and environmental systems will tolerate. We've seen the consequences in spreading social breakdown and the deterioration and breakdown of the life support system of the planet. These have been common characteristics of Empire throughout history, but for the first time the impact is now planetary in its consequences and potentially terminal for humanity. This creates a compelling imperative to change, because the very survival of the species is at stake. On the positive side, this creates an extraordinary moment of human opportunity to break out of the destructive dominator institutions of Empire and bring forth a new era of Earth Community based on principles outlined in the Earth Charter.

Establishment institutions are looking for technological solutions that will leave the existing power relations in place. *The Great Turning* argues that although technology choices are important, the real issues relate to values and relationships. The main barrier to change is presented by the stories that define our culture, stories that legitimate and affirm Empire and deny any other human possibility. The key to change is to change these stories.

WC: What roles do you feel that human creativity and the arts have played in the development and the maintenance of empire and empire stories?

DK: That's an interesting question. I have thought about this a lot in terms of religion, but not in terms of the arts. Certainly to the extent that art becomes co-opted to the interests of politicians and corporations, as in propaganda and advertising, the arts become the servant of Empire. Propaganda and advertising tend to be most effective when they tell us we are imperfect beings who can perfect ourselves only by aligning with a particular political demagogue or buying a particular corporation's brand or product.

WC: Historically, particularly in terms of the power of religion in human history, much of the art made in the world has been in service to those institutions. Whether by choice or not, many creative workers found their sustenance through religious patronage.

DK: That's a very good point in terms of much Christian art. Any art that affirms the anthropomorphic image of God as the jealous patriarch in the sky who demands our unquestioning obedience or the

violent image of Christ in agony on the cross serves Empire. These images divert our attention away from the deeper message of Jesus that we are all one in Spirit and best realize the potentials of our humanity through love.

WC: You talk a lot about the mutation of the Christian message at the moment when it comes in service to Empire. Would you agree that the creation of powerful images for the non-literate populace was a primary mode of delivery for that particular Christian story?

DK: That's true. Of course the themes of Empire and a patriarchal God as magical protector have long been communicated through religious music as well. Any art or literature that conditions us to look for a savior, whether it's a god in the sky, an earthly prophet, or a great leader riding in on a white horse conditions us to submit to a dominator hierarchy. Any art that evokes a condition of despair or existential alienation or loneliness also sets us up psychologically to align with a powerful leader as a vicarious source of strength and identity.

WC: Also, you mention the innate unruliness of the human creature as a foundation for the idea of heaven and hell.

DK: The stories of heaven and hell in the afterlife combine with stories of innate human unruliness and original sin to set us up to submit to human intermediaries who can tell us what God wants as the price of entry into eternal bliss in heaven. That encourages obedience to those who claim a special relationship to God and focuses our attention on achieving salvation in the afterlife rather than on freeing ourselves from the domination of Empire in this life. There is a very significant division among people who self-identify as Christian fundamentalists or evangelicals, between those who are focused on attaining paradise in the after-life and those who are focused on the beauty of this life and the possibility of creating loving societies that fulfill its potentials. That's a big difference that plays out in hugely different politics.

WC: You mention "creative possibilities" and "creativity" throughout the book. Where do you see the intentional act of art-making in the continuum of human development?

DK: Of course, the primary frame I'm working with has to do with the maturing of the individual human consciousness. One of the most critical phases in that development is the awakening to what I call a Cultural Consciousness, which is a waking up to the recognition of culture as a human construct subject to human choice. I guess that might play out in an artist's world in a recognition that the artist ultimately chooses the stories that he or she communicates into the culture—and that this choice has implications for which the artist bears ultimate responsibility. In my public presentations I make a distinction between authentic story tellers who communicate the values and aspirations that emerge through the life of au-

thentic communities and stories crafted to manipulate our behavior to serve the interests of politicians and advertisers. Probably the purest forms of authentic expression are found in traditional indigenous cultures.

We see the power of inauthentic expression in the success of the far right in the United States in gaining control of our political processes through the use of fabricated stories communicated endlessly by corporate media, right-wing churches, and even academic departments of economics that preach an ideology of individual greed, materialism, and violence against life.

WC: Do you see the same impulses in popular culture?

DK: It's obviously complex because sometimes it's authentic and sometimes it's a message for hire. Economic interests have become increasingly effective at co-opting popular culture for private financial gain.

WC: So, going back to this idea of human creativity, do you see it as essential for the development of cultural and spiritual consciousness and earth community. Is human creativity an essential core capacity in that regard?

DK: I don't think I'd put it quite that way. Recognition of our innate creative potential as human beings is essential, in particular, for the creation of new cultures and new stories, and to change our institutions to align with that potential. Of course our social and psychological potential must be cultivated through learning and practice, much as is required to actualize the potential of our physical capacities.

WC: Here's a quote from you: "crises can become an opportunity for creative learning." How do you think human creativity can contribute to the healthy resolution of the tension between the impulse of Earth Community which you describe as love, and the impulse of Empire which you describe as fear?

DK: I'm attempting to communicate the deeper theme that as we recognize that we're in crisis as a species, we have a choice between going into despair—thinking that there is nothing we can do—or recognizing the opportunity that the crisis creates to wake us up from the cultural trance that binds us to Empire and accept responsibility for creating our future. I often open my talks with the observation that "How the crisis plays out will depend on the stories by which we understand the nature of the crisis and the choices before us." People are always asking, "Do we still have time? Is there still a possibility?" We can't know the answer for sure. What we know for certain, however, is that if we choose to assume that it's too late, we create a self-fulfilling prophesy of failure. The only logical choice is to assume it is not too late and get on with acting accordingly. But time is surely limited.

WC: Have you given thought to what conditions might provoke creative work that would give rise to cultural and spiritual consciousness?

DK: One key to the awakening of the Cultural Consciousness is to experience a variety of cultures so that we learn to recognize culture not as a given, but as a choice. Artists can contribute by increasing our awareness of the rich variety of cultural experience. Of course, that can play out as, "The other culture is weird and wrong." With growing awareness, however, we come to see that most every culture has both positive and negative consequences. In their rich variety they illuminate the range of our human possibilities and our responsibility to choose from among them. It is all part of coming to accept responsibility for our values instead of just embracing the received values of the culture in which we live. Instead of living by simple black-and-white rules, "Do this and don't do that," we learn to accept responsibility for choices that are varying shades of gray with a degree of wisdom about which choices are more likely to play out in positive consequences for the whole. The healthy developmental trajectory of human consciousness progresses from the wholly narcissistic consciousness of the newborn to the ever more inclusive consciousness of the wise elder that identifies with a much larger whole.

WC: Joseph Campbell talks about the common threads of cultural perception that we find in the stories of different cultures that often are manifest in creation stories, myths, the hero's journey, *et cetera*. He says, "I may speak a different language, I may look different, my customs may be foreign and strange but when you pull the curtain back on the foundation of our beliefs and values you're going to find all this archetypal resonance." So one role that artists have played is to use this as raw material—literally patching it together—building a cultural bridge to finding common ground. Is this something you have seen in your work?

DK: Absolutely. I don't know if you picked this up from *The Great Turning*, but one of my defining experiences was participating in the gathering at 1992 Earth Summit in Rio of nongovernmental organization/civil society leaders from all over the world. It involved somewhere around 18,000 people and was the first time so many people representing such a diversity of culture, religion, class, nationality, and race had ever come together for an open dialogue. The discussions centered on seeking common commitments to creating a world that aligned with our shared values. For many of us this led to an extraordinary awakening to the fact that underlying all our many differences we had a common foundation of universal values and aspirations regarding the world in which we most wanted to live. The Earth Charter was ultimately crafted through countless further conversations with yet more thousands of people as a codification of shared values and vision.

WC: To be able to explore and articulate these common values was pretty extraordinary. Large group work is not easy, particularly in such a diverse cultural marketplace.

DK: The discussions were organized around a process of creating "citizen treaties." It was a wondrous, often chaotic, process that invited anyone who wanted to do so to convene a discussion on a theme of his or her choice. This produced 46 statements or "treaties" that presented our commitments to one another and the world regarding the work we would carry forward together as we returned to our respective homes. The treaties deal with agriculture, health, equity, the environment, justice, and much else. The results are all available on the web at http://habitat.igc.org/treaties/index.htm.

WC: There is a United Nations document called The Report of the World Commission of Culture and Development that provides an interesting counterpoint to the Earth Charter. It poses critical, pressing questions about social and economic justice in order to determine the relationship between art-making and language, religion, and cultural practice. It could be thought of as a companion manifesto to the Earth Charter.

DK: It is greatly encouraging to see this question placed on the table for serious examination. Perhaps it is an indication that artists are themselves awakening to the deeper significance of their work and the need to assume intentional responsibility for the broader social implications of the images, values, and emotions they communicate.

WC: The world in which artists are trained is not that much different than the world in which everyone else is trained. As such, you're going to find a similar continuum of consciousness. But if you consider art-making as potentially sacred then there is a level of power and responsibility that comes with the practice. Different artists have manifested this power in different ways, some doing damage, others doing the right thing by it. But, we live in a society that trivializes this power. So, many artists are brought up thinking, "Well, the most that I could do is make a little money and add a little beauty to the world," which is not a bad thing. But it is a far piece from imagining that you could actually influence hundreds of thousands of people to change their mind about something or create new meaning. That is the big issue in front of my tribe. How do we manifest this potential power?

DK: There is a big difference between whether the artistic expression of a culture communicates a sense of beauty and possibility or of hopelessness and despair.

WC: Yes, but during my ten years working with artists in the California Department of Corrections I saw how these two world views are made of the same cloth—that our creativity and our capacity for destruction and despair really have a common genesis. They come

from the same place; one is intrinsic to the manifestation of the other. This is particularly apparent when you recognize that the creative process is not just about making; it's about making and unmaking and the miracle of mistakes.

DK: Right, the process of creation is a constant process of dissolution and formation.

WC: And, as we've just been discussing, this power can be harnessed for good or ill and become a negative force when it's out of balance. You've discussed the need for greater balance between the masculine and feminine. Do you see a role for the arts in trying to bring about this kind of balance?

DK: Obviously, yes. Art properly explores the positive and negative sides of both the masculine and the feminine and the potentials for synergy between them within both the individual and the multigender group.

WC: Is it possible that the act of making, thinking of oneself as a creator advances one's connection to the feminine side, particularly for men who often do not have that opportunity?

DK: Yes, we males often find ourselves connecting to the world in ways that are violent and destructive. Erich Fromm wrote about the deep need of humans to affirm our existence, our presence, by having a demonstrable impact on our world. We can do that through either creative or destructive acts. If the creative path is blocked we demonstrate our presence through destruction.

WC: When you consider the stories that inform our view of how the world works, many rely on metaphor. The military's use of sports metaphors is one that comes to mind. Metaphor is also a primary source code for artists as well. Where do you see metaphor fitting in the journey towards cultural and spiritual consciousness?

DK: I think it really comes to the fore when you're talking about creation stories, the ultimate foundation story. I shared a platform with Marcus Borg, a popular Christian writer, at a conference in Seattle in 1999 in which he offered the profound assertion, "Tell me your image of God and I will tell you your politics." One is the anthropomorphic image of God apart in a far place. The other is the spirit image of God as manifest in all being. These are sharply contrasting metaphors and the choice between them is foundational to our values and worldview. One supports an authoritarian politics of domination; the other a democratic politics of partnership

WC: The stories that you articulate in the book, the security, prosperity, and meaning stories are a good way to encounter the power of a coherent world view. The Empire versions of those stories are very compelling and seductive, particularly the meaning story, the spiritual movie, with God the father drawn out so specifically and concretely for easy consumption.

DK: The choice between the conflicting metaphors of patriarch and spirit rarely enter into conscious public discourse. The press gives considerable attention to the debate between creationists and evolutionists. The former believe in an anthropomorphic God who created the world with a wave of his hand in six days. The latter profess a world devoid of spirit, intelligence, and consciousness that evolved over billions of years through a combination of material mechanism, pure chance, and life's competitive struggle for survival. The religious story postulates a supreme creative intelligence that is extrinsic and distant. The science story denies the existence of spirit, intelligence, and consciousness. A third story, although widely believed and more consistent with both the data of science and the teachings of religious mystics, is largely missing from the public discussion. This story postulates a unifying spiritual intelligence as the integral ground of all being. It is stunning to me that nearly everyone with whom I discuss these choices subscribes to beliefs that align most closely with this third story. Yet it rarely, if ever, finds a place in the public discourse. Even more stunning is the number of religious leaders I've discussed this with who subscribe to the spirit model as their personal belief, yet frame their sermons and liturgy in terms more consistent with the model of a distant patriarch. I believe most scientists embrace the intrinsic spirit model in their heart of hearts, but fear professional censure if they speak their truth in a professional or public forum.

WC: So you are saying we live in a world where the scientists and the ministers probably have more in common than they can officially admit. Do we live in a society where our stories are mutated by fear of censure?

DK: I think it's very clear in both science and religion. Each has its own culture or ideology—and its own heresies. Almost by definition, a scientist must deny that spiritual intelligence is at work in the universe in any form to remain credible with his or her professional colleagues. It is much the same reality as in economics. To be an accepted member of the economics profession, one must profess belief in economic growth, free trade, and free markets as beneficent for all humankind. I never identify myself as an economist, because I recognize mainstream economics as an elitist ideology at odds with reality and critical thought.

WC: One of your points is that within an imperial culture it can be difficult to distinguish those adults who have advanced to the level of a Socialized Consciousness from those whose consciousness has never matured beyond the level of the Imperial Consciousness. Do you think that there are some out there who, because of cultural expectations are locked into an imperial consciousness, may not actually view the world in that way?

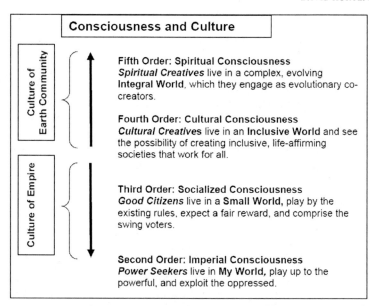

From *The Great Turning*. Used by permission.

DK: Yes, in an imperial society the rewards tend to go to those who live by the values associated with the Imperial Consciousness. The Social Consciousness, the modal adult consciousness, is essentially the swing vote. It adapts to the prevailing culture. If the culture is defined by the values and worldview of Empire, the Socialized Consciousness will swing in favor of Empire. If the culture is defined by the values and worldview of Earth Community, it will tend to swing in favor of Earth Community. The Socialized Consciousness is adaptive. The true Imperial Consciousness remains too self-centered to recognize the possibility of a world in which anything other than ruthless competition and self-centered individualism are the norm. People who appear to be really stuck in the imperial consciousness may have an inherent potential to progress with proper guidance, but in their present state appear wholly unable to comprehend the possibilities of a cooperative and nonviolent society. We can all comprehend the orders of consciousness we have passed through, but not necessarily those we have yet to achieve.

I believe the leadership for change must come from those individuals who have advanced to the level of the Cultural or Spiritual Consciousness. By definition, they have awakened from the cultural trance. They are thus able to participate in the self-reflective work of bringing forth a new life-affirming culture. My most useful contributions take the form of expressing the truths that most persons of a Cultural and Spiritual Consciousness think and feel, but rarely hear affirmed in the public dialogue. By expressing these truths and connecting the dots so that people can see and contrast

the stories of Empire and the stories of Earth Community, I help people see more clearly the roots of the current human crisis and the path to its resolution.

WC: Some artists explore this territory as well, this connecting the dots or, using another term, through synthesis. This is the ability to locate meaning beyond the surface or even to intimate the invisible and the transcendent in image, through vocalization or movement or whatever. So, the abstract is not a foreign guest.

DK: Art in all its many forms has a central role here. One of the greatest challenges for the arts is to communicate the image of an integral spirituality. It's a whole lot easier to draw a picture of an old guy and name him God.

WC: Here's another quote from your book. "The human brain must sort and translate data of our senses, not only into information useful to our survival, but as well into the complex abstractions of ideas, values, and spiritual understanding essential to our creativity, social coherence, and sense of meaning." Do you see a role for art-making in the development of social coherence and sense of meaning?

DK: [Pause.] My hesitation comes from thinking, "If art isn't doing this, then what's the point?" (laughter) On the other hand, the fact that art has never become central to my thinking about these issues, may be an indication that art, at least as I experience it, is not playing that role in the culture to any consequential extent.

WC: Actually, a more intrinsic question might be why do you think human beings make art?

DK: Apart from those who do it solely for the money, it flows from our deep desire to connect, express, explore and understand our nature and relationship to Creation.

WC: Which might also be called social coherence and sense of meaning?

DK: Social coherence has to do with the explicitly shared values and shared ways of interpreting the world that allows us to function as a coherent social organism. Meaning, I think, is a different and higher order issue. But I think we are driven to a search for meaning. And, of course, the conventional religious story is about finding meaning in obedience, which is not a very satisfying meaning. And then conventional science, as far as I can see, just strips away any possibility of meaning. The integral spirit creates all sorts of interesting possibilities. I have come to see Creation as the manifestation of a great spiritual consciousness seeking to know itself by becoming. Creativity, in my view, is the very essence of the nature and purpose of Creation as it engages a never-ending process of seeking new possibilities. Everything that manifests in Creation is a participant in and contributor to that process. We humans are Creation's most daring experiment, at least within the boundaries of our knowledge, in bringing to that process the capacities of a self-reflective consciousness. It should not be surprising that

Creation endows us with a drive to know, to become. Art, at its best, is an expression of that drive and the leading edge of our contribution to the creative unfolding that frames the purpose of Creation itself.

WC: Do you sometimes reflect on the opportunities squandered by humans?

DK: Oh my. At times my grief at the lost opportunities of humanity's 5,000-year detour from the path of Earth Community becomes so overwhelming that I burst out in tears. The grief combines with a sense of outrage at the imperial story that holds up wars of imperial domination as the primary source and driver of human creativity and innovation. What a stupid story. It makes one wonder whether we humans are in fact an intelligent species.

WC: War and markets.

DK: The ruthless competition of an unregulated global market dominated by global corporations is, of course, the contemporary economic manifestation of Empire—the economic counterpart of military domination. To me, if you pull away the lie that war and Empire have been the foundation of human civilization and progress, what you see is the truth that the most dynamic periods of human accomplishment came in the pre-empire period during which we discovered most of the arts of our humanness. Empire itself did bring periods of extraordinary creativity and artistic expression, which successive cycles of imperial rise and fall continuously destroyed and rebuilt—all the while suppressing the creative potentials of the vast majority of the populace. Overall, as a species, we were largely treading water until the beginning of the era of democracy unleashed an incredible period of scientific and technological creativity. Unfortunately, because the forces of Empire still trump the budding hope of democracy, this creativity is all too often put to the service of Empire's destructive ends. The fact, however, that so much creativity has been unleashed, even by elementary forms of democracy that remain a pale shadow of what democracy can and should be, attests to the latent creative potentials of our species that a more mature democracy might unleash. Even our immature democracy has brought extraordinary advances in our understanding of the material world and in implementing communication technologies that create a potential to make conscious collective decisions as a species not available to any prior generation of humans.

WC: One word that I didn't see much in the book is "imagination." I'm wondering how you see imagination figuring in the journey, particularly in the story-changing process?

DK: It's a good question. I tend to associate imagination more with the Magical Consciousness that operates in the world of fantasy and magical protectors. I guess I'm more into grounded creativity, al-

though you can certainly define imagination in a way that is not associated with the Magical Consciousness.

WC: In the Waldorf School approach to education, that magical moment is seen as the period during which the imagination is developed and strengthened for later use as an adult, entering into what you've termed the Cultural Consciousness. They feel that the premature intellectualization of a child in early years will retard the imaginal development and manifest as problems in learning or socialization in later years. I'm wondering if you think one might need a healthy imagination to be able to see the possibility of a dramatically altered course for the world—to choose a different story.

DK: Ah. That points to a frame that I don't think I've articulated before. As the individual consciousness matures, the openness and wonder of the Magical Consciousness tends to reassert itself, but in a profoundly nuanced and multi-dimension form that allows us to see Creation's wondrous, boundless possibilities. The transition from Magical to Imperial Consciousness is a move to a very concrete understanding of reality and its material manifestation. As we move from the Imperial to the Socialized Consciousness, there is a certain suppression of our individuality and abrogation of personal responsibility in favor of bowing to the externally defined norms of the culture. With the transition to Cultural or Spiritual Consciousness, we tend to reclaim our individuality, but with a much higher level of understanding and sense of our responsibility to and for the whole. As manifest in adults, the Magical Consciousness is prone to eschew individual responsibility in the belief that magical beings and magical market forces will ultimately save us from our follies.

WC: The unseen..

DK: The unseen hands that will make it all right, the magical protectors.

WC: Some have posited that art-making offers opportunities to explore and practice new consciousness. How does that coincide with your thinking?

DK: It's not something that I have articulated in my writing, but I'd certainly endorse the idea. If you're going to acknowledge unrealized human possibilities you have to have some experience with the higher orders of creative human expression. It seems that the making and the experiencing of art offers such opportunity.

WC: Working with young people I have found that art-making can be a safe and indirect way to introduce profound experience that may lead to a changed mind. In these instances the artist is asking, "So, what's the story that's rising up for you today? The response might be, "Well, I'm angry. I hate school, that's my story." So, instead of saying I judge that to be an illegitimate or an anti-social story we might say, "Let's tell and explore that story using these different creative means at our disposal. We may be painting pictures. We may be writing songs about it. We may be making movies about it."

In the end, it offers a place to begin engaging and discovering that might not be available otherwise, particularly to young people.

DK: You know this reminds me of Cecile Andrews who works and lives in Seattle. She is a proponent and organizer of study circles. She talks about the importance of story-telling in the early days of the women's movement. She describes how individual story-telling became part of the process of changing the cultural story on gender. At that time, the prevailing story of the culture was that the path to a woman's happiness was to find the right man, marry him, and devote her life to his service. But, lo and behold, when women came together and shared their stories, they found that the standard cultural story wasn't working for any of them. In isolation, if our own lives don't conform to the prevailing cultural story, we think there's something wrong with us. But when women got together and shared their stories, they began to realize, "No, it's not me, it's not us, it's the culture."

WC: The archetype of the artist in the modern story is the solitary genius. But throughout most of human history art-making has been a collective process. If you look at the role of the Shaman in tribal life, this was art-making in service to the community's collective consciousness, not in service to themselves or the market. That kind of behavior would have been a terrible betrayal of the tribe. And so, the circles of dancing, the circles of singing in a collective voice was the visceral manifestation of community. The artists that I work with today do this, too. They make art that is community-based, community-derived and community-manifested. So you have many voices, lots of stories and dispersed ownership. This is not to denigrate the geniuses in our midst. They are an important and contributing part of the community story too, but not the only story.

DK: In order to maintain the idea of the isolated genius as the only story, community must be destroyed—which in turn serves Empire.

WC: There are many different sub-groups which you've identified in the book as natural allies in the movement towards Earth Community, communities of congruence I believe you call them. I find that arts activists, community artists, and the like are seldom identified as potential collaborators in this work. Why do you think that's so? And, most importantly, how can that be changed? What can we do to build that bridge so that this powerful resource, this intrinsic resource, is a part of changing culture, offering a different worldview?

DK: There are people working to create this bridge. You, of course, are an example. Another of my acquaintance is Ali Star who is on the staff of the Ella Baker Center in Oakland. She calls her work Art and Revolution. She has brought powerful energy to major public demonstrations like the Seattle WTO protest in 1999 through the use of street theater and puppets and is now working with a wide

variety of artists, including rappers, on the use of art to bring forth a new human consciousness.

WC: In the chapter of your book called "When God was a woman," you describe a culture that honored the power of creation in its feminine form, and you also point out that in a society the relationship between the tribe and the spirit world is mediated by the Shaman. In my reading the Shaman, whose power often manifested through dance, song, and painted image, is the pre-art artist. Are there ways to insinuate the power of the creative process and of art-making back into this quest for a balance between masculine and feminine and the development of spiritual consciousness?

DK: I think I referred to the Shaman as the mediator between the human and spirit worlds. In our present time I think we need teachers more than mediators, teachers who support us in the processes of navigating our individual journey on the path to a Spiritual Consciousness. I suspect there are also many levels to the Spiritual Consciousness. We need teachers who've moved far enough along that pathway to help the rest of us with our journey.

WC: I would say that the Shaman is somebody who uses the mediating force of symbol, metaphor, and story, to share new ways of seeing so that it can be received by community. My fear is that we have forgotten and denigrated this aspect of art-making. The folks who are trying to sell us things have not forgotten this at all. They are using powerful stories, metaphors, and creative processes in service to some very trivial things. But you say there's a need for new stories that support new ways of thinking and acting in the world. How can the committed art-maker encounter the stuff of the new stories?

DK: I think a lot of this starts with conversation. I have this little mantra: "Break the silence, end the isolation, and change the story." As you speak truth, you attract others who recognize the same truth. You can then engage a conversation that becomes the foundation of a collective voice. Soon you have a choir. The foundation of it all is communicating the story of the integral spirituality, the foundation of spiritual consciousness in the intersection of everything. There is great truth to the admonition that "The Tao that can be named Tao is not the real Tao." The task challenges the highest of our skills at artistic expression.

Chapter 2
Lily Yeh

"In beauty, people find dignity"

From 1986 - 2004, Lily Yeh served as the co-founder, executive director, and lead artist of The Village of Arts and Humanities, a non-profit organization with the mission to build community through art, learning, land transformation and economic development. Under her leadership of 18 years, the summer park-building project developed into an organization with 20 full-time and part-time employees, hundreds of volunteers, and a $1.3 million budget. The Village became a multi-faceted community-building organization with activities such as after-school and weekend programs, greening land transformation, housing renovation, theater, and economic development initiatives. The center worked on local, national, and international projects, and was a leading model of community revitalizations throughout the country.

Since leaving the Village Lily has devoted herself to the development of Barefoot Artists, Inc., a nonprofit arts organization based in Philadelphia, Pennsylvania, that uses the power of art to transform impoverished communities. Using the concept and model proven in her 20 years of work at the Village, Yeh works on projects in Kenya, Ghana, Ecuador, China, and Rwanda, among others.

WC: Do you see this as a particularly significant moment in world history, and if you do, what do you think is going on?

LY: I think we are at the tipping point, maybe, or we're already passed over the tipping point just in terms of the environment and of the almost unstoppable push of the dominating, top-down, capitalistic economy. I don't know of a way to stop it. I feel the threat is at every level; it threatens diversity, people, culture, plants, and the seas, everything. It threatens the well-being of the environment and the possibility of a sustainable future. So, in the communities where I work, I feel it is so important to create a counter-force to provide some kind of balance.

I became aware of a lot of this at the end of my tenure at The Village (The Village of Arts and Humanities in Philadelphia). We all poured our heart and souls, our sweat and good will into our work together. But how do you prevent the market from coming in. Does it all have to end up profit-driven? How do we keep the power of the government and the bureaucracy from selling off what we have created to benefit the people who have the money, the people who have the power and so forth? This is very much in my thinking. I'm asking whether there is a way to create some kind of balance, some kind of resistance, so that the stakeholders can benefit from what they have sowed and reap the harvest. That's why I launched Shared Prosperity Planning Project. It is rooted in a different way. We all claim what our dreams are, and we all deliver so that we do not blame others. We take responsibility; we are accountable to each other when we join force. I definitely see a great danger and a great opportunity.

WC: You mentioned that your experience was that a lot of what people had joined together to build seemed to be dissipating or co-opted. Could you explain that a little bit?

LY: At The Village, we were too much in deficit. It was not immediate danger, but there was danger. For example, Temple University is expanding. They are consolidating their campuses, changing the face of North Philadelphia. We built some low-income housing together with the city at The Village for first-time home buyers and for our staff from the neighborhood. Unfortunately, they could not afford it because of credit requirements and the initial down payment. These are some of the typical patterns that have emerged in urban communities. Artists who can't quite afford the mainstream live in a poorer community. After they build it up and make it nice, then other people come and invest and buy. This has happened again and again in many big cities.

So, this was a lesson. I could see what was starting to happen. In North Philadelphia, in certain blocks the contractors come in and completely level down the existing houses because it's cheaper to build over empty land. People want to sell these houses because

they get money and they move on. They should have the right. But there are times people don't want to sell because they have relatives nearby, they have the church and friends in the community. But the city has the power to make people move.

The developers don't build the way Village was made. We were like water: we come in, we work on one house and we repair it. We raised, I think, $500,000 to renovate four tiny little pieces of property and two pieces adjoining. In the past we got workers and people in the community using their hands and sweat equity to build things quite inexpensively. Then, we fulfilled our purpose. But, when we got some of this city money, it was hard to do it that way. We have to get the architect, and whatever. I said if such little properties take more than half a million, it would be unethical to keep building this way. So, we never built.

WC: Really what you're talking about is a chemistry that doesn't work for everyday people.

LY: Well, the system doesn't work. Our city made it so I couldn't do what I did at the early years of The Village. Because we're more visible the Board becomes fearful. We are all fearful because they all are looking at us. Are you up to code? Are you following the rules? I feel a lot of the money the city gives out maintains the middle level and it doesn't quite trickle down. So then, it boxes in the innovations. It restricts inventive actions and so it gets difficult. One reason I left The Village was that it really was at the point where I either became a developer, an entrepreneur kind of developer, and really plugged into the mainstream development, or that I go where I can be doing more innovative work.

WC: It sounds like you have something in common with Mohammad Yunis, the person who received the Nobel Prize for his work creating the Grameen Bank. He found a way to put the people he was serving at the center of his work rather than making them an extra.

LY: Making them an extra was a requirement of the system.

WC: Yes, so he invented a system to change that.

LY: Right. Well, I failed in that. (laughter)

WC: But you know he invented a system where there wasn't a system. You were working in a place where the system already existed and its self-interest, rules and definitions of success were already established.

LY: Right. We were kind of just kind of overrun by the demands of the system. Sometimes I felt it was more about in keeping the system happy than with making the system sustain creative work.

WC: Let's talk about what conditions you think are necessary for the creativity to remain vital and at the center of the work.

LY: Okay. I think the first thing is that maybe there should be more support for the creative energy to go where ever it needs to go to make the project work. At the beginning of The Village I managed

to turn many vacant lots into gardens. So when people see that, it's immediate. It changed the environment. And so, when I have maybe 12, 13 places changed, then you have a critical mass. Then, later on, we built simple things like a café. We needed a little theater. This simple little 75-seat black-box theater was such a vital economic and a cultural entity. Our attitude was always, "We can make it work". But when it became complicated we just couldn't find a way to beat the system. We got the plan, architects, and then disappointments came over and over. Looking back I should have just built it and then if they want to put me in jail, I would go to jail. But I was being too good a citizen. So the creative energy was there, but the system becomes too cumbersome. Or, I just didn't have the imagination or strength to outwit so many restrictions at the time. In the beginning, we were in the trench. Nobody cared what happened. But then when we became successful, many came, looking at us, loving what we were doing. Then we begin to get bigger grants. But we just needed the money to build little simple things that nobody asked us about. But they wanted us to plan. So, we planned and planned. Eventually, we ended up supporting a lot of projects that others were doing. I just couldn't do that without doing creative work myself. I wanted to be hands on.

WC: It seems like the model that you're describing is the model of an artist making work.

LY: Yes, exactly. So, I think at the end, I am at odds with the whole system. I am more like an artist; I have the feeling where you need to go. It's like water. You don't have a plan, but you have this energy. You have this sensitivity and urge to do something. So, you've got to flow from a high place. The willingness is there. The dynamics are there. The energy's there. Then when you go, you have hindrance, but you just turn the corner and you go somewhere else and then you float right back to where you need to go, but you always go to the low places, where people need water, where people need nourishment. But, then, suddenly, you have to build that dyke just the way they specify. So, I am feeling that the system is changing me rather than support the vision and the sensibility that I have to make a successful organization continue to emerge as the organic village emerges.

So, I am actually quite sad because Share Prosperity actually is a very good way for The Village to raise money. But it depends on the next generation to follow up with this. The ground work is there and it doesn't take another artist. It takes an entrepreneur developer at this stage of the organization. But I still take The Village with me wherever I go. So, whatever I do now, I pass the methodology on. Actually, the way it works now in the Rwanda Project, it's wonderful. I am no longer consumed by the maintenance of a 1.3 million dollar organization. I said, "I'm going to create an or-

ganization, with almost no maintenance." So I became the Founding Director of Barefoot Artists, Inc. I decided to get volunteers who really want to bring their expertise to help people. We went to Rwanda together and they got fired up. Now, we're building a genocide memorial park dealing with the death and people's grief. It has become the official memorial site in the region. It's very powerful and beautiful. In beauty, people find dignity and hope.

Then we went to a nearby village, a survivor's village in Rugerero and we painted images created by children on its many blank walls. People need jobs. We looked at how to create a cottage industry from their imaginations, from children's work and also how to preserve their story. One volunteer is a museum specialist. So, we're looking at how to create a cultural village. We listen to the villagers. They came up with new enterprise ideas; they took the lead in organizing and strategizing. We also have an after-school program and that might become a more intensified educational program. We hope to raise money for an educational fund so we can put 30 to 40 children through a secondary school education.

WC: It sounds like you have returned to your creative roots.

LY: Yes, one thing after another, as it is needed. I brought the Jefferson (University) Medical School there. One of their faculty and a group of students came and started a basic health program. We are working to make a village of survivors who have very few resources, sustainable. The organization Barefoot Artists, Inc. is a low maintenance organization because it is an almost all-volunteer run organization. We hire whatever expertise we need whenever we need to. We don't have a fixed office because we work mostly in the communities. It's just really great.

Then I'm taking this model to China, to Bejing, where I found a host organization, the Dandelion Junior High School for the children of migrant workers. Ms. Zheng Hong, the principal, is so excited. We are offering an educational program which preserves the stories of the children, honors their culture, and builds their confidence. We are training them in mosaic-making and helping them to transform and green their environment. We will use this as a model to make migrant issues more visible. Through this one wayside school community, I want to use the power of art to transform the environment and bring social justice to this disenfranchised community of migrant workers living in a highly polluted area. In China, we do have art. But the public art is highly institutionalized or often portrayed in Disneyland style. Man, we are submitting to cultural colonialization by painting our public art in this western style Disneyland art. They don't even need to send a soldier to our land. We become a part of their colony.

WC: That's amazing. Do you see it evolving beyond this one particular school?

LY: I hope not only just to transform the school through beauty and innovation, but also to create something that people have not seen in China. None of the schools I have seen are doing anything like this: to take the art off the pedestal, from the collectors' hands and from the commercial realm and really empower the people, in this case the whole school, teachers and students, in imagining and learning Chinese culture, folk culture, the world cultural traditions—and creating and transforming their own environment. We first make their environment really beautiful, dazzling, and then we get the children to tell their stories, to draw their stories, and to publish it. So the first stage for these disenfranchised migrant children is building a platform for them to shine and to speak. But we have to be careful to work within the system, so that we won't get squashed.

WC: Where have these people come from?

LY: They come from all over the Chinese countryside. The migrant population there now is 20 million. This is the biggest migration ever in Chinese, in world history.

WC: So, they are being displaced by China's economic transformation?

LY: Yes, by the invasion of the economy. Grain prices have fallen, they cannot make a living in the countryside, the corruption of officials has forced many to sell their land, all of these things and more. Also, China is building, so you need the migrant workers to build multi-million dollar homes for the new rich. You also see the water sources being diverted to feed the economy and the land being parched. Their parents work in these 4, 5 foot high greenhouses that use a great amount of chemical fertilizer. Either that, or they recycle trash to earn a living.

WC: So, you returned home. You've come full circle.

LY: Yes, and I would like to continue working in China. The migrant population is just enormous and there's no language barrier there for me. So, it's easier traveling. I would like to hook in with the existing organizations and colleagues there to connect into the system.

WC: Are the officials aware of what you're doing and how do they respond?

LY: Not right now, but I think they are very aware of what this migrant school is doing. The principal is actually a Harvard graduate. She decided to come back to China to create a school because of the very poor educational opportunities for migrant workers. There are schools, but they're for profit. The school she created is the only non-profit high school in that area for the children of migrant workers. She's totally savvy and she's totally committed to art.

WC: So she is your primary partner there now?

LY: Oh yes. I'm going back in May and then in November. In two years' time, we want to transform the whole school environment into something just totally dazzling.

WC: What's the name of the place in Rwanda that you're working?

LY: It is in the Rugerero district, near Gisenyi on the beautiful Lake Kivu. It is an area where heavy, heavy-duty genocide took place.

WC: Near the northwestern border?

LY: Yes. You can see Goma in the Congo right across the lake. Now, it's dangerous because there are still a lot of Hutu militia in Congo. The way I work is kind of interesting. I would go into a situation without explaining very much at the beginning. In the survivor's village in Rwanda, after some initial introduction, I would start to paint the houses with people. The houses are good, but they're bare. So, we just started painting, with their permission, of course, and people got so excited. They immediately sensed that this is unique and that something more is possible. They see the beauty. They're moved, especially when they're a part of making the change. Because of that, then they begin to organize. They start to think about ways they can make a living. They take initiative to create an entrepreneurial structure. Recently they gave me two proposals and my job is to help guide them to create sound business plans.

WC: You've come a place that is structurally and psychologically depressed. The medicine you have brought for this is beauty.

LY: Beauty, yes.

WC: And then out of that, comes imagination.

LY: Right, beauty can lead to creative action. Action offers opportunities to create more beauty.

WC: Yes, and they have to have a hand in making it.

LY: Right, making beauty and moving to creative action. Then when they experience this, other things come. It's like striking the pilot light. I feel that's what it is to believe in democracy—the equality of all of us; we all have that light within us. So, it's not about one person's light shining very bright. If you get your pilot light lit, then you go and light other people's pilot lights. This is how you create a democratic space. You go to these places where there's a lot of space, a lot of possibilities. You create a simple project that everybody can participate in that creates beauty through action and working together. Then their pilot lights are lit and other creative ideas come that can make their lives better.

WC: So, it's the opposite of being fixed by a system responding to victims.

LY: Right, exactly. You go to the essence of our being. We all have imagination and we all long for beauty. I feel these are angelic qualities given to all of us. There is a kind of beauty that you can buy and put in a museum on the pedestal. But, there is this other beauty

that sings, like the bird. It's like the springtime, the flower, the crocus just breaking the hardness of the ground, stretching their leaves and bringing the most fragile flowers. The longing for this beauty is innate. The power of this beauty is a kind of divine element that's given to us, just like the ability to image. That's our light. We all have it and in that, we are all truly equal.

WC: So, once it manifests, it continues to feed itself.

LY: Yes. When you create this kind of a project you can invite all people to come in and get their pilot lights lit up. I call this the art space that creates the democratic space. The art from the heart creates a democratic space.

WC: I know you saw this happen over and over and over again at The Village. It sounds similar to the idea of "creative space" in New Zealand, in Maori culture. They believe that if you bring beauty to a place using your imagination, you are connecting to the spirits. The more you make this connection in a physical space, the more sacred the space becomes—particularly in terms of healing power.

LY: Yes, yes, and if we not only bring our mind, our capacity, our intellect, but we bring our heart, the art is also an offering.

WC: Yes, a covenant.

LY: Yes.

WC: It sounds like you have given yourself permission to go back into your organic practice. And it sounds like it's a good thing.

LY: Also, I need to tell about The Village's evolution and methodology through stories. I looked at the way we reported on the project at the beginning. Our experience really led the way through telling individual stories. But then, you're always asked how effective it is. How many people came? What is the impact, what are the percentages? A report can get disconnected from the soul of the story it is trying to reflect. It might be accurate. But it can only be true when the people who live the story are at the center, when we use their words as testimony. Those are the words that really move people. It's not how many percentages and how we doubled the profit. It's none of that. When I did presentations I told stories.

WC: So what stories are you telling now?

LY: When I talk about Rwanda, the story of this project is the community and this new idea about volunteers. They have all caught the fire. The potential is there for them to run many projects. The idea is to bring in the people they need to allow it to live and grow in its own organic way.

WC: It's almost like you're looking for places that have rich enough soil so that once you get the seeds in the ground and people learn about taking care of the plants, it is sustainable; it's like being energy self-sufficient and not being completely beholden to external forces.

LY: Right, right. Internal, rather than external.

WC: Another person we have interviewed for this book is David Korton. He has written a book called *The Great Turning* where he talks about the need for reflection and the need for new stories to help us avoid what he calls the "great unraveling." He believes the alternative, called Earth Community, will require a changing of the stories that dominate our worldview—that inform how people see and make choices in the world. We hope that this book will bring more and more creators like you—people who are both manifesting and making a changed story—into that larger conversation.

LY: Actually, I have been moving in that direction myself. I attended a conference in Barcelona about Mohammad Yunis' work. It was about alleviating poverty and community development using micro-credit. I was there to talk about our work, because one anthropologist felt there needed to be some representation of the role of culture and art in community development. He wanted to make sure that it was not just about micro-credit and banking and so forth. That's when I met this person from Rwanda and then I said, "I'm going to visit you." That's how that whole project started.

WC: So, you've been building that bridge already, so to speak.

LY: Yes. Then, I was also in Columbia at the international learning cities conference. Philadelphia was the first city to be a part of this network because the people who launched the project were from there. They knew about The Village and wanted us to be a part of the conference. The question they were posing there was, "How do you make a sustainable and competitive city?" So I was there presenting with city planners and designers. I said, "man, they are all talking about large-scale city planning. Where do I fit? My project is so personal and so small." Then I realized that the whole world is growing towards urbanization and people are being displaced. I said when you move to those places, you need the government, you need the bankers. You need the industry. You need all systems to work for the community to respond to this growth in a healthy way. But when everything is held up and waiting on the government for money to respond, this is when artists take action. That's when we make our voice heard. We are able to help preserve community identity and celebrate the change brought by new members. That's when we do art work. We do culture projects. We do exhibitions. We tell stories. We sing songs. We make art and we create public spaces that are unique and represent the people who live there. This kind of art must be rooted in the community and be sensitive to the cultures of the people for whom the art is created.

 In these urban situations the community is continuously evolving. For example, North Philadelphia has been mostly African-American. Then more and more Hispanics are coming in. So you have to create a new sense of identity that does not exclude, but includes. Otherwise you will have all the sectarian divisions and

differences defining the neighborhoods. So, it's very important to create a new sense of community where people feel an innate sense of belonging--belonging to the place they live and to each other. That's where art and culture must come in to prevent sectarian division and fighting and crime and all that.

WC: There is a difference between a building and a home, between a place to stay and a community. All the best designers and architects in the world can do their magic and that spirit can be missing.

LY: Yes, right. You can make beautiful spaces and so forth, but how do you make people inhabit it with a sense of belonging.

WC: How do you give people an opportunity to make their mark in their own space?

LY: By providing them an opportunity to shape their own environment together.

WC: Where they feel like they are at a place that is connected to their soul, not someone else's idea of who they are.

LY: Right. I think artists have a tremendous role in a world that becomes more urbanized, more alienated from the sense of home and community. This is one of the ways we avoid conflict, find common ground and make a better world. And boy, that is a very important role!

WC: When the armies come its too late. Armies do not build communities.

LY: No, nor do buildings or codes. If there is no community story there is no community. We must preserve community stories to preserve diversity and the richness of human society.

Chapter 3
Dorothy Lagerroos

"Modernism has outlived its usefulness"

Dorothy Lagerroos has had a wide-ranging career as musician and writer, activist and organizer, and teacher and consultant. As a community activist she has held many posts with Wisconsin environmental groups at the state and local levels. As professor of environmental policy at Northland College, in Ashland, Wisconsin, Lagerroos taught and learned about the emerging philosophy of sustainability, especially as local communities in the region announced themselves as "eco-municipalities." Along with Sally Goerner and Robert Dyck, she contributed to a book, *The New Science of Sustainability: Building a Foundation for Great Change*, published in June, 2008, by New Society Publishers. Recently retired from teaching, she consults and gardens in the northwoods of Wisconsin.

PS: Today we're going to talk about the question of whether you think the world as we see it is on the verge of a fundamental shift in values and in the way the world works.

DL: In my work as a professor of environmental studies, I rely heavily on what I learned when I attended the Earth Summit in Rio de Janeiro in 1992. It was at the Earth Summit that I first became aware of what I considered to be a big turning, a huge shift in fundamental values. I went to the Earth Summit as an environmental activist, attending the global forum, the citizen meeting in conjunction with the Earth Summit. I was expecting to meet citizen activists—trouble makers, if you will—from all over the world. I expected them to bring many different views to bear on the question of where the world was headed. What astonished me as I spent two weeks with people from everywhere was how absolutely similar their views and their ideas were. This just blew me away. Sometimes I would just stand still and listen to the conversations that were passing by me. And astonishingly, they pretty much all said the same thing.

PS: What kinds of changes did the people you met there foresee?

DL: The changes that they were talking about were 1) bottom-up decision making as opposed to top down, 2) the importance of women as decision makers and women's ways of knowing, and 3) the central role of spirituality. These were the surprising commonalities to me. Of course, there was also a general understanding about consuming less, at least in the first world, and alternative energy—that was pretty obvious. And much expected talk about sharing the world's resources more equitably. But the really astonishing ideas, as I remember them now, were those thoroughly un-modern ones.

PS: Why do you call these ideas "un-modern"? And what are the implications of that consensus you saw around bottom-up decision making, women as decision makers, and the importance of spirituality?

DL: It was 180-degrees from what most of us understand by the modernist paradigm, from our current scientific, secular, male-dominated, materialistic culture that has characterized Western civilization for about 500 years. It meant a radical change. And that meant we were going to be looking at some interesting times.

PS: It wasn't: "what new law might the government pass?"

DL: No, no. It was not tinkering at the margins. It was not rearranging the deck chairs on the Titanic. It was a whole new ship.

PS: In the about 15 years since you were in Rio, how do you see these ideas coming to fruition?

DL: I am more convinced than ever that all those things that I heard at Rio are well on their way. We still are not to the point where even people who support this value structure recognize that there are others who support these same views. We are still at a point where it is a hidden culture.

PS: Below the radar.

DL: It's below the radar in many, many ways. Yet evidence is beginning to surface that this culture is continuing to congeal, even in the last month or two. Recently *Time* magazine had an apple on the cover and the caption was "Forget Organic, Eat Local." *Time* magazine! Another example would be the rocket sales of the Prius.

PS: I suppose the fact that *An Inconvenient Truth*, the movie about global warming, won an Academy Award might be an example.

DL: Absolutely. I had assumed that the *Time* magazine article about the value of eating local would be a spin-off on Michael Pollan's hot book *The Omnivore's Dilemma*, but that only showed up at the very end. One of the first experts they cited was Gary Paul Nabhan, who studies the indigenous sustainable agriculture of the Indians of the Southwest of the United States. I thought he was one of the deep, dark secrets of the new culture, but here he is in *Time* magazine. Also, my newspaper of choice is the *Christian Science Monitor* and there have been a number of articles recently about a consortium of investors who purchased a power plant or a power company in Texas. There was an environmental commitment involved.

PS: TFX or something. They negotiated with the Environmental Defense Fund.

DL: They negotiated with the environmentalists to put aside the coal-burning plants. Over and over again the changes are starting to come quite clear. *Time* magazine named the Person of the Year as You; but Thomas Friedman, The *New York Times* columnist, said they blew it, it should have been the color green. The color of the year is green. I think we've gotten to the point where the mainstream culture recognizes that we have to do things differently.

PS: Do you have any examples that you want to share about women's ways of knowing? The fact that Nancy Pelosi is now the head of the majority in Congress is something, but I don't think that's what you were getting at.

DL: It wasn't. The women's ways of knowing that I recognized in Rio was that the intuitive and caring approach that women bring to things is useful, is valuable, and needs to be respected. We've been moving towards this, at least in the Western world, for the last 30 or more years. One of the ways that I recognize the prevalence of women's wisdom is in the fact that you can hardly go to a public meeting these days where there isn't at least coffee and cookies. In 1970, that was not true. I think it was as women came to power, they understood the wisdom of having coffee and cookies; to this day, bureaucrats do not have a line item in their budgets for coffee and cookies at public meetings, so they have to hide it or pay for it themselves. But they do it, because it's just crucial to set a cooperative tone.

PS: You haven't said much about spirituality.

DL: I see spirituality as an antidote to our current addiction to acquir-
 ing "stuff." It seems to be arising because we are losing faith in
 our ability to buy ourselves happiness and fulfillment. We continue
 to be told that buying more stuff will make us happy, and then of
 course, it does not. In fact, it seems to be one of the root causes of
 our environmental crisis. So people seem to be turning to the age-
 old concerns of the spirit—being part of the grander purposes of
 the universe, caring for others, and practicing peaceful, loving ways.

PS: What are the issues that will frame this shift as we move ahead?
 What are the central focus points that people or the sub-groups in
 the culture are going to give their attention to?

DL: The key one is environment. That leads to another. Environment
 taught us that everything is connected and so, a secondary key
 characteristic of this new society is the holistic, systems ap-
 proach—learning to look at "forests" and not just "trees." In the
 modern era, the last 300 years or so, we focused almost entirely on
 understanding the parts. We can learn a lot by studying the parts,
 but we can't learn everything that way. Systems thinking tells us
 that a new reality emerges when you look at the whole. You can
 look at my parts. You can look at me, my hand, my organs, the
 chemistry that makes me up, but none of that will give you a clue
 to who I am. That is a new kind of thinking that's characterist-
 ic. I think, also, rather than hierarchical organizational structures,
 we are well moved into network structures, self organizing web-like
 structures. The worldwide web has helped us understand this new
 reality.

PS: I think many corporations are at least experimenting with this. I
 don't know how far they will go with the network or the self-organ-
 izing principle rather than, "I'm in charge, you do what I say."

DL: There have been some really well-storied cases like the skunk works
 at Lockheed. The company was famous for creating a network of
 people, putting them together into a group to encourage innova-
 tion. Now other companies that are into innovation are doing this.
 Innovation does not happen in hierarchical structures. Hierarch-
 ical structures are designed to prevent innovation. That was the
 whole point of it: to keep things consistent. But if innovation is
 what you're after, then you have to put people in teams and let
 them go, saying, "Here, you figure out what's next and just run with
 it." So business has definitely recognized this. Likewise, the story
 of Apple computer and Steve Jobs. It's in the mythology now that
 effective innovation comes from informal coalitions of people with
 authority to carry out what they think of as opposed to commit-
 tees who think up things that somebody else has to do. Groups of
 people who have the authority to come up with solutions and im-
 plement them, that's the model that's new in the business world.

PS: There are certain hold-outs from that though, I would think; public agencies and public schools are often still quite hierarchical and bureaucratic.

DL: Yes and government is always the last place to change.

PS: Why do you say that?

DL: Partly because government only changes when at least 51 percent of the population has changed, because in a democracy, you've got to have support from the bulk of the population. So, government is the last place that's going to change. Business is one of the earlier ones, and, of course, artists have always been recognized as among the first to change. So, to the extent that the arts have moved into networking and bottom-up decision-making and that sort of thing, that's the prescient model that people look to. Twenty years ago I found an article referenced in a textbook on public administration that proposed a model for how things change. The author had a list of the places where you would begin to see change, a set of benchmarks about how you would follow a change. The first place you see new ideas is in the visionary novelists and poets and artists. And then it moves to the kooks and, eventually, it becomes a side issue of a major discipline. So, for instance, environmental ethics was an off-shoot of philosophy and ethics. But now it has become its own field. Anyway, in this set of benchmarks to trace change, the last place you find change is in government. After the kooks come the political visionaries, the Ralph Naders, the Al Gores, and then after that, you get, and I think this was even mentioned in his article, the cover of *Time* magazine. By the time you get to the cover of *Time* magazine, you are well on your way to having established a trend. I used this even 10, 15, 20 years ago with my students to show them how, yes, there is change, but don't expect to find it first on the front page of the *New York Times*. Where you're going to find it is in these other places and you can track it. If we were to track the kind of changes you're talking about, we'd find that they are about ¾ of the way down his list now. They're really pretty well along.

PS: You're arguing that this transformative process will lead to a new way of organizing society and a new relationship to nature and to each other.

DL: Both of those, absolutely.

PS: It's so underway that it's not stoppable. You are optimistic.

DL: Absolutely.

PS: You talked a little bit about your vision of how we should be dealing with the challenges that we face. When I look around the world, I see four major areas of contention: what makes us safe and secure, environmental scarcity and the dangers to the planet, the contending world views between right and left or fundamentalist and liberal, and the questions of social inequality and diversity, both in internally to our society and externally worldwide. So how will your

vision of bottom-up, local versus national, spiritual versus rational be brought into play with regard to those issues?

DL: Several of them are indications of the fact that we are in a major turning. Take, for instance, the black-versus-white, the contending worldviews. This seems to happen when we're in the midst of a major radical shift in values. The last time this happened on our planet was around the year 1500 when we moved from the medieval age to the modern age. That was not a pretty time. When people sense that their worldview is being yanked out from under them like a rug, they get scared and then they get ugly. I think the black-versus-white is largely a function of the last attempt of people to hang onto that which is solid and secure and what they know. The rise of fundamentalism all around the world is a cry, "Please let us hang on to something that we can count on," because everybody senses we're in a time when you can't count on things. So, likewise, the concern with global security follows from that, as do the questions of environmental concerns and inequality. All of those areas of contention are likely to be improved on when the new culture gets a better hold on things. We're now seeing articles all over saying, "okay people, never mind what the president of the United States thinks, let's get together and solve this global warming thing." Again, there was an article in *Time* magazine, My Cry, by Jeffrey Saks, saying "come on folks get together. Here's a web site. You can add your voice. Sign up and say you're on board with this."

PS: It seems to me that at least the U.S. national government is being dragged kicking and screaming to recognition of global warming. Even the state of California is going ahead.

DL: Right. The states have long been called laboratories of democracy. Wisconsin was the first place to have Social Security and worker's compensation. The states have always been ahead of the federal government in really important issues.

PS: You're arguing that when this new paradigm comes to be, the issues we've talked of, like inequality and environmental protection, will be dealt with?

DL: Yes, environmental protection will take hold. I think that the technological advances of the last 20 years or so have moved this miles ahead. People today know intimately people in other parts of the world, far-away parts of the world, including parts of the third world; they have a personal connection, a personal commitment, so that the idea of global society is not foreign. When I was in third grade, they talked about the global village. It was not a global village then, but I think it is very quickly becoming a global village, because people today know and can relate to people on the other side of the planet. They understand how their actions affect people there; it affects what kind of chocolate they buy, what kind of coffee they buy. The whole fair trade movement is very much a func-

tion of the fact that people understand that their fates are inter-
twined. Knowledge is advancing, both of the global environment
and the question of equality, because people have recognized that
those two things go hand-in-hand. Nobody is safe when somebody
is abused. If your fates are intertwined, you understand that. No
man is an island. We used to be able to pretend that it was far away
and didn't exist, but you can't do that any more. People now have
pictures and first-hand knowledge because of travel and because of
communication. When I was a junior in college, I spent a year in
Europe. I did not make one single phone call home, because there
was no way to do it easily. We were told that the connection would
be so full of static that it wouldn't be a satisfying conversation. But,
today people pick up the phone and call the other side of the world
without thought. So, there have been big changes in 20 or 30 years.

PS: I can see that certainly some technological changes, like the web
and cell phones, have made it easier to communicate. People in
fact do that, even poor folk in a far away country can have a cell
phone. What's the down side to technology? I know some are wor-
ried about people just sitting behind their computers and feeling
alienated.

DL: It seems that we hear less about that than we did maybe 10, 15 years
ago, or even 5. There are concerns that kids sit behind their com-
puter screens instead of going outside. There is a great deal of talk
in the psychological community about something called nature de-
ficit disorder; that kids today do not spend their time in vacant lots
climbing trees like you and I did, but they spend time behind their
computers looking at web sites of animals, or playing violent com-
puter games. So, there are some downsides.

PS: We never would have heard of something like nature deficit disor-
der 10 years ago. Nobody thought that was a problem.

DL: But now it's come around to the point where it's recognized as a
problem. I saw a poster for an environmental education conference
called No Child Left Inside.

PS: Isn't environmental education a required part of the curriculum
here in Wisconsin?

DL: It is a requirement in the state of Wisconsin; I don't know if it's re-
quired in other states, but I know that it is taught there, because
the students that I teach come from all over the country. They
are increasingly sophisticated, not only about environmental issues,
but also at operating in teams and in being critical thinkers, with an
ability to sort out the kind of information that comes to them in a
world where information comes unfiltered on the web. There are
no gate keepers. You have to be your own gatekeeper which means
you have to be a more critical thinker. I am seeing evidence that
the kids in the high schools are being increasingly exposed to these
new structures.

PS: That's interesting, because even when I was teaching just 10 years ago, students would fight me on team project assignments. They hated it or they didn't do well, or they complained about it.

DL: I used to have to teach them how to behave in teams, introduce yourself to one another, get phone numbers, blah, blah, blah. I now take a freshman on the first day of class and say "turn to two or three other people and discuss this" and they do it. They just do it. They know how to do that.

PS: We've heard that the public schools are still stuck with test-oriented teaching.

DL: I think it's not true. I think they are overcoming that. I'm finding the students immensely more sophisticated than they were 10 years ago, and better writers, better communicators. I can see change. I've been teaching 20 years.

PS: Let's talk about the arts now. It's fair to assume that the kind of changes you've been delineating will require engagement of the creative energies of many people. What role might the arts and culture play in response to the challenges we have talked about?

DL: I'm a working musician and I consider about 90% of my work as a musician to be problem-solving. I play the organ in church. Most of my musical problems are, "hmmm, how can I make a short introduction that will give the congregation the tempo, the key, and remind them of the tune." This is a problem. This is not artistic *per se*, it is a problem. I don't think that solving that problem is a whole lot different than solving the problem that says, "hmmm, we have buses running up and down the county delivering students to schools. We have buses running up and down the county bringing meals to old people. We have buses running up and down the county doing other kind of things. But, there's no public transportation in the county. We have all of these buses funded by public means so why can we not combine these things and get an efficiency?" Because what I'm doing as a musician is trying to say in as few notes as possible: "how can I set the key, the time, how can I communicate in a few notes so people can do what they need to do?" I think that the problem-solving I face as a musician is very similar to the problems that we face as a culture. So, to this extent, I think that learning to look at things as solvable problems is the key; as a musician, I know there is a solution. While there are infinite possibilities, there is a solution. I don't ever come across a problem where I say, "Oh, I'm not going to play this piece because I can't figure out what the phrasing's going to be." I will figure out a phrasing for this piece. These are solvable problems. I think that habit of thinking makes it easier to move into other areas. That's my own personal example.

PS: Do you extend that model to the arts in general, to visual artists, to poets, writers?

DL: I'm sure all those people have the exact same kind of technical problems that they need to solve. Yes, they have something big they want to communicate. But, 90% of what they're doing is getting past the little hurdles: what am I going to do in this corner of the canvas or how am I going to get this character on stage; that's problem-solving.

PS: The arts employ basic problem-solving so that they can communicate through paint or notes or words. Are there some specific arenas where you think the cultural resources we have here in our society or globally would be of relevance to these big issues we were talking about before?

DL: There's another one I didn't mention. The arts are about quality of experiences as opposed to materialistic, quantitative kind of experiences. So, I think the arts are important. A basic distinction between the modernistic society and this new society that we're moving into is that the modernistic society is basically about quantitative, single measurements. So, the argument for instance about GDP as being the wrong measure of economic well-being is that it's a single measure.

I heard this same argument from a local dairy farmer when I brought my students to his farm. He said that when you maximize for milk production, you lose a whole lot of healthy aspects of the cow. For instance, he is about my age, and he said when he was in college, artificial insemination was successful about 85, 90% of the time. Now it's successful only about 60% of the time. The students said to him, "How could this be? How come?" He said that the animals are stressed. The students said, "What do you mean stressed?" He explained that basically, people have turned cows into milk machines and because of that, all other aspects of the animal have suffered. Their legs are not strong enough to hold them up. They get sick. They have to be fed antibiotics. So when you maximize for one characteristic, the rest of the system goes to hell.

Let's come back to the arts. I think the arts help us understand qualitative and holistic experience better than maximizing and quantitative measures. These measures are at their worst when they are maximizing for one characteristic. When we stop thinking this way we come to systems thinking. And the arts have always had systems thinkers, because the artists are always thinking about the whole, the big picture. While artists may focus on one thing, it will not be to the extent of ignoring the whole. The whole point of the arts is to give you a context, to understand the significance of something. That's a major area in which modernism has outlived its usefulness. Like I said, you can learn a lot by studying the parts, but yet at some point you have to stop. Then you have to put it into a larger perspective. The arts can certainly help us regain that holistic perspective.

PS: It seems you're suggesting that the arts share a world view or an approach to life similar to the ecological approach to life, and that is focusing on the whole rather than a specific thing.

DL: But artists also understand the significance of the parts as well as the whole. My favorite composer is J. S. Bach. The beauty of Bach is that while every detail is absolutely finely honed, it exists within a greater architecture. You can take a 10-page fugue and you say here's where the highest note is, here's where the lowest note is, here's the climax of the piece. The overall architecture is still there. It's not that the details aren't important. The details are important, but they're important within the larger overall structure. I think all artists understand that you need both attention to detail and you need attention to the overall architectural structure.

PS: So, we've talked a little bit about the unique qualities or capacities of arts-based approaches, that might be brought to bear here—both the technical attention to detail as well as large-scale thinking. Earlier we also mentioned the idea that artists are the *avant garde*, the innovators. They're the people who have weird ideas. Sometimes those get accepted.

DL: They're also prescient; they have ideas ahead of other people. I don't know where they get that from, but they do seem to. The creative impulse, shared by artists, is uniquely important to the need to transform. There's this interesting discussion about the role of science fiction writing. There are people who have studied the relationship between science fiction and science. It's not at all clear whether science leads science fiction or science fiction leads science. The people who have studied this will tell you that there's a flip flop. There isn't a consensus about which one is leading, but rather there is an interaction there. What that says to me is that the artistic imagination is important in figuring out where we need to be going.

PS: In his book *The Great Turning*, David Korten talks about the need for new stories. If he's right, if what we need is new stories to frame our view of the world, where do those stories come from? Where should they come from, where might they come from?

DL: I don't know. I don't think artists make the stories. I think people make the stories and artists make the stories memorable. I think the stories need to be more real. They need to evolve out of where we are. But, an artist can make them memorable. For instance, we are in a network society. There's no question about it. But, our old stories sometimes cover up the reality of how networked our society is. If the right artists could tell a story about how networked the world is, we would forget everything we know about red tape and bureaucracy. An artist could give voice to it, give it vision, make it memorable.

PS: So the artists are both the leaders and also the reflection of what's happening to culture at its edge.

DL: More a reflection. I don't think they make it happen. I think they give voice to it. One of the most important memories I had at Rio was John Denver singing *Sunshine on My Shoulder* in front of zillions of people from all over the world. By striking a cord on his guitar and singing, everyone in that audience got goose bumps; they all knew the song. It congealed a sense about nature, about mystery, about all of those things. It was a most amazing moment.

PS: I imagine it was. What should artists and arts organizations be doing? If you had your way, what would the arts and arts organizations be doing to help the transformative processes along?

DL: Probably just being as supportive of artists as is possible, because I think the artistic impulse is unstoppable. Artists just need to be encouraged and given a voice. I don't think there's anything specific that needs to happen. I think it will come out anyway, but to the extent that artists have support and venues, the process will be helped.

PS: You were talking before about the importance of the bottom-up, which I took to be the local impetus to action. That would imply that if artists are going to be important, they should be working locally.

DL: Right. I think the view of the artists as the voice of God, which I experienced in studying 18th and 19th century German poetry, needs to change. The idea was that divine inspiration comes from somewhere up there and that the artist is sort of super-human. To the extent that artists can help others express their yearnings, their visions, that is a different role for artists than being in touch with the divine and having a unique sort of quality.

PS: Artists are a modality through which the creative needs and inspiration of others are expressed?

DL: Right. They can help the rest of us express our experiences. A lot of us still have a view of the arts that I learned when studying Goethe and Schiller and Wagner—those artists were seen as being agents of the divine.

PS: Another view of the arts is that artists are kind of crazy, like Van Gogh. That view says that the only way that creativity happens is through insanity or divinity. So, you're an advocate of the arts being in touch with the Where and the Who that they are with.

DL: Right. Artists need to be the voice of the people.

Chapter 4

Jennifer Williams

"Bridges and translations"

Jennifer Williams is an American based in London, U.K. where in 1977 she founded the Centre for Creative Communities (CCC) and served as its director for 30 years. Jennifer now works as a freelance artist and as a specialist in social change processes. As a member of the International Futures Forum (www.internationalfuturesforum.com), she regularly conducts and facilitates research, evaluations and collaborative projects that link 21st century learning with creative practice, social inclusion and community development. Besides maintaining an active schedule of public speaking and writing for journals, in recent years she has developed a special role as an artist-in-residence at conferences, courses and even parties through an ongoing position with Glasgow's Civic Conversation. Jennifer's artwork is mainly on visual projects ranging from hand-made books, cutouts, photography, illustration and printmaking. Prior to moving to the U.K., Jennifer ran a touring puppet theatre for 10 years known as the Williams Toy Theatre, which was awarded a number of distinctions from the international puppet community. Today she shows her work quite widely, maintains a photo website and contributes regularly to YouTube.

WC: My first question is quite broad. Historically, and in terms of the human story, do you see this current period of time as continuing the pattern of modernism as some have described it or possibly a break, a significant shift in historical patterns?

JW: I would definitely say that the imperative for significant change in patterns has arrived.

WC: What tells you that?

JW: There are signals that say that we can't continue the way we are going, so the need to do things differently is obvious. For many individuals, it is clear that with the exponential population growth and the rapidly developing climate disaster, we cannot sustain the planet by continuing 'business as usual'. What is less clear is how to engage people, institutions and whole societies, in changing their patterns for the common good. For instance, now we are deeply imbedded in an economic system that is based on buying and selling things that are consumed and mainly not renewable. Added to which the things we consume are produced using natural resources and slave labour. The plague of consumerism is now spreading to China and India, where it will prove very quickly to be completely unviable. If people in China and India get what they want on one level, which is 'to be like us', they will all have cars and drive in from the countryside to live in the city. One billion people moving into the cities in India cannot work. Some other processes of how we stimulate and respond to people's needs and desires must emerge on the world stage alongside our attempts to confront shared issues such as climate change.

WC: Are we on the threshold of change or in the middle of it?

JW: Both. We are in change because life-long learning and information communications technology have altered our expectations and are changing the sectors in which we work. As a result, information flows through our lives in completely new ways. The barriers that have traditionally kept sectors (arts, education, science, business, etc.) in separate places have shifted or are beginning to disappear. There is a visible shift in the rhetoric employed by all sectors guided more by widely acknowledged values such as access and participation. There is also a greater value being placed on creativity and on innovation. As individuals we can be an astronomer, an archeologist, a community artist and a gardener all at the same time. The sectors we work in cannot avoid being changed by these new realities. Anyway, I think that kind of change is well underway. I would say this change is evolutionary and responsive to new developments.

 Then there is the change that <u>needs</u> to happen. We have never had to deal with the scale of problems facing the planet now: population growth, food and water supplies, climate, etc. Mainly, we are only on the threshold of change that can deal with these gross prob-

lems, but it is clear that we may need to find some different organizing principles in order to do so. We may need to engage in deep reflection in order to push our consciousness to a new level in order to deal with those seemingly intractable problems.

As individuals and as societies, we are aware of some of these problems, but we go on as if they weren't there. We expect someone else to deal with them. We blame the government or corporations and rely on them to fix things and lament their inability to do so.

WC: Let me ask you about the "them". More often that not, throughout history people have looked to "them" or "they" for solutions when massive problems arise. This would be institutions, the church, the state, the party, etc. Is that changing too? Do you think that pattern still is relevant or still operating?

JW: Clearly it is but, at the same time there is more detachment and more self-organizing. Many people feel pretty cut-off from exercising control over anything in the public realm. In speaking at length with a mix of people from Glasgow recently, their concerns revolved around wanting to be heard and feeling powerless in the face of the problems around them in society--immigrants, health, drugs, money, etc. The problems are complex and their solutions require re-dressing the balance between what traditional institutions have to offer and efforts undertaken by individuals and communities. Compounding this problem is that, as a species, perhaps we have lost sight of our place within nature. So, we have a further problem characterized by a statement I heard in speech: "If all the insects on the planet died, the planet would die. If all the people on the planet died, the planet would flourish."

WC: That's a stark equation, isn't it?

JW: This relates to the Gaia ecological hypothesis that proposes that living and non-living parts of the earth are viewed as a complex interacting system that can be thought of as a single living organism. This paradigm and others are interesting and useful, but perhaps not sufficient on their own to get us onto a new track.

WC: Do you see evidence that the necessary paradigm is emerging?

JW: I think it's in the balance. The reason I was talking about India and China a moment ago is I spent the last two days at a seminar with Rajiv Kumar, who is executive director of the Indian Council for Research on International Economic Relations, an economic policy think tank in India. He's a spiritual person. He was talking about the fact, the extraordinary fact, that there are still tribes in India who live entirely in and from the forest. They know that if the forest doesn't live, they won't live. So, they take care of it. Somehow we have lost contact with understanding that if we cement over the planet, our survival is likely in question.

WC: Do you feel the spiritual aspect is an important aspect of this sort of world that we're entering into?

JW: I think it's hugely important, though one of the things we talked about in the seminar yesterday was the danger that the words 'spirit' and 'spiritual' can scare people off. People might think that they are limited to use within a religious framework. But for me, being mindful of the spirit takes me on a path that is guided by fairness, dignity and equity. Unfortunately, I think we have bred multiple generations of people who worship consumerism basically, and who have lost their connection with their inner selves. How that gets turned around is a very big question.

WC: Is there a significant role in all this for people who are engaged in art-making and all of the things that implies?

JW: I think so. Particularly if you look at what someone like Adrian Sinclair [Director of Heads Together Productions] has done. Adrian is someone who cares about helping people fulfill their capacities. He worked in development before becoming an artist. His canvas is located in social change settings, whether in education or community development. He uses his arts training as a reference or starting point for the work he does. My new theory about Adrian is that while he relies on his trained imagination and creative skills, what he does is something different than the traditional picture of an artist. He is not 'simply an artist' but rather a complex hybrid sort of worker, a transformer. He's somebody that goes in with the expectation that the people he's going to work with both have the right and the possibility of transforming into something more than they are at that moment. His art is in co-creation and confidence building through creative expression.

 If his co-creator is somebody in a factory who is losing his job, then the transformation might be in helping that person to figure out a way to re-identify himself with the next part of his life. Though, if you were listening to Bert Mulder (see Final Section) on this topic, he would extend it to say that though the story of this person's life changing is very interesting, the artist would do well to reflect more deeply on just what happens in this process. In this way, he suggests, the work can be even more effective and long lasting.

WC: Actually, Bert came and worked with Adrian's group, didn't he?

JW: Yes, and what he shared has settled several issues in my head. Bert reinforced the idea that while creative training is an absolutely essential part of work by participatory or community artists, the time for reflection is equally critical. I spoke to Bert last weekend and expanded that thought saying, "That's fine, do the reflection, but, not just with yourself." He said, "Artists engaging communities need to reflect with others too so that they can develop a language for what is actually happening when they go in and do an interven-

tion. So when an artist goes into a school it's about more than doing something creative with the students and teacher. More than just teaching art, which is important, the artist can also be mindful of how their work can contribute to change in the education itself."

WC: So, extending the influence and power of the creative process and creative thinking beyond that moment in the classroom?

JW: Yes, once you have a language that defines that work in some detail, then you can make a kind of model of it. It's not that you repeat the model like the curriculum you did in classroom X. But, it's a model, a universal model that can be translated into various situations. For the work to be at its most effective you need to frame the work in such a way so the teacher too can go beyond the celebratory and immediate. The work of the artist can then be seen as a tool for the ongoing transformation of education as well. The part that really hit me about his lecture was the thought that the information society at its base needs to make sense of things, needs meaning. If the arts aren't for anything else, please let them be about meaning. It's making that connection, without disclaiming it, but really identifying it.

I had an interview with the education director at the Calouste Gulbenkian Foundation in the U.K. who funds 90 pupil referral units. Pupil referral units are for kids that have been excluded permanently from school. He placed an artist in residence in every one in England. He said, "Some of the artists are just natural and intuitively they can make their creative practice work in almost any situation and that's great. But, often they can't tell me why their basket weaving, for instance, would be better than dance for a particular child—or why this kind of dance would be best for these kids." So, he said, "The art therapists often win out because they have done that analysis. Even though their work is not as exciting or interesting as art, they become better collaborators with the professional psychologists or teachers that ultimately must deal with the young person on a long-term basis." In a way he was saying the same thing as Bert but in a different way: unless you can make the connections to the work of others, participatory art will remain on the fringes and not be joined up with the rest of the world.

WC: Would you also say that an additional challenge is to retain the quality of local, individual practice as you build your coherent model?

JW: That's right, and also acknowledge the quality of practice of the other practitioners.

WC: So he is talking about going beyond specific stories of good work and positive outcomes. He is challenging artists to identify how and why the positive outcomes occur. He is asking for more clarity about intention, practice and impact. So in response to my question about where does the creative sector fit into the changing

world, you're both saying, "If you want to play with the big boys, you need to be more rigorous about what you're up to."

JW: That's right.

WC: You're also working with a futurist think tank, the International Futures Forum. How does human creativity and the creative sector enter into those discussions?

JW: In the IFF we are dedicated to the belief that while it is powerful and useful to explore objective, measurable and impersonal data in order to remove ourselves from subjective human experience, other representations of knowledge that tap into the artistic side of human nature can also yield important understanding. Art is transformative. So if we are looking at an economic regeneration problem, we acknowledge that it is not just about economic activity but also about enhancing the feel and experience of a place, the quality of life. Our international membership of about 20 people is drawn from all sorts of disciplines: science, business, education, community health, sociology and the arts but we all believe strongly that we live in a modern world of great complexity. It changes fast. Things are interconnected, and so there are as likely to be unintended consequences from our actions as intended consequences. This world is messy, difficult to understand and can be confusing.

But given that complexity is the inevitable reality, tuning into it rather than trying to tune it out offers a better chance of transformation. Acknowledging complexity and dwelling with it for a while rather than accepting pat solutions offers the possibility of more lasting effective decision-making and action. It increases possibilities, and it forces us to listen to the many voices and many perspectives in every situation. In this world we cannot rely on a few experts to know and to do everything. We need to draw on the intelligence of everyone, acknowledge that the picture will change even as we are seeking to understand it, and recognize that ideas and actions will pop up in most unexpected places.

All of this leads us to creative practice, the development of narratives, and story-telling. We take that kind of group perspective and work in various places. In Falkirk, Scotland, we work with 20 or 30 people who work for many different departments of the Falkirk Council. In preparation, the 8 or 9 IFF members visit everything from the community to British Petroleum plants, to football grounds, and community groups to the health authority. We listen to what they are doing and to their insights and aspirations and then reflect back to the council officers group what we have heard about things they're doing as a community. The meetings are spread over 2 or 3 days. We don't try to advise them, but to join with them in identifying the more problematic issues at hand and together with them practice processes of reflection and reframing futures in the face of uncertainty.

WC: So, what's the hoped-for outcome for these explorations?

JW: Partly, we hope to acquaint people with the desirability of taking transformative action, which is not easy. We help them realize that given the complexity of their landscape, they cannot expect to control everything that goes on. And ultimately, to help them cultivate the conditions necessary for enabling change and the creation of new knowledge. It is an emergent discussion process very like what one might do as a community artist. We use different tools, sometimes including art facilitation.

WC: When you speak about new knowledge what are you referring to?

JW: I would say that it is not about new process knowledge, but rather an attempt to give people a chance to encourage their own consciousness about what is possible to expand and even evolve. The aim is to be optimistic about people's ability to continue on a personal development path and to encourage them along that path. The IFF talks about redesigning an airplane while you are flying it.

WC: Do you think high levels of uncertainty have become a permanent part of our landscape?

JW: I think so. People make jokes about whether we're managing a death or a future. Should our work be about palliative care for a planet that's dying or should it be pushing forward, still being optimistic even though the signs are not good—trying to find ways to think about things differently, ways truly appropriate for the 21st century. In his lecture, Rajiv Kumar was challenging the audience to work on ways to change the collective mindset about the definition and reality of "consumption." He posited that if we were able to redefine consumption in terms of need rather than of desire, perhaps we could alter the direction and content of economic development. For example, how might we help people or communities to change their way of thinking about going out for the weekend. So, it is not about going out to buy a bunch of stuff, but rather, going for more walks. Which might mean, for the city, that

the economic resources should be devoted to building more green parks rather than more car parks.

WC: So he's concerned with changing consciousness to reorient the allocation of resources and effort?

JW: Yes, because the planet cannot sustain what we are doing. At the moment, there is a flow of money from the West to the East to do things like figure out how to improve the manufacturing and distribution infrastructure in their countries in order to sell their citizens more mobile phones and cars. An alternative would be to give that same money to the same countries to develop technologies for energy efficiency both in their own countries and across the globe. This would have the double advantage of creating jobs in India and working on the intractable problem of energy for the planet. It would be a direct blow to consumerism.

WC: In that vein, a number of the people we have interviewed have called for changing the stories that make up this destructive worldview. But, many from outside of the arts community had not given a lot of thought about how art makers, the story makers, might participate in the creation and sharing of these new stories. What do you think?

JW: I think the arts have suffered from being isolated from other sectors. But there has to be a role for artists to make ideas and images to help society create a vision of a way forward. So perhaps the emphasis should be on finding new ways to connect and communicate with people; by this I mean not finding new audiences, but rather negotiating to be present when issues of shared importance are being worked on.

WC: It sounds like one of the things you're saying is that, as a marginalized community, artists cling sort of desperately to the idea that they are artists and what they do is make is art. Which is fine, but if you want a place at the larger table then that insistence can be a great barrier.

JW: You only have to look at all the conversations going on around sustainable development in the 80's and 90's. This work laid the foundation for the making of a new worldview. The arts and culture community was not invited nor did they ask to be included. Here is a major transformation that has had a huge effect and there was no significant cultural presence whatever in any country. Perhaps if there had been artists present, the conclusions about dwindling natural resources and sustainability would have been less about economics and more about social and health concerns.

WC: And around that same time, there was a growing movement of artists who were engaged in parallel social and political activities. And now these two paths are going in the same direction with similar goals. So, where's the bridge between the two?

JW: That's exactly it, bridges and translations. Unfortunately, many of the core funders of the cultural sector and other sectors don't want to know about this. The rhetoric in many cases has changed. Now the arts are interested in access, participation and citizenship. But the fact is that significant steps are few and far between. I think we need to challenge policy makers and institutions alike to put their money where their rhetorical mouth is and to wake up a bit. I don't know. It gets tangled right away because those funding institutions aren't going to change quickly. So, it's probably going to have to come from somewhere else. More cross-sector dialogues.

 The thing that I took away from Rajiv's discussion about changing consumer consciousness leads me to believe that rather than trying to get a network of people around the world who are thinking this way, it's better to try to go to some of those institutions that are really trying new things to pool their insights and ramp up pressure publicly.

WC: So, a new kind of coalition, a coalition of insight and wisdom rather than mailing lists and funders?

JW: A special branch of Creative Commons.

WC: So the challenge is to figure out how useful knowledge is created and shared and then used and then recycled, the learning community idea.

JW: It goes right back to that thing that Bert said at the Common Threads Open Space Meeting in Glasgow in 1997: "All the library walls are down now so, rather than having to get the librarian to let you in or tell you what's in the library, you now have to know the right question. It's all available."

WC: So what I am hearing is that you see two significant challenges. The first is that there are critical questions on the table that have answers waiting to be married up to them. The other one is for the larger world to experience the product of this marriage as compelling enough to alter the way they see the world working.

 So here's a story and a related question. Once upon a time, the St. Paul School District conducted a big study on the difficulties they faced resulting from the rapid racial diversification of their schools. Parents, teachers, and students in this liberal bastion were dealing with all sorts of paranoid and xenophobic reactions to the changes taking place. The study was a big six-inch thick tome filled not only with twelve letter words and charts and graphs, but also some valuable insight about change in race and fear in the school district. Unfortunately the report was impenetrable. So, they'd done all this work in order to affect some kind of change, but it didn't translate. There was no bridge between teachers, parents, administrators, and kids and this body of work. At some point they went to a community arts organizations called COMPAS and said, "Do you think you can do anything with this to help us trans-

late it to the people on the ground?" They said, "Well, let's see what a fiction writer can do with it." So they gave it to a writer who translated the six-inch study into a 75-page story. The charts and graphs and 12-letter words became a novella that was read far and wide in the district. The story became a bridge between the insightful data and the people who needed it. Is that a model of cultural intervention that resonates for you?

JW: It does, absolutely. This reminds me of scenario-building where you map out in four quadrants things that are certain and uncertain and critical and uncritical. The things that require the most attention will end up in the right bottom quadrant with the things that are critical and uncertain. Then you take those critical uncertainties and you might map out each of those. You might find climate change-sensitive and climate change-insensitive juxtaposed with education for life and education for work. Then you map out all of that and slowly, slowly, you start to build up a picture of whatever the subject is and you can start to then build a story around each one. For example, a group trying to figure out what would be the future of economic development in India did this exercise. They came up with stories that they named. One of them was "Buffalos wallowing in a Pond." Children wait by the side of the pond for their chance to get in. But the buffalos can't get their act together – they just continue to wallow. This is the model they had for top-down change, initiated by people we call 'leaders'. The next related to trickle-down wealth generated by economic liberalization of the 1990s. "Peacocks Strut While Little Birds Scramble" for whatever grain is left over. This is the free market model of change. We read about the antics of the peacocks in the celebrity and gossip pages of the press. The third acknowledges that physical power and the power to intimidate can also initiate change. This was named "Wolves Prowl and Control the Jungle." Leaders in this world are the people with guns and power. Finally, individuals without power can take charge and take small initiatives. These are initiatives of the little people, but these projects glow as bright lights emerging out of the darkness. These are the "Fireflies Arising."

WC: So, a story can be a vehicle for change.

JW: Absolutely.

WC: With the internet and global communication, etc., laws of scale are changing. Small doesn't mean insignificant. Influence doesn't have to be about traditional hierarchal definitions of power. So, micro-businesses, micro-lending, local politics, local economies—all these seemingly insignificant little daubs of people and resource can join forces in a community in a way that is transformative.

JW: This has become necessary because the big systems defined and sold by the old stories are just not working, basically.

WC: So how do these small-scale stories compete with the overwhelming presence of the kinds of stories fed to us by the media. You know, "You need a big fast car to be a popular person." Or "Synthetic baby formula is better than mother's milk." How do stories with less horsepower behind them become transformative?

JW: First of all, you need networks for support of people formulating their ideas. In more isolated places people need a way to have some sort of connection with other people who are doing similar things locally. It's interesting to note that despite some major shortcomings of the current government in the U.K. (mainly, the disastrous decision to go into Iraq), they have instituted quite a tight local community policy. I was reading something today that showed something like 12,000 projects that had been funded at 3,000 to 6,000 pounds all around the country that all had to do with creating local space. The idea was to try to tap into local ingenuity and interest in what happens to the neighborhood or town and transfer power to people locally you know, and it's worked.

WC: If local is becoming central and the divisions between community sectors are dissolving, is there a new hybrid, cross-sector creative skill set needed to navigate these waters? Are creative community developers a new kind of artist translators? Or to paraphrase Beuys, are they "social sculptors?"

JW: I could answer that by saying some of the most extraordinary people that I see doing things would be defined as that; I call them hybrid workers. So somebody who was a community help specialist originally is doing all this sort of animation and imagination building amongst people in the community, making space for people's creativity to emerge, based on their own experience. I don't think there are a lot of them, by any means, but I think there are some and I think they ought to be somehow connected with these kinds of conversations. Have you ever met Gerri Moriarty?

WC: The Irish theater director, oh yes.

JW: Gerri's trained as an artist. She's taking her work in extraordinary places now. She just did a project with young people and the tour buses in Northern Ireland. They are taking older people around Belfast and discussing what they find there. You'd be hard pressed to find the art *per se*. But the effect is very like the participants have had an art experience.

WC: But as a playwright and director, my guess is that if you scratch the surface of her strategy, you would see that she's creating a theater of learning in a sense.

JW: Yes, but she doesn't feel the necessity to write that down as theater and have it put into the theater world dialogue. She's content with the learning that takes place. I think that the element that maybe needs to be flushed out a bit in this whole discussion about the role

of the arts in a changing world is how do these creative resources translate to learning?

WC: By learning, a particular kind of learning?

JW: Not a particular kind, but learning for life, learning to visit each other, learning to be whole people, learning in the Howard Gardner sense of taking advantage of whatever intelligences you have to make your contribution.

WC: The learning that might be necessary to change the story?

JW: Yes, so if I discover, which I did a few years ago, that my main intelligence has to do with the spatial, if I'm not educated in that area in some way, if I don't learn about it, if I'm not given permission to tune into it, then I'm not as useful on the planet as I could be. That potential is unrealized. And we need to realize all of the potential person-power out there to solve the bloody difficult problems we have.

WC: How do we go about deepening this potential, this capacity across communities?

JW: I am convinced it has to do with treating people with dignity and with trust. We must trust that given the right conditions, most people not only want to take part in society, but have something unique to contribute.

WC: How do artists contribute to that?

JW: They have to be very open about where the conversation might take them and to not assume that if you're trained in the arts, that you're the only creative person in the room. We all need to recognize other people's ability to invent, to reflect and to use their imagination. Not just as a kind gesture, but as a necessity. Because, you're going to miss something absolutely incredible if you don't do that.

Chapter 5

R. Carlos Nakai

"The many-colored fabric of society"

Of Navajo-Ute heritage, R. Carlos Nakai is the world's premier performer of the Native American flute. Nakai began his musical studies on the trumpet but his musical interests took a turn when he was given a traditional cedar wood flute as a gift and challenged to see what he could do with it. His first album, *Changes*, was released by Canyon Records in 1983 and since then he has released over thirty recordings with Canyon plus additional albums and guest appearances on other labels. In addition to his educational workshops and residencies, Nakai has appeared as a soloist throughout the United States, Europe and Japan and has collaborated with such artists as guitarist/luthier William Eaton and composers James DeMars and Phillip Glass. Nakai, while well-grounded in the traditional uses of the flute, began finding new musical settings including the genres of world, new age, jazz, and classical. Nakai founded the ethnic jazz ensemble, the R. Carlos Nakai Quartet, which allows him to explore the use of Native American musical elements in the jazz idiom. In a cross-cultural foray, he performed extensively with the Wind Travelin' Band, a traditional Japanese ensemble from Kyoto and together they released an album, *Island of Bows*. He has also worked with Tibetan flutist and singer Nawang Khechog on several productions including *In A Distant Place*. A seven-time GRAMMY nominee Nakai has also co-authored a book with composer James DeMars, *The Art of the*

Native American Flute, which is a guide to performing the traditional cedar flute and includes transcriptions of Nakai's songs.

PS: What I wanted to talk about is how you as an artist see your work in the context of the world as you see it; the changes or challenges we face as a globe, as a nation and as a people.

RCN: Much of my work has been delving into what I call a multi-cultural perspective and that also includes the understanding of what the experience has been for American Indians, who, in this case, are now called Native Americans. Even in that way, I want a fairly clear definition of what and who is a Native American. So, we begin there. I became aware of this issue when I began as a performing artist on an instrument formerly regarded as a traditional component of an older society of hunter-gatherer tribes. Individuals that I meet insist that I should approach using the flute-a-bec in a manner that its use will continue to represent that society in a previous time, rather than what we, the indigenous native people, are today. I have problems with that admonition because as a musician, I find that I have to address many different components of AmeriInd and non-native society that exist today here in this country. The other is that many of the concepts, ideas, philosophies, and even the writing that I do for the instrument come from the influences of people I've studied with or from individuals who voice their philosophies about what they think I should be doing with the instrument to further its exposure in the greater world. In my own work, as an educator and performing artist, I occasionally discuss concepts and experiences in American Indian studies, cultural anthropology and spirituality. I continue to find that one cannot isolate oneself from the world as a person of culture or as a multicultural citizen of the United States. For example, the lyrics in a Pink Floyd recording "The Wall" remarks that one can't live behind a wall to avoid contact with others. The world will always intrude. I use that example as one of my lecture subjects—the idea of living behind a wall and being entirely involved with only a singular perspective in isolation, while discounting the surrounding world of experiences and influences. Because of that, I think, as American Indians, we carry not a chip but a huge log on our shoulders about what may have happened five, six, seven hundred years ago, that's passed down from one generation to the next. We learn at the insistence of elders to distrust and remain aloof from becoming a full participant in the complexities of present-day America that will, in most cases, positively affect how we will ultimately successfully survive in the world. As indigenes, we allowed ourselves to carry historic experiences that no longer serve our present-day realities, but enable a blamelessness that reinforces extant dependencies and social disabilities. So, that self-limiting approach is all pretty much a

philosophic and mythic story with no real context except that of past thought.

PS: The context has changed.

RCN: The context, the contextual clues, the understandings of what one might have been at that time and what one is today are confused in differing observations that limit us from experiencing today's opportunities personally and professionally. Everything is different now, but many persist in romantically holding on to what was rather than what is and what will become of the culture into the future. So, there's a disparity about the whole idea of recognizing the effect of time and change. Further, during my own teaching experience, I found a basic tenet of (AmerInd) public education to be very disturbing; that is, learning how to become specifically oriented toward only the components of one philosophic history and insisting that students carry only that philosophy, without acknowledging their own diverse ancestral heritages. I'd ask myself, "what about the other parts that I am ancestrally and genetically and that the students obviously are?"

PS: Meaning while teaching, you were forced into a uni-dimensional approach?

RCN: Right. I had been admonished by the administrators of my school to adopt a mono-cultural approach to integration into general American societal values. Not to teach my students that we actually live in a multi-cultural, multi-faceted society where they'll find their own way to fit in by becoming totally educated about themselves as multicultural citizens. The reluctance continues in native communities; I've had experiences of being told by groups of elders to pack my bags and go away because I was teaching the wrong concepts. They'd say to me tersely, "You're telling our children to leave the community and don't come back." And my reply was, "Before I go, I think the only thing I have to say to you all is, if you continue to lie to your children about what the greater world out there might be all about, when they eventually get there—let's say you encourage them to pursue an extended degree program and begin working in a career track that will take them out—when they see what you've lied to them about, they won't come back. They'll be angry with you because you've denied them this experience; where if you let them go, they go out and they get new ideas of what other people do in the world. Then they'll come back and say I have new ideas that may help our community." Having grown up in a political family, living in that particular kind of impersonal fish bowl-like existence, of course, you're expected to live up to the expectations of others. Anyway, the outcome of all of those experiences is that I'm finding more and more that I must adapt this multi-cultural approach for myself as an indigenous person and as a citizen in order to fully understand myself philosophically, physically and

spiritually. Historically, I belong to three tribal communities that were impacted adversely, but I'm still here. I continue to survive and function based on how I've learned to integrate myself into the world as it exists today, and to utilize that influence to build on the music and philosophic wisdom of the traditions. I have always questioned attitudes of exclusion and denial because, as all people anywhere know, I live in this place where what I do and what I find in the world that surrounds me interests me, too. So, I write music based on that understanding; it suits my sensibilities and understanding of what a human being should aspire to as a result of their own singular life experiences. In fact, one of the expectations in the philosophy of one of my tribal communities is that I must learn to be of service to others and through that experience, I will come to develop a sense of self respect.

The other point is that I'm still looking for what they call a full-blooded, pure-blooded American Indian. I haven't found one yet, although I get comments like that all the time. When I look at the tribal heritages of myself—my Ute, my Zuni and my Southern Athabaskan or Navajo people—they're all products of different cultural orientations and environments that have ended up in the American Southwest. Each of the tribes has influenced one another in a manner that makes them almost entirely different from what they once were in the past. The traditions of being a native person are also products of interaction and influence one another.

PS: What does tradition mean in that case?

RCN: Yes, what does tradition mean? I believe that tradition is a culmination of various tribally-based tenets of experience-based philosophic wisdom exemplified in mythic histories. With that in mind, I shouldn't be exclusionary and should realize that I must also take a look at my northern Spanish heritage. Where does that fit in and how have I been influenced by it? I can't deny myself that, because much of the musical knowledge and interests that I carry also include the influences and music from those cultures of Europe. In looking at other American Indians, of course, they are admixtures of French, Russian, German, English and myriad other world cultures that had been exiled to this country. In that sense, I continually now encourage people to look back into their own family's history and to put down the $24 novel that we're given in high school called American History. Put that in one space, but take the family space and begin to build on that, because each one of those heritages and ancestral backgrounds all carry tools that we can utilize for survival into the future and for our own personal well-being. I represent the continuation of the dreams of my ancestors from whom I have derived a sense of purpose and to whom I owe a great debt for making it possible for me to realize their dreams for accomplishment.

PS: And that survival into the future, how are you looking at that, how are you seeing that as unfolding?

RCN: I think what I've been experiencing—let's say from 1946 up to just this afternoon having attended a meeting here that deals specifically with American composers—is that we're still belaboring a romanticism that puts us in a different light. What we really need to do is begin to look at ourselves as a viable cultural community of mixed heritage, a multi-cultural people, all living together from different parts of the world who carry sometimes different philosophies, which I describe simply as tool boxes for personal survival. Every tool box of culture carries its own way to attend to those things that confront us adversely or positively in the world, in order to grow and build upon. Rather than saying, as used to be the case foremost in American teaching, that Americans are either a mongrel culture or they have no culture like the American Indians. Even though many people were forced to come here, we still have connections to one or more cultures that we were before. It's those connections and history of how they came to be here that are most important to me and allow me to say to another person, "Tell me who you are, not just I'm an American, I live in New Jersey, but tell me about your family's history and I'll tell you mine and let's compare notes of the hardships we've experienced together and why we now live in America, in this country, that I describe as a country of throw-away people, who are making a significant impact in the world." We've taken the English language and built it into a flexible multi-linguistic language that's utilized world-wide now, because it incorporates all the languages of all the people who were forced to come here. It's a universal language now. The culture itself has also taken the music of all the cultures that have come here and recombined the sounds in such a way that it speaks about being here in native America. While, at the same time, I can listen to Mozart, Beethoven, Tchaikovsky, Bach, and Ravel and Debussy or whoever might be out there, for my personal enjoyment. I will occasionally listen to old Spanish-sounding songs and bagpipe music, Navajo or Ute or Zuni chant, and say, "this is all relevant to me because I know why these exist." I think that's one of the important things that may be coming just around the corner, because I'm finding more and more as I speak in concerts and other public events about this idea I have, people are picking it up and building on it and saying, "That's a good idea. I'm going to write a book about this." So, rather than being the one who's going to be at the forefront of all of this, all I'm doing is putting out information and saying, "Who will run with this? Who will take it and build on it?"

PS: Do I hear you saying that you think this multi-faceted, multi-cultural context, which is the United States, gives us positive tools to build a vision for the future, given the challenges of environmental scarcity and inequality we now face?

RCN: Yes. I think it's one more methodology to help us deal with all of the issues that face us today—environmentally, politically, socially—and, on a more personal level, the questions that we all have about our own existence as individuals in a world of others. But, in order to understand who you are today in the world, you've got to know how and where you've come from; that's quite important knowledge. Here I am in New York City right now and, if I have time, I will go to Ellis Island to see what happened there. It's surprising to see, to understand that very few Native Americans ever do that. They may have come through that little doorway. Their ancestors came through there, but as far as they're concerned, that doesn't impact them today because they're here now. "Oh but, how did you come to be here now?" We all carry the baggage of all of the experiences that occurred to our predecessors, things that occurred from our ancestral homelands. What useful knowledge and wisdom should we continue to carry and what are merely flotsam and jetsam?

PS: They may have been driven out of those homelands.

RCN: I think to understand the negative parts and all the hardships that one's ancestors have gone through has made it possible for us to be here today. That is quite important from my perspective, because it will allow me to understand that this is why I respond to influences that impact me daily. This is why I believe the way I do. It also will give people the understanding that we don't have to live outside of ourselves like we are now, being entirely externalized. But, we can begin to appreciate the importance of how those things that surround us in the natural world are very much useful, and will allow us to live and grow in a manner that is more relevant to what we have, rather than what we can take.

PS: Could you expand on that?

RCN: Much of the economy is based on the acquisition of natural resources from other countries. I mean, in the U.S., we survive on the acquisition of imported natural resources. There's oil here, shale oil and coal and other kinds resources, but it takes too much to process. So, it's easier to get it from somewhere else. We're living entirely in a culture where we're dependent upon countries and political systems that are outside of our own awareness. We should, instead, become more dependent on what we are here, and begin to realize that our economy and our sciences can grow beyond anything that we've known before. Rather than being past-oriented we should always look to the future and encourage our children, to train them in a manner that will allow their education to grow bey-

ond what we're doing now. That, I envision, will be the source of more ideas and strategies for the U.S.'s independence materially. Further, many more ideas will come out of that philosophy.

PS: Do I hear you saying if we fostered a more authentic sense of place here in our own land that we'd be better off, not only economically, but also in other ways?

RCN: Socially, politically, especially, because then the majority of us will understand "This is why I exist". The dream of my ancestors was to carry this idea to fruition by expressing the experiential mythic histories to the children, whatever these might be; this I think is sorely missing in many individuals that I talk to, even native people. What was the dream of your ancestors? Why are you here now? Instead of, "I don't know what my career track's going to be; I just have no idea of what I'm going to do in the world tomorrow." We were all born with a dream. I believe that once one begins to delve into the history of how one came into the world, based on ideas and concepts from the past, then we'll also find that key, that dream which will allow us to pick and choose among activities in the world now and into the future.

PS: Some have said we are at some kind of major cultural turning point. Do you think that's the case?

RCN: For the most part, because of the influence of what they call the New Age, there was an attempt to redefine ourselves in the U.S. as a multi-cultural people. So, in the 70's, through the 80's and then the 90's, there was this movement towards how we integrate ourselves into this world that we live in. People said, "Maybe we should adapt American Indian philosophies." Well, a lot of it turned into romanticism. In my case, I would say: "no, no, no, first understand how you came to be here and then find those things that have influenced your family over time. What they thought in their time. If you have grandparents who are still alive, sit down and interview them and say, what is the thing that allowed us to come here, to survive as long as we have? Why am I here? What am I supposed to be doing here?" I believe that each of us citizens must delve into that historic little shoe box that's in the closet of our mind, the one that's covered with cobwebs and generations of dust. If we dust it off a little bit, we'll find those notes that were written times ago that will inform us of the path that we're supposed to be on. Many of those bits and pieces of information, of course, will allow us to begin to grasp how to be here and what way we're going to be, as natives say, of service to the rest of the world. What kind of professions? What kind of activities? What kind of service organizations? What kind of interests do we have, will we have, can we have, should allow ourselves to have, so that we can live and grow into the future and say "I belong to this culture because I have this responsibility to my family's dream." We all carry

stories of adversity and hardship and suffering and pain. There are very few good stories, but we tend to look at only the good side rather than seeing that it took a lot for our ancestors to allow us to be here. For them to say, "I hope that in the future somewhere, one of my descendants will do this. I came to this land with this idea in mind and I'm just hoping my grandchildren will do it." It will happen. Yes, that's what I think we really need here now and I think that's what's beginning to occur.

PS: Why do you think that?

RCN: For me, I'm finding people are asking me questions when I teach this particular subject. Then there are individuals who delve into the psychology of being. Let's see, the latest writer is a man named Eckhart Tolle, who is talking about people sitting down and understanding their own personal state of mind and being. Of course, to understand that philosophy, you've got to get out and collect the stories and research oneself by looking back in your own history: begin to define yourself in this significantly personal manner of self-definition and self-respect based upon self-reliance. Over time, we've allowed our sensibilities to become externalized and outer-directed rather than expressing our unique individuality as viable components within a society of self-aware citizens striving to reach our dreams. In our dependency, we're hampered by FEAR in all its manifestations and we're massaged by media daily about self-lessness and authoritarianism. In the post-WW II era writers have cautioned about the dangers of externalization and inattention to self and family. So, things like that are beginning to show up here and there. Again, we still have the social and political message that says, "No, no, don't think that way because Americans have no culture. This is a mish-mash of different cultural understandings and ideas." In reality, the U.S. uses powers of political force and economics against other people in opposition to the wishes of its citizenry. Now there's a change, and the change, I think, is having a better understanding of where we've been, how we've been, where we've come from, and where we intend to go into the future. Right now, I'm finding that there's a real reluctance to begin to describe that by different individuals that I come across.

PS: Why do you think this is?

RCN: Because it's scary to be out on the edge of the ice, to begin to understand that "Wow, the nice stories I've always heard in elementary school and middle school about the colonial experience aren't true at all." Instead of mythic experiential histories as is the case in indigenous wisdom, we have a morass of overly-romanticized generalities that overlook the diverse immigration of new peoples into the American continent. The ensuing effects of colonialism and efforts at ethnic cleansing are only discussed within anthropological and archaeological seminars, but never in classrooms populated by

students of mixed heritage. I believe the social problem the country's experiencing today is due to this lack of knowledge.

PS: Our educational system and the media do provide a rather uni-dimensional view of what we are or might be.

RCN: Right. I think even that is beginning to disintegrate a little bit. The edges are getting worn a little bit, because it's an old story of externalization rather than defining oneself from one's own sense of understanding. So, I always try to teach people in the workshops that I do about one's inner world, the family relationships and belonging to oneself in a manner based on knowledge of self and family history. Then, there's the outer world of others; by understanding historical experience and the similarities of survival one will understand that being in your inner world is a very personal kind of space, but it's also one that you share with other individuals. You find that they have an inner-world concept, too; when you compare notes, you discover the similarities of historical adversity and suffering. So, now you have realities to compare notes with rather than suppositions and stories that you learned somewhere. The few I have done this exercise with say it's very rewarding, because they feel very comfortable and self-assured now.

The indigenous Native Americans are guarded about letting me into their communities. Over time, with the isolation on federal Indian reservations and urban ghettoes, many have come to rely upon the advantages of economic dependency. American Indians have also assumed the incorrect appellation of being capital n, Native Americans, instead of being "The first Americans". Therein lies the rub, since the American continent was named long after its European discovery in the recent past in honor of Amerigo Vespucci. From my perspective, native Americans are everyone who is born on this continent be it South, Central, North America. In teaching, I remark that, "We're all native, everyone in this room, to the American continent if we are born here. Since we come from many different heritages, we are multi-cultural natives. You would be amazed at what your own family's history is. Look at these as tools. Let's say you have five different kinds of ancestors. Each of those five stories all tell similar ideas and understandings about what the world is to a human being. How one reinterprets those stories of experience is important, because each encompasses philosophic wisdom and strategies for survival that we use when confronted by life's difficulties. Essentially, all we have is our own story of how we came to be in a world of others. So, when you sit down and really think about it, you see that this is why you respond in a certain way. This is why you do what you do. It's all there within your very being." The listeners respond, "Yes, I finally get it," and I reply, "Yes, now it's your turn to teach someone else, please."

I think that's where we're headed right now. I think we're acquiring more of a global sensibility.

PS: Do you consider this to be a kind of evolution of consciousness? I was reading a book recently where the author was talking about that issue. What he argued is that the evolution of consciousness goes from very childish, self- centered, it's only me view, toward a broader global consciousness, which includes all of nature. Are you arguing that that's happening?

RCN: Yes, in a way I think that's happening. I think the reason why it's occurring at this moment is because we're quickly getting into a political confrontation about the environment: over-utilize or begin to pull back and find different technologies that will supplant over-utilization, so we're not so dependent on resources outside of ourselves and the capabilities of our industry.

PS: We're at the point where we need to use those strengths of the past to march into the future?

RCN: Right, but also to find those individuals, organizations and groups to redefine the way that we will approach the future to begin building a new kind of industry, that will be more aware of the over-utilization of natural resources and find a way to integrate ourselves into the world in a more responsible manner. It sounds like I'm an environmentalist, but not really. It's just that there's got to be a better way where everyone can have the security of the availability of resources.

PS: There's no point in wasting stuff that other people could use. I think that's what I hear you saying.

RCN: Yes. Well, consider the garbage piles that are around, the aircraft boneyards that are all over the place. Now look what we're doing. We're wasting a useful resource instead of finding a way to revitalize it in such a way that we can build on it.

PS: And where does your art and arts in general fit into this process?

RCN: Well, a start could be trying to do it by example, or, by talking to people who are at odds with anything that exemplifies change and reintegration into the world. It's difficult, because there are a few who see the positive attributes of being a multi-cultural individual. But, as soon as they get back into the community, it all goes back out the window. It's an expectation relative to the concept of the inner-world and outer-world experience. Once they get back in the inner world of relatives, friends and community then this sense of self-assuredness goes away, but it shouldn't. When I talk with native groups I equate it as, "In one hand you're carrying a sacred medicine bundle that has mythic stories of how you integrate into the world at large but, in the other hand, you're carrying a briefcase. In that briefcase are new ideas and concepts from influences in the outer world that you've found will serve you, not necessarily right now or tomorrow morning, but somewhere in the fu-

ture. Some of the experiences will build upon what's contained in the sacred medicine bundle and others will be from the briefcase, but at no time will both of those two different ways of being become totally integrated. Each exists within their own realm of understanding and wisdom based upon their emphasis. You can utilize both the bundle and the briefcase, if you always realize which side you're coming out of to apply their teachings effectively." We inhabit more than one worldview and genetic wisdom. These varying philosophies influence our daily behaviors and interactions as well as our personal interests. No two human persons are exactly alike, but we should compare notes often to discern who we are. The strength of our being is in knowing our personal family histories, their varied philosophies and the hardships our ancestors endured to make us and their dreams possible. The spiritual sacredness of the medicine bundle is the grounding influence that complements the outer-world briefcase.

PS: Do you think this is something that's easier for artists to do than others? Is there something about being an artist and being identified with the arts that allows one to realize this multi-faceted sense?

RCN: I think so. I've found that individuals in one or more areas of the fine arts have a greater perspective about the difficulties and failures that must be experienced to accomplish their own dreams, than someone who's entirely raised within a culture who has been taught, "Don't look out there because that's not what we are." I still experience that attitude today, but that lack of perspective is decreasing as native peoples become more and more versant in their positive experiences in the greater world. I do see, even within my own cultural group, that there are individuals who are regarded more-or-less as traditional that ask, "How do you do this? How can I go out and do what you do? Do you speak your language? Do you adhere to the ideas and concepts of the older tradition? Do you attend ceremonials? What's your philosophy on living in the natural environment? What's your philosophy of living in a total metropolitan urban environment?" When I explain how I live in two worlds at once and how that requires me to not isolate, but compare and contrast the lifeways in each, they sometimes look askance and reply, "Well, I could never do that!" or "Show me how that works." If it's the second reply, then I've got them. So then, okay, let's first begin by understanding who and what you are. What is your family history and the stories of your ancestors? It always goes back to that. I find with Native Americans or people of European, Asian, or African descent who were forced to come here that there's sort of a block. They won't allow the understanding of knowing how their ancestors came to this country and what the negative components of that experience might have been to intrude on their worldview, except very generally. I say, "Weren't you

born in Chicago? Weren't you born in LA? Weren't you born in Boston? When you're born in a place, you become a native of that place." Let's say I was born in Gallup, New Mexico, but part of my heritage is from northern Spain. So, does that mean I'm northern Spaniard because I want to be that, or because my heritage also includes American Indian tribes, that I must be that and never consider other parts of my genetic heritage? But that sense of denial leads people to think, "I don't want to have that perspective, because then I'm going to be at odds with myself first. Then I'm going to be at odds with the communities that I live in or visit or involve myself in". But, I like to know who I am, and I like too to understand that I'm living in a greater world context with which I can integrate myself because there are others like me.

PS: But people of inherent curiosity or creativity would have a special responsibility in this task.

RCN: Yes. I think that line of misdirected thinking and close-mindedness—that one's acknowledgement of one's cultural heritage is supposed to be cut and dried—is quickly going away.

PS: Why is it going away?

RCN: Because of the understanding presented by philosophers and psychologists about the development of consciousness, and the writings of many people about being themselves in the world of today's America. Actually, this perspective about the integration of multiculturalism, the many-colored fabric of modern America, should be taught in schools. I think that's where we're heading. I really hope so, because then the social ills that we are experiencing will give way to understanding how to find ways to solve our personal and societal issues. This lack of perspective influences the social, the political, the economic way that we are. It influences, gosh, a whole realm of smaller and more personal ideas and understandings. But when we begin to grow out of it, then we find it doesn't really hold water any more, because now we're here in a newer light. I'm hopeful that in the next decade, let's say, that as the millennium grows older and older, we'll begin to find this new sensibility in our day-to-day relationships with one another.

PS: Do you think this development of this broader, more inclusive consciousness is going to be enough to abort environmental or ecological disaster?

RCN: I think so. I think it will, because as we begin to delve more and more into this understanding, we're going to find that we have to have more of a nurturing responsibility.

PS: Nurturing towards?

RCN: Nurturing towards everything that surrounds us in the world that we live in. That's one of the other concepts that I've been grappling with. In the past there has been the understanding that men are the ones who will decide for the world what it will be; it was thought

that the male side, the dominant male perspective, paternal side, has always been. In the social sciences researchers find that there are still cultures that are paternally-modeled, but when you look at the politics in the family or in the community, when isolated from all the other influences, that it's actually managed by the female side of the community. This tells a whole lot about the fact that, when we grew out of being entirely hunter-gatherer peoples, living off the land, that we still saw the importance of someone who could manage without being personally offended by anything.

PS: Well, it was the women who were the gatherers; they were providing half the food supply.

RCN: Yes, and the women managed the whole community through discussion and appointments to duties in the frequent absence of the males in the hunter-gatherer communities. Research also indicates that the women of a hunter-gatherer community could make a plan without saying, "well, let's make war now." So, I'm finding that is going to influence a lot of where we are now. It's like the culture is growing more and more into a balanced perspective on how we integrate ourselves into the world as it surrounds us. That way, we can move anywhere on the planet and be able to socialize freely.

PS: What advice would you offer to a community arts organization on how they might contribute to this process; or does this have to take place one person at a time?

RCN: I've already had those questions. And I say, "Oh, that's easy! There's an organization I work with that will encourage a local composer or two to work with your community to express in music, maybe in writing, and maybe in visual arts, what you are as a community together, mixed cultural heritage. This is possible!" And the response is, "Oh, we never thought of that before." Of course, because the arts are very revolutionary because the arts expand awareness. I think that's where the arts come in, because the fine arts will give you what you really need to know without clouding over the issues that need to be addressed. They'll do it in such a manner that you can interpret, reinterpret, and say, "let's go beyond this dialogue." Now, you're building on an idea that was given to you and you express it in a more personal and in-depth manner. That's, I think, what the responsibility of the arts should be anyway.

PS: You're implying that's inherent in the artistic endeavor?

RCN: Oh, yes. I believe it is, because all the art forms are a way to express understandings and ideas of being through generational time. And we still look back at writings that were done centuries ago about what their experience was in the world and still find it intriguing and interesting. Wow.

PS: Yes, a Shakespeare play can still speak to us.

RCN: Yes, and the writings of the Egyptians on stone walls. Mayan writings and codices from the many different cultures still carry knowledge. I might say "what did your Croatian relative do?" And the response I get might be, "Well, you know, we've never really delved into that. We lost everything when we were forced to come to this country and we were encouraged to speak English." My reply would be, "Go back and find it."

PS: Through the arts, it's easy to do that? Not easy, but easier?

RCN: It's easier.

PS: What are the mechanisms by which it can happen?

RCN: If I found a native Croatian artist, a musician, a visual artist, a sculptor, a painter, a writer, I'd say, "Tell me about your culture." And the artist might say, "I'm part of it but we live here now and we've been given very little information." So, they'll come out and talk about what they know about their culture and its traditions. I would listen carefully and begin to compare and contrast this with my own understanding of who I am. Is there art that I have experienced that will also allow me to understand the perspective of the informant? Do our aspirations and philosophies compare? Is there common ground in our significant life experiences?

PS: So those stories that come out of the arts are tools that can help?

RCN: Right, it's a tool that we can utilize for our own active reintegration into the world. And most times it is free. When I traveled to Spain one year, my main interest was that my ancestors came from there with the forces of Spaniards who came to the American Southwest and married one of my relatives way back when, a great-grandmother now. He came from this particular town, and I wanted to know about this place. The people I met said, "Well, this is what we are. Have coffee with us and sit here." What they told me was, "Oh, don't ask anyone, just sit here."

PS: Oh really? Just be?

RCN: Just be. And you'll begin to find influences that will move you, and that's what we are. But don't ask anyone because everyone has their own story. If you're just there, sit there, relax, listen and be in the community, then you'll understand because it's in your blood. We carry knowledge and awareness in all of our circulatory system. It isn't limited just to the brain. That's what I do now. It's interesting just listening to stories by native people. Right now, I'm doing a research on the emergence of the Athabaskan-speaking people. I have gone to Polynesia, Australia and South America to find clues of similar experiences in the peoples of these environments. The story says that we American Indians came out of Asia, but I'm finding direct relationships and correlations around the Pacific rim which aren't accidental. So, I'm not finding problems with the scientific perspective, but I'm just finding that maybe there's more than one story.

PS: One story gets people in trouble if they only use one story by which to live. Do you work in an interdisciplinary arts context? Do you work with theater people or with dance people or do you mainly just stick to your musical group?

RCN: I'll work with anyone. I have colleagues and friends who are photographers, writers, traditional and modern dance adherents. Many of the modern art forms are also engaged in attempting to understand how this art form evolved into where it is now. Of course, we belong together.

PS: As a way to look forward to the future?

RCN: Yes. It's interesting and I think there's an undercurrent just beginning right now.

PS: Do you see this awareness being expressed on commercial television?

RCN: No, no, of course not. Major media are mainly engaged in keeping us where we are. But, there are communities and organizations here and there that are moving toward that new idea and the waves of expression that'll follow. I think it's going to take its own time. It's not going to happen next year. Might happen within the next generation or two.

PS: That is "time enough?"

RCN: If I keep proposing it enough times, eventually we'll end up with 52 weeks of cultural awareness in this country and we'll have a closet entirely dedicated to that in our homes. We can have, let's say, a French outfit that I wear around this time of the month and next month I wear this other one. You'll have the clothing of your ancestral heritages all there and you'll be able to speak a little bit on each one of the cultures. We'll hopefully all come together and begin to see how we're bound as humans with life experiences that vary a little bit from one to another because of our environmental histories. The story is what's quite important.

PS: It's hard to set off suicide bombings if you look at the world that way.

RCN: Yes. Even that will change. I think if we begin to move out of those countries where we're engaged militarily, that the philosophers will go in, the artists will go in and say, "Have you ever thought of this?"

Chapter 6
Arlene Goldbard

"Create our imagination of the future"

Arlene Goldbard is a writer and consultant based in Richmond, California, whose focus is the intersection of culture, politics and spirituality. Her blog and other writings may be downloaded from her website www.arlenegoldbard.com. Her most recent book, *New Creative Community: The Art of Cultural Development* was published by New Village Press in November 2006. She is also co-author of *Community, Culture and Globalization*, an international anthology published by the Rockefeller Foundation and *Clarity*, a novel. Her essays have been published in *In Motion Magazine, Art in America, Theatre, Tikkun*, and many other journals.

She has addressed countless academic and community audiences in the U.S. and Europe, on topics ranging from the ethics of community arts practice to the development of integral organizations. Recent speaking engagements include the National Conference for Community Arts Education in Los Angeles, the Center for Arts Policy's Democratic Vistas series in Chicago, Temple University in Philadelphia, Creative Exchange in London and Interferencia in Barcelona. She has provided advice and counsel to hundreds of community-based organizations, independent media groups, and public and private funders and policymakers including the Rockefeller Foundation, Global Kids, the Independent Television Service, AppalShop and dozens of others. She currently serves on the Board of Directors of The Shalom Center.

WC: I'd like to begin by asking you to talk about where you think we are historically. Is this just another stop along the road or are we at a particularly significant point of departure?

AG: My frustrating answer is yes to both. Obviously, any moment in time is just another point in history: history presents an infinite number of crossroads. Depending on the road taken, people then look back from the future and see a pattern or unity that enables them to say that was "the renaissance", that was "the revolution." We don't see ourselves that way in present time that: "I'm living through the renaissance" or "I'm living through the revolution." John Berger has that great quote. He says "The past is not for living in; it is a well of conclusions from which we draw in order to act."

WC: Do you think modern media's tendency to commodify history confounds our historical perspective to an even greater degree?

AG: Yes. But, what's the one true thing you can say based on the media account of our times? That is: it's the age of grandiosity. Everything else is opinion or conjecture. We are always claiming that we are the logical end-point of evolution. The assertion is that we can now know things that beings who walked the earth never knew before. Technical knowledge, maybe so, but in relation to ultimate truth, that's got to be crap! I mean, what hubris! I don't know if it's the commodification of history or if it's commodification of all things, but that grandiosity happens to be one of the things manifesting at the moment.

WC: Given that you said we are at both a stop along the road and a point of departure, could you speak a little more specifically about how this might be a point of departure.

AG: The dichotomy that you pose—whether this is the continued development of modernism or a reorientation of some fundamental cultural characteristic, a *zeitgeist* or whatever you want to call it—my answer to both is yes. My hunch is that we are experiencing both. There will be parts of the world where the fundamentalism that we see now will develop to some more extreme point before it finds a turning, and there will be parts of the world where the romance of science and scientism will develop to some more extreme point before we see it turning. But, all things turn, you know. That's a constant in history. When I refer to scientism, (it's something I've been writing about lately), I mean applying ways of thinking and principles and approaches that work well in the physical sciences to human endeavors, to our detriment. So, No Child Left Behind, that legislation contains III references to "scientifically-based research," meaning numbers, quantifiable data. But everybody who works on the ground in schools knows that what's most powerful there can never be quantified. So we have an opportunity, a third way: to come to the end of that road and to say, "Okay, the notion

that only what's measurable counts and only what can be quantified counts, that the only reality is manifest reality—that notion is running its course now. We understand that. It gives us a life that's too mechanistic, it's too thin. It doesn't take into consideration the numinous quality of experience, the ineffable quality of experience; the things we feel and know but can't measure have been left out of our picture for too long and we're hurting from that now. We're hurting a lot from that.

So, what we need is a new integration that—I'll borrow a phrase from Ken Wilber—that transcends and subsumes previous paradigms. That means we don't reject science, we don't reject all the amazing things that have come to us from the application of technology. We don't reject the fact that what can be weighed and measured can be weighed and measured, and we learn some useful things about the world that way and carry that with us. But, we also don't reject spiritual reality, for example, the way Dawkins is doing now, saying that religion is an aberration, that it occurs in some blip of our brain cells and is a great longing for some atavistic thing that can never actually be there, saying that we have to recognize that, more or less, science is God. People like him, the scientistic thinkers, are really turning up the volume on their orthodoxy now, trying to rescue that old paradigm. But we can't go back. The opportunity we have now is to integrate, to say there is tremendous value we're carrying forward from the Enlightenment, that we don't want to go back and live in the woods and think that lightning is a personal sign of God's wrath. But, when we go forward, we want to honor immaterial meanings too. We want to honor the energies and forces that can't be measured and we want to include all of the human subject, not just the part that has worked so well for industrial and post-industrial society. That's something we can articulate. And there is a third force manifesting right now, obviously we're in it and a lot of other people we know are in it, and we are indeed putting that forward. The totally positive scenario for me is that the third force becomes a dominant force for awhile. That that integral view becomes the new paradigm. And when it does, certain things could happen that combine the best of the first two forces. We could use our big brains in a self-conscious way, in this historical way that I'm talking about, since the Enlightenment period. Critical thinking could filter into societies where people are held in thrall to traditional structures of authority that purport to be the voice of God saying, "You have to have female circumcision," or "You have to cover yourself from top to toe," and people start being able to have total choice about those things. So, if they do them, that comes from actual real free choice, women's especially, free choice, children's free choice. And in our post-industrial society, with this new paradigm, we would back off. We would get rid of No

Child Left Behind and all of its counterparts and we'd start having educational experience that recognizes that each person is different and learns in his or her own way and needs a lot of human attention as well as access to technology and systems to do that most successfully, to come into the full development of his or her personhood. In this scenario, we don't become the same but we have more common ground.

WC: Where do you see this manifesting in ways that are concrete? Are there places where this integral path is struggling to emerge?

AG: I'm seeing it a lot in different fields. For example, I've been giving versions of a talk lately about what we've learned from scientists about the importance of imagining action before it's undertaken—how that triggers all the same systems as actually performing the action, and how that, for example, is showing athletes that they can rehearse their performances in their minds. I think this is equally transferable to the realm of social imagination where it suggests to us that we should be getting together to create our social imagination of the future, that doing that will strengthen our muscles, our ability to enact it, will be our rehearsal for it.

We're also learning about the healing of psychological trauma and how the telling of one's story in a safe environment is actually a medicine. We're learning, from the high-tech world of commerce too, where people are acknowledging that there's no educational preparation that the people who started Google could have done to make them better at their jobs, because what they ended up doing wasn't even conceived at the time they were receiving their formal education. Suddenly it turns out that who we need is not highly-trained technicians who have gone down the narrow corridor of knowledge and become certified in that corridor of knowledge, but people who have a capacity to take a whole lot of potentially conflicting information in at one time and see patterns and possibilities in it and see ways to act on those. Those people are going to turn out to be valuable in the marketplace just as they are in the arts and in social organizations of all kinds and in activism.

So what I'm seeing is that the same articulation of the need for this new way of being is coming up in many different fields right now. Rather than pointing to this and that organization or this and that community and say that they're manifesting it totally, I think it's just bits and pieces right now in terms of manifestation. You have to call the need into being; desire is the thing that fuels the movement forward.

WC: This idea has come up in a number of our interviews. Some are saying that little bits and pieces of activity and stories and ideas that previously might have only been connected geographically are, as a result of global communication, building connections and critical mass that nobody can see. They are postulating that there are many

people thinking and doing things that not only are synchronistic, but because of technology, are linking. So using a Google search one person exploring an issue or idea that they are concerned about or passionate about can find a thousand other people who are moving in a similar direction.

AG: I gave a talk about what I call the story revolution. In it, I talk about the story field, the field of stories. I do think that's true. I do think we're seeing a tremendous surfacing of these stories, which I think the community arts movement has a lot to do with. I just saw a story the other day in *The San Francisco Chronicle* where a camera company gave cameras to adolescents in Chinatown to document their lives and tell their stories. The paper made a big deal out of it. So that way of telling our stories is surfacing. But the camera company didn't think of that type of project. It was drifting through the atmosphere and they inhaled and there it was. I definitely think that's happening, and I definitely think it's a backlash to the great man theory of history and the notion that there's only one dominant narrative, a master narrative, and that's the true narrative. It does seem that there are more people everywhere from more different positions saying "Uh, uh, my story is in there too." And there are so many more ways, with the internet predominant at this point, to capture them.

WC: So, where do you think people who manifest creativity in intentional ways—artists, etc.—where do they fit in this new chapter?

AG: If we're right and something's being born, then they have a midwife role. And we (the artists) are not just getting to realize this. We've known it for quite some time and we know how to do it. We know how to sit with people in a circle and get their stories. So that, I think, is preeminent for me: this thing that all these other fields are looking for, I think we are the ones who know how to do it.

WC: Is there a different level of this kind of work that our times call for?

AG: I'm certainly happy to see that there's a slight rise in people needing to talk about it. I'm glad there are more books being written, that are putting it out there saying, "Here are some stories and some views of a different way to look at culture and a different way to look at how it's evolving." Despite the way publishing has gone, it's still true that putting a new way to look at things out in writing can be viral: things can spread with tremendous rapidity and have a large impact. I'm really glad to see that happening. I think there are a number of people like you, like me, like Dudley Cocke at Roadside who are a little bit older, so we've been writing about and doing a lot of public speaking for quite a while now. There is a layer of people like us who can interface with the intelligence of the larger society and talk about the people who are doing the work on a ground level. I think it's important to develop that and support that and have more of that happen.

WC: When you interact with people outside of the community arts realm, like at Jewish Renewal, do you find the notion that human creativity can play in social renewal being discussed? Or, do you find yourself interjecting?

AG: There are a lot of artists among the people at this Jewish Renewal conference I'm attending as we speak, and one of the things that is being renewed is the creative expression of spirituality. So, people write new liturgy and music, they create new images, there are people doing movement in a spiritual practice setting. There's much more integration of all the different forms of embodied and imagined creativity into spiritual practice. Rebbe Nachman said that the antidote to despair is to remember the world to come. The idea is that by having experiences of a perfected world in the here and now, you get a little glimpse or open a door to what could be. That's huge. At this conference, everybody's always trying to concentrate their spiritual energy when they get together in a group, to lift us all. I haven't had many specific conversations here about the role of artists in social change. In this type of space, nobody talks about their work.

I go to Barcelona next week for a conference about public art and public space that they've had for several years in a row. Every other year, it's been someone talking about public art in the more conventional sense. This year, they decided to make the theme community art.

WC: What do you think they mean by that? "Community art."

AG: Well, there's a great group in the city of Barcelona that they asked to help facilitate this program. It's called Artibarri.org, and if you read their website—there's an English page in there—it's just like the community arts verbiage here. They use all the same phrases and everything. They talk about cultural democracy, they talk about community cultural development, they talk about community arts, they talk about working with youth, the whole schmeer. So that's what it's going to be on. Then I'm going to a municipality that's a little bit outside of Barcelona; one of the people who works at Artibarri also works there in their cultural department. There they want me to talk about something that I'm sure you encountered a lot in Europe, their concept of "social inclusion." It's a very, very interesting situation: here is Catalonia, this autonomous province within Spain, which has its own language and its own kind of constitution and its own cultural practices that were so explicitly repressed under Franco. The feeling persists of a minority group asserting its legitimacy and its self-determination as against a dominant culture. In other words, there's still a residue of that, even though the laws and cultural policies give them full rights. Now they're having people immigrate from North Africa and Latin America, especially around Ecuador, and those people don't speak

Catalan. So the Catalonians are tempted to circle the wagons. Now the inside and the outside are the same exact problem, right? They experience contradictory feelings in themselves: what it is to have your culture suppressed as a minority within a dominant culture, and how members of a dominant culture can be threatened by a minority presence. They know it, so that's why they want help.

WC: You spoke earlier of having a vision of the future and the importance of an active social imagination. Do you see exercising those muscles as a mitigant to the tendency to circle the wagons or move toward the safe and secure fundamentalist view of the world?

AG: I do. It's the first step, really, because one thing that's true in really locked down fundamentalist thinking is that it's not even okay to imagine alternatives. It's not even okay to pose the question, "If this were different, then what do we do?" So their desire is to have the mind be a locked room with only one book inside. I can't help but see it as almost entirely fear-driven. So, it feels like an antidote to fear is a wider imagination, just the ability to have stories and spin them and consider different ways they might go. I don't think you can be scared shitless and tell a story of possibility. If you're really scared, it's like your fight or flight mechanism and your adrenaline are activated, so you're just locked down. You really don't have any choices. Once you have choice, you don't have fundamentalism any more. Even if people have extreme beliefs, if they really are grounded in choice, it's not the same as fundamentalism.

WC: In the journey from the safety of the fundamentalists' cave into a place with a wider possibility of choice, is there a practice that needs to be honed? Do we know how to do this? Can you move into a concretized world in a way that's respectful of the fear that lives there, and then help move things along?

AG: I don't know. For one thing, they're not asking us, are they?

WC: No. They're not inviting us at all.

AG: Our hope is based on being invited. A ray of hope for me is the new interest in environmentalism on the Christian Right. Have you encountered this?

WC: Yes, a number of people that we're talking to are environmental workers. The emerging dialogue with evangelicals has popped up in some of these conversations. They are starting to work with people they thought of as their polar opposites.

AG: Yes. There are a lot of evangelicals who are beginning to go there and are beginning to also look at some social justice questions, and saying "Jesus said, Go be with the poor." That opening is happening and those people are no longer going to vote based on only one issue. They're not going to vote for someone who says burn the environment and I don't care about the poor, just because that candidate opposes abortion. That's not going to determine how they move in society. That's seem encouraging. In every country where

we see authoritarian control at the top, there's some opposition-
al movement. There's some peace movement. I think those are
the people that we should make ourselves available to, to let them
know that we're here as potential allies and to ask how we can help.

WC: There's a guy I recently ran into who is in the field of human eco-
logy. He sees fundamentalism at odds with everyday human ex-
perience. He thinks everyone, no matter how extreme their views,
has visceral experiences that reveal the interconnectedness of the
world—that give lie to the idea of separateness. He thinks we're
going to need to get better at discerning those moments and help-
ing people see the beauty and sense embodied in these integrated
patterns. So when someone says, "I am getting tired of seeing the
world as 'us' versus 'them', or 'I win, you lose'," there is a way to re-
spond. Does that resonate?

AG: Yes, it does. Let me say a couple of peculiar things. One is that
most of the people on "our" side of this whole debate do not love
those people on the "other" side at all. We caricature them, we ri-
dicule them, we dislike them, we fear them. I don't think any story
of interconnectedness is going to cure that. So, there has to be
some way around that. The other thing is, where are they? Not,
let's bring them over here, but where are they and how can we meet
them there? I'm working on this prison project called Thousand
Kites right now, and that is putting me in contact with some of
the people we're describing right now. These are people that were
available to be interviewed for an hour at a certain time on Sunday
in their trailer home in Virginia, before they had to go to church
again. These are people whose son was arrested for something that
they felt was a trumped-up charge and got a long sentence in what
is now a no-parole state that is churning out prisoners as fast as pos-
sible as a form of economic development for rural regions. This guy
said, "I was a Republican all my life. You couldn't put something
in front of me that I wouldn't endorse, no matter how far to the
right." When I spoke with him, he said, "Now I see they were lying
to me." So I asked, "How do you think it would be possible to get
other people who didn't have the misfortune that you had with
your son to see what you now see?" He just shook his head and said,
"I don't know. Unless you have a dog in the race, you don't know
what it's like."

WC: Are you there in a sense to share his story? I mean, is that part of
what you're doing?

AG: In this project called Thousand Kites, Roadside Theater and Holler
to the Hood (Appalshop's hip-hop radio program) are working to-
gether, collaborating on a whole bunch of things: a film, a play, ra-
dio show. In the fall, they're going to launch a huge website, that's
basically about the human impact of the prison industrial complex,
to tell that story. It's all grounded in first-person narrative includ-

ing everybody: prisoners, families, guards, officials who built the place, victims of crimes, the whole universe. I'm following the project over the course of several years and writing about it. Within the next month or so I'll be finishing the first essay—which I'd be happy to share with you—which is about the artists who are in the project, why they're doing it, what they believe, and what they hope to accomplish. The second one will be about the families, the activists, the other people who are involved in the issue. The third essay will be about whether it worked or not, because my underlying question is: Is it possible for art to surface into public awareness an issue with a huge social impact like prison in this country now, where we have the highest incarceration rate, the most prisoners, etc., on the planet? So that's my question: is it possible for art to surface into public awareness this issue which has so much impact and has been below most people's radar no matter what?

WC: One of the other people I'm interviewing for this is David Korten who speaks, I think eloquently, about the stories that define the conscious and unconscious world views that form the firmament of American culture. Among those stories, I can't think of one that is more impenetrable or more representative of the times we are living in that the one surrounding prisons and criminal justice. This is the quintessential fear-based story—the story that somehow says that our only option with people who have transgressed is to disappear them and exact revenge. I'm just wondering if this man that you're interviewing had a sense of the bridge you were trying to build between his story and this larger question?

AG: Yes, he did. I was explicit about what I was doing. These people have been part of the story circle that Roadside used to build the script for the play that's part of the project. Then they did a performance in their own community. Roadside created it as a one-act play that represents all the voices. It has a lot of spoken word and music that were contributed by prisoners, too. You can make a real production out of it or you can just do it as a very effective staged reading. Then they built into it a second act in which everybody who is there talks about the issue among themselves. So, these people I interviewed have already been in the play. They're down with the project. They have no problem with it. When I talked to the artists about what they were hoping to accomplish, I thought they would say, "We're going to let people know how bad it is and change everything." And, of course, they want things to change, but they really have a religious belief in the power of just becoming human to each other through the telling of their stories. So, that is their main goal. They're not pretending, it's genuine. They believe in it more than I do. And so, they can be genuine with these people. They value their stories totally, without any ulterior motives.

WC: Maybe that's one of the practices that we have to hone. Honoring and making space for these organic stories, while resisting the temptation to proclaim them as the "truth" that will change everything. It sounds like Roadside believes that our best hope is to release these stories from their silence.

AG: They have a belief that we're able to do such terrible things to each other because we work our way around to not seeing each other as fully human. That this work they are doing is the antidote to that.

Gabisile Nkosi: *Isizukulwane* (Generation), Linocut, Gabisile Nkosi, 2007
from the Healing Portfolio commemorating the 200th Anniversary of the
Abolition of Slavery in the United Kingdom.

Part II

The Web of Solutions

Perceptions of Environmental & Community Activists

The Web of Solutions

Perceptions of Environmental & Community Activists

Rod Mast, Harry Boyte, Sarah James,
Judy Baca, Linda Burnham & Steve Durland

While each of the contributors to this section is well-versed in the environmental and social challenges facing the globe, each also has found ways to work positively for change. Through their work they are confronting the issues of war, inequality, oppression, environmental destruction, and the need for revitalizing democracy. Yet individually and collectively they model the importance of collective commitment and action as we confront the dangers of our times. For Mast, this means using the story of sea turtle as a way to help people understand dynamics of the ecosystem and change their life-styles, while for Baca, it is using art to illuminate the stories of marginal people and forgotten places. Each of these activists provides us with creative ways to transform fear into positive solutions.

Chapter 7
Rod Mast

"One heart at a time"

Rod Mast is a marine biologist and Vice President at Conservation International (CI), a global environmental organization that has worked to protect some of the earth's most ecologically critical sites. At CI, his work has spanned the globe from Latin America to Africa, Madagascar and Asia, always "dedicated to conserving biodiversity and demonstrating that humans can live in harmony with Nature." Since his teens much of his work has focused on studying and preventing the extinction of sea turtles. He has served as president of the International Sea Turtle Society, and has advised and served on the boards of numerous turtle-related organizations, such as Wider Caribbean Sea Turtle Conservation Network (Widecast); Turtle Island Restoration Network and The Leatherback Trust.

In 2003, Mast founded CI's **Sea Turtle Flagship Program** (STFP) to use **sea turtles as icons** to communicate how people can change their behaviors to benefit the world's oceans. In 2007, he helped create the **Great Turtle Race** (www.greatturtlerace.com), which tracked 11 satellite-tagged sea turtles on line from Costa Rica to Galapagos in a media campaign that reached hundreds of millions of readers, television viewers, Internet users, teachers, and students, with a pro-ocean conservation message. Another STFP effort that has gained enormous popular support is **Mr. Leatherback** (www.mrleatherback.com), a comical leatherback turtle costume (with Rod inside) that travels the world and reports back marine conservation mes-

sages via blogs to an internet community of the thousands of members. The recently-born **T.U.R.T.L.E. Brotherhood** (Teenagers United for the Rescue of Turtles and Life on Earth) intends to piggyback on the success of Mr. Leatherback, the Great Turtle Race and SWOT to build a cadre of engaged teenage volunteers worldwide.

WC: From your perspective do you think this a unique moment in human history?

RM: Yes it is. It's a very special time in history, especially for groups like the ones for which I work (Conservation International, and the World Conservation Union) that do non-profit, altruistic work like conservation. We do conservation work in 47 countries around the world, thanks to gifts and grants from individuals, foundations, corporations and bilateral and multilateral agencies that have some sort of an altruistic outlook. When I was a kid, we would have teased somebody for being a spendthrift by saying, "Who are you, J. Paul Getty?" That's because J. Paul Getty and the Sultan of Brunei were the only billionaires around. Now, there are upwards of 500 billionaires in the world. A billion dollars is a lot of money. And when you've got multiple billions, you've got far more than you can spend. So, the available cash for philanthropy is much higher now than it ever has been in the past.

WC: What does this accumulation of wealth mean for the conservation movement?

RM: Most of the fund-raising work that I do is with individuals. You have the increase in personal wealth and philanthropy coinciding with the growth of the conservation movement since the 1960s when Rachel Carson wrote *Silent Spring*. The conservation movement has done a great job of educating the public about life on Earth; just turn on *Animal Planet* any hour of the day or watch "Nightly News" to learn a bit about conservation! Now people are truly aware of nature and the threats to it. They know what a rainforest is. They know what endangered species are. They know what coral reefs are. They know that natural habitats are disappearing and species are going along with them. Now people know that the planet is in trouble. When climate change attracts an Academy Award *and* a Nobel Peace Prize, you know a large range of people are listening and taking heed.

WC: How does that manifest in terms of the mission of your organization? Does it provide a more fertile field for mobilizing people, money and taking action in a way that's going to make a significant difference?

RM: Absolutely. Understanding is fundamental to fomenting change. The fact that there's not a person walking the streets in this and other developed countries who doesn't know about what's happening to the planet is incredible. They may not know the details, but

they know that there are problems and that they're part of the problem and that the time to do something is now. I witness this often, when I travel to remote areas of the world. Even small communities in tiny villages without electricity are aware of the situation—often because they are experiencing environmental problems firsthand in the ocean, rivers or forests near their community.

This growing knowledge of the environmental crisis in countries such as the U.S. provides a more fertile field for mobilizing the kind of finances we need for action. For instance, I run a travel program called CI-Sojourns at Conservation International that provides our major donors and prospective donors with unforgettable, life-changing experiences with nature. The objective of the program is to change these people's hearts. They must see and experience nature for themselves, and then choose on their own to make a difference in whatever way they can. Often that is through a donation, but hopefully it goes beyond that—to personal actions and encouraging other people to act and donate as well. You don't need to tell people that they can write checks. They know that's an option.

At Conservation International, my other job is running a Sea Turtle Flagship Program with the mission of using sea turtles as icons to raise awareness and to change human behaviors as they relate to ocean health. I am a sea turtle biologist, and I'm interested in saving sea turtles from extinction—but the main purpose of the program is to wave these endearing animals as flags to catch people's attention about the health of the seas, to inform them about what can be done to change their own behavior, and to improve the overall relationship between humans and the planet. By focusing a lesson around a charismatic character such as a sea turtle (or whale, tiger or panda), we can capture people's attention.

WC: With a story, a real story.

RM: Exactly, a story about an endearing creature. We're making use of these animals' iconic value, while telling the story of how sea turtles are teetering on the brink of extinction. And then we say, "Here's why: It's because of fishing practices, beachfront development, poaching, and climate change. It's also because of pollution—like plastics that turtles ingest and are lethal to them. Plastic debris in the ocean comes from many sources—including from the shopping bags you discard, which can end up blowing off landfills into the ocean." It's a simple lesson. All these little things you do in your life have an impact. *You have a footprint.* But the most important part of the story is when we say, "You can change your footprint. You can change your actions. You can help sea turtles and other species in your daily routine." And then we list simple solutions—like taking your own cloth carrying bag to the grocery store rather than using disposable bags each time.

WC: So, you're talking about changing consciousness one person at a time and building a critical mass.

RM: Right, I focus on one person at a time. But not everyone believes that the greatest miracle is changing an individual heart. Some people want to measure effectiveness by the millions. We do some of that, too. But to be honest, I feel I have the greatest success when I reach individuals, and that usually happens one at a time.

WC: But it sounds like you also recognize that some individuals can have more influence and impact than others.

RM: True. No one has a zero ecological footprint. Some people, obviously, have larger footprints than others. If you fly a private jet, you're going to have a larger ecological footprint than if you ride a bike. Still, all of us have behaviors that we can change. I'm not saying that you need to change them all, but if you can demonstrate that you've changed some of your behaviors and that you care about your footprint, you might influence others to act the same. It begins with individuals.

Let me give you an example of how my CI-Sojourns program works. There's a man named Rob Walton. His father was Sam Walton, who started Wal-Mart. Rob is currently the chairman of the board of Wal-Mart Corporation. I met Rob through CI's Chairman, who met Rob through friends of friends. At the beginning of my relationship with Rob, I took him into the field—to Brazil; Ecuador's Galapagos Islands; to leatherback turtle nesting beaches in Costa Rica; to conservation sites in Southern Africa and Madagascar; diving in the top marine hotspot in the world in Indonesia.

After a few of these field visits, Rob naturally began contributing money. Someone like that who's among the wealthiest people in the world can make some pretty substantial contributions. But, more importantly, Rob is also the head of one of the world's largest corporations. They've got 6,700 or so retail stores providing for millions of consumers (176 million a week to be precise), and they've probably got 50 or 60 thousand suppliers that all provide products and services to them. The real impact is not the money that this man gives, it's the fact that we sent him home from his trips into the field with a changed perspective on nature. He sat down with his CEO and his senior leadership and said, "You guys ever heard of this thing called an ecological footprint? We're going to do something about ours."

WC: So, is Wal-Mart starting to change some of its practices?

RM: Right now Wal-Mart is one of the most significant green corporations out there, and it all started with one man. Basically, he just went home and said, "Look, guys, figure it out. We consume a lot of stuff. Figure out the areas we need to focus on. Work with Conservation International, and let's make a difference." There are

some statistics that are just fantastic. They looked at the energy consumption and carbon output of their shipping vehicles, and added some simple auxiliary power units that allow the drives to stay warm (or cool) without having to run the truck's main engines while loading and unloading; the CO_2 reduction in that simple action alone is mind boggling—100,000 metric tons a year of carbon now does not wind up in the atmosphere just from that one simple action multiplied many-fold. Of course, that turns into money for them because that's gas not burned, so it not only does good for the planet but it saves the company something like $25 million a year, too, meaning that they will likely continue to do it.

Like I said before, I'm a sea turtle conservationist. One of the biggest issues is fishing and the impact of fishing. Just a few years ago, it would have been tough for me to get a meeting with the companies that create some of the biggest impacts from fishing. They were not especially interested in what conservationists have to think. But, about a year ago, I found myself sitting in a board room in San Diego with the CEO's of several of those corporations and the U.S. Tuna Foundation that represents them. They listened to what I had to say about fishing techniques and their incidental impact on other animals—like sea turtles, sea birds and sharks—and how they could improve their environmental impact and their business models at the same time. Why was I sitting there? Because Wal-Mart called the meeting, and because Wal-Mart is their largest customer. Wal-Mart has actually made a commitment at this point to sourcing farmed shrimp that have been certified according to the Global Aquaculture Alliance's Best Aquaculture Practices standard, and they have given their farmer and processor suppliers a deadline for living up to these standards as well.

WC: So there is a ripple effect. Are you seeing more doors open, more shifted thinking?

RM: Oh yes, business leaders are starting to see examples of how it positively impacts their bottom line. It's good for business to be green. Some really visionary business leaders like Yvon Chouinard of Patagonia figured it out a long time ago. Chouinard is quoted in his book *Let My People Go Surfing* asking the question, "Who are businesses really responsible to? Their customers? Shareholders? Employees? We would argue that it's none of the above. Fundamentally, businesses are responsible to their resource base. Without a healthy environment there are no shareholders, no employees, no customers and no business." And "green" is being increasingly recognized by consumers as being the right thing to do for their own health, as well as the Planet as a whole and the country, too.

As Tom Friedman likes to say, "Green is the new red, white, and blue." I've seen him speak on that topic. It's compelling. Take Starbucks, for example. The kind of clients that go into Starbucks are trendy, hip, young people that are just the kinds of folks that are swayed by a "green" message, and for whom being green is cool. In order for Starbucks to provide environmentally friendly, shade-grown coffee, they had to pay a premium price for coffee that was produced in both ecologically and socially friendly ways. Despite the added expense, it was good for business. Their consumers supported the shade-grown coffee. It's a triple win; customers, business and the environment come out on top.

There are hundreds of examples of this kind nowadays. We're starting to see more and more marketing studies demonstrating that higher percentages of people are willing to pay a premium price for a green marketed item over a non-green marketed item, all things being equal. There is more and more proof that being green is good for the bottom line. There is more and more ridicule by consumers of companies that are not being green.

From Conservational International's perspective, some of the most far-reaching successes we have achieved are with businesses.

WC: So you don't spend a lot of time walking the halls of Congress?

RM: It is not my personal cup of tea to do policy work, because I don't have the patience for it, but it is important. My view is that if you can make conservation work on the ground, the policy will follow. And if the policy doesn't follow it is not that grave an issue—as long as the nature-friendly behaviors are actually happening, and you've got strong local support from individuals and communities. Sometimes policy needs to drive behavior, but it is much better when behavior can drive policy. I don't know about you, but I don't like being told what to do, I prefer to decide on my own.

WC: Do you think that the rate of consciousness change and behavior change is going to head off disaster at the pass?

RM: I'm going to say yes. But, the qualification of my "yes" is that I believe in miracles. If you're into statistics and planning based on past results, you're probably a pessimist about the environment, but since I don't really trust stats anyway, and since I believe that miracles can happen, I am an optimist.

Most experts in social change believe it takes a generation to change people's minds or to drastically change people's behavior. If you believe that, then you'd have to be pessimistic about the planet's future. We don't even have a generation before the Co_2 is built up to the point where we're living in a desert. But, if you believe like I do—that behavior can change overnight—then it's easy to be optimistic. If you think about it, one good advertising campaign can make you stop drinking Coke and start drinking Pepsi, or can convince you to drive a Ford instead of a Toyota.

WC: Smoking behavior has changed pretty rapidly. Smoking is now a minority behavior.

RM: Yes, exactly. Our Great Turtle Race campaign is a great example also. Let me explain. Female leatherback turtles come to nest in Costa Rica, so we came up with an idea to put satellite tracking devices on them and track them live on-line as they make their way from the nesting beaches to their feeding grounds in the Galapagos. A bunch of us thought this would generate a lot of Internet and media buzz and raise some money, but nothing like it had ever been done before. I went to my fundraising department and said "Let's do this! It's going to be really cool; people are going to love it. We're going to be able to sign on all kinds of new people to our on-line community and get them engaged in conservation." And they said "umm, it doesn't sound like a very good idea." I went to our business team and said, "Hey, I need ten sponsors for these ten turtles. It's only $25,000 a piece and they're going to get two weeks of exposure on Yahoo. Let's get all our favorite partners to sign up for it." They weren't overly enthusiastic. I can't blame them really, since there is no track-record of something like this working and it is not remotely a traditional approach. But, we convinced enough people to help out so that we made it happen. Now, two weeks into the thing, the sponsors of these turtles are getting mentioned on the Colbert Report. Companies like Dreyer's Ice Cream and West Marine have turtles in the race—you can't buy that kind of PR. And it has been just a blast. The media and internet response has been massive, just massive. It's the biggest thing that Conservation International has ever done in terms of media and internet exposure, just off the charts.

 My point is that if you believe what traditionalists tell you, then it's easy to get pessimistic. If you believe that creative new stuff that you hadn't thought of before might work, and then you make it work, then there's plenty of reason to be optimistic.

WC: What role do you see art-makers taking in the journey we need to take to manifest your optimistic future?

RM: Nature has always been the greatest inspiration for art. Art can have a significant and life-changing influence on people. I think it can help to bolster the motivation that people have to actually make changes in their lives. I was at a Van Gogh exhibit in D.C. a few years ago. I saw a lady standing in front of the paintings; there were blossoms and those beautiful golden fields of grain that he painted out the window of his cell in the asylum. She was standing there in front of these paintings and weeping. And it wasn't about "information" or a story. She didn't have the recorder on her ear. There was no plaque to read. I thought, what's behind this? It's just an image, but it has the power to go straight into her soul. It didn't stop in the brain along the way to analyze some statistics. That's

what made me start thinking and talking to my sister, Sara (the creative one in the family) about how art alters people.

Music does the same, or theater: any imaginable form of art has the ability to move us. Art connected to nature can be a powerful tool to help us to once again regain our connection to the earth and to stop doing bad things to it.

WC: Beyond its effectiveness for communication, do you think the arts can help heal the rift between human beings and the natural world?

RM: It has the potential of being more powerful than anything for making that connection. I take the people to Nature, not to a picture of it, to create a moving experience. Art is a way to achieve that same goal at home. Not everybody can go stand in a herd of elephants. You've seen some of Sara and Terry's stuff. (Artist Terry Karson is Sara Mast's husband). The exhibit that I remember right now was called "Our Backyard Garden." The images around the outside of the room are Sara's abstracts that make you feel like you're standing in a garden. Then in the center is Terry's work that looks like planted flowers, but it's made out of trash. It brings you an experience of nature, but it also brings you a message that's both humorous and kind of dark, saying, "Guess what, it's not nature, it's trash." So, it's as much about moving us toward oneness with nature as it is about ridiculing us for being part of the giant trash machine.

WC: One of the things that has come up repeatedly in our conversations is the need to change the stories that inform how we imagine the world working. Is this a part of your thinking?

RM: Yes, for me personally, it has been. I've been talking to people about environment all my life. In the early days people would ask, "What can I do to make a difference? What can I do to change?" Back then, I'd say, "You can write a check to the World Wildlife Fund." Nowadays, I don't say that at all. If someone says to me "Can I make a donation to help you out?", my response is, "Yes, thank you, every little bit helps. But, you're not going to get away that easy because if you want the world to change, you have to change your behavior too." In other words, I'll take your money, but I also need your soul. That's a big difference.

But I get criticized for that. Some people are saying to me "Oh, so you've reached how many tens of millions of people with this turtle campaign. How much money did you bring in?" I said, "Money wasn't the focus of it. Reaching people was the focus of it." They'll tell me "I don't know if that's a good thing. If you're going to reach that many people, you should be asking them for money." I don't think that's necessarily the right approach.

WC: I would imagine dollar figures are easier to document than altered hearts and minds.

RM: I have enough anecdotal proof to keep me happy that changing hearts has the biggest bang both in terms of actual paradigm-shifting AND in terms of fund-raising.

WC: Colbert is basically a story teller, using a reactionary character and a pseudo-Fox News set to speak about contemporary issues. So he has integrated those turtles into his narrative. For two weeks they were continuing characters in his story. Given the audience, that's pretty powerful.

RM: Every story has a beginning and you don't necessarily know where it's going to go. You can kind of plan it from beginning to end, but it ends up being the story of every individual that's out there that we're trying to reach. For them, the first part of the story might be, "Wow, there's a turtle called a leatherback?" Then bang, if I've got them that far, then the story's started. Now, where it goes next is up to them. They might go to a website that I've sent them to learn more. They might call me. They might go to a beach to see them. They might get engaged one way or another. But, if I've started that process, it's going to go somewhere. If they're interested enough in turtles, it might lead them to the plastics issue or the fishing issue.

When I am asked, "How do I get involved?" these days, I no longer tell people that they can write a check. What I tell them is, "I want you to think. Start with that. Think." Depending on what kind of group I'm talking to, "go out and lie down in a pasture and breathe the air and figure out where does this come from."

WC: So, rather than just playing on guilt, it sounds like you're taking consciousness seriously. The behavior that you're trying to shift is not philanthropy; it's seeing the world framed by a different story.

RM: Right. You know, I just had this argument today with somebody about how we are going to deal with the people who come to our website. They said, "Oh, we want to get them to take an action, we want to get them to click through and do this petition to the president of Costa Rica." And I said, "No, we can't give them that kind of an easy out." I don't want you to go on-line and think your job is done because you clicked the petition that's going to go to the president of Costa Rica. I'm not a big fan of petitions anyway. They have a tendency to get people mad as much as they get good things done. The last thing that I want to happen is for you to think that your job is done when your check is written or when you sign the petition. I want you to think about how your life relates to nature and everything around you, how it's all one. And then I want you to take something that you care about and take it apart down to the bottom detail and then do something about it.

WC: You said earlier that you felt that the arts could be a powerful resource for moving people in that direction. It seems that the environmental and cultural communities have a lot in common but they are not often joined in common purpose. How can this be changed?

RM: I think what it comes back to for me is this idea of just thinking about the whole. When you departmentalize and you put art in one silo and business in another silo and conservation in another silo and people's lives in their silos, they might read about what's in the other silo, but do they say, "Oh gosh, I just learned about the environment today. I think I'll put that in my art." Or does a businessman say, "Oh, I just learned about the environment. I think I'll put a project in my portfolio." But, seldom do we think of all these things being expressions of oneness. I think we have a tendency to build those barriers--maybe unintentionally--because we're comfortable in our silos. For example, when I was a young student, there were biology classes and environment classes. Many biology people learned about conservation as they were doing biology, and they became conservationists. A lot of conservationists are people with biology training or an interest in biology. Then a whole new field called "conservation biology" was created. So now there is a conservation biology society and separate conservation biology classes in school.

 So, when I when I ask people in biology departments, "Do the people in your degree program do conservation-related work?" They say, "Oh no, we're not conservation biologists. We're just biologists." And I'm thinking, what the hell kind of biology is it that is not involved in conservation related issues? You know what I mean? Yet, we are the ones that created that division, allowing some people to be conservation biologists and others to just be biologists who don't have to worry about conservation.

WC: It sounds like you are trying to connect people to the larger story of the world and help people edge out of their compartments into a view of a larger interconnected world?

RM: Right. One of the things that's going to do that, whether we like it or not, is global warming. And the scary thought of that is probably why people have been resisting it for so long. It's why the government has been trying to deny it.

WC: Do you think that scary story is getting too obvious to deny?

RM: Yes, it's increasingly inescapable with each passing day. The frog going extinct in the rain forest is pretty easy for a guy in Chicago to ignore. But coast lines disappearing and actual climate change and shifting agriculture is not. As climate changes, then the best place to grow corn is going to be somewhere else all of a sudden. It's going to have tremendous impacts, not just for big corporations, but for average people. These inescapable changes, or even the specter of them, are going to make people realize, "Wow, I thought I could just stay here and be in my silo, but I can't." I also think that globalization has had an enormous impact as well, and the ease with which information is available. So, if we can just get people to think, acting then becomes a whole lot easier.

WC: Do you worry about the enormity of the problem becoming too overwhelming, breaking the spirit that will be needed to respond creatively?

RM: I do worry about that a little bit and I think we have to be very careful how we communicate, at least from my perspective as a conservationist. I try to tell people that while it is an enormous problem, the solutions come one step at a time and one heart at a time. I have a story that illustrates this. I've been working on sea turtle issues all my adult life. We used to edit a newsletter about sea turtle conservation. So, I was reading through this article on the use of turtle excluder devices (TED's) that you put in a shrimp net to keep turtles from getting caught and killed in the net. When I first got started as a kid in conservation I had worked on a program to get fisherman to voluntarily use them. When that didn't work, the government legislated it and that *sort of* worked. Anyway 20 years had gone by and here I am reading this article about how this wonderful idea had not yet been fully implemented. I kind of freaked out. So here I am in my kitchen ranting loudly to whoever will listen that I've been working on this issue all my life, we've got a perfectly good technical solution and people won't use it and blah, blah, blah.

My 8-year old boy, Terrill, is watching me flip out in the kitchen and he says, "what are you mad about." And I said, "Oh, we conservationists have developed this really cool tool called a TED that keeps the turtles from being killed in shrimp nets and people don't use it." And he said, "Those people who catch the shrimp, why do they do that?" I said, "Well, they catch shrimp because people eat shrimp." And he said, "If people didn't eat shrimp then the turtles wouldn't have to be endangered." I said, "Yeah, that's a good point." He looked at me and he said, "We eat shrimp." And I went, "ooooh." It hit me! I know full well, my shrimp consumption in a year might have totaled only 15 pounds, but 15 pounds can make a difference.

So when I tell that story people say to me, "Oh so you're saying I can't eat shrimp. I can't drive a car and I can't use tropical hardwoods and I can't eat," I say, "No, no, I didn't say that at all. I said, *I choose not to eat shrimp.* I choose not to eat shrimp because I love sea turtles and I know about the impact that shrimp fishing has on sea turtles. That's one choice that I can make. No one has the power to make me eat a shrimp. (laughter) It's a very empowering thing. I like shrimp, but every time I don't eat one, I feel good about myself. I made a choice. I tell people that they can do that, too. It doesn't have to be shrimp. If you care about tropical rain forest, then maybe that cup of coffee you drink in the morning should be shade grown. If you care about water quality and you want the streams to be clean, so maybe you want to think about the fertilizers you put on your lawn. You cannot do everything, so just pick

the things that are important to you. Make a single choice like that and be really joyful about it. I believe that joy will make you want to do other things.

WC: So, in addition to helping to save the planet you're also giving people an opportunity to have a more enjoyable life.

RM: Absolutely. We've got to get over the idea that the way to get the message across is to say "no" and "don't." The way to get the message across is to say, "Do make a choice, just do something, and then be joyful about it."

WC: So how do you reinforce the idea that making a difference is a joyful act? What's next on your agenda?

RM: I've come to the conclusion that one of the big myths, at least of my business, maybe all businesses, is that when you plan things, they actually happen. If you have a good plan, then you'll have a good outcome. Some of the best things that have happened in my life have been things for which there was no planning whatsoever. One of them is another website that we've done called, www.mrleatherback.com which features a giant leatherback turtle. I received this costume as a gag gift from one of my friends and I started taking it with me on my trips. My kids dressed me in it and then they took a picture of me in front of the pyramids, then the Coliseum in Rome.

WC: Oh, yea! Like that movie *Amelie*, where the garden gnome's picture is taken in front of all the world monuments.

RM: We did it just for fun. We started sending the pictures around and we created a My Space page. A friend of mine is the guitarist for Pearl Jam and he thought this was cool. So from his My Space page—with something like 130,000 members—he sent a blog saying, "Hey, I want you to go visit my friend, Mister Leatherback. He's cool." Bang, our list of friends went through the roof. So, we're working with Pearl Jam fans to get people to go to the website where then they can learn about why this guy is dressed up in this leatherback suit in a dozen different countries.

Then we decided we'd take it to YouTube. I was on a trip with a Hollywood screen writer and his family on one of my Sojourns to Costa Rica. So I said to him, "Hey, I have this turtle suit in the back of the car, let's do a quick film here. We put together a 45-second film and it was huge on YouTube. Then people go to My Space and then they come back. All these things are attention-getting devices. You can't believe the e-mails we get. A lot of them are posted on the site. They'll say things like, "Dude, I never knew eating swordfish was bad for the ocean. I'm never eating it again." Or people writing in and saying, "I started carrying canvas bags to the grocery store because I don't want you to swallow a plastic bag in the ocean, Mister Leatherback." People are literally making changes in their lives because I dressed up in a sea turtle suit.

WC: Incredible. See now, that's artistic intervention. You're in the business.

Chapter 8
Harry Boyte

"People can be agents of deep change"

In the 1960's Harry Boyte was a Field Secretary for the Southern Christian Leadership Conference, the organization directed by Dr. Martin Luther King, Jr. Currently he is a Senior Fellow at the Humphrey Institute, University of Minnesota. He is also the founder and co-director of the Center for Democracy and Citizenship. Dr. Boyte has authored eight books on democracy, community-organizing, and citizen action, including *The Backyard Revolution* (Temple, 1980); *Building America: The Democratic Promise of Public Work* with Nan Kari (Temple, 1996); *Everyday Politics: Reconnecting Citizens and Public Life* (Penn Press, 2004); *The Citizen Solution: How You Can Make a Difference* (Minnesota Historical Society Press, 2008). He has published in more than 70 publications including *The New York Times, The Wall Street Journal, The Los Angeles Times, Sojourners, Christian Science Monitor, Public Administration Review, Dissent, The Nation, Perspectives on Politics, Democracy, The Journal of African Political Science* and *The Chronicle of Higher Education*. His political commentary has appeared on CBS Evening News and National Public Radio.

WC: Do you have an opinion about the course society is likely to take in the next few decades?

HB: Through the Twentieth Century, a focus on human agency—how people can be agents of broad, deep change in institutions and the larger world—has been increasingly marginal to conventional ways of thinking. Theorists as diverse as Max Weber, Martin Heidegger, Hannah Arendt, or Michel Foucault have held that we live in a hyper-regulated world that constrains agency on every side, a world of hidden manipulations, standardized programs, mass mobilizations, and bureaucratic interventions. In a memorable turn of phrase, the South African writer Xolela Mangcu has termed the invisible virus spreading through modern societies that erodes agency, "technocratic creep."

However marginal agency has been, human agency is clearly now emerging in many fields. For instance, in *Culture and Public Action*, a collection of essays on development by leading scholars, the editors Vijayendra Rao and Michael Walton argue for a shift from "equality of opportunity" to "equality of agency," from expert-led interventions to a view that poor people must become the authors of their own development. Rather than doing things for people, development workers need to focus on "creating an enabling environment to provide the poor with the tools, and the voice, to navigate their way out of poverty."

I am convinced that the central problem of the 21^{st} century is the development of civic agency. Civic agency is the capacity of human communities and groups to act cooperatively and collectively on common problems across their differences of view. It involves questions of institutional design—how to constitute groups, institutions, and societies for effective and sustainable collective action. It involves individual civic skills. Civic agency can also be understood in cultural terms, as practices, habits, norms, symbols and ways of life that enhance or diminish capacities for collective action.

WC: Do you have a particular idea or vision as to how we should be dealing with these challenges and opportunities?

HB: Today's populism needs a rich sense of its roots. As a young man, I learned how the freedom struggle was connected to earlier populist movements when ordinary people were valued in the public culture and seen as the foundations of democracy. A dramatic experience came in St. Augustine, Florida. One day I encountered a group of Ku Klux Klan members. I had gone out to the Old Jail because I was worried about a friend who had been arrested in a demonstration; the brutality that the jailors displayed toward civil rights demonstrators was a constant topic of conversation among S.C.L.C. (Southern Christian Leadership Council) staff members. Many people were held without water all day long, packed outside

the building in a wire enclosure called "the pen." The hot Florida sun beat down relentlessly. Some passed out. I talked to my friend, Cathy, through the bars. She was inside the jail and was fine. But when I came back to the car five men and a woman suddenly surrounded me. I realized that they must have followed me out from town. I was terrified. One said, "You're a goddamn Yankee communist. We're going to get you, boy." I took a breath. Then my southern roots flooded back. I said, "I'm a Christian and the Bible says 'love your neighbor.' I love blacks, like I love whites. But I'm not a Yankee. My family has been in the South since before the Revolution. And I'm not a communist." Searching for a word to describe my confused identity—and remembering an occasional remark of my father—I tried on a different label. "I'm a populist," I said. "I believe that blacks and poor whites should get together and do something about the big shots who keep us divided and held down." There was silence. The group looked at an older man, dressed in coveralls, wearing a straw hat, to see what he would say. He scratched his head. "There may be something in that," he said. "I don't know whether I'm a populist. But I read about it. And I ain't stupid. The big shots look down on us. The mayor will congratulate us for beating you up. But he'd never talk to me on the street." He continued, "I ain't a Christian myself. I'm a Hinduist. I believe in the caste system." For a few minutes, we talked about what an interracial populist movement might look like. Then I drove quickly back into town.

Several days later the Ku Klux Klan held a march in front of the S.C.L.C. office in the African-American part of town. That summer was a battle of flags. Civil rights demonstrators marched under the American flag. The Klan countermarched under the Confederate flag. I was standing with the crowd in front of the office, perhaps the only white in the group. Dr. King was nearby. The Klan philosopher, in the front row of their march, saw me and waved. I gave a tepid response, trying to be inconspicuous. But King saw my gesture. He asked me what that was all about. I told him the story. King said, "I've always identified with populism. That was a time when Negroes and whites found common ground." I had only a vague sense of what he meant; the term populist had floated to my consciousness like a rescue raft. But I learned more. Our work has built on this rich history of populism.

The original movement to go by the name, "Populist," formed in the 1880's and 1890's among black and white farmers in the South and Midwest. It included interracial alliances that defied racial taboos. In the early 1990's, we created a different model of citizen-government interaction, that governments and politicians should be seen as partners, not saviors. Clinton gave a couple of speeches on that. Then we built this bipartisan coalition called the New

Citizenship, which worked with the White House for a couple of years. In that, we drew on our partnerships in other groups, like the Kettering Foundation, the Industrial Areas Foundation network of broad-based citizen organizations, the College of St. Catherine, the cooperative extension service, schools and other groups. We worked a couple of years, proposed a number of policies, challenged the "citizen as customer" framework that was becoming dominant in many agencies, and gained a sense of the civic innovations in agencies like HUD and EPA.

Clinton featured themes of citizenship and citizen-government partnership in his New Covenant State of the Union in 1995, after a Camp David meeting where we presented findings and research. But he quickly backtracked, adopting a radically different strategy called "triangulation"–making enemies of both Congressional Democrats and Republicans—after he ran up against Beltway opposition. We learned from that of the need for "citizen demand" if there is going to be a "citizen message" from politicians. We also learned in a deeper way the limits of the "communitarian" approach to civic engagement. The communitarian school of thought—in which Clinton had declared himself a member—emphasizes community-building and service, responsibility, caring about others. It has a keen diagnosis of the unraveling of social ties in modern society. But it avoids addressing dynamics of power and politics, and especially, I would say, the way a language of well-intentioned "helping" can hide technocratic power relationships that undermine the civic agency and standing of those "being served."

Fast forward another decade. We thought 2007 was an important year to try to revive something like the new citizenship. We've been working with leading civic organizations like the National Civic League, Public Agenda, the CIRCLE research center at the University of Maryland, and large associations with a strong civic concern like the American Association of State Colleges and Universities. And the fact is there's just an explosion of civic initiative. The community-based cultural arts movement is an example. They're chronicled in things like Cindy Gibson's white paper, *Citizens at the Center*, or Matt Leighninger's new book, *The Next Form of Democracy*. I think people have become sick of the politics of division and manipulated polarization, what I call "slash-and-burn politics" that whips up enemies with little regard for the long range health of the society.

WC: It seems that many of these initiatives are rising up at the local level. As such they are not headline events. Given this, do you think there is going to be a critical mass of populist civic power that will take some people by surprise?

HB: I think that's right. This is the point of the November Fifth Coali-
 tion, which is named for the day after the election. Part of the cal-
 culation is that we can use the election season to challenge candid-
 ates and challenge voters--both sides. We would like to challenge
 candidates who are acting like used car salesmen and voters who
 are acting like consumers, to reclaim their civic role. We also are
 creating a network of people knowledgeable about innovative civic
 policies—what government can usefully do to catalyze and encour-
 age civic initiative. We hope to build a "citizen transition team" for
 a new administration. Your broad point is right that all of this is
 local and de-centered and pluralist and diverse—so people don't see
 the connections yet.

WC: In your Dewey lecture, you talk about populism as having three
 components. What role, if any, do you see art-makers, creators
 playing in the development of those three pillars of populism?

HB: Populism, when it is more than a rhetorical posture, when it is a
 democratic movement-building force, has three components. In
 the most elemental sense, it is a politics of popular agency, in a
 world of scripts and bureaucracies and dehumanizing routines and
 hidden manipulations. It builds popular power and agency. This
 includes building or transforming the civic institutions that have
 become one-way service delivery operations. Settings like local
 schools and congregations and non-profits once were civic meeting
 grounds, where people learned the open-ended, unscripted process
 of problem solving and dealing with people different than them-
 selves. Now, the school serves customers, and the YMCA has shut
 down community action efforts and opened racquetball courts. A
 key element of populist movement building is building or rebuild-
 ing mediating institutions grounded in the life of communities
 through which people exercise power on a continuing basis, break-
 ing up unaccountable centers of concentrated power. It is pro-
 foundly educative, developing people's public talents and capacit-
 ies; the hallmark of populism is development of what I would call
 civic agency. And it advances values of egalitarianism and commu-
 nity. Any populist movement has a strong culture-changing and
 culture-making dynamic, both in the broad sense of culture related
 to patterns of human interaction--belief, norms, images, and
 identities--but also related to aesthetic and cultural production.

 I would say in terms of organizing for power, developing the
 hope and imagination necessary for building collective power and
 movement, culture workers are crucial. Using the example that I
 know from my own life, the Freedom Movement, one can't imagine
 the Freedom Movement in the south without the songs and the po-
 etry and the aesthetic power embodied in the black religious and
 intellectual traditions.

WC: The theater of inspiration.

HB: Cultural workers are essential for generating a sense of power and possibility. This has been particularly true in terms of values and images of the good society, the American Dream, or the meaning of America. Cultural workers have been crucial to each populist movement. In the 1930's there was a movement of the whole society, basically, including an explosion of cultural work. So, there's a lot to be drawn from that. Works like Michael Denning's *Cultural Front* and Larry May's *Big Tomorrow* about Hollywood do a good job telling this story. Cultural workers self-consciously went about changing the understanding of what America is really about, changing the values and the images of the American Dream. They did it at every level from motion pictures to journalism to theater. And, of course, the government was a resource in that, through the WPA (Works Progress Administration). Explicit, self-conscious, democratic cultural work is of central importance in the 'values' strand and the 'culture-making, more democratic, egalitarian society' strand. Of course, it's also central to civic learning. John Dewey is good on this sense of cultural activity as profoundly educative, in a democratic sense. It is critical to the expansion of identity and the making of more public identities and practices.

WC: Do you think those who are currently trying to animate democracy and populism understand the potential power that cultural practice can have on their mission, their goals, their work?

HB: No, I don't think so on either side. Cultural workers aren't nearly as self-consciously political and confident about making culture change on a large scale as they were in the 30's. And the dominant strands of progressive activism are coming out of a kind of culturally deracinated mode with roots in the early 70's, when there was a reaction against the hyperbolic rhetoric and posturing of the new left, and the turn to a kind of wry, often cynically "pragmatic" focus on narrow issues that could mobilize people. This has been a disaster in terms of recognizing the role of cultural production in organizing and power. Where one sees richer civic cultures, as in the broad-based organizing that has flourished in networks like the Industrial Areas Foundation and the Gamaliel Foundation—the network that shaped Barack Obama as a young organizer in Chicago, by the way—there has been until recently a despair about transforming the larger culture. It's a kind of monastic view of citizen organizations as surviving the dark ages of capitalist decline. There's no thought that you could use the cultural resources within groups to take on and challenge the dominant cultural energy.

WC: Do you feel that there is a legacy of distrust among some activists who see the arts as artifact of class, rather than as a basic human need or capacity?

HB: Sure. Again, John Dewey was good on this, stressing how in earlier societies the aesthetic dimension was woven into everyday life, in a myriad of ways. There has been a distancing of intellectuals from popular culture and the everyday life of communities, as part of the rise of detached, insular professional cultures. The irony is, in a lot of ways the artists have become like technocrats, contemptuous of the intelligence and talent of uncredentialed citizens.

WC: You mean turned in the direction of the market?

HB: By the market and also by socialization. There is a credentialing process of art and artists through our educational system, as well as our cultural institutions. You can't blame everything on the market. The irony here is that progressives have played a leading role in these anti-egalitarian trends too.

WC: Do you see a blurry line between what some people see as progressive politics and this other manifestation that you described as populism. Is that something you run into a lot? That people assume that they're the same thing.

HB: The irony and the promise is that both the left and the right these days think of themselves as populist, they just don't have much of a democratic spirit about it. You know Thomas Frank and the whole citizen action world have been using the populist self designation for a long time. But so does Tim Pawlenty, the Republican Governor of Minnesota. It's a buzz word, but it also shows in some ways how there is this inchoate, civic, democratic, populist stirring that people feel they have partaken, even though there's not much clarity about what it is. But, I think there is enormous confusion.

WC: One of the things you talk about in your article, in numerous places, is the concept of co-creation. Have you had any thoughts about artistic practice as a co-creative activity, maybe even as a place where co-creation is learned or practiced?

HB: Absolutely. First of all, the tradition of artistic work as co-creation comes from the folk traditions of art and culture. There was always a sense of context drawing on and interacting with living communities in folk art, artistic traditions through folk songs, vernacular art and so forth. Any broad populist movement has an enormous amount of co-creation of cultural forms. The Civil Rights Movement was a great example. People used to adapt old gospel songs and just add new verses. Also, there was just a flowering of artistic forms. I remember this when I was a kid and with kids younger than I was. The kids who hated school would start writing music. Earlier, the 30's and 40's movement led to this amazing flowering, for example, of local theater which was a self-conscious articulation and reflection and celebration of local communities' histories and cultures and practices. Scott Peters, now at Cornell, who worked with us in the early 1990's at the Humphrey Institute uncovered the invisible history of the cooperative extension system at the

public universities, including the enormous cultural movement that extension was involved with in the 1930's, especially a vibrant local theater.

WC: I would imagine he came across the name of Robert Gard at the University of Wisconsin extension program. He was instrumental in the development of America's Community theater movement.

HB: And you know during the WPA, Aaron Copeland used to play the drafts of his pieces in front of audiences to get feedback. When we were developing our public work framework in the 90's, I remember talking to an usher at the Minnesota Symphony who talked about how important the audience was to the musical productions—the huge role they play. But all of that is kind of invisible.

WC: Yes, as a vital partner in the creative journey. But then audiences have been relegated to the role of ticket buyer, consumer more and more. And now, some large institutions are trying to break out of that. Our friend Reggie (Prim) was doing that—working to strengthen links between Walker Art Center and the broader community.

HB: Yes, which is interesting, because the Walker was once run by the WPA.

WC: A lot of our cultural institutions have those roots, don't they?

HB: Martha Graham, after all was a great embodiment of the democratic aesthetic of the populist movement of the New Deal.

WC: You mentioned her piece *American Movement* in your lecture. You also spoke about the need to move toward a more democratized culture. I was wondering what does that look like? What are the characteristics of a democratized culture?

HB: It's a much more public culture with much more fluid boundaries. You know my images are drawn partly from my own experience in the Freedom Movement and that vitality and energy and porous qualities of interactions across institutional lines. Then also I have learned a lot from reading about Harlem in 1930's. Some of our students at the University of Minnesota are working on this. They're just blown away by Barbara Ransby's description of Harlem in the 1930's and her biography of Ella Baker. She did such a good job of showing how that kind of cultural and intellectual life of Harlem spilled across all sorts of boundaries. This was a cultural life that was embodied on the street corners, in jazz clubs, in the Harlem library, in study circles and debates, and living rooms all over. You know, cultural productions of all kinds: artists and musicians and poets and people like Langston Hughes and Jacob Lawrence.

WC: I think you described that milieu as something like an opened space. I guess the question is, in the modern context, how do we open a space like that so that it is something people gravitate to naturally?

HB: It's a process. I think it will happen in the context of building a broader movement. You can find your way through all kind of micro examples. But, on a larger scale, Michael Denning's book, *The Cultural Front* really does a good job of describing the richness of cultural and educational life in many, many American cities and communities. He talks about worker education programs, study circles, artistic efforts of all kinds. There is also a rich international experience to draw upon, such as the still-vibrant folk school traditions in Sweden today, to pull people out of their bureaucratic and technocratic routines. On a large scale, to have people see another possibility, it will take a movement. It will take a sense of consciousness that we're into something really powerful, that we are in a time of change that needs a broader horizon.

WC: Many of the people we have talked to who see great hope in local organizing also seem to be yearning for a meta-story as well. Do you think we will need a massive unified change theory?

HB: Actually it's a massive opposite theory. (laughter) Populism is very much the opposite of massification. But it's a mistake to pose it as localism versus nationalism. It's more like a tapestry in a way that has immensely rich, fine-grained art in each piece and also creates a larger pattern. The larger patterns are important because they give lift and spirit and energy and hopefulness and power to the whole. Otherwise, you feel like you are in some kind of a monastery. This has been the flaw of broad-based organizing. They thought they were creating democratic counter-cultures to a profoundly dysfunctional, sick, dominant culture. But they didn't ever imagine taking on the larger culture. It's a big mistake to pose those things as opposites or in conflict. I think the point is the interplay between the particular, the local, and the larger pattern. The task is to find the strategic openings to make people aware that they are a part of large patterns that are profoundly grounded in the particular, the specific, the unique, and the local. We hope the election season may help with this, that we may see civic themes of hope and change and civic agency surface on a much larger scale.

WC: There seems to be a potential for greater collaboration between activists in the creative community and other progressives who are organizing in communities, in the environmental movement, for social justice, etc. I would also say that there is a need. If this is true, what bridges need to be built? Are there obstacles that need to be addressed before this happens?

HB: There are different strategies. One is for the artistic creative community to have a sustained intellectual discussion of politics and the political implications of what they're doing. There's great tradition for this. I remember reading about the musicians' reading groups in the 1930's. I think there need to be paradigm debates, particularly discussion about the legacy of progressive skepticism

THE WEB OF SOLUTIONS

toward cultural workers. Which is kind of telling, because pro-
gressive politics is very de-cultured, very issue-focused. It's techno-
cratic, expert-centered in its dominant trends now. So culture can
become both instrumental and ornamental. It can just be a way to
whip up sentiment around predefined, pre-scripted issues. And, of
course, issues are very siloed.

A dramatic example of this is the door-to-door canvas. A very
fine book by Dana Fisher called *Activism Inc.* describes the psycho-
logical and spiritual devastation wrought by the canvas on young
people every year. The contexts here are very interesting. The Na-
tional Wildlife Federation is really at odds with the other big envir-
onmental groups, who have all barred any discussion of her book,
even though she was a canvas director for Nader, for God's sake,
because it's a devastating portrait of what they do. They outsource
their canvases. They have tens of thousands of kids they burn out
every year. It's a completely scripted sick, deracinated culture.
Dana's book is really something.

Put simply, I would say this is the debate between progressivism
or left-wing politics and populist politics. That's an important de-
bate and figuring how to have that as a broad intellectual conver-
sation throughout the arts community is very important. I think
populism in its democratic form has profound resources to bring to
bear for all the reasons that I argue. It's really an alternative mod-
el to the dominant, desiccated, uprooted, rationalist view of the
human person. It allows one to bring in the insights of the black
consciousness, the black freedom movement, or indigenous tradi-
tions or immigrant cultural experiences in a democratic, egalitari-
an, pluralist way without demonizing conservative communities.
And you can find elements in conservative communities, too, that
you can enlist in a populist context. You don't have the same kind
of automatic pre-set polarizations and ideological enemies.

WC: Yes, getting conversations out of the rut of the "either/or," "us
versus them."

HB: Yes, the other thing we should think about is how to involve the
artistic community in the election work over the next year. I think
there may be a new sense of inter-connection, of getting beyond
Red-Versus-Blue America that people haven't even begun to ima-
gine. I can just feel it.

WC: What's the genesis of the November 5th Coalition?

HB: It had a couple of strands. One was our own work at the CDC
(Center for Democracy and Citizenship) around the new citizen-
ship work. Or put differently, raising citizenship themes in pres-
idential elections and presidential government since back in the
90's. Another was when the Case Foundation commissioned a wo-
man named Cindy Gibson, who works as consultant across differ-
ent civic engagement networks, to do a white paper on whether

there were signs that a new movement was emerging. She did a very good job of interviewing dozens of people and getting a richer, deeper reading of the trends. She came out with an important piece called, *Citizens at the Center*, which the Case Foundation put on their website. It has an explicit theory of power, but it also has a lot on the importance of culture change, and what she called citizen-centered approaches as opposed to slotting people into pre-existing activist or voluntary roles. In the civic engagement world, it's had a lot of attention, because it has a lot of affinity with the idea of co-creative citizenry. Case has had a couple of meetings on that, in which our project participated. Then there are other institutions: Public Agenda, which is expanding its role; the Study Circle Research Center which works with hundreds of communities around study circle action; and the Kettering Foundation. Also an organization called Circle, headed by Peter Lavine, gives grants for research on civic engagement. He has the best civic blog, by the way. He and Cindy actually authored a report for the Carnegie Corporation and the Circle a couple of years ago called *The Civic Mission of Schools,* which has led to a lot of ferment across the K-12 landscape. Then, there are higher education efforts like the Askew American Democracy Project and Campus Compact with Bruce Oliver.

WC: So, the idea is to insert a new mode of inquiry into the coming political season—to call on the candidates to address democracy as a critical issue?

HB: Yes, we're basically calling for a change in the culture of the elections, from scripted, slash-and-burn politics to movement politics. We want to raise especially strong citizenship themes and challenge candidates to talk about if they're going to be partners with citizens, not saviors. On the citizen side, we want to challenge the citizen's default, which is to ask whiney questions as consumers. We've begun to talk to several campaigns about this, on both sides: Obama, Edwards, McCain. This is going to take work, but we're getting great response from young people, so think its going to be possible. One of our partners is the Institute of Politics at St. Anselm College, which is the host of a presidential debate. They've also been doing our Public Achievement Youth Initiative. Our website, with the declaration and lists of groups involved, is www.novemberfifth.org. I was talking to the associate director there a couple of weeks ago and he said, "This is going to be a challenge because voters in New Hampshire really act like customers." I looked at an Edwards meeting on C-SPAN and saw that that was completely true. The only person who raised any vaguely citizenship themes was Edwards himself. He addressed a global warming question by saying this is a thing I can't solve alone as president. Generally the voter stance is, "What are you going to do for us and how are you going to fix things?" So, there has to be a lot of chal-

lenge on the voters, too.

But, there are interesting signs of change here. Obama comes out of broad-based citizen organizing. Both his books bear the imprint of his work in the 80's with Gamaliel (Foundation). His message is a citizen message, that broad-based organizing has for 30 years seen political campaigns without citizens as well as without candidates. They've had a narrow way of talking about that, but they did a great job of holding citizens and candidates accountable at meetings. That's his experience. That's why he's saying that the campaign is about all of us, it's not about me. So, it's both a possibility and also a limit because you can't have a candidate own the movement theme.

WC: Yes, a movement is not a candidate. So, given the lack of cultural community participation in this process how do you think that would that occur?.

HB: At this point, I think we should share communication and provide an opportunity to make the case that there's a lot of potential in the area of community arts and culture. This is very important. We can't have a movement without cultural work. I know that.

References:

Denning, Michael. *The Cultural Front: The Laboring of American Culture in the Twentieth Century*. Verso, 1998.

Fisher, Dana. *Activism, Inc.: How the Outsourcing of Grassroots Campaigns is Strangling Progressive Politics in America*. Stanford University Press, 2006.

Gibson, Cynthia. *Citizens at the Center: A New Approach to Civic Engagement*. www.casefoundation.org/spotlight/civic_engagement/summary

Ransby, Barbara. *Ella Baker and the Black Freedom Movement, a Radical Democratic Vision*. Gender and American Culture Series, University of North Carolina Press, 2005.

Chapter 9
Sarah James

"Toward sustainability"

Sarah James has consulted with municipalities for over twenty years in the areas of urban and town planning, growth management, and community development. She specializes in participatory planning and the integration of sustainability principles in community planning. James is co-author of *The Natural Step for Communities: How Cities and Towns Can Change to Sustainable Practices* with Torbjörn Lahti (New Society Publishers, 2004), which received a *Planetizen* Top Ten Book in Planning Award for 2005. Along with Lahti, she directs the Institute for Ecomunicipality Education & Assistance (IEMEA) to provide leadership training for emerging sustainable community initiatives. She is also a co-author of the American Planning Association (APA)'s Policy Guide, *Planning for Sustainability*, adopted by APA in April, 2000. James has taught at MIT, Harvard, Vassar, Rhode Island School of Design, Tufts University, University of California at San Diego (UCSD), the California State Polytechnic University at Pomona, Conway School of Design, the Swedish Blekinge Institute of Technology, and at other educational institutions on the subjects of sustainable communities and participatory planning. In 2007, she was awarded the 2007 Dale Prize for planning excellence and contributions to ecological planning from California State Polytechnic University at Pomona. She lives in Cambridge, Massachusetts.

PS: Today we wish to talk about the challenges that you see ahead for our society and the globe and how your work fits into that.

SJ: Well, I'll start at the global level. There are two converging trends. On the one hand, the natural systems of the earth are deteriorating at an increasing rate. On the other hand, population and consumption are rising. These trends are two sides of a funnel which are converging upon each other; we don't know at what point there will be a crisis. Some have said it is going to come sooner rather than later; we see evidence of this all around us in our communities and in nature.

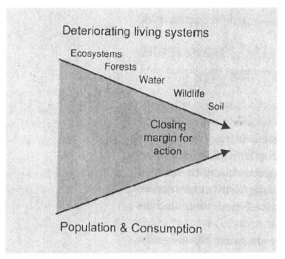

From James & Lahti, p. 6. Used by permission

I'm trained as a city planner by education and experience. So, my work primarily focuses on helping communities — municipalities or local governments — and equipping them with the tools that they can use to change to sustainable practices at the community level. I've been doing this since the 1980's. In the mid-1990's, I heard of an approach that was developed in Sweden called the Natural Step Framework and took some advanced training in it. Almost instantaneously, I saw that, of all the sustainability approaches that are out there now, the Natural Step framework makes the most sense for communities, because it is a systematic instead of a piece-meal approach. The four principles based upon the Natural Step framework can be used at any level of society or in any of the broad topical areas that communities have to deal with: housing, economic development, public facilities, recreation, and all the rest. I've been using that approach as a tool in working in the community context. In 2001, I heard of a group of communities in Sweden who had officially adopted this approach. So, I went on a two-week tour of sev-

eral of these, led by Torbjörn Lahti, the planner who got all this started in Sweden. What I saw in those communities so amazed me that I came back and I said, "somebody has got to tell people in the United States and beyond about this." So Torbjörn and I collaborated on a book which introduces a framework that helps us become clear about what we mean by sustainability and sustainable practices, giving a clear direction in which to move. After sharing the remarkable actual examples of success from Sweden, we outlined the practical steps that we can take at the community level to move toward sustainability. Torbjörn came over to the U.S. and we gave talks and workshops on the idea. Wonderfully, out of those workshops, quite a few people went back and started to work on applying this in their own communities.

Natural Step System Conditions

In a sustainable society, nature is not subject to systematically increasing

* concentrations of substances extracted from the Earth's crust.
* concentrations of substances produced by society.
* degradation by physical means.
* And in the sustainable society, people are not subject to conditions that systematically undermine their capacity to meet their needs.

PS: In my own Chequamegon Bay in Wisconsin.

SJ: Exactly. So, there's a real prairie fire in Wisconsin, and in other communities—Portsmouth, New Hampshire; Lawrence Township, New Jersey; Vandergrift, Pennsylvania—all moving in this direction, working in different ways with this framework. So, my work, at the moment, is to try to support that in every way I can by continuing to give talks, workshops and trainings.

PS: Some have argued that our culture is at some kind of a crisis point. Do you think that's true?

SJ: I don't think there's any question about it; there is absolutely no question. And I think the movie, *The Inconvenient Truth*, the Al Gore movie, has really helped to wake up people in this country. I think we're going to look back on 2006 and see that as the year of a turning point.

PS: Turning point?

SJ: Yes. I completely agree with David Korten and Joanna Macy; we are at that point, and the situation is very dire indeed. But I have hope because, at the same time that things are deteriorating and collapsing, in my work I've had the opportunity to see the growth of the new attitude, the new awareness, and all over the country, local efforts moving in a sustainable direction. I think there's more going on now in sustainable development in the United States than

one organization or person, can possibly see. I've watched this over the last ten years and it's increasing, I think exponentially.

PS: You think these local initiatives are creating a prairie fire. Tell me about some of those that you've worked with and what you see happening.

SJ: I think one of the best examples is the Chequamegon Bay, Wisconsin, initiative, where a group of three municipalities and two American Indian tribes are trying to work together in a regional approach. That has inspired other communities in elsewhere to move in this direction. I just got a copy of the *Wisconsin Trails* magazine which includes a wonderful article on the Chequamegon Bay initiative. Madison, Wisconsin, just had training for a group of its municipal officials. There have been a growing number of people who have gone on tours of the Swedish eco-municipalities to see first hand what's going on and what's possible to do.

PS: You think that this one-community-at-a-time approach is enough? You called it exponential.

SJ: Oh yes, I think it's definitely exponential. And I also think that regardless of what happens in our national government--whether we have a Democratic or Republican President or a Democratic or a Republican Congress--change still has to happen locally. One community, one by one, because local governments have a substantial amount of authority over what happens at the local level with land use. There are some notable exceptions like the Clean Water Act, Clean Air Act and transportation. But most other land use and planning issues are within the local level of jurisdiction. This is why I think the Swedish eco-municipalities are such good examples for the United States. Even though their national government is light years ahead when it comes to this, in Sweden the local level is important. Nothing can happen unless every municipality adopts its own plan regardless of what the national government says; they have a very strong and old tradition of home rule.

PS: I agree that a bottom-up, participatory approach is the most likely to have a long-term effect. But I also see that at local levels, there are all kinds of cross currents, differences of interest, conflict.

SJ: That exists at every level. It certainly exists at the national level. I think that's part of what we have to do differently. That's part of what needs to change. If we just build windmills, put on solar panels, and do more recycling, but still treat people unfairly, that's not a sustainable society. And so, that's one of the reasons why the Natural Step framework is effective, because it includes concern for human needs. As I see it, the Achilles heel of the environmental movement was that they didn't address these needs.

PS: So then the argument became that owls are more important than people.

SJ: That was our old divergent thinking. But, we need to take a systematic approach which includes all of those things. It's possible to understand what a systems approach is by working with these four principles. System condition #4, meeting human needs fairly and efficiently, is key. One of the fundamental human needs is the need for creativity and identity. That's where the arts and culture come in. The Chilean economist Manfred Max-Neef has identified nine fundamental human needs that have existed throughout time and are independent of culture, meaning they exist everywhere for all humans. The needs have not changed, but the way we satisfy those needs has. Those of us who work with the Natural Step framework use his typology to help us get a deeper understanding of what we mean by human needs; if we're going to work to meet human needs, we have to understand what they are. And so much of our approach to human problems has been at the surface or single level. We have poverty programs. We have single issue approaches. What we're not doing is getting at the deeper needs.

Fundamental Human Needs
- Subsistence
- Protection
- Affection
- Understanding
- Participation
- Leisure
- Creation
- Identity
- Freedom

Manfred A. Max-Neef, *Human Scale Development*, pp. 32-3

Max-Neef redefines poverty. When we think of poverty conventionally, we think of people who don't have money. But Max-Neef is saying that if any one of these nine fundamental human needs isn't met, that creates a poverty. So you see poverties of needs.

PS: Like multiple intelligences, there are multiple poverties. That's interesting.

SJ: Yes. He goes on to say that the poverties of needs lead to pathology, to social problems—unrest, fighting. For example, one of the fundamental human needs is participation and if people are blocked from participating in forces that change their lives, they'll rebel. And history has proved this to be the case.

The things that meet these needs he calls "satisfiers," and he points out these vary in their effects. Examples of pseudo-satisfiers are teenagers thinking that their identity can be met by having

$250 sneakers, or people building these huge McMansions that they really don't need. The need for security met through an authoritarian government is a violator; such a government actually destroys security. A poverty program is a singular satisfier; it gets to one of the needs and is neutral on the others. And then he talks about synergistic satisfiers, those things that meet several needs. For example, a baby nursing at its mother's breast meets the need for subsistence, and also the need for affection and security. Those synergistic satisfiers are the ones we need to start identifying.

In thinking about the role of arts and culture in a sustainable society, I think arts and culture are synergistic satisfiers. For example, they clearly meet the need for creativity, but also identity, who we are in the world around us. Freedom, the freedom to express, participation, understanding. So, all of this is the conceptual framework I see for explaining how the arts and culture fit into a sustainable society and why they are so important.

Types of Satisfiers
- Violators: while appearing to work, they actually destroy satisfaction
- Pseudo-satisfiers: provide a false sense of satisfaction
- Inhibiting: impair the satisfaction of other needs
- Singular: one need only addressed
- Synergic: simultaneously address more than one need.

Max-Neef, pp. 33-36

PS: This framework is very insightful and helpful. Would you assert that as communities adopt the Natural Step framework that a broad reorientation of values and lifestyles society-wide will occur eventually?

SJ: That's certainly the goal. That is certainly the way it has happened in the Swedish communities; I want just to give you an example of the very first Swedish eco-municipality, the town of Övertorneå. Led by Torbjörn Lahti, the community had a desire to really revitalize not only its local economy, but its social life and culture. There was actually a minority group in that area, of which Torbjörn is a part, whose culture had been squashed—language, music, theater, all that. So, the revival of this local culture was a key part of Övertorneå's revitalization journey, but within the capacity of nature to support that. That's what set it apart from other conventional revitalizations. They were very much aware of ecological capacity. But, the cultural renaissance or revival was a critical part. And so, the language did survive. There are theater and music that have been supported by the local communities. So, I think that need was

being fulfilled, which gave them the energy to do the other hard work that they needed to do.

PS: I think there is an analogy with Chequamegon Bay, where the Anishinabe or Ojibwe Indian communities' culture revival has, in effect, almost led the way. But, how about those communities like Boston? Here people think: "Oh, we're doing just fine. We're rich. I've got two or three cars. I can drive on the J-Way even if there's a traffic jam. So what."

SJ: I think what Max-Neef might say is that those things that they have that they think are contributing to their happiness—big cars, a big house—they're pseudo-satisfiers. That they're not really getting at the deeper need. A good example of how this is likely true is the awful Columbine student killings that happened in Colorado. Those kids had everything they could want. They had fancy cars. They had computers. They had a nice house. They had lots of pocket money and there were still those unsatisfied fundamental needs that translated into pathology. So, I think, the people who live in the big houses, and I know many, a lot of these people are not happy people. At some point, that's going to surface in some way. But at the same time, this brings up the need for education in raising awareness, because more and more people are going to have to understand one way or another, the hard way or an easier way, that the path we are on is an unsustainable one. We will all have to deal with it at some point

Let's come back to Mr. Gore's movie. I think it's made a huge impact. There are people who are talking about this who never used to talk about it before. People who never used to give sustainability or unsustainability a second thought have seen that movie. I go to gatherings now of people in my own family and this is the topic of conversation. So, it's now on the national agenda.

PS: It is. That's true. I've heard that the governor of Minnesota in his State of the State address announced that Minnesota should have 25% alternative energy by 2024. I heard him talking the other day, and compared to the way he talked two years ago, it seemed like he had a brain transplant. And so we can move forward even without the national government?

SJ: Yes, and we have. I mean we have. There's already a huge movement. I've heard several people say that the fact that our national government is so hopeless had a lot to do with galvanizing people, because they realized nothing would come from Washington; so we have to do it at the local level. I think there is a lot to that.

PS: I suppose California is another example, forging ahead in spite of the national government.

SJ: Yes. So, when our national government catches up, and it will have to at some point, then we can, hopefully, see things like changing the CAFE standards and setting goals to reduce emissions. But

meanwhile, I think that local governments really are leading the way. I think I've seen enough now of what's going on in this country so that I would really call it a movement, although one that doesn't realize it is a movement.

PS: Paul Ray talks about that in his book *The Cultural Creatives*.

SJ: That's right. But at some point awareness will increase and then things will really start to happen. Then we'll see all this energy going into sustainable change becoming a real political force with the recognition that everyone's working toward the same goals.

PS: Is there anything that is going on now that discourages you?

SJ: I wish it would happen fast. It's happening fast, but I wish it would happen faster. It is discouraging when you see people doing something like throwing trash out the window of a car or driving huge SUVs around. It's certainly discouraging.

PS: The media is so out of touch with this.

SJ: Oh, the media, hopeless. They have been a problem.

PS: David Korten talked about the issue of the media quite at length in his book.

SJ: But there is some change there as well. *Time* magazine, do you remember that one where the cover and almost two thirds of the issue was on global warming? The cover had a polar bear on a piece of ice. That was a real break-through. I think that was the first time a national publication of that stature has featured the issue. And then *Vogue* magazine put out the green issue of *Vogue*.

PS: How is *Vogue* green?

SJ: In its own *Vogue* way it had Julia Roberts and George Clooney all dressed in green. They had a whole feature on eco-pioneers, people who were moving and doing work that went in that direction. I think that the media will change, too. But, the best way for people to learn about sustainability is still the Internet. That's where you can really get a sense of the huge amount of change that's going on. I was asked to go over to Sweden last spring and give a talk about what was going on in the United States, as if any one person could. I just googled "sustainable development in the United States." Can you guess how many hits I got? Fifty-three million.

PS: Oh my word, wow.

SJ: I've been doing this over the last ten years and that's one of the ways I've seen this exponential change. I mean if even half of those are repeats, it's still remarkable.

PS: I think there is still some number of people who think that for us to live sustainably, we will have to give up too much. That we'll be poor, that we won't be comfortable, we won't like it. We have believed that if we have more, we're going to be better off. We have had that myth for so long, that it's hard to give up.

SJ: I think there are so many good examples now of how people can live comfortably. Torbjörn talks a lot about how to live the good

life. A good life is one in which these nine needs get met. It is possible to do that without the huge amount of stuff around us, these pseudo-satisfiers, these gadgets and toys and clothes and huge cars. When our basic needs for identity and creativity and affection and participation are being met, we don't need all that stuff. Again, as more people realize that, I think we'll see less accumulation of stuff. I'm getting out of my field now, but look at the huge growth of Buddhism and alternative spiritual practices. People are realizing there are deeper needs in all of us that are not getting met by our materialistic society.

PS: You've already mentioned how Max-Neef talks about the importance of creativity. Can you be a little bit more specific about how the arts and artists can contribute to meeting needs and creating sustainability? My vision would be that in a sustainable society there would be lots of art-making going on. My question is how the arts and artists can be part of the transformative process to get us there?

SJ: I think in two ways. One is to keep doing what they're doing, because what they're doing through creating art and theater is helping us to meet the rest of our deeper needs, even though we may not really realize that's what's going on. That's the first thing. There are many artists who choose to express or to convey ecological and sustainable messages to their art. I don't know how many people I've heard say, "I really don't want to read one more book. I don't want to hear one more person talking at me, but when I participated in that dance or in all that singing, I got it." I think there are people who get the message through that mode rather than the other modes with which we choose to communicate. I think that's important.

Then I think another way is this. I do watercolor painting as a hobby. Another route is for artists themselves to start applying these sustainability principles to how they do their own work. For example, as a painter, how can I reduce dependence on fossil fuels and reduce dependence on synthetic chemicals, reduce encroachment upon nature. One of the main basics of paint, watercolor and oil, is cadmium. Cadmium red, cadmium yellow. Cadmium is very, very toxic and it accumulates in our kidneys. Remember the periodic table of chemical elements in school? It doesn't break down so it accumulates and can cause cancer and death. It doesn't go away. And that's related to the Natural Step system condition #1. When I was in Sweden, we were told that 30% of all the cadmium in Gothenburg's water supply comes from artists.

PS: Oh, my goodness. .

SJ: That's a shocker. We have all these watercolorists who rinse out their brushes in the water and send it into nature. And many if not most of the toxic substances that painters use, turpentine, etc., are

fossil fuel-based. They're poisoning themselves and others around them.

PS: Well, that pertains to visual artists. How about dancers, dramatists, musicians?

SJ: It would be interesting to take a group of artists and have them brainstorm in a couple of hours how the four principles apply to their own work, to see how they could change their own practices. I was hoping that a group of the artists that we were working with in Portsmouth would do this. But, ultimately that is what all of us have to do.

Then, of course, the arts lead by example. How could a theater group help? I actually stopped going to the theater for many years because so much of the subject matter just seemed to focus on the dysfunction of our society, dysfunctional families, dysfunctional unhappiness, violence. Why not focus on things that move us consciously in this direction?

PS: Part of the role of the arts is to turn a spotlight on those dysfunctions. That's part of their job.

SJ: That's right, but it's nice when it offers us a solution or a way out. I think it would be valuable if the art and culture community, in addition to realizing what they're already doing for the larger community, were also to look at themselves and see how they could move more in this direction—moving away from toxics, from the fossil fuel dependency. There are a lot of artists and musicians that travel all over, and that's very fossil fuel dependent. So how could this be reduced? We can't tell people what to do, but I think people need to find their own path. Maybe I have to take several airplane trips a year, but maybe I can offset that carbon by planting trees somewhere. I've been learning to play the Irish whistle and my teacher is an Irish musician. She and her husband are very ecologically conscious. So, they're planning a tour all around New England with all their instruments on bicycles. They're really thinking about what kind of instruments they can take that can get banged around a little bit. How can they carry them? Clearly, not everybody can do that, but they're finding their own way of how they can contribute.

PS: I suppose if they show up in Springfield or New Haven or somewhere on their bikes with their instruments, it would have a huge education effect.

SJ: Yes, that's right. Or if somebody has to travel around the country in a bus for a concert, maybe they could use a bio-diesel bus, something like that. So, I think that's the other way that artists and people in the world of culture and theater could contribute: by modeling and doing this themselves.

PS: Clearly, in order to deal with the changes needed, we will have to involve the creative energy of a lot of people, and that includes artists. What are the unique qualities or capacities that you think

the arts have to offer to the kinds of changes we're talking about? What are the unique possibilities they can offer?

SJ: I think by their expression they inform us of different levels of our being, that there are other ways of looking at day-to-day realities than we see in our conventional plodding lives. And by the same token, there are other parts of our own being that we might not be aware of as we go through our daily lives—go to our 9-5 jobs or change the diapers on our kids or whatever—that artists remind us of. They show us that there are depths in all of us as well as in themselves. The poets show us how this conventional boring language we use all of a sudden can say something beautiful. We can think of something that we never thought of before. Music transports us out of our troubles, or it makes us get in touch with a deeper spirit of all of us and all humans. It allows us to get in touch with emotions that we might not have done otherwise, that we might have kept a lid on. I think that that's where the identity comes in. Artists help us get a deeper sense of our own identities and out of this little box that we might put ourselves in. Sometimes they coax us out with beautiful music. Other times, they shock us out of it. I think that it is very important. I don't know how else to say this: there is such a richness that art and culture brings to life that I shudder to think what life would be like without it—living in a community where there were no artistic expressions. How dead and how empty and how dull that would be. There is just a richness that's there. Not in a monetary sense, a deeper sense.

PS: You seem quite optimistic that the arts are already "the good guys," that they are already participating in this project in a helpful manner.

SJ: I think they always have since the beginning of time. It's just that the rest of us may not have realized it. Again, this is where I think these needs Max-Neef identified can help us to understand what it is they touch in us at a very deep level, why it's so essential to human life. Art has always been doing that; we just weren't admitting it or were not aware or clear about the actual way that contribution was happening. As artists become more conscious about their role and their contributions to community and human society, they can be even clearer with the rest of us, show us more clearly, how to live in a sustainable way. As artists and people in the theater and musicians become clearer about this in their own minds, then they can communicate to the rest of us.

PS: In a way that others can't.

SJ: In a way that others can't and in a way that some people can hear more clearly than from someone like me giving a lecture about it.

PS: I am thinking about the importance of community in making change. Where I live in northern Wisconsin, I can see that people come somewhat more easily to a sustainable kind of lifestyle. The

artists are important to this. Some artists have been there always and others come because of the rural, less materialistic, less hectic life. People make that choice. So in places like that, I don't know that it's easy, but getting people to think about how they are living in a systematic, coherent way, like the Natural Step provides, is not hard, because there are so many people who understand this already.

SJ: When you have that kind of support, it makes it much easier and I think it makes things go much faster, too. Things go much faster.

PS: At the same time, there are always those who benefit from the system as it stands. There are "developers" for whom more and bigger is how they made their money and how they think the community should build. There's still that tension going on. In my county we can't seem to get our comprehensive plan passed because many residents think that planning is communist. "You are going to take away my property" or something. I think it's hard even where it's much easier. So when I consider the massive metropolitan areas we have created, the prospect of sustainable change is quite daunting.

SJ: You asked before what discourages and certainly those kind of things are discouraging. I think we need to remember that we're in a transition time and some people are going to be moving ahead faster than others. As I said before, at some point the funnel of declining resources and growing impact is going to force everybody to change. And it's going to be extremely painful when things start collapsing if it has to go to that point.

PS: What's the prognosis of that?

SJ: The Wuppertal Institute in Germany that says we have to reduce our resources by a factor of ten to stave off collapse in the next 25 years.

PS: I'm not surprised, but I hadn't heard that specifically.

SJ: Obviously, nobody wants that to happen. But people are now saying, for example, that climate change is happening much faster than earlier predicted. It's very sobering. You've seen that movie, *The Inconvenient Truth*, haven't you? It's pretty shocking what would happen if Greenland melted and the effect of the rising water. That's what I think the great value of that movie is. Scientists have been saying this for a couple of decades now, but somehow he's been able to put it in a way that gets through to people. Also, by giving people some hope that there are ways that we can avert complete disaster. At the end, he talks about a couple of simple things people can do to start getting the change done. Raising awareness is very important, too; we have to make people aware of these deteriorating trends and the effect of them. At the same time that we do that, that's not enough. If you just tell people all the horror stories, they are just going to say, "I can't deal with it." We have to at the same time show that there is a way out.

PS: That's where the arts will be helpful?

SJ: It would. Artists, too, have a choice whether they show the destruction or the way out or both. If they can help us to show us the way out at the same time as the destruction, then I think that will help more people to understand and not have them just completely shut down.

PS: Assuming we avert total disaster, what do you see the Boston metro area looking like in ten or twenty years?

SJ: I'm not sure I'm the best person to ask. I think there seems to be a real effort now to promote green building. I think that every year, an increasing number of buildings that get built will be greener buildings. What I would like to see happen is a greater awareness of the importance of food and local food production in New England. We're so vulnerable depending on having all our food come from California and the Midwest. I'd like to see that.

PS: Do you have farmers' markets in Boston?

SJ: Yes, a growing number of farmers' markets, a growing number of community-supported CSA's. Again, that has been happening. I think that there's a real wake-up about the need for and use of a renewable energy. I think we'll see a lot more focus on that. A lot more focus on people driving cars that are using alternatives, some alternative fuel or power.

PS: There has to be a huge transformation on the way we deliver transportation. The alternative fuels, whether sawgrass or ethanol or whatever, have got to be available and the cars have got to be built, and you have to have mechanics who can repair them.

SJ: Again, other places, Sweden being one, have shown us that this is possible. There are now stations all over the country that have bio-ethanol. So, people can drive somewhere and know that they can get it. These stations are all over. It didn't take that much time. I mean, all it really would take is an agreement with the major fuel providers to do that. That's how they did it. It was jointly worked out with the car manufacturers; getting the car manufacturers to increase the number of alternatively-fueled cars on the market, plus getting the energy companies to provide more pumps at the stations. That's really worked. I don't know what the numbers are in terms of increased number of cars, but enough so that places like Övertorneå now are saying that they've set a goal of getting their whole community, not just their local government, but their whole community off fossil fuels by 2020. Iceland has set a goal of 2010. It's not very far away.

PS: Sarah, thanks for talking with me today. You have offered an important perspective.

References

Sarah James and Torbjörn Lahti. *The Natural Step for Communities: How Cities and Towns can Change to Sustainable Practices.* New Society Publishers, 2004.

Manfred Max-Neef. *Human Scale Development: Conception, Application, and Further Reflections.* New York and London: The Apex Press, 1991.

Chapter 10

Judy Baca

"Spitting in the wind"

Since 1976, Judith F. Baca has served as the Founder/Artistic Director of the Social and Public Art Resource Center (SPARC) in Venice, California. SPARC espouses public art as an organizing tool for addressing contemporary issues, fostering cross-cultural understanding and promoting civic dialogue. Working within this philosophical framework, over the last 31 years SPARC has created murals and other forms of public art in communities throughout Los Angeles and increasingly in national and international venues.

As a visual artist and one of the nation's leading muralists, Baca is best known for her large-scale public art works. In her internationally-known *The Great Wall of Los Angeles*, a landmark pictorial representation of the history of ethnic peoples of California from their origins to the 1950's, Baca and her planning/painting teams of approximately 700 participants produced 2,435 running feet of murals over seven summers, from 1976 to 1984. Baca is a Professor of Art for the University of California where she has taught for over 20 years. She was first appointed at the University of California-Irvine in Studio Arts and since 1996 has been appointed in two Departments at UCLA: the Cesar Chavez Center for Interdisciplinary Studies of Chicano/a Studies and the World Arts and Cultures Department in the School of Art and Architecture. Professor Baca offers courses in muralism through UCLA in the Cesar Chavez Digital Mural Lab housed at

SPARC. Her work has long been dedicated to working in the community and she continues to bring that perspective to SPARC programs. She is a frequent lecturer and continues her work in public art, nationally and internationally.

WC: An important impetus for this book is the idea that there is a potential alliance that could be established between the activist and community arts community and the sustainable development, environmentalist community. How does that idea grab you?

JB: It strikes me as a tried and true strategy used through the 60's and 70's civil rights era when artists joined with various movements—African-American, Chicano Movimento, Feminist movement, Asian, indigenous—to become the heart-center of activism with images, language, and music.

People have a tendency in an anti-historical United States to believe that history begins at the moment they entered. We would do well to build on what preceded us, continually advancing seminal ideas to the next level. Though it is an old idea, it is nevertheless, an important one that is essential at this moment. What is it that people are saying? "Green is the new black." We as activist artists have demonstrated the idea successfully many times. People are now revisiting the cultural productions of the feminist movement also. Women have had major shows everywhere. The Feminist Project is going on all over the country and creating a feminist revival. The exhibitions are examining the particular period from 1960 to around the early 80's feminist movement in the arts. The feminist art movement was central to the transformation of the images of women. This question of art and social change becomes of interest at specific historical moments. I think there is something to learn in the similarity of these moments, when interest in the arts as an activist strategy arises once again. What is important is that this type of engaged art always exists in all the times in between when scholars, curators, and critics are gazing elsewhere. A certain desperation of hard times causes people to turn to the poet or to the writer or to others who make art to see if they have some idea on how to turn our psyches and consciousness in a direction that is more just, humane, and sustainable. Ideas currently being played out among corporate power-brokers and their political leaders are leading the way into a dark corner from which we cannot return, environmentally, economically and spiritually, on a global level. People are desperate for alternative ideas that can be actualized at the local level.

WC: Talking to people involved in sustainable community development, it seems that that movement has very little to do with the arts. This is despite the fact that many see that the current worldview is dominated by stories that need to change. They are saying that new

stories need to be insinuated into the ecology of human consciousness, literally.

JB: Yes, and artists have been central to the creation of metaphors and stories that define our consciousness throughout history. What is contradictory, or maybe is not, is what we are looking at in this moment of history, a time in which the arts, in their perceived importance, are at an all time low. There are many reasons for this. One is the competing interests of so many social causes that have been brought to the philanthropic world for funding, when government has decreased its participation in the public realm on many different levels. The arts are now just one of many issues demanding dollars and they fall below urgent needs of health care, the environment, education, etc. Another is the erosion of the individual's sense of our need to participate in a "civil society" with the creation of the "commons" as a shared and participatory endeavor of communities. It is also fueled by the "buy-in" by many that *"we must have endless war"* and, of course, the U.S.'s re-occurring national intolerance and xenophobia. We cannot trust our neighbors as we live in fear and conduct a "war on terrorism". It plays out here in Los Angeles, as an example, with the disappearance of an entire mural legacy, which we at SPARC produced with hundreds of participating artists over our thirty-one year history. Hundreds of street murals, which helped define community issues and cultural identities and were derived from community dialogues and neighborhood interactions to develop the imagery painted on our streets, are in jeopardy. These important works are disappearing as we speak. Unfortunately, our political and cultural leadership is allowing it to happen. Across the board we are looking at this back-turning on art as a non-essential, when it is actually more essential than ever in a disconnected, fearful time as a method to find our common humanity. But, I think that these extremes typically bring a swing back to the arts again.

WC: Yes, and maybe for artists to be asking themselves questions about what they are doing, what's our role, what's our purpose, why am I making art? With that as a backdrop do you see this moment in human history as particularly unique, or are we just experiencing an intensification of patterns that have played out throughout history?

JB: It's an interesting question I have been thinking a lot about, since the recent death of Arthur Schlesinger, the truly great American historian. He played a key role in the founding of my institution through his daughter.

WC: I didn't know that.

JB: Yes, Christina Schlesinger is the co-founder. And Arthur Schlesinger's notion of history as partially a construct of its citizens came through Christina. I remember that at a certain point, during the shift away from the values of the 60's-70's to Reaganomics, I asked

him questions about the current trend in history. Was this where America was headed? And he said that he thought that political swings lasted about 30 years and were in cycles. And that even though we were in this right-wing swing during the Reaganomics period, that there would be a swing back to more democratic ideals. The history of America could be measured in struggles between rich industrialists high-jacking a democracy for profit and the belief in a society for rich and poor alike, more egalitarian and democratic in values. Interestingly, he was talking about history in the last article he published. He had come to believe that there are multiple histories and that history was partially a construct of its citizens. He had a remarkable view from a lifetime of being an historian and what it meant to be an interpreter of history, the multiple vantage points of it. I think every period has its belief that we're in the worst period. Our era is the most catastrophic moment. One of the problems of an anti-historical country is that everyone believes history began when they walked through the door. People arrive in a community and cannot see those that preceded them.

Recently I worked in Durango, Colorado, where affluent people come from the east coast seeking summer homes or retirement dreams where they can live a piece of American folklore in the Old West. The romance of the American cowboy still attracts people. As the silver mines (an economy of extraction of resources, which is always finite) ended, then the service industry boomed to accommodate the new recreation/tourist based waves of peoples. The original people, Utes and Hispanos, became service workers and conflicts arose between their children in the shifting population. What is interesting is that Durango residents are all in the shadow of the same mountain. Some of the people call the mountain "Mother Mountain"; another group calls it "Silver Mountain". A third will call it the new mountain ski resort. It depends on when you or your family arrived and your relationship to the land. I helped a diverse group of youth create a memory of the land map for the people of Durango. The map and the Ute cycle of life became a digital mural done with the youth in conflict in the area. They were experiencing drive-by shootings and violence among Anglo, Ute, and Latino youth, who reflected these variant perspectives of the same land they share. This is a common problem in many places in America. The youth made a land and memory map which became part of an image that included their drawings about their family's arrivals and contributions to the region as part of the cycle of life images derived from interviews with the Ute elders. In this way students were able to see themselves as part of the whole, in relationship to a more holistic history of the region. We need more work that helps people see themselves in relationship to others and to history in community settings.

As for the larger story, I have not seen a worse moment for us as a country in my 60 years of life experience. I might be limited in my vision, but my mother who is a very politically-astute, 84 years old, says the same although she lived through a world war and a depression.

WC: Many say real change doesn't happen until the moment you hit "rock bottom." Do you think that the increased awareness that we're destroying the world is one of those moments?

JB: I do think so. We are at the end our capacity to rely on fossil fuel. It was predicted long ago but had to reach catastrophic, global warming consequences before we paid attention to the problem. Daily consciousness is changing on this issue. The "green movement" has to be browned, however, to truly become effective. There are strides being made in this direction that are heartening.

I've been here in the studio analyzing the 60's with my team of 11 very smart UCLA students over a 20-week period. We've been reading many iconographic books from the 60's. We've each read three books with the assignment of "becoming" those books, presenting their various viewpoints in the interpretation of the 1960's history which we are designing for the half-mile long Great Wall of Los Angeles. The Great Wall, now thirty years old in some sections, is being extended and restored.

Speakers have come in to offer us unique perspectives of the era. It's a remarkable experience to hear Jesus Trevino talk about what it was like at the moment of the walkouts in East L.A., as a filmmaker. It is essentially story-telling in the best sense, with people who lived through a particular moment of history sharing their stories with younger students who were not even born when these important historical events occurred. He talked about what he was trying to do as a young filmmaker in his twenties during the 1960's; he brought in footage. Looking at this historical era from the vantage point of people who were born in the 80's has been so fascinating. It's multiple views of a story—that there is no absolute truth essentially; it's a story of variant positioning. Some people walk up to the elephant, see the toe nail and say "this is the deal, this is the whole deal right?" Another comes to the back of the elephant and they see the tail, but very few people have the vision to stand back and say, "here is the whole creature."

WC: What are your students coming up with as they move through this history?

JB: I think what I am seeing in my students is a kind of blinking light. It's as if, simultaneously, elements of the 60's live in the hearts of these young people, AND a complete opposite positioning lives there, too. In other words, they identify with the struggles for civil rights and other elements of sixties history, because it is the only reason they are able as minority students to attend a University

such as UCLA, and then the light blinks, and one of my students says, "What was all this about? I mean all this civil rights activity? Did it mean that history could then deliver us a Colin Powell, or a Condoleezza Rice?" Of course, the question is a good one. What did activism of our era truly yield? Did it mean equal opportunities for all racial groups to become oppressive leaders?

But then, I saw a girl who had never spoken in my class, a repressed young woman who could barely bring her voice to audible in class discussions, be completely transformed. I saw her completely transformed by becoming Betty Freidan's *The Feminist Mystique* book. Her job was to become *The Feminist Mystique* and *Our Bodies Ourselves* representative. I thought, "My God, that's what happened to us, back then. Here I am watching it happen again." She began to truly represent the viewpoints of women taking control of their sexuality, their healthcare, etc.

WC: There it is recreated again.

JB: Exactly. What I really feel is that there's great hope in the processes that we invented. This is a bigger view, I guess. There's great hope in the processes that we invented for our own transformation. Those of us who have not come to the idea that there is a connection between art and social change yesterday know how to do this. I have been working alongside environmentalists to create the Great Wall mural with 400 youth, 40 scholars and artists, which we describe as a tattoo on the scar where the river once ran. We made a relationship between the destruction of Los Angeles' river and the destruction of the stories of the people of California who spent a lifetime making the state. I mean, truly, we know how to do this and others can build on this knowledge with new inventions.

WC: So you're saying that this may be a unique moment for challenging and changing the stories that inform our lives. And that is that there is a significant history of doing this; we don't have to invent this wheel.

JB: We don't and that's what I'm really getting at. The role of an artist within society as a provocateur and as a citizen participating as a change agent has always existed. It just falls in and out of favor of power. What I'm also saying is that it all exists simultaneously. That's a hard thing for me to grasp. I want to have Arthur's idea that things move progressively forward in predictable 30-year cycles. It would be great if it were nice and neat that way. But historical movements seem to be more messy. These kids face enormously confusing choices. On one hand, they are encouraged to become a vice president of Coca Cola's marketing, selling Coke to Third World countries. That will give you the biggest reward. But simultaneously, in my classes among the young people I meet, is somebody like a young artist I am working with now whose family came from El Salvador during the war in the 80's, who is among the

most talented students I have ever had. He can not only do computer work and animations but is brilliant at all kinds of computer graphics and design. He also is a painter and works with materials and with his hands. He's a musician and video artist and is an excellent teacher because he can communicate what he knows. He is a good scholar. He is truly interdisciplinary.

WC: So, this is the new citizen.

JB: That's who they are. It's interesting; I may be among the last generation of discipline-trained people. What does that mean? It means that on the Internet, simultaneously, all at once, students and the public alike can now see vignettes of moments of history. You can go back to an instant for an instant. So, I tell these kids about the Hollywood Ten and Edward Beaverman and in a hot second, they found everything on the Internet about him. They get all this material in a second. Whatever is there becomes a sort of gospel to them. But, it is just snippets. It's not deep. It's not studied in the same way we are deep and studied in a discipline through books and practice. I was trained in minimalist painting as a student. The minimalist painters did painstaking experimentation in the creation of color palettes to understand the optic effects of color and gesture as a formalist principle. I became a colorist, as I learned to paint in this manner. Later I would reject what I didn't need of this discipline and become a muralist in the tradition of Mexican muralists of the Twentieth Century. None of my students will have that type of experience.

WC: Unless they decide that they want to specialize in something intensely.

JB: To be successful, they can't specialize. They must be multimedia and creative in new ways.

WC: That monastic path is no longer available.

JB: No. And, frankly, I wish it were not true, because I believe that's the place that makes you deeper and more human. I think I've had the privilege of being grounded in a discipline, grounded in a belief system, and being able to operate in a way that is, in a sense, almost monastic. But I'm also unusual because I've had five lives. I've run an arts center, been a teacher, and been a Chicana leader in terms of social issues that affect our communities and so forth. Then I've had my own public commissions and public art.

WC: You're a contradiction in some ways.

JB: A contradiction, but you know what; I am also precursor to this period.

WC: A period of extreme contradictions.

JB: Yes. I am simultaneously sitting at the University of California in the special ballroom receiving the Copenhagen Award in innovative technology teaching at UCLA. Then I can walk back into my community and receive death threats from the Minutemen.

WC: Incongruous and everyday, all at once.

JB: That's what's happening.

WC: So, the question of how one responds in this environment is critical.

JB: Exactly, and how we can respond in this environment as artists is really unique and exciting, really exciting. I can give you an example. Every year we do an Oaxaca art sale for Christmas; it helps the Zapotec Diaspora from Oaxaca living here in Venice. Venice, California has the largest Zapotec community outside of the Siete Valles de Oaxaca. In Oaxaca, in the seven valleys, the tribes often don't speak to each other. There are 18 indigenous groups and many don't speak the same language. They have different variations of Mixtec, Zapotec, and all different languages. They have a fabulous history of craftsmanship. They make beautiful hand-woven Oaxaca rugs, fabulous sculptural pieces. Josephina Aquila, an indigenous Oaxacaquena, has become famous for her ceramic figurines which she produces from the mud she digs out of the ground and fires with wood in a dirt pit. These beautiful figurations are collector's items. We offer the ceramics of Oaxaca and wooden fantastic figures from Oaxaca in our store at SPARC and have a special Christmas sale each year.

 This year we started to receive information from artists from Oaxaca on the Internet and images from photographers. One was Antonio Toruk, a Mexican photographer who has done extraordinary photos in Chiapas and of the Zapasistas. He is a magnificent photographer and artist, working in digital imagery. Anyway, he started sending me .jpg's while a revolution was breaking out in Oaxaca. The governor had tried to stop a teacher's strike and some of the teachers were killed by his military troops trying to repress the essentially indigenous people of the region. Every year the teachers had been striking to get a little wage increase and better conditions for the school children, because they live very poorly. It blew up into a revolution of the indigenous, who came out in support of the teachers and against the Governor's oppression. I started getting these photos showing the beautiful city of Oaxaca transforming by the hour. I sat back and said, "These images are so powerful and amazing. Send me more."

 Pretty soon I opened a port on our Internet site. About 10 to 15 artists, some really amazing documentary photographers, started to send me daily journals of what was happening in Oaxaca. The news media were not covering this, but what we were seeing at SPARC was a revolution unfolding on computer screens on a daily basis. We were watching the coming together of these indigenous tribes to work together to stop an oppressive government and to begin to deal with this incredible disparity between people as one of the most touristed sites in Mexico, one of the most-recognized artistic sites internationally, a treasure of a city was turned into a war zone.

In fact, they brought federal troops in. It ended in the killing and incarceration of many indigenous, but particularly struck the international community with the death of Bradley Will. Bradley Will was an American Indy photographer who was killed while filming an attack of the military against a blockade created by the people. They killed other people, but when they killed an American photographer, a filmmaker, who was video-taping the moment he was being killed, it went everywhere. SPARC mounted a show called "Oaxaca in our Hearts". The images were also on our Internet site; we were able to download them in our lab and make big prints and we opened a show, in conjunction with our holiday show, of the images from Oaxaca. The L.A. *Times* then picked up the story. *L.A. Weekly* wrote, "Why must we go to an art center in Venice to learn the most important things about what is happening in Oaxaca—things we're not getting from the media?"

WC: Important question. Actually, it could be the other way. "If you are interested in stories that are being ignored by mainstream media check out SPARC." You have always been a source for alternative views.

JB: Yes, exactly. But this is an example of what I'm saying about what is becoming possible. This wasn't a traditional art show. We didn't ship anything. We didn't have a budget. There wasn't any agreement signed. We shipped the art via the Internet at high resolution and the artists kept working in Oaxaca.

WC: No, you had these bits and bytes coming over to you over the Internet.

JB: Right, so now go to our site and see the work; you can download the Declaration of Independence written by 17 different indigenous groups in Oaxaca, in English and Spanish. It's magnificent. It's like America's Revolutionary document. It's beautiful. It's also about saying, "You can't oppress these people and you will not stop them."

WC: I have written about a similar kind of campaign that took place around Aboriginal land rights and the poisoning of the environment from nuclear testing in the Australian desert. Artists and independent media people were instrumental in shining a light on this.

JB: Exactly. What is fascinating is all these contradictory things are happening simultaneously. While people there continue to be oppressed, while Mexican family farmers are facing the fact that American companies are inventing corn that doesn't have seeds that can reproduce, while all this is happening, we're beginning to hear about these things in ways we've never heard before. We have the means to gather and manage and act on information in ways we never had before. Artists are poised to become significant actors

WC: in these kinds of situations. If we can join with activists in critical ways, it's going to be powerful.

WC: It seems that one of the unique elements of this is the powerful presence of first voice, more and more people sharing their own stories with a world audience.

JB: Absolutely. Here's another incredible part of this story. The indigenous women in Oaxaca were traditional and often silenced in relation to public interaction and were dominated by the men. But because the men have left the city, they are starting to have very dramatic influence; they're becoming the voice that speaks out. And like I said, the borders are disappearing.

We're in a global community with this permeation coming from everywhere in the world. I love what my friend used to say years ago to kids trying to explain the border. She said "if you spit in the wind, it comes back in your face." We've been spitting in the wind and it's coming back in our face from everywhere. That's what I think is happening.

WC: Yes, karma from actions taken today and yesterday. And of course the wind is stronger coming back.

JB: Exactly, stronger and faster. And now that we have the means of communicating, we can't isolate ourselves. The impulse toward isolation as policy of the United States is impossible. We can't build a wall between us and the rest of the world. The futility and the madness of this is fence-building is an example. These fearful people are saying, "We can stop this from happening to us, let's build a fence." What they forget is that everything moves through cyberspace, everything moves into the consciousness of people through visual images and ideas that go back and forth constantly. We live in each other's minds and hearts.

WC: I'm not sure they realize that what they are afraid of has already happened. They are trying to turn back the clock to a time that never really existed—the pure and true America. This is a country of immigrants. People in need will always move to higher ground. There isn't one of us who wouldn't do the same under similar circumstances.

JB: The interesting thing is that the same thing is happening in the arts. The mainstream art world is still trying to live the 19th Century notion of artists. They're training in the 19th Century methods. They have these ideas who these students will become and they don't fit.

WC: Outsiders are erupting all over the place with incredibly creative work.

JB: Look at the graffiti artists who are destroying everything. You either choose to channel it or they will take down your public environment in total. In L.A., they are spending some astronomical sums of money to deal with this. It probably could support ten times over all the arts in Los Angeles. All the arts organizations

could be funded for the next ten years with what they spend annually to remove graffiti.

WC: Isn't that a pattern that repeats itself over and over and over again. Moving forward, harkening back. Action, reaction.

JB: But it's going from the top down. In other words what I do think Arthur was right about is that you could, you can extrapolate from certain things. He wrote about the whole notion of Camelot in the Kennedy administration and how that notion of Camelot then spread to the American public. Or the WPA and how that idea spread to the American public. What we have spreading now from the top down is these retrograde notions, No Child Left Behind, the war in Iraq, and the insane economics of oil. And then we have the prison industrial system in which corporations are buying up the prisons and the criminalization of the youth directs our young people to prison. So we are basically saying, "We're not going to do rehabilitation, we're not going to do redirection, and we're not going to do prevention. We're going to put them in the prisons and they can work for $1.50."

WC: Right, a labor force.

JB: A labor force in the prisons that is an example of our addiction to slavery—the addiction to slavery upon which this country was founded. This is why we have these issues going on. We have always sought immigrant populations to be part of our work forces, and have been ambivalent about having these workers become part of our society and the "American Dream". We didn't want their cultures intermixing. What is so fascinating is that those cultures became the new American culture because they were so exquisite at reinterpreting the American experience.

WC: Do you think being excluded allowed them to avoid the tyranny of comfort that mainstream Americans enjoyed?

JB: Yes, they avoided being sedated.

WC: So these survivors from outside then become the vital force in the country. They are hungry. They become the future leaders.

JB: It's interesting isn't it? The leaders are the people who are doing the pioneering. Most people do not want to make change. What is it my poet friend said once? "If we could all grow at the rate we chose, we'd all be 4 ½ feet tall"?

WC: Do you think the possible death of the earth is going to push us into making decisions and thinking about things that we would avoid if we could?

JB: It may be the unifying force, although, I'm not sure. We are all temporary residents of the earth and hold our relationship in common. It is so important to make the relationship clear, however, between environmental justice and social justice. Indigenous people, of course, do have that relationship but on a whole different level. A great irony is the notion that we talk about land as "developed" or

"undeveloped". But if you go around talking about land that is not built on as "undeveloped land" then we might as well say that it is waiting to be destroyed. It's that Manifest Destiny way of seeing things. It's the notion that undeveloped land is waiting to be exploited.

WC: Here is a final question. In times of stress, there are many responses. Some are like the sow bug that goes off into the corner and curls up for protection. But there are others who reach out because they realize they can't survive alone. I'm wondering if you see opportunities for new alliances, partnerships between the activist cultural community and other progressives.

JB: Of course, we've always made those alliances. For example, last night I was at the Center for Law and Public Interest. The director sent me a note and said, "I've got something I need your help with. It's about a site in Manhattan Beach which was an historic black beach where, years ago, they ran the black people off." Can you imagine, here in Southern California, there was a black resort up the beach and it's all been completely disappeared? It was called Bruce's Beach. The city, apparently under some urging of the Bruce family, was going to do a token commemoration of the site. Roberto said, "Can you help me with this immediately." This city was planning to put up this nondescript plaque that really saves them from having to own up to the fact that the developers in Manhattan and the city council at one point ran the African-Americans out of this place. So they put this nondescript plague up. He asked me to produce giant banners in my digital lab that will be carried in by the Center for Law and Public Interest and all the community people who are related to the site. Then we'll propose a public art monument, which we'll put on the site. So, I am working hand-in-hand in the creation of monuments of other people whose histories have recently been disappearing.

Another example: There is a huge redevelopment project going on right now along the Los Angeles River. We are working on 15 markers along the river that will mark significant sites that are currently not marked. The site of the deportation of over 75,000 people from Los Angeles during the 1930's in the repatriation period of Mexicans is not marked. The site of the Zoot Suit riots, where Latinos were attacked wholesale on June 3, 1943, by Marines is not marked. These important sites were all along the river, because the river was the Mason-Dixon Line for L.A. So, the river development project, as it was configured, was not looking at any of that kind of material. The Great Wall will become the fountainhead for the marking of these sites along the river, bringing together social justice with environmental justice. The same mentality that destroys a river and concretes it for expediency and for real

estate development destroys the stories of the people for similar reasons.

WC: So, you are resuscitating buried history, the lost stories.

JB: Exactly. And what better way to tell the story than through poets. We're going to put poets to work to tell the stories all down the river on podiums that are not didactic, like typical state markers. So you will be able to take a poetry tour and read about the river. And while the river is restored, we're making the same point we made when the Great Wall was created. The river was hardened in concrete. The arteries of the land were destroyed. And in the same way that you destroy the environment, you destroy the stories of the people. It is an extension of the same story. If you recover the river and recover the stories of the people of the land, the "gente de la tierra" then we see ourselves as one with the river, then we are connected with the river. Bring back our stories. Bring back our river.

Chapter 11

Linda Burnham & Steve Durland

"The leader inside"

Linda Frye Burnham is a writer who is co-director of Art in the Public Interest (API) and the Community Arts Network (CAN). She was founder of High Performance magazine and co-founder of the 18th Street Arts Complex and Highways Performance Space, all in California, and co-founder of API, in North Carolina, and CAN, on the Internet. She is co-author, with Steven Durland, of "The Citizen Artist: 20 Years of Art in the Public Arena" (New York, Critical Press) and editor of "Performing Communities: Ensemble Theaters Deeply Rooted in Eight U.S. Communities" (Oakland, Calif.: New Village Press) and numerous CAN publications. She has been a staff writer for Artforum, contributing editor for The Drama Review and arts editor for the Independent Weekly of North Carolina. She holds an MFA in creative writing from UC Irvine.

Steve Durland has worked as an artist, writer, magazine editor, non-profit arts administrator, designer and web consultant. He has been a type-setter in New York, a computer consultant, a grade school art teacher, and an art gallery director. He has taught performance art at the University of California, Irvine, and worked as a community artist in South Dakota. He edited High Performance magazine from 1983 through 1997. In 1994 the magazine won the Alternative Press Award for coverage of cultural issues. With Linda Frye Burnham he co-edited the book *The Citizen Artist: 20 Years of art in the Public Arena*, an anthology of 20 years of High Per-

formance magazine, published by Critical Press in 1998. He has a BFA from
the University of South Dakota and an MFA from the University of Mas-
sachusetts. Since 1995 he and Linda have directed Art in the Public Interest,
which produces the Community Arts Network.

PS: First, would the two of you talk about where you see the world
heading these days?

LB: There is such a terrible crisis right now. Just take global climate
change alone; they keep telling us we only have ten years, so
everything we do makes a difference, everything, from who we elect
president to how we recycle all the crap we buy at Costco. I would
point to an article that we published on our website: (www.com-
munityarts.net/readingroom/archivefiles/2006/11/converging_stre.
php) about the confluence of the environmental movement and the
community arts movement. It made me think of all of us boomer-
age people coming to this moment where we want to share what
we've learned throughout our whole lives. We do share values and
there are so many of us. The article really led me into some hopeful
avenues.

SD: We're at a place where something's got to change, obviously,
whether we're lucky enough to have it move in this direction. We
really need a brilliant person of global stature who can step up
and re-contextualize in some way to release some of the tension.
What I'm thinking is that given tensions wrapped up like they are,
a paradigm shift seems unlikely because there's no space for it.

PS: Because everybody's behind their own little wall?

SD: Yes, they're scared. There's the micro-level where you have kids
with guns in school and everybody's worried about that. We should
be talking about the arts in school, but we're not. We're talking
about self-defense. Tom DeLay recently said we need to let kids
carry concealed weapons so they can protect themselves. And at
the macro-level you've got exactly the same thing going on. Every-
body's in a kind of cold war mentality, where we all pull out our
guns and point them at each other. Yes, things are going to change.
Are they going to change the way we want them to, I don't know.

PS: You're not convinced that cooler or more artistic or more peaceful
heads will prevail?

SD: I don't think it's automatically a given. There needs to be some-
body or a group of somebodies who stand up, who has the authority
that people will recognize, perhaps it's someone from the Islamic
world, somebody from our world.

LB: You mean with the stature of Gandhi?

SD: Yes, there's an opening now for that person. But, it's not going to
just happen.

PS: You don't think local people in their own little communities have enough vision and recognition of the issues to make things happen on the ground? You are thinking we need some kind of leader who would create a vision for us?

SD: I think that actually a majority of people are in line with an alternative to the kind of government that we have now. But that doesn't make it happen. In spite of the fact that those people are out there, the person who could marshal that energy wasn't Al Gore, and it wasn't John Kerry, and it wasn't Michael Dukakis. Is it possible for political leaders to propose paradigm shifts, or do they have to work in this incredibly slow and incremental fashion, move to the middle and then you try to move the middle an iota to one side or the other? In terms of paradigm shifts, the conservatives in this country have been laying the groundwork for a long time and they're seeing the results of that now.

PS: I hear you agreeing that we are in some kind of crisis point. We can either continue down the road of more empire, more hierarchy, more inequality, more violence, or it's possible that there might be, as David Korten hopes, some sort of change in the other direction. We don't know which one it would be, but something is going to happen. Is that what I hear you saying?

LB: Every scientist that talks about climate change says we have ten years. That seems like a crisis to me. What Steve is saying is that for several years, we've had the living daylights scared out of us every single day. I heard Pat Buchanan talking about guns; he said that people want their own guns because they're scared to death. They're afraid the center cannot hold, that there will be a total breakdown of law and order and their family will be exposed. It's logical. Look at Hurricane Katrina and everything else the Bush administration screwed up. If the most powerful nation on earth can't control anything, then a climate of fear is believable, understandable, logical. When you have that, people begin preparing for the very worst, rather than envisioning something better. But I think that this climate change crisis is going be our salvation, because we're just not going to let that happen. I remember the 70's when we had the gas crisis: everybody started recycling and it made a difference. I think that, at least in this country, we're capable of that. But there are so many more people on the planet than there were then. Steve's point about leadership is who is going to bring these ideas to the fore, when such a debate will only scare everyone more.

SD: My theory of community is that it basically is a self-defense mechanism. And so I always think of aliens from outer space. We all need the same enemy. If Al Qaeda comes in and figures out a way to kill 50,000 people, then that's who we will form our community in defense of, just as we've already done. Think of how that short-circuited thinking in our entire country. We've gone out and killed

150,000 people to deal with the psychological trauma of 3,000 people killed. Climate change is the alien from outer space. If we don't defeat it, everybody dies. So, it's a way that everybody can find a common ground to work together without all having to form a democracy or having to worship Allah or whatever the various terms are these days for complete and total surrender.

LB: Thinking of leadership, as long as I can remember, I've been losing faith in all my leaders. I mean, I lost faith in my first husband, in Richard Nixon, literally everything has turned into feet of clay. I don't see how any young people can look at a hierarchical situation and expect to have faith in something that's told to them by a leader. We have to figure out ways for people to find a leader inside of them.

PS: Maybe that brings us back to the notion that people are scared because they are used to assuming that somebody else is going to do it. Now, it's pretty clear that somebody else isn't going to do it.

LB: I was very disappointed in the 2004 election. Artists really tried hard to affect things, especially in New York. I went out of my way to write an article on what was going on around the Republican Convention. It had no effect whatsoever, absolutely none. There were just hundreds and hundreds of arts events that were trying to make themselves heard in the face of that Republican convention. They did all kinds of things that have been done before. They were the traditional protests, marches and things. Marches don't seem to change things. Do you remember that incredible worldwide march that went on right before the Iraq war started? Millions of people all over the world. The right co-opts everything we come up with, as soon as we come up with it.

I remember back in the late 80's, there was a lot of talk that there was going to be a sudden shift, the hundredth monkey syndrome. Bam, just like that everything was going to change. People's minds would change all of a sudden and there was talk about the harmonic convergence. People were sitting around meditating in these vast groups, we're going to change the world. Of course, everybody laughed. After the harmonic convergence happened, supposedly, nothing changed. But the very next year, the Berlin wall came down and apartheid ended.

There's a great book called *Hope in the Dark*, by Rebecca Solnitz. It is about all the great things that have changed and that we have to keep noticing them and keep remembering them no matter how oppressive contemporary life becomes.

SD: A lot of the demonstrations in New York at the time of the Republican Convention were funny and amusing, but it wasn't going to get anybody in South Dakota to change their minds. What they see is this vast group of people in the world who want to kill them. They want to see somebody come up with a way to address that.

Dressing up in funny costumes and carrying funny signs isn't going to do it.

PS: Well, if we come back to global warming, you said you think that we just won't let it happen. How might we respond?

LB: Yes, we'll definitely do something about it. It's already in motion.

SD: Well, take Al Gore. He is just basically being Jimmie Carter, saying we have to make sacrifices. On the other hand we've got Schwarzenegger in California being Ronald Reagan. He's saying: "no, you can keep your Hummer, we'll just find something else to put in it."

LB: He said people are not going to stop driving fast, so we've just got to make a car that gets better mileage.

PS: All those things would help.

SD: This has been an argument at various levels since we've all been kids which is technology is evil and the way you solve it is either more technology or less technology.

PS: I used to be a person who was technology-adverse. But I'm to the point, maybe it's because I've always been optimistic, that there ought to be at least some technological things we can do to improve things and to change the destruction we're creating on the planet. Speaking of technology, would you comment on how technology is changing our society and the work of artists?

SD: The difference between young people now and our generation is that they are totally main-stream with the new technology. Their communities are all over, they're global. They move at light speed. As much as I know about technology, as much time as I spend on the internet, there's no way I can keep up with them. They are developing the ability to perhaps make these kinds of paradigm shifts almost overnight. It's like my feeling about issues that we worked on in the 60's and the 50's: racism, sexism, and stuff like that. There's a certain point where it's really not going to go away until the racists and the sexists of that era die off. That's when things finally change. Before that, you're just legislating. What happens after we die off and these kids are our age with this kind of global reach and speed?

LB: They have no idea what the people look like that they're talking to. All they want to know is they're making connections.

SD: The kind of thing that Karl Rove is trying to do—manipulate thought and image. It can't stand up to that non-hierarchical information flow that they have.

PS: I think that's right and I think that's significant, very significant.

SD: A question that comes out of that is "What are they going to call art in that kind of world?" That is more a curiosity than a question.

PS: You mean, what will art be under the global technological, upload-download kind of world that we have come into?

SD: As soon as we die they're going to grab all our stuff, cut it up in little pieces, rearrange it, and put it out there.

LB: I see a field out there in between old fashioned fine art and community art, where the brightest people in the art world are bringing all this stuff together. There's an incredibly eclectic site on the internet called The Provisions Library. It brings in strands from science, technology, art, sociology, all kinds of things. Provisions Library is all about social change; they bring together people from all over the world with different kinds of expertise. They sponsored a multi-media festival to bring together artists from the Washington, D.C. region around the theme "Capturing the Capital." Their purpose was "to energize the D.C. arts community with new ideas about arts, society, and politics." There's also an organization in England called The Arts Catalyst, which is about the connections between art and science. Scientists and artists are creating this synergy, where they talk about each other's work, what they're confronted with, and what would you do? And Liz Lerman's company has been holding a series in their public space called "moving dialogues." Recently they did one called "Art and Science: Partners or Polarities?"

PS: Well, those are two groups of creators—the scientists and the artists—problem-solving creators.

LB: In the 80's we were part of a group like this in L.A. called International Synergy. We got to sit in groups like that and just toss balls around. A scientist would turn to an artist, say, "How would you approach that?" Then the dancer would say what she would do. They were crossing artistic disciplines.

PS: That kind of interdisciplinary coming together of creative people to deal with issues continues?

LB: Yes, we are in problem mode now, so people are bringing them together.

PS: That could be a pretty powerful force, in a world where technology flattens out hierarchy.

SD: There's a charter school over here in Saxapahaw that is repositioning the entire school beginning next year to be focused on arts and environmental sciences. The point there is just that it is an idea that's sifted way down past the high thinkers.

PS: I just finished reading Thomas Friedman's book, *The World is Flat*, which is about globalization. He ends up with a huge call for creativity and imagination as the way to deal with not only the flattened world of the half of the population that's tied together, but also the other half of the population that's being left behind. He says without creativity and imagination, the arts and sciences, we're not going to solve these kinds of things.

LB: But, the real change is the internet, I think. It's a change of mode and vision and everything and it just took over. We've only lived here for 12 years and before we came here the web didn't even

exist and now, it's definitely the biggest social change that's ever happened as far as I can tell.

SD: Now, another thing happening on the internet is a whole new world of critical feedback. You go to Amazon and look at a book you're interested in and there are already 20 people who have said this is a great book, this is a terrible book, blah, blah. So, you get this range of responses.

PS: There is an interactive global internet-based interaction that wasn't there before.

SD: Exactly. Right. This is totally the next generation. What we find is that people our age, this whole group that Linda was talking about, is scared to death to say anything and put their name on it. They'll call us up and say that was a good story or that was a terrible story or I liked this or didn't like this. Think they can actually write something, post something, say something in a forum? Not this generation; they're not going to say something and put their name on it. In all these other subcultures out there, these kids who are 15 to late 20's, people will say whatever they want about anything. They're all over the internet and have been for 10 years with their girlfriends, their dates and their opinions about movies and their blue jokes, whatever. As they move through culture, basically this will be part of their world. But it also basically democratizes criticism.

LB: It toughens people up, too.

SD: We did one story about two months ago that a young white woman wrote from Maryland that she was working with inner city black kids. It just lit a fire under a whole bunch of her peers; there was a real back and forth with these kids posting comments at the end of the story. We always provide that option. This particular story probably has more comments on it than the whole rest of the website put together, because these kids just are fearless. They're screaming at each other, yelling at each other and calling each other names and saying it's this and it's this and at the same time, making very articulate arguments. Yet, you couldn't make a decent chapbook out of all the comments we've got overall.

LB: Somebody else came in and said, "Let's review. So and so said this and so and so said this and both your comments were useful in this way." It's amazing. You can call them names. You can call them racists and they keep going. Our generation is just terrified of being called racists.

SD: We grew up in a world and you saw something you didn't like and you really didn't have a whole lot of recourse other than to go to the bar with your friends and complain about it. Or, worst case, you actually wrote a letter to the *Village Voice* about it. But that was always a set up. At any intelligent left-wing magazine, all the writers wanted was to dare somebody to write a letter to the editor so they

could really use their writing chops to whittle a person down to a bunch of saw dust, giving them another chance to respond. But now, they just keep coming back at each other.

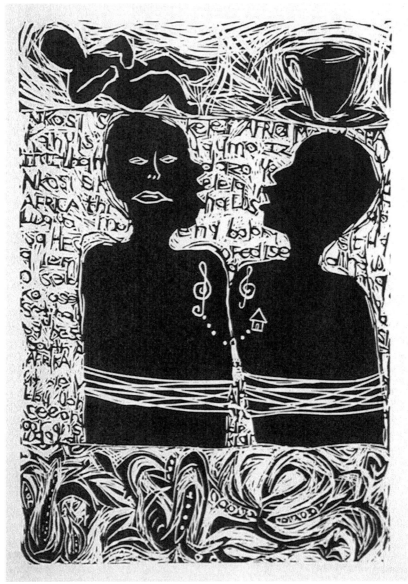

Gabisile Nkosi: *Culanami* (Sing With Me), Linocut, Gabisile Nkosi, 2007 from the Healing Portfolio commemorating the 200th Anniversary of the Abolition of Slavery in the United Kingdom.

Part III

The Persistent Thread

The Role of the Arts in Society

The Persistent Thread

The Role of the Arts in Society

*Steve Heitzeg, Richard Ringler,
William C. Banfield, Wilson Yates*

The interviews in this section provide an important perspective on the ways in which artists have encountered significant social issues, both past and present. Both Steve Heitzeg and Dick Ringler use examples from the visual, musical, and literary arts to describe how socially-engaged artists confront war. Since the current environmental crisis holds great potential for continued violence as competition over dwindling resources increases, these insights have great significance. Bill Banfield describes the ways in which the popular and vernacular cultures have always provided a conduit through which people confront social forms. His description of the continuous and fruitful interplay between these expressions and high art leads directly into Wilson Yates' analysis of the common roles played by art and religion, both past and present.

Chapter 12

Steve Heitzeg

"Its not just about you"

Composer Steve Heitzeg is recognized for his orchestral, choral and chamber music written in celebration of the natural world, with evocative and lyrical scores frequently including naturally-found instruments, such as stones, birch bark, and sea shells. An advocate for the "peaceful coexistence of all species through music," Heitzeg has written more than 100 works that address social and ecological issues, including compositions for orchestra, chorus, chamber ensemble and films. His music has been performed by leading orchestras and ensembles, including the Atlanta, Detroit, Houston, Philadelphia, and Minnesota symphonies as well as Chanticleer, the Dale Warland Singers, and VocalEssence. Named "Composer of the Year" at the 2000 Minnesota Music Awards, Heitzeg received a regional Emmy Award for his original score for the public television documentary *Death of the Dream: Farmhouses in the Heartland* in 2000. His score for the PBS film *A Marriage: Georgia O'Keeffe and Alfred Stieglitz* premiered nationwide as part of the American Playhouse Series in 1991. In 2003 Heitzeg wrote incidental music for the Shakespeare Theatre's production of Ibsen's *Ghosts* in Washington D.C. He grew up on a dairy farm in southern Minnesota. Following undergraduate work at Gustavus Adolphus College, he received his doctorate in music theory and composition from the University of Minnesota School of Music.

PS: In May of 2006, some of the Continental Harmony composers and
hosts got together with others from the field of community arts.
They were feeling that we are on the hinge of changes that they, as
artists and community folk, needed to be involved in. Since then,
books by David Korten and Daniel Pink have received a lot of at-
tention, because of their arguments that we are at a turning point.
The potential exists, they both say, for the emergence of a more hu-
mane and equitable society. That's the issue that we want to talk
about today.

SH: Well, I certainly hope that is true. I think the internal human spirit
is much better than what the current U.S. government and oth-
er power centers give it credit for. But, I think about the envir-
onment. People talk about the possibility of wars over water and
things like that. That would be tragic. But I think many people's
eyes have been opened in the last decade about, for example, global
warming. And people are also seeing that perpetual war, as Gore
Vidal talks about it, just does not solve anything. It is just a major
drain on people's lives and on the planet. It's very negative. But
there are many positive things happening all the time--people do-
ing things, on a very small scale and sometimes on a large scale, for
the planet, for humanity, or for animals. We just don't even hear
about these things because they aren't covered in the mainstream
corporate media.

Anyone involved in the arts sees the power of the arts for change
both on a personal level and also because they bring people to-
gether. In my experience and perspective, music has always been a
metaphor for working together, showing that people can work to-
gether in the world and make things more peaceful. Another part
of this metaphor is that the artist can go into a different world of
imagination, and separate from being driven by consumption and
money.

I know that if people have more experience in the arts, they
have more confidence, feel better about themselves, and feel in-
cluded. It also enables you to be removed from yourself. If you are
in a play or reading a poem, you are injected into someone else's
world so you can see that perspective.

Let's talk about war for a moment. If you could get everyone to
just not use war as an option, think about the amount of money
that could be transferred. The current [G.W. Bush] administra-
tion or the war machine in general spends money to set up the myth
of a black-and-white, good-versus-evil scenario. This also takes
money away from the arts, so that people who are already in a dif-
ficult position are less able to know the power of the arts. The cur-
rent [Bush] administration is afraid of other perspectives, which
artists always represent, or of opening up worlds so people could
say, "Hey, I'm studying this music from another culture." That

doesn't gel with their particular scenario of marching forward and taking over the world through war or economic exploitation.

Take, for example, the film "The U.S. versus John Lennon".

PS: I don't know about that.

SH: The film came out in 2006. It's all about the U.S. government's move against John Lennon, why they wanted him deported, the whole history of that. He was involved in the peace movement, as you know. He and Yoko were going to do a whole peace tour. They already had billboards on Broadway and overseas for peace (e.g., "War is Over," "Give Peace a Chance"). So, Nixon was very freaked out.

PS: You seem to be saying that the liberating power of the arts is a threat to those who benefit from the war system and environmental exploitation?

SH: The environmental problems relate to the war system. Think about the 500-pound bombs of depleted uranium that the U.S. is dropping in Iraq. I don't know how many have been dropped, even if we just count the Iraq war. What is that doing to the planet? I mean, the war has pretty much ruined the water in Iraq and has caused earthquakes. Heat in the atmosphere and the making of negative weaponry also is damaging to the planet. And land mines are terrible, too. But that has been an ongoing thing since human existence began; the real flaw of humans is that they torture animals and each other.

PS: But the war system that we have in the modern industrial world is a whole lot more dangerous and destructive than in the Middle Ages or with tribal warfare.

SH: Those wars were person-to-person. Now you press buttons; you're more removed and it is so much more extensive.

PS: Do you see any prospects for transforming this global war system into something more equitable, into an earth community like Korten talks about?

SH: Yes, I think there are people who are doing that now. A lot of people are trying to live green, building green and trying to make the move away from fossil fuels. Gwen and I recycle like many people, support several environmental organizations and all. But, I still drive a car, we don't have solar panels on our house, and our house is not 100% green. But, I'm trying to make a statement through my art. Really, I'm hopeful, because a lot of change is happening.

Just go back to the example of war and just to the people in the U.S.; look how their view of the war has changed, how they're against the war now.

PS: It seems like people's concepts are changing regarding global warming also. I think the Al Gore movie, "An Inconvenient Truth," finally got through to people.

SH: What was interesting, I think, is that he went very grassroots with it. They just were showing it at Friends Society House and at a lot of churches and schools. He just said, "It's out here. I'm not going to get it on every major screen." Initially, it came through quietly, and then attention increased. It's very interesting. There is no way to be in denial after looking at that film. If someone is in denial after that, it's very troubling. If there was no money or value attached to oil, I wonder if they would still feel the same way.

PS: Do you have a vision of how people in general might be dealing with these challenges: the war system, environmental problems, and so on? Or how artists and arts organizations might be of help?

SH: As an artist who does school residencies, I think it is important to talk about handling conflict non-violently on all levels.

PS: Do you see that happening in schools?

SH: Most of the artists that go into schools are talking about celebrating all cultures and not about annihilation. Being in the arts has taught me to value freedom of expression. I can't tell someone else to write a particular type of music nor should I be told what to write. I'm definitely an artistic populist. I don't have time for elitism in art. Being an elitist in the arts may make it easier to be an elitist about other things. Take some popular music. All the musics have their place and they appeal to different people. I think the purpose of music is to be enlightened or also for enjoyment. It can enrich or make you afraid. It can challenge your ideology or it can reaffirm.

PS: Do you believe that the arts have the potential for transformation, not just of individuals but also the broader society?

SH: The combination of individuals makes the collective whole. I definitely feel that music has ideological possibilities for people. There's a famous Bertold Brecht quote that art is not a mirror held up to reflect society, but a hammer with which to shape it.

 For me, I think that no matter what style of music you write, since it comes from nature, it inherently celebrates nature. It celebrates impermanence and the points of impermanence. That is not a negative thing, but just the cycle. I mean that music is beyond humans. It can be composed by humans, but there is a larger music that we have no control over. As humans we only get snatches of music from this more cosmic level. So, music is beyond us. But it has the power to change us. You can go through all history; music and the other arts have always been there transforming. Some people want to push it back and say that it always comes after political or other changes. Sometimes works of art do reflect what has happened. But I think the flow and the energy of the arts have as their purpose to change lives in a positive way. That's why there are very few people who don't like music or listen to music, because it is inherently natural.

PS: I think that's true of visual arts, too.

SH: Yes, people just crave that. It is instinctual in the human species. But even if you say that art is reflective, it is not following behind. For instance, Rory Kennedy, one of Robert F. Kennedy's daughters, has a new film "Ghosts of Abu Ghraib." Her art came after the event, but it addresses the event so that people can understand and be more empathetic. Maybe people may not have understood when it actually happened. It is more powerful sometimes to reflect on the horrors of the Holocaust or the U.S. Civil War. The film "Hotel Rwanda" is another example. It is too late for the people who have been the victims of the atrocity. But you hope this wouldn't happen again quite so easily in the future.

PS: Do you know of any artists who are working in Darfur?

SH: When I spoke with the poet Terry Tempest Williams early this spring, she said she and her husband were going.

PS: You were talking about the possibility of transformation through the arts. On one hand they reflect on events, holding them up to the light. But then, you were also talking about the spiritual energy of the world being explored or captured in part through art.

SH: Kind of like a collective unconscious. Because I think that there is an energy that music and the other arts come from. It is connected to healing as well. While there have been studies done on the medical impacts, in another sense, the impact of the arts is illusive and can't be measured. If you try to explain that to people who are against the arts, it is always a dilemma. A lot of people haven't had any arts experience going through school. I think the dilemma with this tunnel vision is that the power elite wants to have people stay in their niche and believe that anything out of it is strange, weird, or automatically negative. I think if a person has that approach with the arts, so very rigid, thinking, "Oh, that's really yucky, that person's out of their mind," that proves to me that if a person is that quick to judge art, then perhaps he is quick to judge other people who might be out of the norm. If we cannot place ourselves in a different perspective, we have more conflict through violence and intolerance.

PS: You're suggesting not only the making of art, but even just participating in the arts creates this openness?

SH: Yes, it includes the listener, too. I don't think artists should be held up as higher than others. The arts are just the vehicle through which we artists connect with the world. Then there are people who listen and are great appreciators; they don't write music and don't perform, but dearly, dearly love music and the arts. The people who perform create in a different way. And the listeners create a world for the artists. It's all very organic and interconnected. For me, this has always been a metaphor for the cycles of the earth and humanity.

Those who feel that the arts aren't about change would be likely to think that they are more fluff, for entertainment. There is an implied sexism in that—wanting to believe that art is effeminate and therefore weaker. That is just not true.

PS: Let's go back and list what you think are the unique qualities or capacities of the arts to be transformative.

SH: Art has a healing power, both individually and collectively. Aside from the healing aspect, it is transformative in state of mind or worldview. Art is cosmic and connects us with the collective unconscious, so that we are transported to imagined worlds beyond this world. This empowers us to see a different vision, a more positive vision. Art is always about change.

PS: Would you talk a little more about why you think that art is always about change?

SH: I am not saying that past art isn't important. Every piece of music or piece of art that's been created is important. It's not that we are progressing or have to progress. I am not saying that recent art is better than the Renaissance or 14th Century China art or anything like that. It's just that each artistic gesture is dangerous because you go into the unknown. The architect Frank Gehry says this: that the danger or drama is not a negative thing, but rather that the first risky gesture determines everything in a project. For me, each piece I write is different. So as each day we change as human beings, the art itself is bound to be about change. It is a living entity. You can hear that with composers; as they go along in years, their voice never stays the same. There's a subtle nuance shift; dancers change how they move. Writers have different experiences. They see different things, writing on a different type of day or in a different place.

PS: I think that is also true of those of us who are not creators, but who are participants; participation doesn't leave you the same.

SH: So, why is that important? Why is it important that art is about change. I think if you are involved in the arts in whatever capacity, you are more open to change and to other perspectives. That makes you a more tolerant person, a more peaceful person, hopefully non-violent, more interested in other people's lives. We all get self-absorbed, but I've always felt that people become more empathetic through involvement in the arts. That is what I've experienced in being involved in music. The arts are universal and show us that we are all related and need each other.

PS: Besides the fact that artists or arts organizations do what they need to do, how might they take those gifts and make them more broadly applicable?

SH: If the mainstream corporate media were more open, alternative ideas would have more exposure and there would be more funds to get that message out. Creating further alternative ideas.

PS: What you just said is discouraging, because if there is going to be change, it can't just be about money.

SH: No, it can't be. But the dilemma in America is how you get more people drawn to diverse styles of music and other arts. It has to do with exposure, so if children and kids in school see different art works, hopefully, they would have a more open palette. But it's not just about youth; there are a lot of people of all ages who have great interest and are more diverse in their art selection.

I don't know how you encourage transformation other than doing your art and doing it sincerely and with deep commitment. A lot of organizations are doing this, but it is hard. They have to charge for tickets, and not everyone can afford that. It all wraps up into this insanity of war, because there is less and less money to distribute throughout the economy and to individuals.

PS: Well, it is true that we have a war system. But, if we had a true peace system, there would be time, money and other resources for people to be creative and be involved.

SH: Imagine if people didn't have to struggle with three jobs and they had health care coverage. That sounds like utopia, but I think things could be better than what they are now with the war machine. People would have more time to participate in their communities.

PS: Do you think that the war system has run its course at all?

SH: Yes. There are still individuals who think that war is the solution. But I think war is dead. I think the majority of the people on the planet know that war is really useless. It just creates more war. It always has. We've had centuries to prove that. It's all based upon greed. Unfortunately, people who are greedy beyond anything always latch onto something. When they suck the last drop of oil out, it will be something else. If it wasn't oil, it was gold or diamonds.

PS: You sound both optimistic and pessimistic about the future.

SH: I tend to be more optimistic, but you have to be realistic.

PS: I know that in music, there is a lot of interest in electronic formats and technology. But also, from the perspective of a community, there seems to be a lot of movement for people to get together to play and sing. It seems to me there is a great longing for those occasions when people can be brought together with each other and with nature. I hear you saying that the benefit of the arts will happen if artists and people who participate in the arts at whatever level, whether creators or performers or audience, continue to make this be true.

SH: Oh, most definitely. It's happening now. Organizations are struggling and doing everything they can to keep giving lessons and to keep performing. People are very creative when it comes to doing their art on a personal or a public level. Imagine if there was a huge national movement in the U.S. through which you could get bene-

fits for your art; or for supporting or participating in the arts—a Department of the Arts. And also a Department of Peace through which war would be discouraged. Think of all the wonderful things that could have been done for peoples living throughout the world with the multi-trillion dollar budget that the U.S. military and the administration has spent and is spending on the Iraq war.

PS: Many of the changes we have been talking about are coming from outside this country. But, there is a lot of change going on here also, of course.

SH: America has a very ugly history, for example our whole slave industry. Wynton Marsalis has this new CD out *From the Plantation to the Penitentiary,* addressing Angela Davis' idea that the penitentiaries are just the new plantations. Prisons continue to enslave and profit from a largely black population.

PS: I was talking to Bill Banfield about the importance of the music of the street as a source of social criticism—pop, rap, etc.

SH: I would agree with Bill that the majority of social change has come through the street. I was talking with James (Sewell of the Sewell Ballet) about somehow trying to work Gandhi into the ballet we are working on together. There are people now who are fasting like he did, but I wonder if Gandhi were around now if people would just let him die of starvation.

PS: The arts have always been a part of major movements like the civil rights movement and the peace movement. People have always used song and dance and visual imagery to bring those ideas forward. I think a substantial number of artists are realizing that their creative energies are not just their own business. But, some artists silo themselves, and say "Here's my art and what's going on out there is not of concern to me."

SH: I think that's delimiting for the artist and for their art. Being involved in social change doesn't come just from ourselves. The artist stands at the edge: in the culture and out of the culture at the same time. There have been a lot of artists who have been daring and brave and have put themselves artistically and politically on the line. Some have survived and some haven't. Pete Seeger went through some hellish stuff. There is a picture of him with his banjo in Andy Lebowitz's book *American Music.* He's there with his banjo over his shoulder in front of the ocean and on his banjo it's written, "This machine surrounds hate and forces it to surrender." That's been inspirational for me.

PS: Didn't Woody Guthrie have something on his guitar like "this guitar fights fascism"?

SH: Yes, that's right. The last time Joan Baez was out here in the Twin Cities, she told the story that she had her guitar worked on in the 1960's. Recently, she had it worked on again and discovered that the person who had worked on it earlier had written some very neg-

ative thing inside it. It had been there all these years. But, her message overcame it. This is a metaphor for the power of music that goes beyond us.

PS: Who do you see in the arts world as being the most powerful voices toward a more reasonable approach to nature, or toward ending the war system?

SH: There are many: I could mention Steve Earle, Bruce Springstein, Bob Geldof, and Bono. For nature there is R. Murray Schafer and Bernie Krouse. Jim Nollman is with the Interspecies Music Society (www.interspecies.com). But also I want to mention Philip Glass. A lot of people take him to task for minimalism, but I think he is really critical for political change; he composed the scores for the films "The Fog of War" and "The Thin Blue Line". He wrote an opera about Gandhi, *Satyagraha*, in Sanskrit in the '80's, but it has been performed in a couple of places recently. His whole ethos to me is a wonderful hybrid of East and West. His meeting and working with Ravi Shankar seems to have been life changing.

PS: I think that eastern philosophies and religions have so much to offer us here in the West. Also the arts of the East, including the microtonal music. I think we can learn a lot from eastern music; the different tonalities seem to expand the brain. Are there any other reflections or thoughts you want to share with me about social change in general or about the place of the arts in it?

SH: For me as a composer, it is always a mystery where the music comes from. You always have to be very humble toward music, because it always comes from a much larger source. My music isn't more important than someone else's music. It is an honor that I can have a voice. The other thing I would say is that as a composer you really need to be a good listener. We were trained to get our voice out, to be heard. But composers need to remember to be generous, because it is a gift to be able to listen to someone else, either in the arts or just in general. I think that the arts ultimately teach us that it is not just about you. Other people want their voices to be heard, so you need somehow to listen and help those voices be heard, to honor them through your art. We're all just visitors on the planet and we must live gently with tolerance for all beings. Make music, not war!

Chapter 13
Richard Ringler

"Artists have always known their art is imperiled"

Richard Ringler is Professor Emeritus of English and Scandinavian Studies at the University of Wisconsin-Madison. He is the author of *Bard of Iceland: Jonas Hallgrimsson, Poet and Scientist* (2002) and the recent *Beowulf: A New Translation for Oral Delivery* (2007). He is one of the founders of the Wisconsin Institute for Peace and Conflict Studies and director and principal author of the Institute's Annenberg-Corporation for Public Broadcasting project *Dilemmas of War and Peace*. He has written numerous articles on war and peace issues, many of them dealing with the way these subjects are represented through the visual arts, literature, and music.

PS: Dick, today we want to talk about what changes you see coming to our world in the next relatively short period of time and how we might respond to those. Then I'd like to hear your views about how artists and arts organizations, how creative energies in general might be engaged in that task.

DR: According to everything I read, Pat, if we don't somehow reorient ourselves we're going to be in a lot of trouble. The kinds of changes we have to make will be very, very difficult changes, especially if we go on hoping to conduct our business as usual. It may, one sometimes thinks, require some disaster, some large-scale disaster, to make people realize that they have to change their way of life.

PS: Why do you think that is?

DR: Because I think people desire things, objects, Hummers, shopping malls. Their desire to possess things is exacerbated by advertising and publicity, making everybody think that they need things that they don't really need. But they certainly want them! It's bad enough in this country, but some of the up-and-coming countries in the world, and I'm thinking particularly of India and China, think that they want to go the same direction we've gone: to produce all sorts of consumer goods and improve their standard of living. The results of this, considering that resources and everything else are finite, is bound to be disastrous if we keep expanding the economy and thinking that there is no natural limit to what we can produce and enjoy. That's one crisis.

PS: The crunch between the ability of the earth to support us and what we think we ought to have.

DR: That's right. In addition, I imagine that as resources get tight, there are likely to be resource wars, which, at a certain point, will probably involve the use of nuclear weapons. I don't see why people would hold back from using them if the chips are really down. That's a possibility. And I was reading recently about the issue of species extinctions. I didn't fully realize that species extinctions act in synergy with one another.

PS: I'm not sure I knew that either.

DR: For example, honeybees are dying in various places, and in those places, the bee-pollinated wildflower population is also way down. That's a good example of synergy. Since we don't know really the way that various species interact with one another, we don't know what taking one of them out will do in the end. These are all converging crises.

PS: The challenges you see are the threat of violence associated with resource scarcity and also the destruction of the natural world?

DR: Yes. These are the ways that the problem manifests itself in the real world. I have always thought that the problem of violence and the issues associated with it are the result of greed and ego. The Buddhists say that the three cardinal conditions that cause trouble

for human beings are greed and anger and ignorance. Greed and anger are certainly in the driver's seat right now; they underlie violence. Ignorance is on display everywhere, for example, our invasion of Iraq in spite of the lesson of Vietnam. All of these things are what the Buddha might have called ignorance in action, ignorance in operation. These three things together are a lethal cocktail: greed, anger and ignorance.

PS: Didn't the Buddha also argue that these conditions are self-delusional?

DR: Something like that. But recognizing the way they work psychologically doesn't cause them to vanish. Early Christian monastic writers like Evagrius Ponticus divided the pie of ego into seven slices instead of three like the Buddhists. These slices are the negative mind states that get people into trouble; and from them is historically derived our notion of the seven deadly sins. Seven of them in Christianity, three of them in Buddhism. Analyzing them into three or seven categories doesn't make them go away, of course, but it is the first step in understanding them.

PS: As individuals, we can try to change our own minds. But the issues you mention are a bit different: they are part of a global power structure.

DR: Our individual, unnecessary desires are fostered by advertising and by people who want to make money. I'm not very optimistic about the world situation. I think it may require a string of real disasters for people to come to their senses, for resources actually to start dwindling, for example, or for ocean levels to start rising dramatically.

PS: New York City under water would certainly prompt thought and action, one would think! I'm hearing a bit of pessimism about the abilities of the human spirit being able to rise to the occasion.

DR: It is a pessimism which is founded on ancient spiritual and psychological insights of Christians and Buddhists alike. Also, there's another point about all of this. If you look at things *sub speciae aeternitatis*, from God's point of view, the disappearance of human beings and human cultures is really no bigger a deal than the disappearance of the saber-tooth tiger or the dinosaurs. Something else will come after us; we can't destroy all life on earth. We can just throw it back down a couple of steps and give somebody else a chance. This long-term view is not exactly consoling, of course, because it would be terrible if human beings committed species suicide out of greed, anger and ignorance, by not looking at long-term consequences. One would feel very bad about the disappearance of exactly the sort of things that we want to talk about: art, music and literature. Artists have always known that their art itself was imperiled by war and by violence.

PS: What do you mean artists have always known their art was imperiled?

DR: Artists have always known that war destroys the creations of people's minds and hands. There's a famous painting by Rubens in Florence which is variously called "The Outbreak of War" or "The Beginning of War." Rubens lived through the Thirty Years War, which was a terrible thing. A lot of his art is war protest art.

PS: I didn't know that.

DR: People don't. People associate Rubens with buxom females, but a lot of his artwork was war-protest art. The most famous picture is in the Pitti palace in Florence. It was actually the source of Picasso's "Guernica". Picasso modeled "Guernica" on Rubens' painting, although he inverts right to left, changes other things, and drains it of all the color. The Rubens' painting shows war at the beginning, at the outbreak. It is a big allegorical picture of the kind that Rubens frequently liked to paint. We can identify the figures in it because we have something quite extraordinary and revealing, a lengthy statement from the hand of Rubens himself in which he describes in detail the full program of the work. The statement is contained in a letter written on March 12, 1638, to a countryman of Rubens, who was living in Florence and who had acted as middleman for the commission. The statement was undoubtedly intended for Grand Duke Ferdinand himself, to help him find his way around his new picture. Here's what Rubens says about the program of that picture. This quotation is just as important as the picture itself in a sense.

> "The principal figure is Mars who has left open the temple of Janus which in time of peace, according to Roman custom, remained closed, and rushes forth with shield and blood-stained sword threatening the people with great disaster. He pays little heed to Venus, his mistress, who, accompanied by amours and cupids, strives with caresses and embraces to hold him back. From the other side, Mars is dragged forward by the fury Alecto with a torch in her hand. Nearby, are monsters personifying pestilence and famine, those inseparable partners of war. There is also a mother with a child in her arms, indicating that fecundity, procreation, and charity are thwarted by war, which corrupts and destroys everything. In addition, one sees an architect thrown on his back with his instruments in his hand to show that that which in time of peace is constructed for an ornamentation of the city is hurled to the ground by force of arms and falls to ruin. I believe, if I remember rightly, that you will find on the ground under the feet of Mars, a book, as well as a drawing on paper to imply that he treads under foot all the arts and letters."

PS: Well, yes, I see what you mean about artists knowing that their work is imperiled.

DR: That their works will perish. This is Rubens' great anti-war statement which served as a model for Picasso. The problem with art about war is that nobody wants to hang it over their mantelpiece, whether it's Rubens or Goya or Otto Dix or Picasso. So, myths get started that all Rubens was interested in was opulent females. Whereas in both his secular and his religious paintings, he comes back again and again to the theme of war and peace and shows how terrible the effects of violence can be.

PS: You were suggesting that many artists through the ages have used their art to raise our consciousness about the destructive forces that are around us?

DR: The answer to that is not easy. In earlier periods artists were supported by patrons, who were usually the people who were also making wars and raising armies. You don't find what you would call anti-war art in those earlier periods. Instead you find a lot of ambiguity. Shakespeare, for example. You can't call Shakespeare pro-war or anti-war. A lot of his characters enthuse about how wonderful war is; one of them talks about the "pride, pomp, and circumstance of glorious war." Other characters talk about how bad war is. Did you see Branagh's *Henry V*? Shakespeare's language presents the great victory of the English at Agincourt as a tremendous national triumph, but with just enough ambiguity in the way that triumph is presented—all the dead and so on—to justify Branagh's depiction to the whole thing as disastrous, bloody carnage. But this is the director's interpretation. Rubens is unique; he is the first artist who gets out of that box of wanting to please patrons, partly because of the nature of the Thirty Years War.

Later artists in more revolutionary times, like Goya, adopt an out-and-out anti-war stance and with the art of the First and Second World Wars and the Vietnam War, you find really quite stunning and deliberate anti-war statements.

PS: I think about the poets that I have heard you talk about like Wilfred Owen.

DR: The soldier poets of the First World War knew what war is like and described the horrors of it. Sigfried Sassoon is another one who is just terrific.

PS: These poets also talked about the destruction of nature, I think.

DR: Yes, and that's very true particularly of artists and poets who talk about the First World War. Paul Nash is a good example. He was sent by the British government as an observer to paint what the government expected would be propaganda pictures to support the war effort. It was called the War Artists Scheme. Some of the leading British artists were commissioned to go to France and paint what was going on. People didn't have confidence in photography then, and they thought the artists would give a personal touch. They were supposed to paint pictures that could then be shown

back in England in exhibitions that would function as part of recruiting drives, really, to get people to join up.

But a number of these artists changed their whole approach, after they saw what was going on in the Western Front. Nash's most famous picture, "We are Building a New World," shows the ruins of nature on the Western Front. He shows the ground all churned up into mud and holes filled with stinking water, all the trees stripped of their leaves and branches, just naked trunks in this horrible, desolate landscape. Another painting of his is "The Menin Road," a breathtaking view of the destruction of nature by war. He continued this work during World War II. One of his most famous pictures from that period is called "Totes Meer," Dead Sea. It shows wrecked German planes in a dump in England looking like waves on the ocean.

This kind of irony is something you find in a number of the major English artists coming out of World War I. It was a war which makes this sort of art easily comprehensible, in a way, because it was a war that a lot of people quickly realized didn't have to be fought, shouldn't have been fought, was killing huge numbers of people for very little gain, for no reason, unlike World War II for which there seemed to be a justification. In World War I all the great poets, novelists, and artists turned against the war once they got a taste of it.

PS: Would you think that the artists, the writers, the playwrights could, should, or might be called in to service, if I can use that word, to help us deal with this crisis that you see impending: the crisis of violence and of scarcity and environmental destruction?

DR: The arts have certainly always had a lot to say about this sort of thing. Of course, the arts themselves are neutral, morally, and can be used for pro-war purposes or anti-war purposes. They can be used to laud and praise and further economic development and say it's a great thing. You see that in advertising everywhere. Or they can be used to call attention to problems, to flag problems and worries. They're a two-edged sword. You find that most of the war art from the 18th Century is pro-war art: pictures of Napoleon's battles, English battles and so forth. One of the things that characterizes pro-war art is the minimal use of the color red. People are shown dying in brilliant white tunics with decorations on and so forth. It's only when you look at artists like Goya, Dix, and Picasso that you find an ample, liberal use of red as part of the artists' palette. I think what artists have got to do always is find a stance. They have to find the right vehicle, the right sorts of images to protest against the things that should be protested against.

Writers have to do that, too. Kurt Vonnegut was a prisoner of war in Dresden during the firebombing of that city in 1945. He and some other Allied prisoners were shut up for the night in Dresden's

Municipal Slaughterhouse number 5. This was the really catalytic event of his life. It was a heavily insulated building, so they all survived. When they came out the next morning, they discovered that the city was gone all around them. This ultimately resulted in his novel *Slaughterhouse Five*. But he had to spend 20 years almost, I think, brooding and thinking about what had happened before he found the right tone in which to talk about it. If you look at some of the things he wrote right after the war, describing his experience in letters and so on, the tone is hysterical. "This is awful. This shouldn't have been done. Women and children were killed. We were guilty of war crimes," and so on. You can't get much artistic mileage out of that. It's a propagandistic voice, in a sense. You're saying the same thing over and over again. You have to find some new way to talk about it. What Vonnegut does is develop an elaborate science fiction element and plot, science fiction laced with futurism and all sorts of philosophical ideas. This gives solidity, substantiality to the anti-war protest.

Then of course, you can find these things in music, too. Benjamin Britten's *War Requiem* is a famous example. There isn't as much anti-war protest in music, though Beethoven was an anti-war sort of person. Most composers wrote masses to celebrate victories and that sort of stuff. It was part of the patronage game. But at the end of Beethoven's *Missa Solemnis*, in the "Agnus Dei," when he gets to the text "Give us peace," *Dona nobis pacem*, (which is usually regarded as religious peace, internal peace), he chooses to interpret it as a prayer for general peace on earth. Just after the theme for "give us peace" is introduced, all of a sudden Beethoven transports us to the battlefield with drums and trumpets and the instruments of war and the soprano is screaming "give us peace" before the passage ends. That's pretty clearly an anti-war moment in music.

Then in modern times, there is Schoenberg's famous piece *A Survivor from Warsaw*, about the Warsaw Ghetto and the deportation of the Jews to Auschwitz. It is a hair-raising piece of music; Schoenberg's 12-tone music lends itself to being angular and rough. There isn't much anti-war classical, symphonic music. But popular songs, of course, are a huge source.

PS: Daniel Bukvich wrote a piece for band called, *In Memoriam Dresden – 1945*. The last movement is in graphic notation. The score actually has a picture of fire and the instructions to the players are to make all kinds of cacophony.

DR: Shostakovich also has a piece about Dresden, his 8th String Quartet. He went to Dresden after the war with a filming group to do a movie about the surviving treasures of the Dresden Art Gallery. He was in Dresden for maybe a week. He was shown the ruins of the city and photographs of what it was like before and after the bombing. He wrote his 8th String Quartet as a result of that. The score is

dedicated to the victims of fascism and war. Can you imagine trying to suggest the nature of a disaster of that scope in a string quartet, the *tour de force* that's involved in that? It's a brilliant, brilliant piece. He's the preeminent composer of the 20th Century anywhere in the world. I think that when the dust settles a hundred years from now, people will realize that that Shostakovich caught the miseries of that century and its outrages and ambiguities and dark places better than anybody else. His Seventh Symphony and all of his symphonies from the Seventh onward deal with either various Russian revolutions or the Nazi invasion of Russia. The Thirteenth Symphony uses texts by the poet Yevtushenko to decry the massacre of Jews in the Ukraine. There's no doubt that Shostakovich has written an enormous amount of anti-war music. He's a good example of a composer who's always alert to these things.

PS: We can't forget the work of Penderecki, *Threnody for the Victims of Hiroshima*; that's another example of what we have been talking about.

But let's shift gears now. If we should avert disaster, what would the world look like? What kind of changes in society would you wish you could see, assuming we don't destroy ourselves through nuclear war or environmental destruction?

DR: Do you know the American Quaker painter Hicks? He painted over and over again the same scene, which was William Penn meeting with Indian chiefs in the Delaware Water Gap to sign the treaty. It's a picture that shows Penn and various Indian chiefs in the distance signing their treaty. In the foreground along the sides of the picture are all the animals in the world co-habiting the scene. Really, it's the lion lying down with the lamb and they're very, very prominent in that picture. He was a Quaker and believed in all that. Well, is that what we need, the lion lying down with the lamb? I don't think that's going to work genetically.

PS: Symbolically maybe.

DR: Yes, symbolically. I think to the degree that we do away with interracial strife, racial discrimination, and hatreds of any sort, we will be doing well. These are causes which can be harnessed to the war machine. But the problem, of course, is massive. You've got weapons manufacturers who represent greed. And you've got governments which all too often represent ignorance. Both sides, once a war gets started, represent anger. On and on it goes.

PS: Some have suggested that there are forces under way which make the nation state less capable. There is globalization and there are people at local levels saying "We need to create our own world here. We need to live more sustainably right here. We need to buy food from our neighbors and make our own music together."

DR: All of these things are important. Every single one of these things is important. Anything that moves society and people in a positive

direction is good. For example, a lot more attention should be given to the United Nations and the activities of the U.N. It should be strengthened. Our government always wants to weaken it instead, but it should be strengthened. One is suspicious of institutions like that, because one is an anarchist at heart, but nevertheless, it should be strengthened and people should also act locally and do things locally.

Artists have a responsibility, both locally and internationally, to present positive views of peace. I think a lot of artists' creativity in the past has been deterrent in its purpose, showing the horrors of war in order to try to discourage people from that sort of behavior. It's been a lot harder for artists to come up with persuasive, attractive imagery about peace except in a religious context, the lion and the lamb, pictures of heaven, that sort of thing. The difficulty with peace, in the minds of a lot of people, is that compared with war it's dull. It's the same old, same old, day in day out.

PS: We've been taught that myth.

DR: Yes, we've been taught that myth.

PS: Do you know about the orchestra that Daniel Barenboim has created?

DR: Yes, with Palestinian and Israeli musicians. Everything of that sort is positive. Of course, you also have to work at the political level to try to see to it that war-mongering types of people don't get into high-ranking political office. There are good signs. It's amazing to people of our age that the Northern Ireland business has apparently been settled. It took a long, long time for this to happen. But, apparently, the lion is going to lie down with the lamb up there, after hundreds of years of stupidity, of greed, anger, ignorance, and useless violence. I think if a couple of people would get their heads straight, there's no reason why the Palestinian-Israeli thing couldn't be settled also. It may be in 50 or 100 years.

PS: You think it's going to take that long?

DR: I don't know. You wouldn't have thought the Irish settlement would have taken 50 years plus.

PS: What are the unique qualities of the arts which you think make them suitable for transformative kinds of action.

DR: They're inspiring. And the different modes have different roles. Literature is more discursive and tells stories. The visual arts, of course, show scenes, which can attract people. All the arts have tremendous emotive power, but it is neutral power. This power can be used for any purpose, but when it is used on the side of peace, it can be quite powerful. Unfortunately, it's hard to find images of peace that galvanize people in the way that images of war galvanize young men when they are joined with PR campaigns and patriotism and that sort of thing.

PS: Maybe I agree with you that in the visual arts peaceful imagery may be difficult. But it seems to me that in the case of the literary arts it's possible to draw a plot, or write a poem, or write a play which comes down on the side of peace and justice rather than war and exploitation.

DR: Yes, theoretically this is true. But, for reasons which are beyond my understanding, partly cultural, partly genetic maybe, works about violence always seem to draw a much bigger audience and readier audience than works about anti-violence.

PS: That seems to be true in popular culture. Take video games.

DR: And also for murder mysteries and all sorts of pot-boiling sub-literature and even serious literature. It often takes off from that sort of realm.

PS: You seem to be suggesting a dark part of our own selves that wants to enjoy violence or something.

DR: No, I don't think everybody is like that. But I do think the majority of people have a dark side, at least potentially, and especially young people; that is the stage of life when it is most terrible for this dark side to come into evidence.

PS: As you pointed out, the media and advertising play up to that side of us, allowing, justifying, and glorifying violence.

DR: Right. I worry sometimes that our dark side is stronger than our light side.

PS: Let's come back to the unique qualities of the arts. We were talking about their inspirational and emotive power.

DR: Yes, this inspirational and emotive quality can demonstrate things in a visceral way, rather than in an abstract way. That can be very effective. The French philosopher Simone Weil has an essay called *The Iliad or the Poem of Force*. I think it is one of the most brilliant analytical essays I've ever come across. She reads *The Iliad* as essentially an anti-violence poem. She links it to events in the 1930's during the rise of fascism, which is when she wrote it. I think she's right. But most scholars think that is a hare-brained idea, and that Homer is like Shakespeare—neutral. Warfare is something that just happens, so you show it happening. For older people, like Priam, their sons get killed, and that's just the way it is. Achilles behaves the way he does and they all behave the way they do because that's the way people are. But, most scholars don't think that Homer has a distinctly anti-war program, anti-violence program.

PS: The fact that the body of Priam's son Hector gets dragged around by Achilles, who is mad with blood lust, is hardly a positive view.

DR: No, it's not. But as with Shakespeare, I don't think Homer is saying that violence and war shouldn't happen. I think Homer is saying that war does happen. Whereas a lot of the artists we've been talking about today are saying, in one way or another, that war *SHOULDN'T* happen.

PS: That's what Shostakovich was saying.

DR: That's what Shostakovich was saying. That's what Rubens was say-
 ing. That's what Goya says over and over again. "This shouldn't
 happen. This shouldn't be allowed to happen. This should stop."
 There is a story about the famous Goya painting of the execution of
 a bunch of Spanish protesters by Napoleon's soldiers ("The Third
 of May, 1808: The Shootings on Principe Pio Mountain"). The
 story may be apocryphal. Goya's body servant told the story in his
 old age. He said he was with Goya in their quarters in Madrid. The
 word got around that shootings were to happen, which were meant
 to teach the people of Madrid a lesson to deter them from anti-
 French uprisings. In the middle of the night, Goya said he wanted
 to paint these things, so he had the body servant collect his easel
 and his paints. They went up to Principe Pio Mountain; there were
 carnivorous animals prowling around, nibbling at the bodies still ly-
 ing there where the French had left them. The servant reports that
 Goya set up his easel and started sketching the bodies lying on the
 ground; this was used as the sketch for the final painting. The body
 servant said to him, "Master, why do you paint these, why do you
 paint these barbarities committed by men?" And Goya is said to
 have replied, "To teach men never to be barbarians again." Which
 suggests that the painting is about as close as one can come to a de-
 liberate anti-war statement through art.

PS: I assume if we should prevent environmental disaster and have
 a sustainable community, that there would be time for the arts;
 people would be making music and doing artistic things together.
 But how do we get them from here to there? How might those
 artists who have that vision as well help us move forward?

DR: That is very interesting, because there are two murals by Picasso,
 one for war and one for peace, that provide a graphic answer to
 this question. The paintings are on two sides of a barrel-vaulted
 chapel in the south of France in a place called Vallauris and they
 meet along the center of the vault. War is a demon-like figure with
 a sword stained in blood, driving a carriage through an ocean of
 blood, carrying bacteriological warfare stuff. He is being pulled by
 skeletal horses, one of which is tramping on a burning book. That
 detail is borrowed from the Rubens painting we were talking about
 earlier. He is being opposed by a good warrior, a just warrior who
 stands there confronting them. There are only men shown.

 The peace painting answers the question of what the role of
 the arts would be in a post-war world. People are writing, playing
 musical instruments, making pots, dancing. A mother is feeding a
 baby. There is a winged horse pulling a plow driven by a little child.
 The sun is sprouting wheat and there is an enormous mobile, which
 I think is probably intended to suggest balance. The mobile con-
 sists of a fish bowl full of birds and a bird cage full of fish. There are

mainly female figures. Trees, flowers, no blood.

I think the arts are very important. I give lectures from time to time about what the arts have to say about war and peace. Sometimes I include people whose artwork is just terribly bloody and off-putting, like the German artist Otto Dix during World War I. Sometimes people ask me, "Doesn't it depress you to study these sorts of things?" After a while I realized that my answer to this is, "No, it inspires me." In a sense, what elates me is that the artists' protest against war and violence never stops. Artists of every generation have come up with new ways of protesting these things which should be protested against. Of course, that's the answer to the question you asked about how we deal with global warming and things like that. Artists have to find inventive and imaginative ways that will capture their audiences' attention and imagination, making the moral problem very, very clear.

PS: I gather you think that the arts and artists have it in them to do that.

DR: I think they're up against a real terrible enemy. They're up against a whole destructive system fueled by the psychological forces that the Christian seven deadly sins and the three Buddhist problems stand for. These things really exist. These are the problems of ego. All of this bad stuff is fueled by exactly these forces; it's hard to imagine getting people willingly to clean up their act.

PS: The institutional structures encouraging war and violence which we have talked about have not always existed. There are other ways to live.

DR: The point I would emphasize is that the protest has got to continue. I'm not sure it will be successful in the end. But, it would be an abdication of society's role and the artists' role to give up, to stop protesting, and to become co-conspirators with greed, anger, and ignorance in the destruction of the world.

References

Lucy Dougall, ed. *War and Peace in Literature*, (Chicago: World Without War Publications, 1982). This is an attractive and easy-to-use list of poetry, prose and drama. It includes anthologies and reference works and a chart of literature on specific wars. It does not include science fiction.

D. J. R. Bruckner, Seymour Chwast, and Steven Heller, *Art Against War* (New York: Abbeville Press, 1984). An ample, sufficient and beautifully illustrated book with an excellent introduction by Bruckner and a good bibliography.

Several of Paul Nash's most famous paintings, including, "We are Building a New World," and "The Menin Road" may be viewed at the on-

line gallery of the Imperial War Museum:
http://www.iwm.org.uk/server/show/conArtist.17 "Totes Meer" is
in the Tate Gallery and may be seen at their on-line collection,
www.tate.org.uk

Goya's painting is in the Prado Museum in Madrid. An image may be
viewed at http://www.spanisharts.com/prado/goya.htm

Chapter 14
William C. Banfield

"Popular culture as critique"

William C. Banfield is a teacher, author, composer, and performer. Bill is currently Professor of Liberal Arts at the Berklee College of Music in Boston MA, joining the faculty in 2005, after several years as the Endowed Chair in Humanities at the University of St. Thomas in St. Paul MN. He is the author of *Landscapes in Color: Conversations with Black American Composers* (2002) and *Black Notes: Essays of a Musician Writing in a Post-album Age* (2004). His compositions have been performed by numerous symphonies, including Atlanta, Dallas, Detroit, and San Francisco. His compositions and performances as a jazz artist have been recorded on Atlantic, TelArc, Collins Classics, Centaur, and Innova. In 2002 he served as W.E.B. DuBois Fellow at Harvard. Other awards have come from the National Endowment for the Humanities, the National Endowment for the Arts, and the McKnight, Lila Wallace, Lily, Jerome, and Telluride Foundations. A native of Detroit, he received a Bachelor of Music from New England Conservatory, a Master of Theological Studies from Boston University, and a Doctor of Musical Arts in Composition from the University of Michigan.

PS: Bill, we have had a good time this evening talking about what could be happening in our culture in the next few decades, whether there is going to be a fundamental shift or whether we're just going to keep muddling through in the same way. Now that I've turned the microphone on, please tell me what you think about this.

WB: I spend a lot of time thinking about this. Sometimes I think that you can become very negative if you just read what's in the news each day; I guess when you're working, you do have to have a sense of some hope for the future. Or, why else do we keep breathing? I think that even if we see the doom, somehow we've got to work to understand, and to give that to younger people that we deal with. How I do that, as an artist, is to try to imbue young people with a sense of their mission, goal, vision, and the impact their artistic work has on the world. That sounds very lofty at first sharing, but it really is an important part of how American popular music developed. That's where I have done the most of my research; and then, that spins out to my teaching and the music I make, my own artistic work. I think it is very, very, important to really look at popular culture; it is critique, ritual, and narrative of what's going on in the world, both the good and the parts that are problematic, the challenging parts. When you deal with popular culture and young people, you are enmeshed in that discussion about what we need to be doing. I teach a lot of young musicians, college age. I think that both high school and college age students get their meaning from popular music. This is the place that their kind of art and music and identity is bubbling from. I think a lot about what popular music culture has allowed us to see, both as a way of critiquing the culture and as a way of celebrating who people are, and also as a place to envision where we ought to be going.

PS: So, popular music is a map or a series of pictures of our culture?

WB: It's the road map. It is a series of pictures and it's a series of reflections, not just of what we create, but which holds what we collect of both meaning and triumph and tribulation. Then, it projects forward. I put together a series of little articles for students when I first started teaching college called *Reflection or Projection*. The argument was: is popular culture just a reflection of where we are or is it a projection to the larger macro culture? Does popular culture project what we believe and what we see about who we are? Is it because someone who is in power decided this is what you like, or is the music that we hear a reflection of artists who are from the streets saying "this is what we want to do"?

PS: Isn't popular music both those things? Part of the power structure and the reflection of those without power?

WB: Yes, absolutely. In my classes, I talk about four players in the popular culture's projection of ideas, images and values. First, the artist; second, the audience who buys; third, the apparatus that dissem-

inates these expressions; and fourth, technology. Those four work together. Popular cultural expression is a commodity as well as something from the folks. As a commodity, we know that somebody had to decide, "Oh, I'm going to record these young girls, young guys over here and we're going to put it on a disk or a video, and then we're going to mass market it." But it's like the chicken or the egg: what comes first? Did somebody envision "Oh we must go out and report on what the people are doing?" Or did the people say, "This is an expression of who we are. Therefore, we need you, power structure, to make what we do something that people can get their hands on." So we need the power structure. Do the artists reflect what their communities are hearing and feeling? And if the artists are beginning to become a voice of that community, then, how are people hearing it?

PS: What are some issues of the community that you see artists attempting to project?

WB: I think we have a tendency to look at where we are now and to say that artists have only just discovered these issues right now. If you listen to rock and roll, hip hop, these reflect the issues of our times. What I try to teach students is that artists, from the very beginning, were always dealing with what the central issues of community are. From a cultural study standpoint, in what way does this music, this poetry, this dance, this painting give agency to common people so they can have a voice? The first thing that art does is provide a voice of identity: I am me, I am a human. Then it says, I'm a thinking human. I'm thinking about what's around me. I'm using my art to either talk about the joy in that experience or some of the pain on the downside. If I have a downside, then somebody's causing that. So, who is it, Mr. Man, who's on my neck, keeping me down. It has to operate on all these levels. Those are some of the central themes of popular culture. It could be about foolishness and vanity or about farce or about symbols, too. Take somebody like Gertrude Stein playing with the imagery of words. All these expressions can be a reflection on the human condition. I think these are the central, most pertinent themes of the popular artist. Then the question is: is this the artist's own view, or is this artist connected to a community that he or she grows out of and is a picture of?

PS: I think I would say both.

WB: Yes. What I try to do in my classes is to look at artists who are reflective of all of those perspectives, but especially those whose viewpoints most particularly provide vantage points of community. On one hand is this an artist who is so gifted that he or she exemplifies the traditional definition of what an artist is: art created to be a reflection of the beautiful things that we hope or dream of, which is a very subjective thing. On the other hand is this an artist that commits to being a voice of the people that he or she is from. Or is

this artist created as a commercial commodity, because people like to envision another world? They don't want to deal with the world they're in, so they need fantasy or farce or entertainment. All those pieces, I think, help us understand what we need the art to be.

PS: Where do you see that taking us to the next 10 or 20 years?

WB: I think there are two major things going on that are not new. I think to make an honest assessment of where we are and where we're going, you have to look at both of them simultaneously. The academic, high-brow world tends to look at the definition of art from only one side of this playing field: it's either commercial and popular, or it is on the higher road of that which we define as art.

The traditional sense of art is very important, because it is an expression of artists' imaginations to create desires of the heart. It's a sculpture or piece of literature that someone has created to move along the human narrative, the human vision and condition. This classic, traditional definition is an ultra-idealistic sense of art as something we value. I mean the removed, sweet thinker who has the space to be creative. That's a very important group. It is also the group that gets a lot of love for what we value as art and how we count art moving. We count art moving ahead by their record of what they're doing. So, there are these great movers: the Expressionists, whatever the group or movement, Salvadore Dali, the Surrealists, all that. So Andy Warhol comes in and the common object artists, they're making art. Those are high ideals. That's not going to stop.

But, I think that in popular culture you find these young people that are creating all kinds of new ways of attaching and reconfiguring and doing their thing. You look at what's going on in hip-hop with the turn tables, the media, the visuals, the electronics, and the internet. Those are very artistic moves. Young people are taking an eclectic approach, taking the best of the varied sources and bringing it together to make something that's totally new and moves expression on the human narrative artistically.

PS: What we traditionally understand as creativity.

WB: Yes, that's happening. I think the other group—if we had to do this and bifurcate into two groups—is the vernacular music. That would be country and western, blues or hip-hop or any of the stuff that common people create, who don't have the space to reflect on the value of creativity *per se*, but use their creative energy to address an expression of an art form that deals with every-day issues. Not only every-day issues, but this art also is created and expressed in a form that's vernacular, home-made, not refined. So the form would be blues. The form would be jazz, rock and roll, country and western, hip-hop. Those will be the forms of these expressions. Now, the themes that come through those vehicles of expression will be common every-day issues. These would be a cultural critique: sexu-

al identity, police brutality, racism. It would be on partying and about life with the most basic stuff: drugs, dance, rock and roll, wine. Those are the themes to allow people to navigate through a very difficult kind of social/cultural world: finances, politics, you know, busting the 9-5 every day so they can work. At the end of the day, they might want to party and let it loose. Look at a movement like punk. These were young people who felt alienated from commercial culture, so they created this form to help them deal with alienation and abandonment and loss of hope.

To answer your question about where we're going sincerely and completely, you're going to have to look at the narrative and expressions of these two groups. But the bifurcation between high art and popular art is not that simple. There are groups right in the center. There's a commercial group that is innovative and artistically forward looking, but also popular. It has some connections with the vernacular, but it's cleaned up, mass-marketed, shined up, and put out there on the Hollywood screen. It is artistic in the traditional sense, but it's also a reflection of the common people; somehow it represents their fantasies. But I think what's most relevant for our discussion and the kind of things you and I have been talking about this evening—I think to get a real grasp on where we're going—you have to look at those things simultaneously.

PS: The artist as creator and the ordinary folk for whom the stresses and joys of every day life are expressed through art—those are both ways to understand how the arts reflect our culture?

WB: I think you have to look at both sides simultaneously. Many critics tend to focus on the parts that are very sexy and get a lot of money and attention: hip-hop, rock and roll, therapy rock, and MTV. I think high brow art finds these expressions not artful at all, and will only look to the removed, creative, inventive, separated folk as their vision of art. But there were a lot of classic artists on the high brow side, the "artistic" side, who thought it was their cause to report on what the common folk saw. They found themselves reverberating in between the needs and the insights of those two schools. I think you have to look at both sides to get a picture of where we're going.

PS: How do those artistic communities deal with the questions of safety, of inequality, of diversity, of environmental scarcity, of the sources of alienation, of the difficulty of finding space and time to have a meaningful life in this crazy world?

WB: They both do. I think the high-brow artist is going to express his or her alienation through the mediums that they use. The question is where their art gets heard? You have to consider the venues where these expressions are being viewed and how the artifacts are being unpackaged and appreciated or critiqued. Museums or the symphony or the academy are places where a lot of artists are talking

about these things: alienation, identity, sexuality, racism, sexism, these ills in society. So those are the places where you will find contemporary artists.

PS: Does this art have a transformative capability?

WB: If I go to the museum and just see European art that is portraits of noble men and noble women, I'm only going to get that view. If I go to a modern art museum—and most art museums now have both the contemporary and the traditional—I'm going to see artists from all parts of the world who are using the artistic medium to express distortion of identity, distortion of power, abuse of power. The way in which two interesting figures that are juxtapositioned or colors put together that express the kind of dissonance in visual imagery reflective of the dissonance you might find in society. Each generation of artists expresses the same angst through the art medium. But then bounce back to hearing a hip-hop record or a rock-and-roll record, and see how those young people are using different sounds in juxtaposition to show the kind of chaos they're seeing in their communities. I think that you have to look at both of these.

We don't have a lot of patience, time, or sensitivity to be able to decode this and say: "Wow, everybody's seeing it now. So, let's all sit at the table to figure out how we're gonna fix this thing." What I think that art allows us to do always is to break down the barriers that are among us, whether political or economic, whether it has to do with generational differences or class differences. The artist would hope to create a musical or dance or literature piece that allows us all to stop for a moment and hear that human narrative and then say: "Wow, you know what, that kind of looks like my sister Jill. That expression looks like my brother Johnny. I guess we all have something to talk about here."

There followed a discussion about the need for balance in modern culture between the ability of technology to provide information and speed of communication with the importance of taking time for reflection to develop critical thinking and a holistic self. The pervasiveness of on-line forms of communication has the potential of impoverishing human interaction at the same time it widens the sphere of connection. The conversation returned to the development of music as an example of how culture changes.

WB: Let's go back to the musical world. I want to speak more specifically about that which I know, where I see musicians and communities rebelling. Big band music at first was kind of rag-tag, but then it got very systematized and sanitized and became the big band music of the 30's and 40's. People got tired of that, so they broke away and said: "this music represents the reflections of an arranger and not a real musician." So, the players created a new form called be-

bop, which completely said "this music is ours, the musician's, it doesn't belong to an audience. It doesn't belong to record companies." Let's look at popular music, post 1950's; look at how rock-and-roll developed in the 70's. It was invented and then it got caught and became big corporate rock-and-roll. What happened? People rebelled again and created punk rock, because they wanted music that was more natural. It was more of the real angst people felt everyday. It wasn't controlled by the power structure; it was more authentic and more humane, even though it was risqué, rough, ragged, and all that. It still expressed the way people really are, the range of their emotions and their feelings, their issues, their angst, their joys, their trials and their fears. That's what people feel that music is supposed to express.

I think that is an example how we might look at technology. On the one hand, it's great. It has us really evolving in our modernity towards more refined thinking and more control over our information. We had ideas on paper before but now they are electronically accessible, and so they can be more refined and perfected. But the fight is still on. People are still going to find a need to express something that's more about where the folk are, not controlled by three guys in a room that can create a digital program to answer all your questions. I think the internet—these chat rooms and what have you—is a revolution within technology. I think that's going to continue to happen, just like we saw revolutions in music forms. I think it's the same kind of thing.

PS: You talked about how over a long period of time the authentic music of the folks has bubbled up passively, been co-opted by a power structure, and then something new bubbles up. What I hear you saying is this is the trajectory of all the arts.

WB: Right. If you think about the arts and culture being the language and the experience of people, then they must continue to return to the people or come to the people again. The people are always going to go back to those basic instincts again, and again, and again.

PS: So you find it positive that the authenticity of the people will always continue to reassert itself. I find it kind of discouraging that the power structure continually co-opts this authenticity.

WB: Yes, but see, some people would argue that the more the power structure does that, the more it gives people places to run and create other forms. So, if it stopped, then maybe our evolution would stop. If people have nothing to fight against, everything would be co-opted. You know that great movie, *The Matrix*. The Matrix is the perfect society, everybody's working fine, it looks beautiful, but it's been constructed by a group of aliens who have constructed the world to control people. But underneath the Matrix are the revolutionaries who have found out ways to not be a part of the matrix, to not be controlled. Or, the other wonderful science fiction expres-

sion is in Star Trek: the whole notion of the Borg. The Borg is this monster into which you have to be assimilated; but you don't want to be a part of the Borg. You really want to be a part of the free spirit that resists the Borg. Then the Borg's thing is "resistance is futile. Don't even try to resist. We're gonna take you over." I think that this is a common fight that's going to continue to erupt.

PS: Is one a sufficient counterweight against the other? Is the sub-rosa, constant seeking for creativity and freedom a sufficient counterweight against the hierarchy, the bureaucracy?

WB: It always has. Let's go back to the forms. I want to speak again from the angle, the notion, of music as a part of community and culture. Art, in that paradigm, always results in surprise. That's the way it always has worked. Let's look at slavery, for instance. Here is a situation where the power and the institutions said, "We're going to take away your language, your culture, your family and your religion." What happens then? The slave narrative results. People put together new forms from what they could remember; they took some pieces of the new superimposed form, reconfigured it, and out came black church religion which is African and Anglican and American. The slaves said, "Hmmm, you say that the God that you worship believes in liberation and freedom. That's what we see Jesus representing. So, you're a hypocrite. We'll take Jesus and we'll use the Jesus figure to be our salvific moment, our salvific enterprise to allow us to critique and to call out salvation, call forth righteousness for liberation of the poor and oppressed people." It was a brilliant move by the slave preachers to turn a kind of hypocritical, white Christian kind of religion on its side and American society on its side. Again, because that oppressive structure was there, it allowed people to be pushed to create new forms that gave them agency; these were both socio-political and creative. Out of this came the spirituals.

I think you can look at the blues the same way: as a way of using different languages and literary forms to create a new structure that helps in the quest for freedom. In other words, if I can't figure it out, then I'll sing you a song about it; it helps me sing my way through to an understanding of my angst. So, here's a great art form. Now we think,"Oh, he's just singing the blues." But the form is philosophical, poetic, and functional, because it allows somebody to actually identify those pieces they're experiencing that are problematic, and then to create a rhyme scheme around it to create some wisdom about this. Because you will encounter it again; you will encounter not paying your bills again, you will encounter all these things again. Here, we've created a form which allows us to say, "Okay, here we go again," and we sing. The interesting thing about the blues, the funny thing about it, is that it is an AAB form. So, the question is why did you repeat the first part, why do you

hear it the second time. And the old guys will say, "Because you didn't hear me the first time when I said it." So, he repeats it again and then you get the punch line which rhymes. So, you've created a literary form that allows you to do this. It's brilliant. Here is a way that common people bring the best sources that they can pull together to create a form that allows them to have agency, to have ritual, and to have identity. I think that's the way art works. And you're not going to have new art until you crunch and squish the people. When you constrict people, that's when they're going to find new ways to be able to get around, to be able to speak, to be able to celebrate their angst and to celebrate their potential. That's where art and culture, meaning and living occur. That's where it happens. That's what you want to see.

PS: Is this process a cyclical process or an evolutionary process?

WB: It is cyclical because it's the same good stuff and bad stuff, the same old shit that is spun every way, but the same old thing. Is it evolutionary? Yes, because we can look back at the trajectory of history and culture and see that these things have actually moved us ahead. We looked at the spirituals, then we went to the blues, then we went to jazz. Jazz brings it all together in an urban environment. Then you look at gospel: the spirituals in an urban environment that use the conventions of jazz and popular music. Gospel was an evolution of the spirituals, which were more rural and vernacular. Popular music is a reflection of how musical forms evolve. And in that evolution, some cyclical things keep coming around. Also, these forms help us evolve to the next new form, which finds its challenges and its limits in a particular time period, whether it's the 20's or the 40's or the 50's or the 2020's. It is a reflection of what's necessary at the time and that's the cyclical part. But in that struggle, people use that form, the new form to move ahead. So there is your evolutionary piece. So, the music or the poetry or the politics or the cultural meaning allow people to assess where they are and to try to have some hope in making a prescription of where they need to go. I think, in that case, it moves ahead, is an impetus to the creative process.

PS: Does that constitute in any broader sociological or cultural sense "progress" of justice, peace, love, a better world, or are we just talking about the development of creativity?

WB: I was listening to DuVal Patrick today, the [new Massachusetts] governor in 2007 who was talking about we are the future: "Now is the time, we have this opportunity to build a better future." It sounded very exciting. But, if you look at the speeches of Kennedy or Roosevelt, they said similar things. It's the same story, let's move ahead. We are moving ahead in some ways, but in other ways we still have the same old shit, the same old oppressive power, the same old people feeling pain. They are just doing it in another era.

What will we move to next? There is going to be a new set of problems. But in many ways it is the same old shit. So, then, the question would be what brings about the same shit? Identity, image, power, oppression, greed, the classic sins. Those classic sins keep coming up and they corrupt our evolution forward.

PS: Are you suggesting that this is our original sin and we're sort of stuck with that forever more? Or can we evolve our consciousness and our humanity to a higher level?

WB: That's what I think we're all working to figure out. Look at the world situation now. Let's humanize the terrorists for a moment. Let's say part of their issue represents a real legitimate angst of people all over the world. And they are willing to die for it. They say: "You know what, if you're not going to give me a better life here, then I got a better life someplace else and, guess what, I might take you along with me." It's a very scary conclusion but, it does represent a legitimate angst. I don't think they're just inventing this to be sorry because they want to be sorry. There's something really going on with the way the West has figured this out: that it was going to get all the goodies and create democracy or capitalism or power or modernity without having everybody at the table. To erase the same old shit, to figure out where we could be you have to have everybody sit at the table and say, "some of this is the same old shit. So, what is stopping up the pipes here? Is some of that stuff the greed, the inhumanity? Well, let's just figure out a way to stop that stuff from happening." But you have to be honest enough to identify it.

See, that's what the blues does. The blues sounds the same all the time because of, guess what? The same old shit. It is at least honest and says: "My baby left me, ain't got no money, ain't got no job, the man's got his foot on my neck, so I can't pay my bills." But it gives a mechanism that allows me to identify the same old shit and try to sing my way or humanize my way around this issue. See, I think it's a great model. We could get everybody to sit at the table and sing the blues, basically. Or at least identify what those are and be honest enough to deal with the issues. Then I think we would have a trajectory forward.

PS: What are the artists doing? They fit in because they are pointing out when the shit happens?

WB: I think so. They're being honest about it. All the arts—High Art, Middle Brow Art and Vernacular Art—do us a favor because they sing the people's issues and they dance the people's issues and they paint the people's issues. This has been transformative. A friend of mine defined theology this way: "theology's task is to illuminate the way and to move the people on." I think great art does that, too. It allows the people to move on because it illuminated something; like the blues bit, we have identified what the demon was. Now, be-

cause we've identified it, we try to figure out a way that is humanly possible to move beyond it, to not let it disrupt our humanness, or not let it disrupt our motion forward. That's what art does.

PS: You seem to be saying that art is a spiritual enterprise.

WB: Well, no, no. Now we get into the question of aesthetics and what people say music and art are supposed to do. Here we get a couple of camps. That's why I say in order to define what art is, you're going to have to talk to all of those people. Some people say art is supposed to be this high brow thing. Then, there are other people who say that art is, in fact, the most vulgar thing that you hear. As vulgar as it is, that's what's artistic, because it really is an expression of the people. The spiritual is not always God-like. Spiritual sometimes means human-like, sometimes anti-God. To be spiritual means to be totally dealing with innate inner feelings. There's something about that that's transcending; that my pains and angst are the same as someone on the other side of the continent; that is truly inward and spiritual.

I believe the arts are supposed to do all of that, not just one thing. I can get down, man, and hear and dance and do boogies, oh man, this art, man this art makes me move my bootie, man, in community. We're up here dancing, that's why people dance. They go to a dance hall because music is supposed to make people move together. That's an artful thing, because it's expressive. It's spiritual, it's humane. That's what it's supposed to do. Then, you could be listening to some Bob Dylan and hear the poetic critique and hear how he makes us think as a community about things that allow us to move forward. That's the way art is. Then, you can go to a museum and look at some dynamite piece that makes you envision a better world. That's what art is supposed to do, too. I think you have to look at all those different camps.

PS: Some see that art can be used as an apologia for the status quo.

WB: Then you have to ask, who caused it to be disseminated? Was that the art of the common people, or did the power structure use it to express their views or their vision of the world? Take Bruce Springstein's tune, *Born in the USA*. [sings] "Born in the USA, I was born in the USA." A big rock tune, right? In that tune, he's actually doing social critique. He's talking about I can't believe that all this shit is going on. This is what happens when you're born in the USA. He's a Vietnam vet singing that. Now Reagan used that tune to celebrate the beauty of the victories of being born in the USA. But that's not how the artist meant it.

PS: Now that I think of it another example is Woody Guthrie's, *This Land is Your Land*. People don't sing those verses about the poor, private property and all; they just sing the main chorus. How do we encourage you, as a teacher, or how does society at large, art institu-

tions or organizations, encourage that transformative property or possibility of the arts?

WB: One way I do it in class is to show how the art was reflective of and grew out of the critiques of the people. It grew out of the people inspiring to be great. It grew out of the people actually singing, ritualizing their daily experience. It's singing about angst. But it's also singing about joy. And it's also imagining a better world. I think that when you look at every period, you see how art was used to do those things. Then, you can better appreciate who's singing that around you. What are the artists saying in this day and age? In fact, we move our trajectory forward, because we get good views of the world through the artists. I think when you look at the 60's that was the case. Look at Bob Dylan, look at the social protests; their singing helped to humanize us and the times. It's through the vehicle of song that people are able to express the common angst of the time. I think that's what we have to do with every art. The last thing I say in *Black Notes,* my book, is that when we lose touch with what the common people are singing, then we've failed society. So we cannot move forward unless I'm hearing the angst and the narrative of those folks.

PS: The responsibility of the artists and arts organizations is to continually try to hear what's being said. Is that what you're saying?

WB: Yes, a society that loses its connections with the beat in songs and the scream of the common folk is one that cannot stand, no matter how vulgar or loud or disturbing those screams are. Musical art and other arts are an expression that has the ability to go raise the spirit and to speak to the common humanity of the society. Musicians and artists don't make music to change the society, but they're vehicles of expression. The music is an example of the transformative activity. In order to move forward you're going to have to be sensitive and patient to listen to all, even if we don't want to hear. In order for us to move forward, you really have to do that. I think the way the government is run now is an example of not hearing. It's really not sitting down and saying, "What are these people saying, what is their issue?" But they're not going to recognize them as legitimate, because they are coming from a part of the community that they don't value. So they are never going to hear what they have to say.

The responsibility of arts organizations is the same. The value of an institution is judged by the fact that it becomes progressively inclusive. In other words, the people who support the orchestra cannot be the same group generation after generation. They have to be the same group plus 10 or 15 others who weren't in that group before in the last generation, or the last concert series. So that new concert group, the season ticket holders, become people who got turned on because of a children's concert.

I remember my mother and father took me to see the symphony, and I just thought that Jimmy Hendrix, who was my guitar hero, should be playing with the symphony orchestra. I was thinking "how am I going to write me a symphony for Jimmy Hendrix to play." That's how my mind worked as a child. I'm a child who understands Jimmy Hendrix, but I like all those sounds I heard up there on the stage. So, I'm trying to figure out, I'm going to write something that Jimmy Hendrix can play, or I'm going to play with the symphony in a rock band. And as a composer I get to do that. But it's because my parents took me to hear the symphony, and I got that experience. But now I'm 40-something years old and now the current generation of symphony people includes me, because I went to a children's concert that was in the public schools. That's the way it's supposed to work.

So I think that that's how the high-brow arts organization has to run. And many of them are doing that, it's not magic. I bet the ones that are most effective, most beloved in their communities are ones that have intimate connections with the community with that kind of understanding, that philosophy that we can't exist without increasing our constituency by reaching out. We can't just continue to sell our season tickets and pass the season tickets on to the next generation who are in our family. In the American common culture, it's not what should happen. What's going to have to happen is that you going to have to do a gospel concert or rock-and-roll or something. Now I know I'm getting into some areas that some people will have a problem with, but I think you can have a popular culture kind of concert. I think there are educational bridges that can be made to increase people's exposure but to connect with them at the same time, to reach them where they are. I think you have to be creative in that, not to throw out excellence and craft and great traditions, but I think there must be a creative way for you to bridge, so that you can bring some people along who might be made aware of this other tradition. I think that's what has to happen.

PS: Is the same true of the community art organization?

WB: That's what community arts do. They are aware of that. That's what their model and mission is. They understand that they cannot exist without being rooted in the needs of the community.

PS: So the role, the responsibility of artists and arts organization is to be increasingly inclusive so that the creative process can continually bubble along?

WB: And I think that when you expose that kind of thing to a child, a child can say, "Wow, that's some new stuff that inspires me to think about some new things." But you have to present the music in a way that is creative and exciting. You can't say, "we've created this box here called art and great thinking and now we're going to

let you view it for a moment and then we're going to shut the door again, and when you are ready to come back in, we will open our box and let you see what's inside." That cannot be the attitude.

PS: So the notion of a canon of great music offends you.

WB: No, it doesn't offend me. I understand the need for a canon. I understand the need of tradition. But I am of the opinion of the open and expanding canon. The canon is not a closed box. That's because the human narrative continues to happen. And the idea of a set canon is the stupidest concept in the world for artists. No artist believes the canon is closed. It's a continuing canon, made by taking the best of the resources, the best of the expression, the best of what's going on now and you add to it and it continues to expand. You just keep looking for ways to expand the old war horses. I think that's a fair model. That's the operative model, that you want an open canon.

I get a chance to talk to graduate students as a composer, and I'm pretty sure that most of them, while they're high-brow because they are writing art music, many of them are on this page that we're talking about; their music is reflective of rock-and-roll, electronic music. They're just figuring out a way to express those things using an orchestra. The vast majority of young creative people are culturally responsible. When I say, culturally responsible, I mean they are resonating with the wide variety of stuff that is in their culture and they bring that into their art. I'm a composer in residence this year at Indiana University. It's our job as composers who are a little further on to, in fact, encourage the composers to venture there, to be open, to say, it's safe to be there. That if they like rock-and-roll or hip-hop or Celtic or popular music or vernacular or whatever, symphonic music, the academic world is a safe place for them to bring that to, to expand the canon. I guess that an older creator (I guess that's what I am now!), is supposed to encourage the younger guys and ladies to say, it's ok, it's safe here in the institution to do that.

PS: And then if you create something that resonates with the people, the canon will expand. The way we understand the ways we express ourselves artistically will expand.

WB: That's right. I think that's right.

Chapter 15

Wilson Yates

"Homo religiosus... Homo aestheticus"

Reverend Dr. Wilson Yates is President Emeritus of United Theological Seminary of the Twin Cities Minnesota, as well as Professor Emeritus of religion, society and the arts. Ordained in the United Methodist Church, he holds dual standing in the United Church of Christ. In 1998 he founded the journal, *ARTS (Arts in Religion and Theological Studies)*, continues to serve as its senior editor, and has written extensively on the arts in theological education. Most recently he co-edited *Arts, Theology, and the Church, New Intersections*, with Kimberly Vrudny (Pilgrim Press, 2005) and *Theological Reflection on the Grotesque in Art and Literature*, with James Luther Adams (Eerdmans Publishing Co., 1997). He is the current president of the new national Society for the Arts in Religious and Theological Studies. Other professional associations include the Society of Christian Ethics, the American Academy of Religion, Societe Europeenne de Culture, the Society of the Arts, Religion and Contemporary Culture, and The Arts and Christianity Enquiry.

He is a graduate of Southeast Missouri State University, B.A. (1960); Vanderbilt Divinity School, M.Div. (1962); Harvard University, Ph.D. (1968) with post-doctoral work at Cambridge University (1973-74, 1978, 1992) and Yale Divinity School (1985).

PS: Does it seem to you that our world is on the verge of a fundamental shift in worldview?

WY: I think we have had change at an exponential rate, especially with technology. It is an interesting question whether, in fact, the modern world, where most of this change has occurred, is actually absorbing, adapting, and changing in a constructive and accommodating way. Or whether the changes have created tensions, so that finally there's going to be a break point where we have to face up to the genie that we have released and say "we're not prepared to handle this." So there are two ways you can approach that question. My own judgment is that these changes are quite significant, quite revolutionary. Wealthy nations are less likely to feel as dramatic an impact from them as developing nations. Yes, you can give computers or cell phones to all the villagers in Zaire. However, there's limited infrastructure and cultural ease in handling this technology. So, the disruption for such nations that have lacked an effective infrastructure is more dramatic than for nations such as the United States, which has so deeply embedded the notion that if we're not changing at a rapid pace, we're in trouble.

PS: What might those changes consist of? What might the genie look like?

WY: I think we see the genie with military weaponry. As a world, we're scrambling to try to control the proliferation of nuclear weapons. And nations, like Iran, are going to press to have a nuclear capability of their own. The possibilities of nuclear power are there, but as a world, we don't have the international structures to provide adequate guidance and control. Reinhold Niebuhr once said that we are living in an age in which nation states are breaking down, but international structures have not emerged as strong enough entities to provide both order and freedom. Thomas Friedman in his book, *The World is Flat,* argues that we are becoming a global community. But do we have the structures to guide us that can provide some limits and guidance to international corporations? We do and we don't. Just establish yourself in Bermuda and you don't pay hundreds of millions of dollars in taxes.

 What do these changes do to the individual? I think one downside is to so rationalize processes and the search for efficiency and cost effectiveness that the human quotient can get lost. If you can outsource the work to Bangladesh without consideration of the impact on some town in Illinois which depended as a community and labor force on a factory where that industry was primarily located, then human beings and their community lose in multiple ways. Technology levels and asks for the greatest way to maximize profits. The fair questions to raise in the midst of that thrust is to ask "What impact does our action have on people, on the community, on the people, on the human spirit?" The Sociologist Max

Weber long ago pointed out that technology needs reason, order and a highly rationalized effectiveness. Yet what happens to the part of life that's not so neatly quantifiable? To our values, our emotional life, our sense of identity, our communal connectedness?

PS: Some have argued that we are seeing a tremendous search for meaning, morality, and spirituality. Others say we are just a bread-and-circus, or maybe we should say pizzas-and-football kind of folk, and that we're not really treating what is spiritually important in our lives.

WY: Let me respond with an example from the arts and the corporate world. The incident presupposes that people are seeking at some level to nurture and enliven their spiritual life even in their work world and if given the opportunity, which they can be, such nurture can take place even in the midst of the routine rhythms of the work day. Some years back, I worked with a person who was a curator of a corporate art collection. She insisted that art works not be put in a gallery, but spread among the offices for people to experience and enjoy. What I did was work with her around the spiritual, nurturing, or healing effect of art on people, wherever they might encounter it, including an office. I treated this idea in a speech I gave on the arts and spirituality at a conference of corporate art curators that my curator colleague had organized. My speech was about how art informs our spirituality and how our spirituality can be engaged by what the artist does. And it called for the curators to take that seriously in providing art for corporate environments. After the speech some of the curators talked about concrete cases where office workers were invited to choose art they wanted to hang on their walls out of the pieces of art that were available. The workers debated and traded and finally decided on works they were happy with. They were delighted to have art that they had selected to be a part of their office environments. But, most significantly, they chose works that 'spoke to them' about what was truly important to them—family, nature, community, religious and civic celebration. They sought art works that moved them beyond their particular office routine to those worlds that nurture their spirits. The point this illustrates is that even in a highly technologized context where a highly rational order is necessary, there can still be opportunity to nurture people's inner life of the spirit.

PS: Marx talked about the stultifying nature of much of industrial work. I don't know if outsourcing to Bangladesh or India changes that much. The argument has been if the drudge work is done by others, then that frees us to do more creative things. I'm not sure that's happening, however. And someone is still doing the drudge work. Do you have a particular vision of how we should be dealing with the challenge of the technologized world? Or do we just ride the technological tiger?

WY: I think technology needs to be guided by the values of a culture so that the shaping of work and its institutions take into greater account the common good of the community itself. For example, the current laws regarding corporate behavior favor a largely unquestioned technological activity, and, in unparalleled fashion, allow excessive financial manipulation. We have seen the effects of corporate greed and corporate corruption over the past ten years that beg for legislative controls or the exercise of the controls we now have written into law. But many factors undercut our dealing with corruption. We have seen how a failure of oversight contributed to the Enron debacle. Efforts to curb corruption in Iraq war contracts has been stymied, as much as helped, by the acts of congressional and administrative figures and we are now seeing in hindsight the failure to police the mortgage industry regarding irresponsible loans. Of a different order is the health services situation where medical organizations are pressed foremost to make a profit. But what if the health system subordinates health services to the profit line?

PS: It seems to me, at this point in our history, there is a willingness to seriously consider the relationship between private companies and the health care system, which wasn't the case a few years ago.

WY: I hope so. I think there's got to be some changes or the system will collapse. There are too many people uninsured. And the cost of insurance is straining both business and individuals. The big burst in medical care has come through technology: chemistry and machine technology. The problem is not that we don't want breakthroughs in medicines that will control diseases. That's good, but we need policy governing insurance and decision-making regarding such basic questions of which technology to give priority to and how it should be allocated to the population as a whole.

PS: I think there's been a tendency to think of the machinery as medicine rather than the whole person who gets the help.

WY: That's a fascinating point. We all are glad for the technological breakthrough, but the medical establishment doesn't always consider a more holistic approach, doesn't always recognize a broader approach than the prescription of drugs.

PS: A correlate of the technologizing world you mentioned is increasing inequality, not only world-wide, but also here within our own culture. Do you have any thoughts about how that issue ought to be dealt with? Or is this just an inevitable offshoot of the world we live in?

WY: I don't think it's inevitable. There are some societies that don't have this great gap, much of Europe, for example. And they live quite well. But we do have it, and it raises questions about our commitment to both justice and equity. It is terrible to have over 20 million children in this society go to bed hungry. Yet it's very hard to address, because agreement on solutions are hard to arrive at.

It seems to me that art plays different roles. We have talked about art nurturing people's spirituality. But why not also talk about the prophetic role of art which calls into question injustice.

PS: Since religion also can be prophetic, art and religion seemingly are partners.

WY: That's right. And you can argue, as well, that both art and religion are about nurture. Indeed, the church is dependent on the arts. Think of Sunday morning. You walk into a building that is architecturally-designed as sacred space, we participate in a liturgical drama, and we have the reading of poetry with the Psalms, and story with the Gospel. We have music. We walk in, we sit, we rise, we stand, we fold our hands: the rudiments of dance. We usually have fabric art and stained glass windows. We can see that worship, both simple forms of liturgy and much more elaborate forms, are dependent on the full range of the arts to usher us into the presence of the Holy. So that whole nurturing, inviting presence is there. And then the prophetic church takes a stance on issues, using the arts; and all of the arts can be and have been prophetic.

PS: The world we live in has seen, both within our own culture and world-wide, contending worldviews. I don't believe we're in a clash of civilizations necessarily. But there is a clash between modernism and traditionalism, between the West and the non-West, and, in our own culture, between liberal and more traditional thought. Do you have any perceptions about why that is and what might be the outcome?

WY: I think the most obvious one at the moment is between Islam and the mainly Christian and Jewish Western, modern, and humanistic world. I think we do have a clash of values. Islamic culture is as diverse as Christianity and not all Muslim thought or culture has a necessarily destructive conflict with the West. But Islamic fundamentalism and Western theologies and cultures do sharply conflict and the clash is profound. Indeed, fundamentalisms in all the world religions, as well as the secular world, appear intractable in their conflict. If you look at the Hindu-Moslem encounter, it's the fundamentalists of those groups that turn on each other. To some extent, in the Northern Ireland situation, the Presbyterians and Catholics most destructively engaged were absolutists and fundamentalists. Then in Israel the ultra-orthodox Jews and, in turn, the ultra-orthodox Muslims. I do think it's fair to say that those fundamentalist groups in Islam, Buddhism, Hinduism, Christianity, and Judaism share more in common than they do with moderate or liberal or progressive groups in those religions.

PS: It seems to me that these fundamentalisms that you have identified have become more obvious or more powerful in the last decade or so. They seem to have captured more attention in the media and become more powerful in politics.

WY: I think that there are some different factors working. One is re-
 lated to politics. For example, Wahabism in Saudi Arabia is fun-
 damentalistic and the house of Saud is very interested in keeping
 it so. In effect, this rigid fundamentalist religion in Saudi Arabia is
 politically baptized and protected by the state. Another factor that
 we can identify is theological. In all the great religions there ex-
 ists a theologically sanctioned literalistic reading of the Scriptures,
 whether it's the Bahagavad Gita, the Hebrew scriptures, the New
 Testament, or the Koran. The effect is an absolutism and literal-
 ness about the expression of Truth which places all those who are
 not in agreement beyond the pale of acceptability.

PS: But why do you think at this time in our life on this planet that this
 tension is so pressing? Or has that tension always been there?

WY: I think to some extent that tension has always existed. But it seems
 to me we are at a point in history where the fundamentalists in each
 of the religions have risen to greater power. A range of factors en-
 able conflict to develop among these powers, such as ready tech-
 nology and instant communication, easily accessible weapons sys-
 tems, economic changes including social dislocation of masses of
 people, nativism, differences among moral codes, as well as others.
 With technology, we can communicate across lines and we know
 what's going on. If I'm a fundamentalist, I can make contact so
 easily. That would be one, but another would be politics. I mean
 the Christian right really did weave its way inside the Republican
 Party. Somehow, the political climate and the information climate
 worked together. But there were also economic variables which
 contributed to the rise of fundamentalism. One of the major ones,
 in the sociological terms of Weber and Durkheim, is social disloca-
 tion. Where social dislocation has occurred in various parts of the
 world it can create a dug-in stance that draws on the most conser-
 vative elements of the religion.

PS: And the history of colonialism doesn't help.

WY: No. The West, in part, planted the weeds we're now dealing with.
 Political control, economic dominance, the alteration of indigen-
 ous institutions, policies of racial superiority, and the nativistic at-
 titudes towards other races and cultures—all contributed. I think
 art can be a very important force in addressing the ignorance and
 the parochial mindsets of people with regard to another religion.
 When I've talked to groups about the mosque, there's been de-
 lightful amazement at how beautiful it is; when I've shown
 manuscripts with Islamic calligraphy there has been deep appreci-
 ation of the work's beauty. When I've worked with statues of the
 Buddha, lights of understanding seem to go off.

PS: One issue we haven't talked about is the issue of environmental
 scarcity, climate change, resource distribution. Do you have any
 thoughts on that?

WY: That's a situation that is paradoxical relative to technology. For example, technology is a major contributor to global warming. On the other hand, we're dependent on technology to provide solutions that will address global warming. Again, values have to be articulated to demand change in the laws governing the technology, if we are to succeed. Take the Detroit car manufacturers. There is no reason why they couldn't have done what the Swedes and the Japanese were doing with their cars regarding gas mileage, hybrid engines, and so on. All of them could have done more. I think we are seeing changes in values and stances, however. If not a revolution, it's an evolution in thought regarding, for example, "greening." We see this among some evangelical groups. Until now they have stayed out of this debate.

PS: I read in one place that some of the more extreme evangelicals view global warming as a liberal plot. Or the end-of days thought of some leads to the conclusion that, while we're not going to try to speed up the end, to some extent "Who cares, because the end is coming."

WY: For some on the far right or who are millenialists this sort of reasoning occurs. Again, I think values play a crucial role regarding our response to the environmental crisis. Certainly, Al Gore speaks to this matter. So in a way we have to "convert" people to a new values mind-set regarding the environment, including new understandings of stewardship and our relationship to nature.

 It's an interesting question about the role of arts in this whole issue. I think that the artist has and will continue to define and redefine our relationship to nature. Whether we are looking at a Constable or a van Gogh or a Goldsworthy, we are being engaged in a relationship with nature that offers new ways of perceiving our relationship to natural reality.

PS: You don't have to go back to the romantic poets to find that either.

WY: That's right. Let's take the poet Mary Oliver as an example of someone who has a deep relationship to nature, who listens and responds to it. She is living in New England on Cape Cod. Or take her New England predecessors Thoreau or Frost. They are our teachers.

PS: You suggested that you see a lot of change in our values going on, because of a perception of things being out of kilter in terms of technology, the environment, or the economy. When you said you see them running to catch up, you didn't sound like you were convinced that the values race would be able to create a major change in time.

WY: American culture has a vessel of values that can be configured in different ways. They are dynamic; we can create new configurations that will better define a view of stewardship regarding both technology and nature. This would not be foreign; those ideas are already

deeply rooted in that vessel of values. Value systems, such as religious systems, are dying when the symbols are so rigid that they no longer are malleable and no longer have the capacity to respond to change. I think that's a dilemma of the fundamentalist groups. Religion provides a people with the values for making sense of the world, of coping in the world. As changes occur in society, the values must provide us with the means of guiding, critiquing, affirming, making sense out of those changes.

PS: I think the conflict over evolutionary theory is an example. And, therefore, some fundamentalists are for taking their children out of school and censoring books.

WY: That's one response but I don't think it is the dominant response. There is something we need to keep in mind about values. They aren't created in the abstract on a drawing board. As Jim Seller, the ethicist, once wrote, we are a crisis response culture; we wait until there is a crisis before we start devising ways to address it. In terms of a general mindset about our values and our common good, we too often wait until there is a crisis. We wait until the forest is burning.

PS: I think you're right. That's very insightful. We've never been taught to think in terms of what might go wrong. We've always assumed that going forward is progressive and if we do, we will become better.

WY: We must think through our values in terms of future consequences, in terms of what will be right, good and fitting beyond our own immediate time.

PS: In his book *The Great Turning*, David Korten talks about the need for new stories. Clearly, the arts and religion are partners in the creation of story. We have talked some about the place of the arts in religion and in the culture generally, but may we turn our attention more specifically to the role of religion and the arts in response to these crises we have been talking about?

WY: One of the things that both estates, art and religion, need to do is rethink how they under gird the status quo by what they do. Take, for example, the idea that human beings should have dominion over the earth. This implies a kind of colonial understanding of dominion: control, manipulation, it's there for the taking. You won't find many people today preaching or liturgies reflecting that quite so bluntly. There is a rethinking of the idea going on. Recently, I heard a Hebrew scholar observe that the root word for "dominion" from the Hebraic actually translates as "stewardship," not dominion as a political category of controlling the realm, but rather stewardship of it. There's a world of difference. I do find some of the religious traditions I deal with thinking about how we contributed to the problem. Therefore, how can we help the congregation think in a newer way about our responsibilities?

With art, there's an awful lot that's produced that can be lovely, humorous, warm-hearted, that is good art. But we also need to pose to the artist the question of what type of art we need as a society that will shake us or enliven us or invite us to probe the crises that confront us. Artists, particularly since the 19th century, have maintained that creative art-making is very personal and needs to come out of personal needs and interests. This is true, but the artist also needs to recognize that he or she has a responsibility to the community, the larger society, the common good. The social responsibility of the artist does not deny the very personal act the making of an art work is, but it does ask the artist to attend to the larger community as well in determining what to make. And I think we see that happening. One of the most beautiful illustrations I know is that of artists who painted city murals on the walls of large buildings. The Society for the Arts in Religious and Theological Studies gave a scholarship this year to a woman who is doing a study of murals in Philadelphia. Philadelphia is noted for the way that, in the face of social dislocation and the built-in sub-cultures of poverty, art was used as a form to support renewal in neighborhoods. On the sides of warehouses, there are huge murals—in the Hispanic, Black, and Somali communities—which celebrate the communities with their heroes and their beauty and strength as a people.

PS: I wonder if you are familiar with the Great Wall of Los Angeles?

WY: Yes, and we have some in Minneapolis—murals in the neighborhoods which affirm and celebrate the community's own ethnic identity. This woman's project is fascinating, because she is trying to show if and how the murals impact identity. Art has a prophetic role and an historical role. But it also has a sacramental role in which the art invites people into its images to be nurtured and sustained. It can allow you to participate in what is of ultimate importance, what is holy. It can enrich your spiritual sense of yourself. I think that's what some of those murals are doing, performing a sacramental function. By looking and participating, I am nurtured and healed. It becomes a means of grace.

So we have to simply raise the question, "what responsibility do we have to the community as artists?" In Western art by the mid-19th Century, there was a tendency for art to explore primarily the inner world. That's good. But there is a difference between exploration of the interior world of the human being and self absorption. Dali did some interesting pieces, but why should Dali's rather quirky, self exploration of himself be so celebrated? What about the artist who is exploring the fabric of a community? I think of the black artist Romare Bearden who did Harlem images. Or Marc Chagall who engaged both the interior and exterior worlds of individuals and communities.

PS: There's a fine line between self-absorption and expression which speaks to others. Do you see a serious discussion within the art world of this responsibility toward the community?

WY: I can speak to what is happening here at United Seminary. We publish ARTS, an arts magazine that speaks to issues of social response in the arts. We have art exhibits where artists treat our inner world of the religious life and our religious and moral action in the world. We teach courses that help students understand both the prophetic and the sacramental role of art. We have forums and work with arts organizations, such as the Minneapolis Institute of Art (MIA), to explore with artists the personal and the social roles of art in society. One of the projects of the MIA and United Seminary initiated conversations between artists and religious leaders to try to break down possible antagonisms or suspicions. One of its successes was in enabling both to see that the community is a place of common ground, and that they are both trying to contribute to the health of the community.

PS: I recently did a similar exploration with a friend of mine about the parallel common purposes among the community artists and people who are working for sustainable community development. I think some religious leaders are also on that path.

WY: It might be interesting to do some case studies of artists and clergy/congregations to see if the question you are raising, the place of religion in the development of a sustainable future, is happening.

PS: My colleague and I plan to do something like that—to study communities where the various institutions are coalescing in cooperative work for a healthier future for the region in which they live.

WY: This is a very important question. If we are a nation that deals with crises, if we are a nation facing a world where there are deep and profound problems, we need to ask how the different power centers in the culture—the press, the government, business, the unions, the churches, and the arts—are responding. Are they ignoring the situation or accommodating to it? Are they leading or are they following? Are they making a difference in building the good community or are they providing escapes for people to avoid social responsibility? And in particular, let's look at religion and art, because they share affinities in creating meaning.

PS: Yes, they both deal with how we understand our world and from which we can gain understanding.

WY: That's right, both are windows onto the world. I also think we're at a moment where we have had an emergence of interest in spirituality, which we spoke of earlier. Much of this is outside the church, among people who have no use for the church and are scared to death of the word "religion." But, they want to say: "I, too, am a spiritual creature," as Max Weber called us: *Homo religiosus.* And I would go so far as to say we are also *Homo aestheticus,* aesthet-

ic creatures. I may not paint, but I organize the living room and the knick-knacks in a certain way and you can come in and express an opinion on the form, line, and color. There is a relationship between the aesthetic experience and the spiritual experience, the arenas in which they contribute ought to be explored. Just as spirituality is so vitally important both within and outside the church, so people claim art in ways we may not have seen.

Both Minneapolis Institute of Art and the Walker Art Center have extensive community programs, which were not there 20-25 years ago. The leaders of that art world turned and said: "there is a community out there. We're not just a museum for people like us who are educated to the arts." When the Walker built the sculpture garden, they did a study of who was coming. They discovered that people who would never set foot in the Walker were there and their children were climbing on the David Steel piece of sculpture. They were not folks who were at ease with art, yet they were out in the garden playing with it, being with it. I think there is a responsiveness in the culture to the arts, a bubbling, if you will. And this is good, for it means more people are opening up to the arts as sources of enjoyment and meaning.

PS: The National Endowment for the Arts and others have recognized that the arts are not just what's hung on the museum wall or butts-in-seats. It's what's happening all over with all kinds of things, like painting classes and community theater.

WY: One of the things the women's movement gave us was the recognition that quilting is an art form. Now the MIA has a quilt exhibit, which it would not have had in 1960. So the fabric arts and the decorative arts, which a lot of people have an immediate relationship to, are more appreciated.

PS: I hear you say that you think that our culture is embracing both the spiritual and the artistic sides of our nature more than before. The question is whether that is going to be transformative of the culture at large?

WY: I think spirituality and art, which are linked insofar as they deal with such profound religious and cultural matters as human purpose and destiny, justice and injustice, love and hope, courage and identity, are alive in ways that are very constructive. And out of the ferment, I believe we will see how the arts and religion can be partners in serving the needs of the human community. They can be partners in finding a way to proceed in a troubled world.

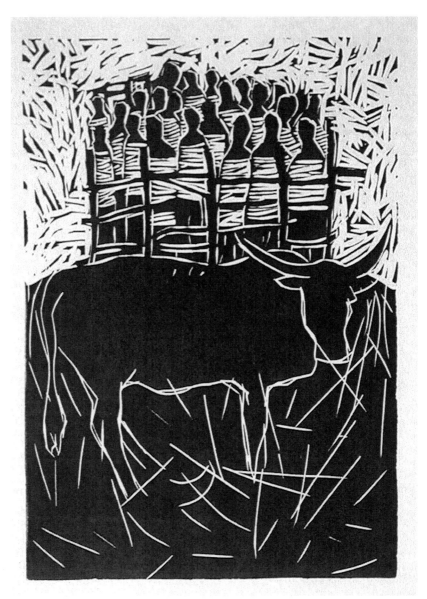

Gabisile Nkosi: *Umthwalo* (Baggage), Linocut, Gabisile Nkosi, 2007 from the Healing Portfolio commemorating the 200th Anniversary of the Abolition of Slavery in the UK.

Part IV

Other Voices

Reflections From Philanthropy,
Religion, Education, Politics

Other Voices

Reflections From Philanthropy, Religion, Education, Politics

Claudine Brown, Neil Cuthbert, Lynn Szwaja,
Krystal Banfield, Linda Whittington

These voices all speak of the need for artists and arts organizations to forsake their silos and work in concert with others to confront the pressing questions of our time. Brown, Cuthbert, and Szwaja describe their work in the philanthropic sector; the need for cross-sector collaboration is emphasized while the difficulty in creating these structures is fully recognized. Both Banfield and Whittington are concerned with how to provide youth with creative experience so that they may find a stable sense of self. Dr. Banfield emphasizes how she tries to engender commitment to community in the young musicians with whom she works. Whittington applies her theater experience to assuring, both directly and through her role as a legislator, that her state's at-risk youth are given a chance to discover their own creative selves.

Chapter 16
Claudine Brown

"Who tells the story effectively?"

Claudine Kinard Brown is the Director of Education at the Smithsonian Institution. From 1994 to 2010 she served as the Director of the Arts and Culture Program at the Nathan Cummings Foundation. She began her professional career as an art and drama teacher in New York City Public Schools. In 1976 she joined the staff of the Brooklyn Museum, serving for thirteen years, as a museum educator, Manager of School and Community Programs, and Assistant Director for Government and Community Relations. Brown left the Brooklyn Museum in 1990 to direct the Smithsonian Institution's initiative to create a National African-American Museum. In 1991, she added to her responsibilities by concurrently assuming the position of Deputy Assistant Secretary for Museums. Her responsibilities included developing policy affecting 13 national arts and humanities museums, reviewing their long-range plans and assisting in prioritizing institution-wide budget requests which were presented to Congress. She has taught graduate courses in the Arts Administration program at New York University, and the Museum Leadership Program at Bank Street College. Claudine Brown has a Bachelor of Fine Arts degree from Pratt Institute, a Masters of Science degree in Museum Education from Bank Street College and a Doctor of Jurisprudence degree from Brooklyn Law School.

WC: Does the idea that this is a particularly critical moment in human history ring true for you?

CB: I think it does. And I think that there are economic issues that make it so. One, I think, is that in the arts, we can't overlook all these immigrant issues that are emerging in this country and in Europe. We're also looking at how economies are shaped and who is producing and what. I think that some of the tension in this country around immigrants has to do with the perception that immigrants are taking jobs away when actually jobs are being outsourced. The shift in who produces food and who produces technology and who produces the manufactured goods, I think, is something that people are paying more attention to than ever before. Whether or not they're living in a clean environment and whose communities can be polluted and whose communities will not be polluted is a volatile issue. Whose children are more likely to go to war and whose children are less likely to go is something that I hear from urban communities, where one would expect to hear those conversations, but also from rural communities and as a nation. A lot of whose children will go to war are from those communities that have high rates of unemployment.

WC: Do you think people perceive these as separate issues or as part of some larger questions?

CB: I move in public policy communities where certainly the links and connections to larger questions have been made. But, I also move in indigenous communities and in under-resourced communities where people's notions of lack and oppression are fairly immediate, so they're not looking at broad policy issues that may be the root cause and they don't have access to data. They simply know that their communities tend to be communities that are either overlooked or are not receiving the kind of concern that they deserve.

WC: Do you think that level of conversation has increased because people are becoming more aware or because the conditions are becoming more acute, or both?

CB: I think it's both. I will say that the Al Gore film has been talked about everywhere I go, especially now that it is on cable. I have friends who say that they heard this stuff in a barber shop and a beauty parlor. There are even people who are saying he should have fought harder to become the president because they find the film itself to be so compelling.

WC: Do you think that the message that the world is facing a critical turning point has gotten through?

CB: I think that his method of conveying that message is highly believable and I think people buy into it. I think that where that message stopped was the need to help people figure out what they need to do as individuals. You can believe in a particular message but also come away thinking it is someone else's responsibility to make

it better. If you believe it is only the responsibility of the legislature to make it better, then you can be frustrated and you can be angry, but you don't know what your action should be in order to change things. Certainly, there is consumer activism going on where people will say, "I'll only buy these products because they're safe for the environment." But, even with these kinds of behavior, I think the message is not permeating lots of communities in a big way. A lot of those products are expensive. Sometimes they have to be acquired by catalog; they're not being sold in the big warehouse stores where poor people are doing most of their shopping. So, there are levels of education that need to happen. I think that that film was the big picture story. But it didn't convey next steps for individuals and communities.

WC: Some have said that that a barrier to understanding that poverty, the world economy, and the environmental crises are all linked is the dominance of a worldview that obscures those connections. The point has also been made is that in addition to things like Al Gore's movie, etc., we need stories that represent other ways of seeing the world—a worldview that validates cooperation and interdependence as a balance to a winner-take-all perspective. Is that something that resonates for you?

CB: Let me put in terms of my previous professional experience. As a person who worked in the museum, the traditional way of telling a story has been to have an exhibition, a scholarly catalog in addition to a small brochure for the general public that is often free. If there were school groups, they could have an educational program where they would spend between an hour and ninety minutes with an instructor one time, which is pretty much the average. The same would be true for adults who would come for adult tours. That would be the extent of an educational experience. But, I think in this world of digital technology there are some new options. One of the things that scholars talk about is how they really want their research to reach a lot of the public, but it takes a long time for that to happen. You know that the polar caps are melting, but you also know, just because of your frantic process of changing textbooks, that it could take three to five years to get the new information into enough textbooks for it to make a difference.

One of the ways that I look at conveying information in an exhibition is what I call layered tiers of information. Yes, you do the exhibition, but the same kind of research that you do for an exhibition could be used for a documentary film which would have a life that is longer than the year that an exhibition would tour. Why not use that intellectual capital to develop two products from the very beginning? My other interest was in what I call layered material. So, you not only have the scholarly catalog but also a series of books, one for elementary-aged children and one for adolescents

from the same material. The adolescent piece could be a graphic novel. Make sure that there are layers of information that can be available for a longer period of time. The other new strategy is having information, a website. But one of the things that I've learned myself in doing research on the web is that information doesn't stay on the web. People take stuff down and put new stuff up. This means finding a way to provide to access to these sources so individuals can collect them and own them and use them when they are needed.

WC: Given the needs and the strategies that you've talked about, where are the artists in this? What role might they have in this sort of unfolding play?

CB: Again, I can give you an example. I believe artists are storytellers in all kinds of ways and are capable of telling stories in ways that people remember them. Sometimes, they can tell the story metaphorically at a moment where telling the actual story could be unsafe. The notion of having artists as storytellers, whether they are playwrights or media makers or visual artists or graphic artists or designers, I think is an important piece. But, sometimes, they're also problem-solvers. This is especially the case if they are designers or if they are storytellers who offer multiple scenarios as answers to nagging questions within the context of our society. So, when you think about them in those roles in particular, one of the things that you begin to think about is who tells the story effectively so that people will pay attention to it. One of the reasons why I raise this is that if you think about the work of Michael Moore—and I see him as an artist—you know the right wing developed several political documentaries to counter his work. None of those have achieved their purpose because they were up against an incredible storyteller—both a visual as well as a narrative storyteller.

Another example: we gave a grant to a social organization that wanted to take a lot of film footage that they already had to deal with the issue of benefits for workers. We asked them to work with an artist and do a documentary film; because they weren't involved with unions they decided to work with members of the television workers' union. They got a film, but it was so boring that nobody would look at it. We then linked them up with a media arts center which took all the same footage and reorganized it, added graphics, and made an incredibly powerful film. The gift of storytelling is not to be underestimated and not to be devalued because a great story is like great oratory—it can galvanize people and encourage them and motivate them.

WC: In your work are you seeing artists who are motivated in this direction acquiring the translation skills, the bridge-building skills that are necessary to do it well?

CB: What I'm seeing in my work are people who can do it naturally. Also, people who are learning to do it better.

WC: Are you seeing innovation in this area?

CB: There are a couple of things that are happening. One is that, in many instances, the timetable has been collapsed. Due to digital technology, a film that would have taken three years to make can now often be made in three months for less money and be of very high quality. You don't have to go into separate labs; you can shoot and then edit the film on your home computer and it can be of very high quality. The interesting thing was that there was a short window, a time when, I think, young film-makers felt like they were entering a period where this could be the cheapest period ever for making films, especially documentary films. Then fair use and all the copyright laws tightened. So if you're doing an historical documentary, it's either harder to find the material, or based on the new copyright laws, corporations are gaining control as opposed to someone's estate. So, they are charging much more money to get access to the needed material. So, even though the cost of production has gone down, the cost of rights-for-use of material has escalated incredibly. It used to be if you were an educational institution, you could get access to material under fair use, but that was eroding since corporations were threatening to sue. There is a group out of D.C. that wrote a fair use manual, encouraging everyone to adhere to fair use under the guidelines in the manual so that if corporations push back, there can be a class action suit settled in court. So the interests that choose to make money and exploit information have complicated that process. But, if you choose to use original music or images, it's much easier to get a powerful message out there in a shorter amount of time using less money.

 Once the new technology becomes available it empowers people who would not normally have seen themselves as creators to become creators. This is true of people of all ages. It's interesting because when desktop publishing first came out, a number of my grad students stopped using artists for their brochures and started doing their own. Some of them have done well but others have produced terrible brochures. We had one person who came up with a brochure with ten different type faces and each in a different color and it was unreadable. So, they learned their lesson and realized that they needed a person who had real skills who could do this, still keeping costs down, in order to put out really interesting flyers about one's work.

 The same thing has happened with websites. It used to be that you had to find a technically smart person who could make a website. But now there are templates. Just like you can do PowerPoint on your home computer, you can learn to design your own website in the same number of steps. I think more people will be taking ad-

vantage of the information technology that allows them to get their data out in a meaningful, beautiful way.

WC: One of the other things that we are hearing in these conversations is the power of artists who work in and with communities using first voice to tell unmediated stories. Are you seeing this? Is there an increased expertise in this area?

CB: We're seeing a lot of this and we're seeing growing expertise. We fund about six universities that have set up degree programs in art and community-building. Their students have specifically chosen to be in programs where they learn to work effectively and competently with communities. That's the formal education aspect of the work. Then we also see what I call the informal education processes in places like Cornerstone Theater. There are also a number of media centers who have programs where both artists and community people learn these skills.

WC: What are the universities that are involved?

CB: Columbia College in Chicago, California College for the Arts in the San Francisco Bay area, The University of California at Monterey Bay, Maryland Institute College of Art, and Xavier University, in New Orleans. We also fund, Tyler School of the Arts at Temple. Their program is not a degree-granting program but they're trying to move in that direction.

WC: You also supported a program in Minneapolis, the Institute for Community Culture Development. Are you seeing this educational component as sign that the field is maturing?

CB: I think it has been going on for a very long time. I think that people have been borrowing methodologies from one another. What has been interesting to me is the fact that the way the arts community is divided has made it difficult for people to know about the work outside of their discipline. For instance, people in theater weren't necessarily informed about what was happening in the visual arts or in dance. By the same token, people who cared about communities and social change who worked for symphonies weren't talking to people who were doing world music. One of the things that we're seeing more of for the first time is cross-disciplinary conversations so that people are borrowing pedagogy from one another. What that achieves, I think, is the building of a community that is not just discipline-based.

WC: Are you seeing cross-sector interaction as well? You gave the example earlier of a film that had been created by labor activists and a media center. It sounded like it might have originated through another program at the Foundation.

CB: A lot of the cross-sector work happens because, in our foundation, we are encouraged to do partnership grants. For instance, we support the work of a remarkable woman who has been filming communities that are dealing with the issues of being uninsured. Be-

cause that is a part of the work of our health program, we ended up funding that work together. We originally funded a publication that she and her partner did, documenting who was uninsured in America. Next that publication became a traveling exhibition that traveled for about five years to about 30 different venues. Then they wanted to follow up with some of the families that they had met; they did a publication and just recently did a documentary film. That was a natural partnership between two program areas. We actually believe that the photographs, their film work, and the stories are a very, very powerful way to learn about who is un-employed through stories that are not stereotypical. For example, there is a story about a woman who is unemployed who has cancer, and who is also a care giver to an elderly person. Another person who is uninsured is a woman who was battered and who is now in a state home, very ill; but the only insurance she ever had was the husband's insurance, and she has pre-existing conditions that are not covered by her public insurer. Then there are all the people, who I never thought about, who can use up all their benefits for the year, even if they are insured. So, a woman whose child is termin-ally ill can use up all the benefits within the first few months of the year. Then there are all the people who tried to pay for treatment but became bankrupt. It's stuff that most people in the public have no idea about. If those stories don't get told in a very powerful way, then we won't embrace them.

WC: One of the characteristics of the stories you're sharing is that that they prompt others to recognize that they are not separate and im-mune from the causes and impacts of these social problems.

CB: I think that is an underlying message. The other thing is that some of our work is done with others; for instance, we funded an exhib-ition in partnership with our environmental program about hous-ing. One of the reasons why, as an arts program person, I was en-couraged to do it is that most of the public programs were being done by local carpenters and plumbers who were teaching people that you could improve the quality of the home you already owned without it being terribly expensive. We liked the fact that the spe-cialists who were working on this exhibition were people from the community.

WC: How do these bridges between creators and people who have been working in the trenches to improve their own communities get built? Are you seeing any connector strategies that might be ap-plied elsewhere?

CB: First of all, I categorize artists with other creators. I think if we be-gin to think about artists as a cohort all by themselves, then they don't have a lot of power. So, I always picture artists as parts of lar-ger publics. The other piece of it is that I think that artists are also feeling very comfortable making partnerships with scientists, and

expert practitioners in other fields. An example is a work that Liz Lerman did called *Ferocious Beauty: Genome*, related to the Human Genome Project. There was recently an article where they talked about what the expectations were and how the geneticists said, "If you can make what we do understandable, we will value what you do." At the end of the process, they really believed that that had happened. There are people who live and work in communities where the language is so complex that most members of the lay public wouldn't understand. If the arts can make that understandable, if art can help communicate to others, then people in other disciplines will really value the power of art.

WC: Interestingly enough, some of the people from other disciplines we have interviewed have, in fact, said that their greatest challenge is that they don't know how to tell their story. They know how to present a case, but they know that the complexity and the nuance of their work requires a story delivery system they don't have access to. Stories like Liz's are pretty powerful. You get a lot of stories and ideas coming across your desk in the form of proposals and reports. At the end of the day do you feel optimistic or not?

CB: I do feel optimistic. My only trepidation is that I think there are not enough funders supporting this work. When I look who is funding my grantees, there are wide varieties of funders who provide support for different reasons. We recently had a meeting of funders interested in art and social change or art and social justice. About twenty-five people came. But when we looked at who was in the room, we realized that a number of them were intermediary organizations and most of them were getting support from Nathan Cummings or Ford. Ford is going through a major transition that will culminate at the end of the year. I would say that Nathan Cummings has consistently been engaged in this work, but who knows what the next step will be. That meeting was important because of the question that my grantees asked me is, "When you stop funding us, where will we go?" That's a real big question that I feel obligated to try to answer because a lot of the projects that we have incubated are now fairly stable. They do have some diverse funding. But, I think I have a responsibility, as do others who care about this work, to grow the field. We're beginning to cultivate others who will do it; I've actually had meetings recently with two foundations who are interested in supporting this kind of work, but the question is what kind of assistance can we give them to make sure that this really happens?

At the Nathan Cummings Foundation, we only sponsor organizations that have multi-state or national impact. But, certainly there are grassroots organizations that are doing this work. We get to some of them by re-granting through intermediary organizations. But, one of the things I realize is that it's in the grassroots or-

ganizations where the new leadership for community-based work is growing. If those leaders aren't getting the support when they need it the most, then their organizations will not mature and the work will not be perpetuated. It's almost like we need to be building an ecosystem that sustains the work over time.

There are a few things that we can do. For instance, there's a possibility that Cummings may not be funding universities any longer, or not at the level that we funded them at before. If that happens, we want, over the course of the next few years, to fund their ability to convene every year and begin to develop a journal, which can be on-line. We want to make sure that this cohort of groups that have been working together have the ability to continue to do that. There was a major conference at California College of the Arts last fall and we expected the "usual suspects," but, in addition to the six universities that I was aware of, about 15 others sent representatives to discuss this issue. It is a field that appears to be growing. We need to be able to support its growth.

WC: Do you think greater collaboration between the community arts sector and those dealing with sustainability and the environment will produce more resources for this kind of work?

CB: One of the directions that we may be moving in is what has been called design education. Design education is pretty advanced in London, and there are a couple of organizations there that have created design and civic engagement curricula for young people. I'm working with them on the whole notion of involving young kids in urban design and playground design and in design for places where they live, so that they really understand that the design of public spaces is a civic engagement process. If they intend to use it, they should have some say in how it is done. In some of the programs that already exist, kids have actually gone to public hearings, taken their own schematics and designs, and talked about what they want. There's an organization here in New York called Sweat Equity Enterprises started by graffiti artist Marc Ecko. They have a contract to do a major website for young people interested in design. Each young person has their own page. They can have examples of those things they want to design or have designed, but there will also be competitions with professional designers from all over the industry who will look at what they do. And in some instances the designs will be made.

WC: Their work will also be exposed so these companies can see new talent.

CB: Exactly. All of those things are possible. But, part of what is being emphasized through this work is that design is a growth industry and also a global industry. The kids who are in the program here in New York are put into teams, they do a series of designs, and get critique; but they also meet the people who manufacture these

products. So, people come from all over the world to sit down and talk to them. The kids get to see what the factories look like. Marc's premise is that if you don't get that it is a global society, then you're not going to be prepared to work in it. A lot of the work in design education is about knowing where our materials come from, who is actually doing the labor, what it costs to produce, and what the marketing budget is. They're learning all of those things so that they're not mindless consumers and have some notion of everything that goes into the creation of a product.

WC: That sensitivity will then be reflected in their design. One of the things we haven't touched on is public policy. Is this something you have been addressing in your work?

CB: Yes, public policy is very important. One of the things that we're interested in, even though it's not a big part of our program, is who controls the media. For instance, we're working with The Center for Rural Strategies which is concerned that, due to media consolidation, the stories of rural America are not being heard any longer. Most of the local newspapers and radio stations are being purchased. Who is going to tell the story of what's going on in rural America? Is it somebody who's sitting in a major city who decides, or someone at a corporation who thinks that local stories are not important? One of the things that they are seeking support for is a web portal where rural news can be on-line and available, both through video and stories. They are identifying what they consider to be authentic voices in rural America, writers they can trust to tell the stories really well. What is the news from their communities that is really important? Doesn't the world need to know that sixty percent or more of farm aid goes to corporate farms? They feel that they have much in common with the urban core, because both communities have been neglected and abused. The jobs that would have been available in both communities have been outsourced. They want to be able to tell that story, but, due to media consolidation, it will never be told. This will be an interesting conundrum for the web: where do authentic voices show up, who affirms this message? It's one of the reasons why we have to be concerned about public policy related to media, because we want to make sure that our grantees know how to tell their stories, if they're not blocked from telling them.

The other thing that we find interesting is that even those entities who want to make money are attracted to storytelling. So for instance we have a grantee that tells fairly radical stories. They started out as a literary program for incarcerated and homeless youth, but now they also do video and all kinds of media. A local telephone company that wants to send video messages on phones is picking them up, because they believe that their content will be compelling to young consumers. Even though this particular corporation

has to be conservative, they want to get ahead of the curve and they want to make money.

WC: So, you're describing the ongoing struggle for control of the message. Whose story gets told? Who tells the story? You are saying that there is an increasing threat from media consolidation but that there have also been new creative responses, new opportunities.

CB: One of the things that we need to be cognizant of is that the contracts our non-profit groups are signing right now do not restrict them later. There was this trend, maybe a decade ago, that children's museums all wanted new media centers. A lot of computer companies said "we'll design the media center, it's a corporate opportunity, we'll put our name on it." But then a lot of problems arose. For instance, none of them negotiated contracts assuring that the computers would be upgraded. None of them figured out what technical support they would need. These are media centers that get a lot of wear and tear from really young kids. There were some computer companies who provided equipment that was not compatible with the best software and who restricted the use of compatible computers in the room. One of the most egregious instances that I heard of was a cultural institution which created an exhibit in their corporate-sponsored media center that was very, very popular. The corporation said, "If you want continued support from us, we have to own part of the exhibit."

WC: Wow. What comes to mind is Monsanto trying to control agriculture by copyrighting the genetic code of some seeds. A creative sprout comes up in a cultural institution and they say, "We want a piece of the action."

CB: Those kind of lessons need to be learned to make sure that there's not a loss of intellectual property as a result of people being taken advantage of.

WC: What you're saying is that some people are entering into these corporate relationships unaware.

CB: In the past most of this kind of abuse has been in the recording industry. When you start seeing language in a youth contract that looks like the language in a recording industry contract, you have to be especially careful. This is a whole new day, though. All these design-based companies want the content right away, and I think that they're going to be willing to do unusual licensing agreements as opposed to ownership. They're going to start off wanting to own everything. But, I think that they can say "somebody else also wants our material. We prefer to work with you, but we have to preserve the right to generate earned income for this not-for-profit organization." I think possibilities are real at this moment.

Chapter 17
Neil Cuthbert

"A big shift in cultural energy"

Neal Cuthbert is the Vice-President of Program at the McKnight Foundation; he oversees a grant-making budget of $90+ million that supports children, families, and communities in Minnesota and the entire length of the Mississippi River. His portfolio includes programs in renewable energy, economic development, neuroscience and third-world food security research, work in East Africa and Southeast Asia, and the arts. Prior to this, he was McKnight's Arts Program Director; the arts program provides between $8-10 million annually to support arts organizations and artists in Minnesota. While directing the arts program he developed the reports *A New Angle: Cultural Development in the Suburbs*, its follow-up, *You Are Here;* the study of the impact of the arts on rural communities *Bright Stars;* and several other studies and publications. With the Walker Art Center, he led the development of the artist website, *mnartists.org*. He was formerly the director/publisher of the monthly art and culture journal, *Artpaper*, and a planner in the Metropolitan Council arts and housing programs. He is also a visual artist and writer, and has exhibited and published both in Minnesota and nationally.

WC: Put simply, the question we're asking is, where is the world going, is it making a unique and significant turn, and what role does the arts community play on the journey?

NC: My quick answer to the question of change is yes. It is framed by a number of observations and my own questions. One of my old anthropology professors talked about shifts in world cultural dominance in human history and how they are always tied to energy. These shifts are always tied to changes in how energy was used and controlled. How could a small country like England essentially dominate the world for as long as it did? In his analysis it was always tied to issues of energy and how a nation was able to propel itself forward in such a big way. So here we are now, reliant on an old form of energy with no discernable way of moving away from that. So the question is, how do we move forward away from carbon-based, fossil fuels? What are the future means of production? What are the future sources of energy? Our incredible dependency on our current sources is a huge vulnerability. It's interesting to hear Republicans talking about our energy policy in terms of national security. But, there is this obvious link between our gluttony and our economy and our lifestyles. And they are saying, "Oh, we have to defend the kingdom here." Can we keep consuming at the present rate? Can we come up with different energy sources? To my mind that question has been sitting there for a while. The fact is that we don't seem to have any answers for these questions and that makes this a particularly unique moment.

 The other thing that we are seeing is a big shift in energy of a different sort—cultural energy. That's the thing that is particularly unique about this time in history. What is happening culturally worldwide is, in part, fueled by the web. There are three key things here: 1) the dissemination of information, 2) the interconnection of like-minded people who can find each other all over the world, and, 3) the internet as a means of spreading culture. Western commercial culture is so powerful as a cultural force. To my mind it is an unstoppable wave of energy, so seductive and so liberating on so many fronts. And the world is so big and so small at the same time, given what you can connect to on the web. That's my short answer.

WC: Let me go back to the point you made about energy. If, in fact, we are at a hinge in history that is precipitated, in part, by our relationship to energy, is there anything that tells you that the script that got us into this mess is being seriously questioned?

NC: I think the entire global-warming *Zeitgeist*. It's Gore's film. We have gone from a theory of global warming that the Republicans framed as debatable, to people taking it seriously with an actual real fear of it. The idea that coastal cities are threatened, the continued freak nature of weather, and what happened in New Orleans.

That's all pretty profound. As baby boomers start to get older, whether they are Republicans or Democrats, they will observe that winters are a lot weirder they used to be. Storms are weirder and these things that happen in other parts of the country and world: something's changed.

The notion that we as a species have fundamentally changed something that is causing the earth to respond in ways that are threatening is new. The idea that the world is responding to us is entering the common psyche. It's kind of like that 100^{th} monkey thing. Now people have moved it off of the list of the thousands of things you can ignore. Now it's an actual threat.

WC: Do you see this in your daily work as a philanthropic policy maker?

NC: Yes. I see it in artists who are engaging in environmental issues much more than they ever had, with much greater levels of urgency. Even if they are not calling up issue-related content, artists are also addressing it in other parts of their lives as citizens working on political issues. I also see it on our board. You know, we have a river program here. We have been involved in alternative energy funding for fifteen years. The sense of urgency on our board is much stronger. Though they are wealthy, our board is like the general public; they are not a bunch of activists. And so one of them, a 74 year-old, retired lawyer has seen Al Gore's movie three times. I can see he is thinking about his grandkids. So I think we have entered a different kind of realm.

There are just all of these signs all around regarding the interconnection of things. For example, the push for corn-based ethanol, has been huge here in Minnesota. There's something like a corn mafia here now. So, corn production and prices are going through the roof. Protests are emerging over the competition between corn as a food and corn as a fuel. Some are saying it is good for the environment; but actually it takes so much energy to produce that you might as well just use fossil fuels. There are all of these unexpected consequences.

WC: So you see us faced with unprecedented challenges. Do you see opportunities?

NC: The challenge to me is dealing with the fear. To me it feels like there is this fundamental shift in consciousness. I feel we are on the brink of a global culture, which will be happening over the next hundred years, if we can survive the next hundred years. I feel like I get a glimmer of what that global culture can be. But the challenge to it is fear. Essentially fundamentalism becomes the response that a lot of people are experiencing—the fear of losing the familiar reality. That's what's so powerful about it. Culture forms people's reality. There is a cultural force that's just sweeping all over the world. To have something so powerful telling people in all of these countries all over the world, in small countries, in little villages,"Hey

dude, the sky isn't blue, it's orange." With that major a shift, then you get a fundamentalist response, like, "no, the sky is blue and you will believe and even if you look up there and see that it's orange, you will tell me it is blue or you're going to die." They are saying, "You cannot shake my reality." Our whole culture is based on the belief in reality being a certain way. This is the nature of a lot of the struggles right now. What we see popping up in the Middle East are fundamentalists. What we see popping up in this country is similar. Bush is, to me, just a mainstream version of a kind of fundamentalist fascism, which is pushing back in the face of inevitable change.

WC: One of the things that I see a lot in my work overseas is a dynamic tension between two inexorable impulses. One is the reverence for what is familiar, what is family, what is tribe. The other is to connect, translate, bridge, explore and understand. The fundamentalist response is the extreme of the former precipitated by perceived threats to identity and the concept of right or wrong. In these extreme circumstances change becomes the enemy. But don't you think the roots of fundamentalism are a set of basic human needs that we all share?

NC: Yes, I think there's a desire to have home and tribe and an understanding of reality. But, then, there's the other impulse, the connection thing. On one hand, you can look back to tribal times; people would create these little pods and they would war with other pods that believed something different even if they were just over the hill. But on the other hand, that's just part of the history of people-kind. There is a dynamic tension and struggle between the two, and that's why I think we're at this brink.

I don't think we're there yet, but I have a periodic glimmer of a common world culture that doesn't necessitate my reality cancels your reality, with a kind of interested coexistence and enlightened self-interest in our acknowledged common ground. This is critical because the other impulse is genocide. That's the other place we go. We either keep trying to genocide each other—like what happened in Cambodia, in Germany—or we go somewhere else. It's the somewhere else that I feel is evolving from the phenomenal power of digital connection and common linking around the world. It's a thing that has never happened in the history of the world. There's this grid that connects everybody. People can truly be connected all over the world. We are barely understanding what that means in terms of human consciousness.

I think a lot about what role will artists play in this the realm. One of the people who has influenced my thinking is here in town, Steve Dietz, who used to be the new media curator at the Walker. He has been working all over the country and just did a big festival out in California. He's probably one of the most fluent people I

know in new media. When I look at the art scene, I see it becoming more and more traditionalist, even in our embrace of *avant garde* work. It's traditional. It's not new. It's traditional within these parameters of what *avant garde* work is supposed to be. But there is this whole new digital medium where there are a lot of artists who are not getting daylighted or mainstreamed. They don't have a whole lot of connection with other people. This is a phenomenal new terrain in the art community that is being ignored. People in the mainstream art community don't know what to do with it, since they look at it as foreign. There are people doing weird things to programs like Windows and Outlook; these weird events take place digitally, but don't take place anywhere else. For many the concepts driving this work are so foreign that it's easier for them to understand the Beijing opera or Hmong traditional culture or Somali folk singing or textiles, than it is to make the leap to this.

WC: It sounds like you're describing a new kind of artist, maybe even someone who doesn't self-identify as an artist. Can you give me an example?

NC: Yes. Well there are people that Steve has made me aware of. There are all of these artists who are doing incredible things: they're making pieces for wireless PDA's, for cell phones; they're making pieces that get laser projected on the sides of buildings downtown. So, they're kind of guerrilla. In this group of artists, their art is in information and in information systems. It's a realm of art and culture and activism that is very hard for traditional baby boomers like me to completely get my head around.

WC: The two words that come mind that characterize what you are describing are "self organizing" and "ubiquitous." It reminds me of the original miracle of radio which was, you tune in when you want, it's always there. But it also sounds like these artists' developmental path is very different. Instead of the linear journey—I go to school, I make art work, I get into a gallery, somebody buys it, I go back to my studio—it sounds like it's in a very different universe.

NC: It's all because the web is uncovering things that we didn't even know were there to uncover. I read an interesting article the other day about something called face blindness, which is when some people are unable to recognize other humans by their faces in spite of having good eyesight. It really wasn't recognized until people started finding each other on the web; a researcher was able to find people and work with them enough to understand what was going on. It was all because of the web.

WC: So you are saying that there is a hidden network of discovery and invention on the web that is just starting to show its influence around the world. Do you think traditional indicators for cultural shifts are relevant in this milieu?

NC: No. They're not going to show up at the Walker Art Center. It might show up at the Walker ten years after it happens. It's not going to show up at mainstream institutions. The normal arts infrastructure will have a really hard time capturing it.

WC: It sounds like a universe where there are fewer barriers operating between the art-making impulse and all the other kinds of impulses. So, the social-networking impulse and the art-making impulse and the commercial impulse or the social change impulse could all be....

NC: Could all be in one big mosh pit. You're absolutely right. People who are operating in these arenas may or may not identify themselves as artists. But, they are shaping, forming, and effecting culture, just like artists do.

WC: So, so you see any downside in this new emerging universe?

NC: There are not enough curators in it. (laughter)

WC: Do you think there is a role for a curator in this environment? (laughter)

NC: Actually, I don't think there are roles for curators. But I do think there is a need for something like these giant ugly readers on the web that are trying to cull the enormity of the web for you and bring it to your desktop. There's a huge call for people who are culling and editing and reshaping and forming. So there is a role there. But, I think this other stuff is even beyond the scope of that. It's beyond YouTube. It's beyond MySpace. A lot of this really occupies its own world. In that sense, it's like higher mathematics in that that you have to know a lot to understand what's going on here. It's not general public stuff often.

WC: Isn't it likely, though, that as people find a certain kind of richness or connectivity through the digital universe, they could potentially become digital-centric or web-centric as human beings, so that their physical world capacities atrophy and suffer. I don't mean this just in terms individual obsession as a social syndrome. Is that an issue you think about?

NC: Yes. I think you already see that because it's very seductive. It may sound corn ball, but it's about balance. I have nephews who have spent literally months of their lives playing World of Warcraft (WoW); it's a shared-use site where you explore this giant world, guilds get created, and you trade and buy. The communities online organize at certain times to make things happen. It's really interesting. In some tech environments, if you have a certain status in World War Craft, it is shorthand for letting employers know that you have a whole lot of skills. They know how to organize; they know how to work an ISP. But it's not the physical world. I think that's where this tipping point is coming in. We haven't figured it out. I mean, it's like with everything else that comes into our culture. Alcohol's not regulated, so we drink too much alcohol.

Tobacco isn't regulated, so we smoke too much. The digital stuff, we don't understand how to balance it, so we've got kids that spend 12 hours a day on these sites. To my mind, the question is, "How do we figure this out as a species?

WC: What do you think this means for the larger society?

NC: That's what I love about the artists that I run into from Steve. Like a lot of artists, they make you look at things. And they're making you look at things digitally. They're making you look at your PDA, making you look at sites on-line. They're making you look at these experiences. This is a role artists have always had, particularly in modernism. They are spurring self-consciousness. "Look at this and think about this." Going back to Duchamp's urinal, what is sculpture? "Look at it. Isn't this beautiful? I say it's beautiful." They're playing that role with digital culture, with this digital universe that's being created. The artist is saying, "Let's look at Microsoft, at Windows, at these interfaces." There's this one guy who made this perfect Windows site. It looked just like your Windows desktop, but these subtle shifts would occur. It would morph, so this very familiar template that millions of millions of people use daily would start to dissolve. You would be made aware of it all anew. It was a fascinating little thing that this artist did: "Look at this thing that you look at all the time, but look at it with fresh eyes."

WC: You could say it is provoking people into reflection in a very non-reflective age. It also seems to lean more toward populism than elitism. So, what happens to the concept of "audience" in this universe? How does that get shifted?

NC: Audience becomes the on-line community. I mean how do these people connect? How do you connect with other people who understand art and culture the way that you do? You're an oddity, but you've got connections with people all around the globe. Imagine figuring out a network like that 40 years ago.

WC: Yes, impossible.

NC: It couldn't self-actualize. That's one of the things. But then, correspondingly, people do need flesh time. I don't think it's going to be the end of actor and audience because I think that there's still something that's phenomenally profound and human about that. They want that with each other. They want that physical community because we're physical beings. But, we're also mental beings. We have this powerful head that can layer onto this whole other set of relations. There are people who are living deep in the woods on the north shore of Lake Superior or out on islands off the west coast and they're connected to the world.

WC: It also sounds like the traditional notion of artist is expanding; the resume and skill set for "artist" is changing dramatically. There are people out there who regard collage and layering and appropriation

as natural processes, like breathing, not art processes. There are people who will not have gone to art school, who will be doing art-like work, but for whom the word artist will be obsolete.

NC: Yes. I agree, absolutely.

WC: Among the artists that you interact with these days, do you see these changes in practice and consciousness manifesting?

NC: No. (laughter)

WC: Why do you think that's the case?

NC: Because, the art community here and most places, is a physical art community. It's based in buildings and performances and places people go. Everybody's doing e-mail and has their websites. But that world and this digital culture don't interact a whole lot at this point. We are finally getting Steve to do some of this stuff locally. I think it's hugely important for other artists to bump into it, because they don't have to. They can keep painting, they can keep writing. But I would love for them to bump into things other than other painters, other theater people, and the occasional movie. I think it's really, really important for other sectors of the creative community to begin to respond to it or to think about it or at least have some reaction to it.

WC: If we could go to a wide shot for a minute. As the world comes to grips with the external physical and political realities that are forcing a shift in worldview, what role do artists, old and new, have in meeting that challenge?

NC: I think the role that they've always had as provocateur, reflector as truth teller, as activist, as the canary in the cage.

WC: Do you think human creators, artists, have a specific role in the making of meaning for community, for society?

NC: Absolutely, yes.

WC: We both know many creators who are exploring, individually and with their communities, the big questions facing us. Questions like: What's our worldview? How is it destructive? How do we shift or change it to heal or save the planet? Do we need to? Then we see other people like environmentalists, politicians, sustainable development advocates and community activists who are basically asking the same questions and working toward answers, advocating and mobilizing. But those two worlds don't interact very much. So my question is: If stories need to get examined and changed and the people with the content and the conscious story-makers are not talking, what do we do about that?

NC: I think that's one of the big issues. I think there are more and more connections that are always being made. There's the incredible science and art lab at MIT and there are different kinds of crossovers that are happening more. The notion of creativity, I think, is becoming more broadly valued in other fields. That's important. I think in part, though, it's not just looking to the artists to be the

storytellers. It is like when you look at a lot of these new digital artists, who knows what they are. But they're telling new stories and, in a way, these are some of the people who are acting as translators for the new science. They're in the middle of all of that stuff. Part of what a lot of these people are mining is information—they are daylighting things. That's one of the new art forms—bringing this information to the public eye. Let's make it free. Let's make it known. That's one of the roles that this new group of cultural digital workers is fulfilling.

WC: Access as an art form. That's a really interesting idea. It's not just making or duplicating and passing on. It's sorting, synthesizing, interpreting, morphing and then disseminating, which is, of course, both a new, and, a very old role for artists.

So, at the most basic level at the McKnight Foundation, do the silos of the institution interact more now then they used to, because the world is perceived as more connected or integrated?

NC: I think we're trying to. I think that's one of the $99 questions that we're trying to answer. In part, that's what my new role here is going to be about. When you have specific programs areas that have specific goals and expertise, how do you make things that are synergistic and bigger come to fruition? That is one of the interesting things that we're going to be figuring out over the next few years. Is it a matter of finding another pot of money? Is it a matter of finding some flexibility? Is it a matter of re-forming our program areas? To me, there's an art form here that we have figured out in discrete ways, with our various programs, but as a whole organism, we're a spider with six or eight legs. We're connected to this joint body, but I don't know if we have a joint mind.

WC: The ubiquitous, self-organizing, digitally-enabled universe you've described is a very different creature from the one you work in. That model of interaction, exchange, and influence is almost antithetical to a more traditional, organizational structure. If that is an emerging model, how do you not throw the baby out with the bath water?

NC: I honestly don't know. Seriously, because all of our program areas are great. I think the way that our arts program has run for the last 15 years has been great. The way our river program has run for the last 15 years has been great. The interactions between those programs, I can count on one finger, other than collegial interactions, the formal things out in the world that we've worked on jointly. There's been more natural crossover with our children and families program. When I first started here, there were all these after-school programs that didn't get funds, because they had arts components. Now half of the after school projects have arts components and I don't even hear about it. So there is a natural thing that has happened there. There are probably a half a dozen things that

239

we fund through social service agencies that are placing activist artists in settings that they wouldn't understand or fund. That has just happened over the years, but it's challenging.

Chapter 18
Lynn Szwaja

"To think in new ways"

Lynn Szwaja is Program Director for Theology at the Henry Luce Foundation, where she is responsible for making grants to strengthen theological education and research. A primary focus is preparing religious leaders for effective ministry and participation in a religiously plural world. Other program interests include theology and the arts, and the relationships between North American and Asian theologies and faith communities. From 1977 until her appointment at Luce in 2004, Lynn was associated with the Rockefeller Foundation, serving as a research associate for the president and as a program officer in the arts, humanities and religion. She served twice as acting director of the Rockefeller Foundation's culture division, where she oversaw programs of support for humanities scholars, media and performing artists, museums, and religious and cultural institutions in Africa, Latin America, Southeast Asia, and the United States.

A graduate of Yale University, she is president and chair of the board of directors of The Feminist Press at the City University of New York and a trustee of the Connecticut Historical Society. She has served as a deacon and co-chair of the pastoral search committee at the First Congregational Church of Norwalk, Connecticut. She co-edited *Museum Frictions: Public Cultures/Global Transformations* with Tomas Ybarra-Frausto, Ivan Karp, and Corinne Kratz (Duke University Press 2006).

PS: First, how does what you do fit into the challenges that are before us as a people? And second, how might the arts contribute to this work?

LS: We are in a time of great divisions. I don't ascribe to the clash of civilizations theory at all, but I do think that there are huge divisions and religion plays a very big role in those divisions. I don't think that most of the conflicts are actually about religion, but I think that religion is sort of a marker or an excuse. The work I'm doing here [at the Henry Luce Foundation] builds on the work I did in the past at the Rockefeller Foundation. I think that we desperately need to understand other religions, engage with them, and respect them; not just tolerate, more than that. I believe that some of the most powerful work that can be done is religious or spiritual people working together on a common problem. Some organizations like Religions for Peace International help religious people, people of faith, translate their beliefs into a more public language. They don't say everybody's the same. It's not that everybody believes the same thing. But you can take a challenge, a question, for example, what do the Koran or the Torah or the Gospels say about widows or poor people or children or orphans? So, in my current job, I direct a program that is devoted to the preparation of the next generation of religious leaders. Traditionally, that's been Christian, but I'm now interested in engaging other faiths. Most of my grants are supporting or strengthening graduate theological education. I am pushing theological schools to take this understanding problem much more seriously. It perhaps is a small contribution to the huge problems that we face. But I think that students intending to be rabbis, priests, ministers, community organizers, or NGO staffers--wherever they're going to take their M.Div.—need to understand other religions and understand what it means to be a person of one faith in a world that is religiously plural. It is much more than an Introduction to World Religions 101. It's asking the institutions that train religious leaders to take religious pluralism seriously and figure out how we can work together and live together.

PS: Are you able to cross the liberal-evangelical or fundamental religion divides?

LS: That's a challenge. I'm trying to do that. Some of the more fundamentalist denominations are not interested in inter-faith understanding, per se. But, sometimes, actually, even when they're not thinking about inter-faith, they're doing a program in the arts and they find that there are either ecumenical or inter-faith components to the work. (The evangelical) Fuller Seminary in California has an inter-faith arts program. When they went around and looked at places of worship in Los Angeles and began to document the arts, they found that they were looking at many different

houses of worship. It is a challenge, but I'm experimenting with different models and I'm trying to be open. Sometimes, there are surprising success stories. One of the programs we support is Auburn Seminary; the Center for Multi-faith Education there offers courses for faculty and students at other theological schools. A couple of years ago, the Church of God Seminary in Cleveland, Tennessee, sent a group to New York City for the summer to learn about other religions. They had not ever encountered a Jewish person. I mean, it wasn't just that they were going to come to New York and learn about Muslims and Sikhs and Hindus. Rabbi Daniel Brenner, the director of the center, took them to his synagogue and they went to other places of worship. They were transformed. So it is a challenge, but it's possible to approach people; we are trying to work across the spectrum.

PS: If you are successful in training the next generation of religious leaders, what will the outcome of that be? What is it that you hope that they will do?

LS: I hope that they will be able to lead their congregations in a way that they will understand other religions. And that they will also be able to work with religious leaders of other faiths on community problems, such as the problems of homelessness or immigration. Again, I think a lot of clergy are finding that the poor people, the displaced people, the people that are in most need are coming from other places—they are refugees. They are coming from another part of the world; so, for example, in St. Louis, they are finding that there is a Muslim population, there are Afghani refugees, people from Bosnia and Somalia. I'm also hoping that it is going to influence their action working in their community, but also to be able to counteract prejudice–the blaming the other.

PS: Right. We do seem to see a lot of that, unfortunately. I think that is intensified because of the war in Iraq and the other issues of the Middle East. We in the West have difficulty understanding that part of the world.

LS: Definitely. For example, the Lutheran School of Theology in Chicago that has a new center on Christian/Muslim engagement for justice and peace.

PS: Are they focused on the local level?

LS: They are, yes. But the school trains people who go out and become Lutheran pastors in rural or other areas. Such a person is going to approach Islam in a very different way than the traditional pastor in a rural congregation.

PS: What are the challenges that we face besides this problem of lack of understanding of other groups, which results, of course, in all kinds of nasty behavior? What other major challenges do you feel the world faces?

LS: Environmental. I think this also connects to religion and spirituality.

PS: I've been interested in the discussion within the evangelical community about the environment, whether or not global warming really exists, and Christians' responsibility to creation.

LS: Yes. It's been very encouraging to see a number of evangelicals take common cause with people who are concerned about creation. The National Religious Partnership for the Environment [http://www.nrpe.org/] has done some good work.

PS: I don't know that group.

LS: Paul Gorman is the director; the office is in Amherst MA. He used to work at the Cathedral of St. John the Divine here in New York City. It's a partnership of religious groups. He's been very successful in reaching out to conservative Christians and evangelicals; they were behind the Endangered Species Act, because they saw that our duty is to protect creation and nurture it. I worry about what kind of world we're leaving to our children. I mean everything is connected. We can't really lecture developing countries about the way they are using up resources, because we're still the biggest consumer. But as China and India and other big poorer countries continue to develop, the environmental challenges are just getting worse and worse.

PS: You feel that the people of faith can press together to cope with this?

LS: I would hope so. Some groups are just focused on environmental questions. There are other faith coalitions that are engaged with development more generally; for example, supporting the millenium development goals. Again, I think that the issues are related.

PS: It's hard to do just one thing.

LS: Exactly. I do think that coalitions or groups that work together on a thing can be very effective. I like to be optimistic, although it is hard in these times.

PS: I think pastors working together in local communities can be quite effective. Many people feel that action at the local level is the way people can make an impact. That doesn't deal with the globe particularly, but it is a way people can make an impact.

LS: Yes. There's a program in Atlanta called Faith and the City and it was started by Andy Young and Jim Laney. They work with the seminaries and religious institutions in the Atlanta area. While it very much grew out of the Civil Rights Movement, it is an acknowledgement that times have changed. There are new issues to deal with and people of faith have to figure out how to address the issues that are facing metropolitan Atlanta. They didn't bill it as an inter-faith program, but it turned out to be. They're working with the Jewish community and Sikhs and Hindus and Muslims and others.

PS: You say it didn't start to be, but it turned out to be?

LS: It was a leadership institute done in conjunction with the three seminaries in the area. But when they started recruiting people, they put the word out that they were looking for a clergy person and a lay person from all area congregations; the outpouring was amazing.

PS: It started with the Christians, but others became involved?

LS: Right, but they are focused on local or regional issues. Each year they have a new cohort of folks who then go on from the Leadership Institute. They have bonds and they can work together in the future.

PS: I was talking to a lady in Cambridge, MA, last week and she was feeling that there is a huge amount of activity going on under the radar of the national media. Do you agree with that, or do you think that we still have just one foot in the pond, in terms of the changes that I think I hear you saying that are coming?

LS: I think that's right. If you hunt you can find information. But I think the average person does not hear about problems or issues, especially those dealing with customs of faith. There are groups that are trying to improve that, but a lot of the reporting is not very accurate and it doesn't give a good picture. Just the way that positive stories don't often get told. Over 800 world religious leaders met in Kyoto, Japan, in August, 2006. They signed a statement (the Kyoto Declaration on Confronting Violence and Advancing Shared Security) condemning suicide bombings and violence in the name of religion (http://www.wcrp.org/news/statements/Kyoto-Declaration). It didn't get reported in the media.

PS: I didn't hear about it

LS: No. But, the Pope's speech got blown out of proportion.

PS: How do you see the challenges that we face developing in the next decade?

LS: It is hard to be optimistic given the war in Iraq. I'm not sure I agree with David Korten that we're at the edge of a completely big change, but it does sometimes feel that way because of the serious challenges that we face and the violence.

PS: I'm not sure that I agree with him either that we're in such a crisis that something's got to happen and pretty fast. That could be or maybe not. Maybe we're just in a muddle.

LS: Yes, exactly. I just worry that we will continue to pour lives into these useless conflicts. That's where, I think, both the arts and religion can play a role because they both can offer hope and a way of thinking about things in a different way, telling stories in a different way.

PS: Both are keepers of the stories?

LS: I think we need our people of faith and we need our artists to re-
mind us of why it's important to go on and to struggle against in-
justice and to make a better future for the planet and our children.

PS: Why are the arts particularly capable of doing that in your view?

LS: I guess because they provide imagination. They allow you to get
outside of yourself and see the other, to see people in a different
light. And they can take very traditional stories from the culture,
but they can retell them. That's the power, I think, of art and also
religion. That's why, in many cultures, it's sort of hard to separate
the two. When I was working in Cambodia, we were supporting
the revival of the traditional dance. Some of the health officers at
Rockefeller said: "Dance, what does that do for those poor people
in Cambodia?" I was out on the Tonle Sap with a guide one day
(he was doing this to put himself through college) and he recounted
this harrowing story of watching the Khmer Rouge kill his father.
We all know about the killing fields, but I had never had a one-on-
one conversation with someone just telling me his personal story. I
was just feeling, "Ooh, this is so horrible and what I'm doing here
in Cambodia is so pointless. It's not helping him." He didn't know
where I worked or what I was doing and he turned to me after the
story and he said, "Do you know anything about the Cambodian
dance?" I said, "Are you an artist?" He said, "No, no but everybody
in Cambodia loves the arts. The dance is what tells us our myths,
our stories of creation, our Gods. They keep us going; that is why
we can go on, because of the dance. The dance is the spirit of Cam-
bodia." That story illustrates the point I am making.

PS: Certainly the creative energies of lots of people, religious people
and artistic people, need to be engaged. What are the processes by
which that engagement can be made manifest or most effective?
How can we make sure that artists and people of religion are not
spinning their wheels, but are actually engaged in a way that's going
to be helpful?

LS: I think, although more and more people understand that there is a
need to learn about religion, or take it seriously, that there still is
a tendency to dismiss it or be worried that somebody is trying to
erase the division between church and state. There is some hostil-
ity to religion and I understand where it's coming from.

PS: You mean, given the tinkering in politics that's been going on?

LS: Yes, exactly. I do understand those concerns, but I would hope
that we could work to have more respect for and acknowledgement
of the importance of values questions. I also think a lot of artists
are very socially committed and are able to affect that understand-
ing. The work that American Composers Forum did in Continental
Harmony and their program in the congregations, Faith Partners,
are great examples, I think, of artists helping to engage people and
get the communities to work together.

PS: It's true that community artists are doing this kind of thing; but some still see a disparity between the "real" arts, the high arts, and community arts. Maybe that perception of a disparity also exists in churches: between what happens in the sanctuary and what happens in the outreach programs of the church. Maybe some congregants perceive that both are not equally "religion."

What should artists and religious people be doing that they're not to bring about social betterment? Or are they just pretty much the "good guys"?

LS: In my experience, artists are very engaged, but the support systems have withered; that, to me, is a tragedy. The federal support has wavered and a number of the big foundations that supported the arts have stopped funding nationally.

PS: Why do you think that is? I understand the federal decline because of past controversy. I don't understand the loss of support of the foundations.

LS: I don't either and I can't really speculate. I think there is a tendency to think that culture is not as important as other problems; I don't happen to agree. The community arts folks are much more used to working for change on very little money. But I wish that we could find ways to get those two communities to work together in partnership. Because the more alliances we build, the more progressive the outreach there is to other problems. I have been really shocked at the apathy, that people haven't been outraged at the things that are going on.

PS: When we spoke on the phone, I mentioned Robert Wuthnow's book, *All in Synch.* What is really impressive about the book is his documentation of the role of the arts as a medium spiritual growth. The data he collected were powerful. So, in your work do you see that the churches are using the arts as a mechanism of spiritual growth, as a way to engage people with the questions of faith?

LS: Yes, I see that both in the programs I support and in my own church. We're sort of an unusual congregation—an old Congregational church with a very diverse membership. We have a gospel choir which has attracted people to worship who probably wouldn't have come before. That's a very personal example; but I have seen programs where people from the community get together with seminary students and artists. An arts program at Chicago Theological Seminary produced a play about the religious issues associated with AIDS, for example. So sometimes the arts are able to raise difficult topics.

PS: I think that's true. People can consider difficult topics or conflicts, perhaps, less threateningly in an artistic way, than sitting being lectured at.

LS: Yes, that's what I think.

PS: Does The Luce Foundation actually work with religion and arts specifically?

LS: Yes, we've had an interest in the intersections between those two fields. Some years ago, Ellen Holtzman, the officer who heads the American art program was disturbed by the culture wars and the fact that the religious right was de-funding the NEA. And so the theology program and the art program did a series of meetings to see if there were ways that we could encourage more dialogue. While we don't have a joint program anymore, the theology program has continued to care about the intersection between theology and the arts. My major emphasis is on interfaith understanding, but when there are innovative programs involving the arts, I'm also very happy to support them. And some of those programs can be powerful interfaith programs.

PS: With the difficult question of mutual understanding, the arts can maybe clear away the resistance people might have?

LS: There's a program at the Ackland Museum at the University of North Carolina, called Five Faiths. The museum happens to have a collection that is representative of Christianity, Islam, Judaism, Hinduism, and Buddhism, so they have used these materials in their public programs and educational efforts. I think the arts can be a very powerful medium of interfaith understanding.

PS: Do publically-funded arts organizations get in trouble with the church-and-state issue if they approach the questions of faith too directly?

LS: Well, yes. I'm sure that is an issue. The Ackland was actually responding to the North Carolina legislature's mandate that religion be taught. I don't think that some of the legislators had any idea that they would be teaching anything other than the Ten Commandments. But that is an issue that comes up with public institutions.

PS: Do you work globally or is it mainly American seminaries?

LS: It's mainly with American seminaries. But we also work a little bit in Asia. That was a traditional interest of the family. Henry Luce was born in China.

PS: Right. I remember reading about that.

LS: So a number of the programs in North America relate to Asia or are on Asian theology or Asian-American issues. But we also have some work in Southeast Asia.

PS: I've been interested in how much interest there is in Buddhism in the United States. I know the Dalai Lama says that people should come to whatever understanding they have through their own tradition, but clearly for many people moving into some form — Zen or Tibetan or some other form — of Buddhism seems to have an appeal. Does your interfaith dialogue include Buddhists?

LS: Yes, it does.

PS: Certainly the issues of Islam and Christianity are the most compelling ones.

LS: But many of the professors of inter-religious theology—they might be a Jesuit who also studied Buddhism or Hinduism—many of the people who do interfaith work have an interest in Buddhism. The Asia program here also supports scholarly work about Asia; for example, they supported the Tibetan Studies program at Columbia and other universities, so there has been a traditional interest in Buddhism.

PS: The Buddhists in this country, while their communities are small, seem to be very much interested in talking to other faiths. Is the same true of the Hindu community?

LS: I don't think as much. As you said, the Buddhist community contains many converts, Westerners. Whereas the Hindu communities are immigrants. And there are not the same ways of training religious leadership. The priests don't go to seminary and get an M.Div., so it's a very different process.

I think that a number of interfaith councils in cities or in regions have grown over the years. And I know Buddhists and Hindus are very active in those, because they want to work together on things like peace, but they also see it in their interest to participate with civic and other leaders. The more other people understand their issues, the easier it will be.

PS: After 9/11 there was a certain amount of violence and other actions against American Muslims; there were also attacks on synagogues. Is that still happening or has that quieted down some?

LS: I think there have been some unfortunate incidents. And actually a lot of Sikhs have been attacked. People don't understand that they are not Muslims. Another example is the criticism of the new Congressman from Minnesota, questioning his swearing his oath of office on the Koran.

PS: Did you hear how he got around that? I was told by a friend of mine that the Smithsonian Institution lent him Thomas Jefferson's *Koran* to swear his oath on. I was told that the Smithsonian staffer actually brought it to him in a locked case like you would a diplomatic document for the ceremony and then he swore his oath on it.

LS: The people I'm supporting will hopefully be able to counteract those kinds of acts in the future. You know, there were those terrible stories after September 11th, but there were also some very hopeful ones. The Pluralism Project that Diana Eck directs at Harvard has a website [http://www.pluralism.org/index.php] that documents both the instances of religious bigotry and hate, but also documents positive stories. For example, in the days after September 11th a mob was beginning to gather and to threaten outside a mosque in Cincinnati. And the clergy from the Christian churches in the area all just called their congregations and they made a ring

around the mosque. There are powerful stories like that. And it's my hope that people who go through one of these programs to learn how to relate to people will be much more inspired to counteract that kind of result.

PS: Well, the churches in the Civil Rights Movement and other movements have always been in the forefront of these things. And so I assume it won't change. It will continue to be important.

LS: But we do have to guard against the very exclusive and fundamentalist tendencies. There was that prayer service in Yankee Stadium a couple days after 9/11 and the Lutheran minister who participated in a prayer service with an Iman and a Rabbi and a Catholic priest was censored. Even just praying with people of other faiths got him in trouble. So we do have to work on these things.

PS: What else would you like to tell me about what you think the arts and people of faith ought to be doing in the next few years?

LS: Well, often the programs in seminaries that do deal with art do it in a celebratory or aesthetic rather than transformative manner.

PS: How to make the worship service pretty?

LS: Which is important; we all want to be able to enjoy the choir, the stained glass, so I'm not denigrating that. But I hope that programs would also think about how the arts can transform consciousness, challenge things that are wrong, tell a new story, and galvanize people to think in new ways. That is what the arts are capable of doing. Since that is also what religious people are called to do, I think it would be even more powerful if people can see that connection. Art can also be very ordinary and not very good and it can dull consciousness. You know those terrible Swept Away books and Mel Gibson movies can dull or impede consciousness. And so I'd like to see programs that engage the arts and engage all those wonderful community-based artists that you and I have worked with in asking difficult questions.

PS: I wrote a paper with a friend of mine about the parallels between community arts and the community sustainability movements. We pointed out that while they really are based in very similar sets of beliefs and values, they haven't really merged or cooperated all that much. But I would assert, perhaps, that the same thing is true of peace and justice movements within churches. Those three things together would be pretty powerful.

LS: Yes, I agree.

References

World conference on Religion and Peace http://www.wcrp.org/
Fuller Seminary http://www.fuller.edu/; Brehm Center http://www.brehm-center.org/
Auburn Center for Multifaith Education http://www.auburnsem.org/multifaith/about.asp?nsectionid=4&pageid=1
Lutheran School of Theology in Chicago http://www.lstc.edu/; Center for Christianity-Muslim Understanding http://www.lstc.edu/centers.html
Faith and the City http://www.faithandthecity.org/
Asian Cultural Council http://www.asianculturalcouncil.org/
American Composers Forum http://www.composersforum.org/index.cfm; Faith Partners http://www.composersforum.org/programs_detail.cfm?oid=1796§ion=community
Chicago Theological Seminary Arts Program http://www.ctschicago.edu/
Ackland Museum Five Faiths Program http://www.ackland.org/fivefaiths/

Chapter 19
Krystal Prime Banfield

"Find the Shaman"

Dr. Krystal Prime Banfield is Director of Berklee City Music-Boston, Berklee College of Music's division of preparatory schools. As a concert singer she is recorded on the INNOVA label and was an adjunct professor in voice and music education in the Graduate Music Education program, University of St. Thomas, Minneapolis. As an administrator, Banfield was Director of Education and Community Partnerships for VocalEssence, Minneapolis. For eight-years, she was Director of Education for the American Composers Forum, working with education and community-building initiatives, including: *BandQuest®* (distributed by Hal Leonard) concert band works, CDROM curricula and online resources; *Composers Suitcase®*, an elementary arts-infused program; and *FaithPartners,* music commissioning for churches and synagogues. Dr. Banfield assisted in producing concert education projects at Indiana University-Bloomington, working with the African-American Arts Institute and the Latin American Music Center, and the Charlin Jazz Society in collaboration with the Kennedy Center for the Performing Arts and the Washington Performing Arts Society. She holds a Bachelor of Music Education, Howard University, Washington, DC; a Masters of Music, Indiana University-Bloomington; and a Doctorate in Education, University of St. Thomas—Minneapolis. She serves on the boards of Learning Through Music Consulting Group and the Boston Children's Chorus.

PS: Do you think our culture will see dramatic change in the next few years?

KPB: I think about that almost constantly. I think about it as being an up-close change that can shift radically here and there, as related to the big picture, in that all of these things were meant to be happening anyway. If you observe how we have evolved as a society over a period of centuries, then the whole trajectory of recent change—how we are communicating with one another and learning from one another or not—is "part and parcel" of the larger trend of how we are moving along.

PS: Are you suggesting that a lot of small changes will add up to something big or is that not what you meant?

KPB: Yes. A lot of the small changes that are seemingly jarring in our lives do add up to something big.

PS: These might be transformative?

KPB: Yes, exactly.

PS: What kind of changes do you foresee to be happening now?

KPB: Two of the many elements are the effects of technology, as related to access to information, and the consumer mentality of immediate gratification compounded by the influences of commercial media. These are my observations, of course. However, these elements have shaped our USA society in so many ways in recent years. For example with technological innovations, we communicate more, but it's not physical—in the manner of expressive body language and touch. We are overwhelmed with information. Various parts of society differ in this; some of us are overwhelmed with information, while others do not fully have access to it and choose to subscribe to commercially prepared "sound bites." Many of us may not have developed the capacity to really process all that information. But somehow we all still have to respond to this change. In all that information, certainly, exists our collective cultures—ethnic and class socialization and the ways in which people live and communicate daily. Older generations are reticent about the idea of the easy flow/access of information for a variety of reasons; but to make a case in response to your question, they are reticent because they are sensitive to the fact that many youth assume any and all information, including commercial media (for example: Reuters), is somehow correct or they don't think it's necessary to gain any deeper understanding of anything, because information is there for them at anytime. Or, in the case of communicating through the physical, the face-to-face, our modes of complex interaction have seemingly atrophied. In some circumstances people are confrontational or mistrusting as a result. How does this affect us? When considering the impact on our young people, the expression of most youth culture through music is one-dimensional; e.g., where are their love

ballads?

I listen to and talk with our high school and college students, to high school teachers, college professors, counselors, youth community leaders and parents. Generally speaking I've learned that many youth and young adults take the accessibility to information and regular introductions of new technology in stride—it's what they know, more than their parents and previous generations. Youth take their access to information and the immediacy of it all for granted or as being a common occurrence. This creates a tension of values, assumptions and mores between generations. Although similar to their parents, they have their own youth language, when it comes to communicating in-person. Even though their world is so totally push button, unlike their parents, they've learned to accept and achieve communal experiences, which lessen the social boundaries that were at one time defined strictly by local community, religious or familial relationships. Their parents' generations struggle in trying to maintain social boundaries that have or are dissolving. While youth are seemingly more fluid in their definitions of relationships, many lack a depth in understanding or simply don't care to understand what's going on with their "neighbor," so to speak. This mode allows them to remain on the surface, feeling as if they are both connected and somehow disassociated from everything, while at the same time, feeling as if they can take-in everything, maintaining a comfort-level of being "right in the moment." These are generalizations of course.

PS: Are you suggesting that the young people you work with are pretty present-oriented? If so, one of the implications might be that they are pretty comfortable and are maybe not doing the big major course changes.

KPB: Not all young people, but many are. Where that might lead us, I don't know. But at some point, they'll take ownership of the societal mechanisms and systems that are in place just to continue to keep them going. In other words, they'll have to "follow course" to survive. Considering where I am now situated in an urban setting, barring more chaos (economic, environmental, basic infrastructure, religious/cultural clashes), I'm hopeful that they'll become better at communicating and will realize that, while some of the boundaries of understanding that once existed may not be appropriate for them, others are as necessary as they are practical—i.e., respect for relationships, marriage/unions, the regular practice of spirituality, caring for one another, caring for community, etc. Everyone will somehow be pushed in various ways to survive, making the most of what was left for them to deal with.

PS: There are contending worldviews, if that is what I hear you saying, in the case of technology. Do you think that those boundaries will lessen or that there will be conflict?

KPB: There will always be conflict. There will probably even be a greater divide among the classes, if the educational and economic inequalities continue.

PS: So you see the inequality that our culture is facing as a place of division? And also access to technology and acceptance of considering one's neighbor. Are there other challenges that you feel that we are facing besides worldviews and inequality?

KPB: Sure. Certainly one part of this is the segment of the population where families have not been educated in the basics of raising children. In these families there are the issues of malnutrition among children and the limitations that accompany that—cognitive abilities, good health and things of that nature. With the exception of recent immigrant arrivals to the States, great numbers of extended families no longer exist where the traditions and values of rearing children and shared responsibility were passed on through the generations. Everybody looks at 9/11 as a kind of turning point. It certainly has awakened people. But I have great hope. Young people will respond, today and tomorrow, with a more conscious idea of cause and effect and the importance of the need to be responsible to one another through universal love. I have hope. As an educator, my colleagues and I are working with youth to be alert to their circumstances and come to their own possibilities and responsibilities for how they will continue. They will also have examples of how to live and communicate from many new emigrant and immigrant families and individuals. In short, all that I just tried to say is that life is messy—change, conflict, living day-to-day are all messy endeavors.

PS: Does this include the recognition that if other people disagree with you, there are other things to do rather than squash them down?

KPB: One would hope.

PS: Are you optimistic about that?

KPB: I'm always optimistic. We're always going to have bullies or people who are addicted to aggression, power, or who feel empowered to condemn or be over another person, to be an oppressor. It's part of the human make-up; we're basically animals that have thoughts, a sense of self/purpose. I think those elements will always be a challenge and will always exist. However, we also have elements within us to allow reasoning and caring.

PS: But it's more or less possible to create structures which minimize or maximize those things. Some kinds of structures maximize oppression, others minimize it.

KPB: Yes, quality of life; and change in values; this would certainly include the basics of food and shelter and some kind of unconditional love or reciprocated relationship.

PS: Do you have an idea of how we should be dealing with these challenges, with inequality, with scarcity, with conflict?

KPB: Yes, as a music/arts educator, I always think in terms of giving people the tools of possibility, informing/transforming young people, so that they feel that they have alternative means, not only for creating something to be shared, but also for creating a world-view for themselves, so that no matter where it is that they're existing or whatever they're walking in, they have a way to create or see themselves in a positive manner. That they can create a quality life, and that it does not necessarily require much other than the basics—that they can find themselves and have alternatives to living. This also extends into spirituality as well.

PS: I hear you saying engaging the creative possibilities of individuals might be the way to deal with the challenges ahead. What would it take to make that happen?

KPB: Working with each other one person at a time. I liken it to doing missionary work. One of my great teachers, a philosopher once said, "Don't be concerned with everybody, just the people in your community. That's it. Don't feel as if you have to change the world in a large way but in a manner that you can encompass and change will happen." In this way you are effecting change. It does really go like this—one individual is somehow connected to other individuals.

PS: I agree that the local level is where people need to focus their attention. That's an idea that I've heard many people saying. The big picture is so far away, but here is where we are.

KPB: But, keeping in mind that the big still affects us, no matter what. That's how I feel. No matter what it is that we do on the local level and in our small communities, the larger world does affect us everywhere, just as we affect the larger world.

PS: So it is fair to say that if we're going to deal with these issues that we have talked about, the creative energies of many people will need to be engaged. Through that process, I heard you say it will be possible for kids, at least, to get a sense of self so that they are empowered as individuals.

KPB: Yes.

PS: That brings us to the arts and the place of the arts and culture in this task. Are there some specific ways that you think cultural resources could be of particular value or relevance to the task of creative development?

KPB: Sure. We need to get kids into deeper forms or higher levels of thinking where they can look at something and discover how it was created, but then use that information as a springboard into what they may want to find in themselves. By creating something and using imagination, thoughts and perspective can change. Some connectedness is what we need as humans—to be empathetic, respectful of one another, to find meaning in things and to enjoy life and in that way to have a sense of purpose.

PS: That seems to bring us to the educational system. Some would say that it's not functioning very well.

KPB: Not in the large sense, no. But there has been a response, of course. You have all these little schools popping up everywhere—parents doing home schooling or all the charter schools. They have something here in Boston called pilot schools, where they have individualized programs that exist inside of the school system to try to cope with the structure that exists, the huge bureaucracy and so forth. There is a fight between creating what society views as contributing to making an economic happy home and what contributes to developing an individual. The latter is critical, so that people can have peace within themselves, have a sense of curiosity, and look for a balance within their communities and businesses in working relationships and things.

PS: You are clearly optimistic. Are you saying, in other words, that there are enough little things going on that can be transformative?

KPB: I don't think what is happening is enough. In some circumstances, it's too much where kids are overly-stimulated and both the parents and the kids are so driven that the kids are burning out. The other side, of course, is where you have children who are almost independent and are in desperate need of attention and love, in order to be able to find themselves. They are falling further and further behind their peers in their development, the developmental stages.

PS: What are the unique qualities and capabilities of that arts-based approach to life or learning which could result in good developmental results? What would be the outcome of such a developmental approach?

KPB: There would be a place where children can use their imaginations, a place where everybody can find themselves, where they can express themselves and be problem-solvers. Certainly the end result is that there would be a way that we can live together and enjoy living together, having respect for space and all those kinds of things.

PS: Would you argue that the arts are the way to do this, a major way to do this, or one of many ways that this might happen?

KPB: Yes, I think it's a major way. The visual and performing arts are another mode of human communication. I think that moving through the elements of art, you can see and engage the imagination and discovery; every arts discipline lends itself to this. In the arts, you learn how to express something through another language, like music, for example, or visual kinds of expression. These give people tools to use and ways to synthesize information which transcend the original and that are applicable when delving into other areas and other disciplines. The idea of creativity transcends all, I think. Certainly we have music which is a form of communication that's very specific.

PS: In that case, I think it would be fair to say that we would need to expand our arts education delivery system.

KPB: Yes, absolutely. It has to also be one that is more inclusive and reflective of our always existing multi-ethnic and multi-national society.

PS: How would you go about doing that?

KPB: It would be great to see more arts-centered programs like what the Perpich Center for Arts Education in Minnesota, the arts high school, (www.pcae.k12.mn.us) is doing. It's not a conservatory model, per se, although if a child wants to pursue that they can. But, it's one which fosters the spirit of discovery and creativity no matter where you are, by trying to find connections through the senses. In other words, they use all modes of expression—oral, visual, touch—for the making of connections, across all of the disciplines. It's a different approach, I think, and probably not one that everybody's comfortable with. But I think that everybody can find themselves in it. And certainly it is one that's more inclusive in the way in which people take time to think and allow space for discussion and thought and tinkering.

PS: Do I hear you say that arts-based education allows more experimentation?

KPB: Yes. I think it allows or at least is receptive to it. Some schools may be more rigid and some are too free, lacking enough discipline. But in general I think that it provides an opportunity for respect for others.

PS: And probably more so than in sports?

KPB: I think so. Having participated sports myself, I think that may be true to a degree. There is certainly some element of experimentation and creativity in sports, but not everybody can find themselves in that way.

PS: My impression is that the sports system is selective of the kids who are super physically.

KPB: Yes, if you're going back to the way the school system and education is structured now. Yes, it is. It's not as inclusive as the arts probably.

PS: That implies that artists need to be taught to be teaching artists. How does that work? What needs to happen in the way we train artists, in the way in which artists or arts organizations work? What should they be doing to make this happen?

KPB: Well, what I'm finding is that those artists who desire to do teaching have a real passion for what they do as artists, but also they get something from being able to share and watch others respond to the art form. I don't know that the personalities of all artists are conducive to doing that kind of work.

But, the way young scholars here (at Berklee School of Music) and at NEC (New England Conservatory) are being trained is through the idea that you empower the young artists to find themselves in other ways than through their art. For example, let's just start with a performer, a professional performer. Getting into the music industry and getting a contract that will support you—a record deal or something—just really doesn't exist any more. Large corporate-level industry is more interested in making money than developing artists to create what responds to audiences. So, big record industry artist contracts are rare. Also the dissemination of the recorded materials doesn't happen in the manner it used to, because people can purchase data files on-line. Artists can distribute and sell their own materials on-line. And, for performers interested in the orchestral institutions, positions are few and far between.

PS: There are a lot of gray hairs in those positions.

KPB Yes (smiling). Then you have places like Chamber Music America. They have encouraged all kinds of chamber groups to be creative in what they are doing. Part of that includes also teaching. So, these artists are finding themselves trying to do that. The idea is to try to catch them before they leave the academy, before they get out of college, while they're still in training, to consider multiple ways—not only by being a teaching artist—of how your art is contributing to society. How do you find yourself as a leader, not only as an artist, but also as the Shaman, the Griot? How do you suddenly realize that you have this great responsibility as a cultural bearer, a historian, a healer? So, the high schools and colleges are starting to respond. For example, a new program being developed here at Berklee is in response to that vision.

PS: And what is that exactly?

KPB: A cross-disciplinary program called Africana Studies, which includes all the music of the Diaspora. The music here is primarily jazz and rock, so the focus is to broaden understanding through a cross-disciplinary approach with an historic perspective. The idea is that you are empowering the kids to be able not only to look at the past, but to understand the way they are functioning in the present, representing continuity with that past and with others in the present day and into the future. This means they have to be accountable to what it is that they're doing as artists. That's a big responsibility. It is not enough today to just go into your room and just play and gig, gig, gig, gig, gig. Certainly, you can do that, but there is more that can happen here. And if you're going to survive as an artist, then you have to be creative out there. And these are the multiple ways that you can find yourself and be fulfilled and how others can be fulfilled by you. So, I think that there are training programs that are coming up that are focusing on helping young artists find those multiple ways.

PS: The notion is of the artist as a Shaman who stands for the community. Would you talk a little bit more about that?

KPB: That they're informed, that they feel that they are leaders, that they are looking to do a little bit more than just performing, that they have a responsibility. I think this is true of the teachers also. Many are starting to find themselves and wanting to look at ways to do something in the area of education. When they begin to dig and explore, they realize "Wow, this is a whole other world. I can surely find myself in it and can really contribute and really give back. How do I get started, what do I do?" So, I think that the Shaman is somebody who is looking to be a good communicator, a healer who helps those listening find ways to express some of the harsh realities of life—like the blues—or be uplifted and united, like the music of the U.S. Labor and Civil Rights Movements. It would be that s/he would be looking at ways to better communicate and to address the needs of the many others who want to identify with him.

PS: If an individual's creativity is developed and that person is taught that they have some responsibility to use that, not only for their own gratification, but the larger community, this would be transformative.

KPB: Yes, exactly, over the long term.

PS: One kid at a time?

KPB: One kid at a time, over the long term. But there are multiple chances. We need "multiple hits," like you get on a website. With "multiple hits," a market analyst eventually discovers the website is popular. We have to keep trying to infuse ways in different places everywhere, i.e., "it takes a village to raise children." I think about the trajectory of the Witness community program I worked with in Minneapolis at Vocal Essence (www.vocalessence.org/witness), watching the schools that have been involved over a period of time, the kids who have been contributing, and the teachers who have been involved. Maybe they have another sense of purpose where music, the culture, and education are concerned. That is, of course, reinforced with having a teaching artist come in to work with the kids.

PS: In the past, art schools just tried to make kids into performers. But you think that this is changing?

KPB: Yes. There is a real shift but it is hard because there's been such a traditional way of doing things and it's a business; education is a socio-political-economic industry. The various educational disciplines and socio-cultural education should not be disconnected. While music is the center, all the elements are necessary to put it in context. The thinking is moving towards that. In many schools the various disciplines are rather like silos. The institution I'm in is one example. They haven't had a tradition of "talking" across disciplines to one another, even though the focus is music. Now, the

atmosphere is shifting, and so everybody's trying to find out ways to better communicate here.

PS: Why is it happening here? What is the vision for this school and for the role of the arts in society?

KPB: Actually, I can give you the vision, from the statement that goes on the back of all of our cards.

"Vision for 2015: Berkelee will be the world's leading institute of contemporary music, attracting diverse and talented students passionate about careers in music. We will also offer a relevant and distinctive curriculum in music and liberal arts. We will engage an unparalleled faculty of inspiring educators and cutting-edge industry professionals, provide state of the art facilities for learning and living and produce tomorrow's leaders of the global music community."

PS: So, assuming all that happens and Berkelee graduates are leaders of the global music community, what are the implications of that for the globe?

KPB: (Laughter) The artists take over the planet and there would be music happening everywhere! Seriously, I hope that people will find themselves as responsible individuals in their communities, sharing information through the "meeting ground" of music. This initiative extends internationally. Berkelee really does have a lot of international students, from Japan in particular. In general, our idea is that we empower students to become leaders and to stimulate, connect with and energize their communities through music.

PS: So, the implication is that kids who come to this program are not necessarily going to be professional musicians, but would become better human beings, which would translate into their communities.

KPB: Exactly. I would say both.

PS: Are there any other reflections you want to share with me about social change in general or about the place of the arts in it?

KPB: I think that people really value the arts, especially music. Kids like music because they feel they can "tool" with it more on average due to technology advances. They can feel a sense of being creative without even knowing what it is that they're actually doing, as related to truly understanding the how the elements of music work. I think that this ongoing practice will continue to generate a space where people can communicate and find themselves. Music is part of the human language—it will always happen. On a more formal level, exploration and education will continue to happen on both the national and international levels so that people communicate through music and the arts, and, in the process, both find themselves and respect one another.

An example would be the Theater of the Oppressed, established by Augusto Boal. These are approaches to theater with which people are learning how to communicate, through theater exercises, simulation, improvisation and movement. It's an approach to using the arts to help people communicate, transcend and to feel themselves on the "other side," to have a sense of empathy, and to begin to see shades of meaning, and to have an understanding of the causes and effects of how the choices we make affects the lives of others. I was taught some of the concepts, movements and gestures practiced within the Theater of the Oppressed while in my graduate studies, not in music, but in my education courses. It was effective in helping my class to understand the act of oppression, as the exercises left many feeling very uncomfortable. I think exercises like this start conversations about uncomfortable issues and help to begin to motivate those on the outside of circumstances to begin to acknowledge and respect people. It is not the quick-fix solution, but place where change can begin.

Chapter 20
Linda Whittington

"Say yes to the universe"

Linda Whittington is a member of the Mississippi State Legislature and Executive Director of Communities in Schools of Greenwood-Laflore. Since assuming that position in 2001, Whittington has re-focused CIS from after-school tutorial programs into developing arts/humanities strategies to impact and engage area youth. She has expanded the program from just serving youth in Leflore County to serving youth throughout the state of Mississippi. She was elected to the State Assembly in 2007. From 1995 – 2000, Whittington was Executive Director of the South Arkansas Arts Center, El Dorado, AR. While there, she expanded arts-in-education programs from 1 school district to 5 school districts and changed the emphasis of the center from local to regional. Whittington served as Education Director of Imagination Celebration Fort Worth, Inc. from 1991 to 1995. That program, affiliated with the Kennedy Center, was a co-curricular arts and education program responsible for scheduling, coordinating and funding over 53 artists and/or arts groups into schools in Fort Worth and surrounding communities. This program reached approximately 90,000 students annually. Whittington is the 2004 recipient of the Mississippi Humanities Council's Special Recognition Award for leadership in developing cultural plans for towns in the Delta.

WC: Could you begin by talking about your background a bit?

LW: The reason I sit here now doing what I do is because I come out of ensemble theater. The whole premise in ensemble theater is that you are part of an interdependent circle. The circle represents that we are all equal because if the technician does not show up to turn on the lights, then the actor's not seen. If you don't sweep out the garbage, the audience doesn't come in. I was a member of that troupe for right at 20 years. That experience allowed me to hone my intuition, to be able to read an audience, and also not feel threatened by partnerships or true intimacy with people.

WC: Talk a bit about Communities in Schools and your path to the Legislature.

LW: I came to the Delta seven years ago. I was here a year before I found a job, a position that I thought would be meaningful to me. Luckily I began to volunteer with Communities in Schools of Greenwood-Leflore. After several months the directorship became available and I was hired. At that time, Communities in Schools was doing a lot of tutoring in the community. Many other community organizations were also providing after-school tutoring. I am not a great supporter of after-school tutoring. I believe in Howard Gardner's theory of multiple intelligences, which says that we all learn differently. Some learn by listening, some by seeing, but some learn best kinesthetically. Therefore, if you take a kid who has been unsuccessful in school for six hours and you set him down for two more hours' after-school and you try to teach him in the same way he's not going to succeed. That's torture for him. Communities in Schools in other locations deal a lot in the social service realm. Well, that was really covered in Greenwood. What were not happening any place were the arts. Because of who I am, where I come from, and what I believe in, I immediately said, "Let's begin to move in that direction." At that point, I crossed paths with Jessie Ross, who ran the local juvenile detention center and he said, "Hey, there's this grant that the Mississippi Arts Commission is giving out that puts arts in detention centers. Do you think you'd be interested in that?" I said, "Yeah." So, we got in the car and went to Greenville to see the situation at the detention Center.

It was horrific. They had kids with chains on their hands, tied down to their feet. They were in orange jumpsuits. I was horrified. It was the first time I'd ever been in a place like that. It was so impersonal and so hard that I can't imagine a rehabilitated soul coming out of place like that. So, I said, "Sure, I'll write the grant for you with the detention center as the applicant." But when the deadline came and I needed signatures, Jessie wouldn't sign. I called the Arts Commission said, "I'm sorry. I can't make this deadline because our fiscal agent just bowed out. At which point, they cut me some

slack and said, "Why don't you just become the fiscal agent?" I said, "Okay."

WC: That little detention center program has grown to become a statewide arts-based youth development program. And now you have stepped onto the political stage. How did that happen?

LW: Sometimes you just have to say yes to the universe and that's what I did. Never in my wildest imaginations would I ever have thought that I would have entered politics. I was one of those folks who would go and advocate to politicians but I never thought I would become one. But when my cousin May Whittington, the State Representative for this area, died, the Representative from the neighboring community came to me and said, "Let's go to lunch. I want you to run." And I said, "No. I've got all the job I need. No thank you." But then I got a lecture from Leesha Faulkner, the editor of the newspaper here, about how it was my civic responsibility because I had been given certain opportunities and that now I could be in a position to help in the community and statewide.

I also then begin to think, "Hey, not a bad idea to be able to sit at the table where the policy is being made on what happens in these detention centers and what happens in these adolescent offender programs." A place where I could ask, "What kind of money are you really going to give the education department and what do you expect from them in return?" So, I ran. And won.

On December 14 (2006), I was sworn in at a ceremony and on January the 2nd I drove Artcartraz to the capital where and I took my seat in the House of Representatives. There's a funny story about that. Artcartraz is a project that CIS did which allowed incarcerated youth in three states to paint a car. We didn't give them any guidelines. We didn't say you can do this, you can do that. We just said, "We're going to have a car and the boys at Mount Meggs are going to paint the hood and the fenders. Then, we come to Oakley, Mississippi, and they're going to paint the roof and the four doors." And then Bridge City in New Orleans had the trunk and the fenders and they had the inspiration to do the hubcaps. It's a very interesting organically-evolved car. So, I decided that since I'd been elected, I wanted to make a statement about who I am and what I believe in and this car does it.

So I drive up to the capital and I think I know where my parking place is, but it's not where I think it is. So, I go around and I go under this portico near the front door where the Governor parks; I drive to the next parking tier. My parking space is also not there. I'm coming around to that portico the second time and this guard steps out and he holds up his hand to me. I'm a little irritated because I'm running late and I can't find my parking place and I'm going to be late on my first day to the legislature. He's on the phone and he said, "Yeah, she's already been by here once." I explained to

him I'm a representative. He gets this huge grin on his face and he says, "So, you're Whittington." And I said, "Yeah." He directed me to the correct space and I continued to drive that car for the entire session. It's a grand statement that often opens up a great conversation about juvenile justice.

WC: So, given your experience, in your community and in Jackson (Mississippi's state Capitol) do you think we are at a critical moment in history and if so, how would you characterize it?

LW: For some time I've been saying that we are in decay. I see decaying structures on all levels. It's in our families. It's in our kids. It's in our communities. It's in our world. Somebody said that the world has a temperature. I believe that. I believe that we are at a critical state where we are decaying now.

WC: Do we have a fever?

LW: Yes. I tend to believe that. Then if you make that assumption, there are two ways to go. You can allow this decay to happen and eventually, you will get down to the ground where a new thing will emerge. I don't know exactly what's going to happen to the human race but I do know that if we allow it to decay, then it will be like a leaf returning to the soil.

I also believe that there's another route. And again, this is because I come out of the ensemble circle—if you believe that the world is sick, it is the mother, it is the woman that tends to that sickness and provides the nurture needed to bring the patient back to health. It's really funny, when I ran in the special election, I ran with another woman who was running for the senate. We laughed and we said, "yeah, the sisterhood's gonna take over." To a certain extent, that's it. We need a different view, especially when you have a current [Bush] administration in the United States that fails to recognize any of the feminine in them.

An artist who is a very successful businessman came into my office the other day. He said, "You know, I was 60 years old before I found out that it was okay to show my feminine side." When you talk about the feminine or nurturing, it is in all of us. It is in the man as well as the woman. But, if you allow that nurturing feminine side to come out, then I think instead of spiraling down, we begin to evolve, revolve in the circle in a healing manner. I believe that's what's going to pull us out of this.

WC: When you think about this force, the feminine, what tells you that it has the capacity to shift the potentially calamitous course we are on?

LW: First, I think it is women stepping up into the political process. The Mississippi House of Representatives has 122. I don't particularly want to be a legislator, but I think it's the right thing to do and I think you're beginning to see that with the women stepping up into all sorts of power positions.

You look at a woman like Betsy Bradley who was, when I came to the state, the Director of the Mississippi Arts Commission. She is a force. The only reason I felt I could move to Mississippi is because the Whole Schools initiative was here. That initiative trains teachers, principals and superintendents how to integrate arts into the core curriculum. The results from that initiative have been spectacular. Betsy also allowed the Core Arts Program to evolve. There again, I think it was Betsy, a very powerful woman, looking on a state-wide level what could be done and then doing it. That's the important thing. At some point, you've got to stop talking and do it. I think that women are doing that very thing. Betsy then moved from the Mississippi Arts Commission to the Mississippi Museum of Art. Well, hey, if you look in the legislation this year, we appropriated a million-dollar bond for the Mississippi Museum of Art. That had never ever been done to my knowledge. But, it is under Betsy's leadership.

In moving here, another thing that I did was look at the city and county strategic plans. Nowhere did they mention the arts or heritage—culture just wasn't there. Also, about this time, I crossed paths with Grady Hillman who wears many hats, as a consultant, as a writer, as a poet, and as a performer. So, he understood my theater orientation and he had worked in the prisons teaching poetry. He became involved with our program because the Mississippi Arts Commission understood how important it was to provide these little arts programs with technical expertise from nationally well-known people, like Grady and you. The whole program was born in the right way. And it was another powerful woman, Lynn Wilkins, the first Core Arts coordinator, who kicked it off the right way. She looked around, not just community-wise, but she looked throughout the state, she looked nationally, and internationally asking, "What can we do to help heal the horrible juvenile justice problem that we're having in Mississippi? Who can we bring in to help us?" It all relates back to these kids. What we're all saying is, "If we don't nurture these kids, then the world is going to continue this spiral of decay."

WC: So, on a broader scale what role do you think the arts should play as we confront a world in decay?

LW: I think the arts function on a dual level. What has been most prominent in the recent past is its capacity to entertain. In that entertainment realm, through video and through music, what has evolved is a culture of disrespect, of hatefulness and violence and sexual exploitation. A very small part of the arts community is doing what it's always done. That is, you learn your discipline, respect yourself, and respect the work that you're doing. I think it's that model of practice that the arts need to bring back into the larger society. I was having this conversation with my friend Don Shaw,

a really interesting artist who works for us doing videos called Our Point of View with Kids. But what Shaw and I were talking about is the fact that if you look at the art forms of the entertainment industry, video and music, these mass-produced creations have, to a certain extent, become the language and learning vehicles for our kids. It is how our kids express themselves, its how they relate to others, but more importantly, how they take in information from their environment and say, "Oh, this is what the world is about. I see." It forms their worldview.

WC: This relates, very specifically, to one of major points rising up in the conversations we are having for this book. Many are saying that we live in a world that is informed by, infused by, and in many ways dominated by a certain set of obsolete and destructive stories. So, you're saying, for young people in particular, that there is an avalanche of hurtful stories being heaped on them at a very critical time in their lives—the time when they are in the process of forming their own stories.

LW: That is true. In some cultures children are educated through stories. All cultures have a creation story and I think in our present manifestation of family life, we no longer tell the important stories to our kids. So, where they get those stories, again, is from a very violent, predatory way of looking at the world. The Point of View videos gave me a window into this. We take no more than ten kids and say, "We're gonna make a film." We show them a documentary film like Ken Burns so they sort of get the idea of what the structure's going to be. Then we ask them to come up with ten or so questions all together about what they think is important in their lives. Then we send them out to answer the questions in teams of two—one is the cameraman, the other talks. Then they switch. All of the teams operate in separate locations so they don't know each other's answers.

You get all that onto tape and Shaw comes back and edits. Question one is all edited together. Question two and so on. Then we tell them, "Okay, what I want you to do is bring me back visual images from magazines, from the community, get pictures from your family, whatever it is that will illustrate and explain your verbal answer to these questions." Those are cut in and then they underlay it with music. I saw the one that came from the Greenville Alternative School. It brought me to tears. What came out was that they're all afraid of dying. They live in this incredibly violent culture in their minds. I mean, almost all of them had scenes of war, shooting, and disruption.

WC: Is that a reflection of their daily life or is it from external input?

LW: I think it's both and I'll tell you why. The Greenville Alternative School, like most alternative schools, is a throw-away school. It is ugly and it is set in a neighborhood that the principal warned me

not to go running in. He said, "No, the drug dealers are across the ground. It's not safe here." There was a woman killed on a barbeque grill in that neighborhood. I'm talking about really awful ugly stuff.

Anyway, when we do the Point of View videos we also run creative writing workshops. Through this work you begin to get a glimpse of what's going on in that child's life. So you might get a scene where a woman and a man are arguing. She says, "No, it's my birthday. Don't go hang out with your pals. Don't stay out. Let's do something." The man responds by saying, "You know I gotta go to the casinos. That's where I make our money." The child is being brought up in families like that with values like that and on top of it, seeing all of the ugliness portrayed on TV and that goes on in the world where she lives.

WC: You have talked about the positive influence of the feminine side and creative cooperation. Are there places where you do see this? Are you hopeful that this force will manifest sufficiently to mitigate these destructive elements?

LW: I do. It's just like I believe a kind word to a person reverberates throughout many people. So, when we began to see how effective these arts programs were we began to talk about them around the state. After a while, people began to come to us. "Could you do this program with us?" This has happened over and over.

We did a statewide art exhibit of our children's work at the Smith Robinson Museum which is an African-American museum. We did it when the Legislature was in session and invited them in. Along with the Legislators came state agency heads like the Department of Human Services and Youth Services. This woman from Youth Services came up to me and asked, "Do you think something like this would work in the training school?" I said, "Yeah, I think it would." So, she said, "Would you like to come take a tour?" I said, "Yes." In a week, I was in a car with her and Grady Hillman looking at these training schools. They were running military boot-camp style programs that don't work because you can't keep pounding on them. Just like with tutoring, you can't keep pounding on them.

Anyway, we decided pretty much that day, yes, we wanted to work with them, but we had no idea where the money was going to come from or whether the many levels of state bureaucracy would even let us in. It took about four or five months just to get a Memorandum of Agreement that allows us to be there. So, now, we are working with these kids in the training centers statewide. But that's just the start. You also want return them to communities that offer the environment where each child's creative expression is encouraged, honored and respected. That's the leg that we're on right now. We like to say that our program offers prevention, intervention, and after care. This means having these creative oppor-

tunities move with the child as the child moves through the system. When you affect the child, you affect the family. When you affect the family that affects the community and that affects the state. It's like that one kind word that you say and it just ripples. Yes, I think absolutely what we're doing changes and makes a difference. But we have to look at this long term. You can't say, "Oh next year, we're gonna have fixed all the juvenile delinquents who are dropping out of school." That's not going to happen. You've got to be committed and you've got to see that this way works, because hammering on them doesn't.

WC: Artists, arts organizations and people who support the arts often operate as a separate constituency apart from other community concerns. But, your work crosses sectors. It involves education. It involves youth services and community development and business and criminal justice. Some have said that the challenges of the future will require a collapsing of silos and a greater sense of common purpose. You seem to have done this pretty effectively. How have you made this happen?

LW: Again, I go back to my roots in ensemble theater. What you learn there is cooperation, collaboration, and communication. You take those skills and you put them into a community. So, like I said, at Communities in Schools we started by cleaning up the mess and doing what we said we were going to do. That let the community know that I was not doing any back door deals. After I took that strong stance, I looked around at what kind of partners we could make. Where are the connections? Where is there cooperation? When we couldn't get into the detention center I went to the Greenwood Adolescent Offender Program.

 Once we started to have success then other people looked up and said, "Hmm, well look at that." It builds, but it's slow and gradual. You never start out writing a million-dollar grant. You start out writing one thousand, two thousand, five thousand and if you do what you say you're going to do, and you provide quality programs, then you begin to have funders talking to other funders, which spreads the word and the seeds for future collaboration. So, one day a prospective partner might come up and say, "Oh, I just found out you had that program." And I say, "Well yes, and here's what we do. Maybe we could do this together and together we're stronger, our resources go farther and we reach more people."

WC: Is the fact that the arts are not typically associated with criminal justice or youth services an added barrier?

LW: A lot of people do view the arts and what we do as fluff. They say, "Oh, isn't that nice." Even the national organization that I'm affiliated with doesn't understand it. It has taken a while, again, to show quality product. I happen to believe that the arts are the glue that binds the community together. When you look at community

activities, what do you see? You see a community band. You see a church choir. All of it goes back to the arts if you only look at it that way. One of the things that I'm working toward here in Greenwood is having an art center. Once you get a poor person, a black person, a white person, whatever, working beside another person making a bowl, a poem, whatever, conversation, communication, community naturally come out of that. But it's a hard sell in many instances because they don't understand that the arts are already in the community. You must recognize them. You must elevate them and I think, through that, then the community begins to get a little more healed.

WC: It seems like one of the critical aspects of your work with youth is giving them a means to express their story. Do you think a community also needs to have ways to express its stories?

LW: Absolutely. This ties into our cultural planning efforts here in Greenwood. After I looked at the strategic plan for the city and I saw no arts or cultural heritage in it, I raised $40,000 and over a two-year period, we held small town hall meetings. We did it in black communities. We did it in white communities. We did it in neutral communities, with the whole idea being that you want the communities to tell their stories. Even prior to the town hall meetings, we interviewed what we called our cultural treasures. We interviewed the 93-year-old woman who remembers the shotgun house and chopping cotton. It's not just a black story. It is a white story. We interviewed all these cultural treasures and held these town hall meetings. Then we culled through that and wound up with a shopping list of what the community thought would help them tell their stories and the culture they felt they needed to sustain their lives here.

That became our cultural plan. It's really interesting. We published that and presented it to the community in August of '04. Even before we published it, things began to bubble up and take form from these community conversations. So, the mere fact that we began to talk about our stories, and what people wanted, and where they wanted to go, started the ball rolling. Again, it gets back to the kind word rippling out.

WC: Morgan Freeman and his wife live in this community and have, in their own way, taken on the nurturing stories of this place. Could you talk a little bit about that?

LW: That's another one of the reasons that I love living here. The Delta is so special. I love the land. I love the people. What you have in Morgan Freeman and Myrna Colley-Lee are two people who love the land, love the people, and want the stories told. Myrna has a great vision of having an artist's retreat, a writer's colony, if you will, that works out at their home on Morgan's family property. Their home is called SonEdna which is an abbreviation of Morgan Free-

man's parent's names.

So, Myrna has begun to hold writers salons out there. The first one was in September of '06. It was a small gathering and we did it in the house. She had five writers. (Ntozake Shange, Roscoe Orman, Ifa Bayeza, Hasna Muhammad, Curtis Wilkie, Clyde W. Ford.). It was electric. They did the second event on this huge expanse of lawn with the sun setting down behind a large white tent with chairs, almost like going to a revival. It had that kind of feel with a stage on it and nice candle lighting and a menu of writers that you wouldn't get in New York: Ruby Dee, Toni Colley-Lee, Tyehimba Jess, Denise Nicholas, Lerone Bennett. I mean, these people are fabulous.

They come because Morgan is who he is and because Myrna is who she is. What happens for us in return is an education. It's a link to a greater awareness of the broader world and an opportunity to reciprocate. At the last salon the young poet Tyehimba Jess shared his work with an incredible passion. He really understood the theatrics of presenting and really held the audience. It was inspiring. Afterwards I had a brief conversation with him. He told me that this was not the Mississippi that he thought he was coming to. We are often stereotyped. People wonder, "Oh, who would want to go to Mississippi, racial strife, people chopping cotton." But it's evolved from that. It's a changing story.

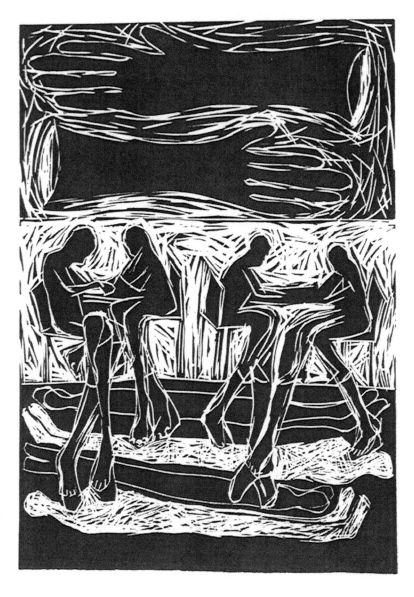

Gabisile Nkosi: *Ungubani* (Who Are You), Linocut, Gabisile Nkosi, 2007 from the Healing Portfolio commemorating the 200th Anniversary of the Abolition of Slavery in the UK.

Part V

Slow Culture

Local Initiatives in the Arts
and Community Development

Slow Culture

Local Initiatives in the Arts and Community Development

*Karin Ringler, Erik Takeshita, Sharon Rodning Bash,
Gregorio Luke, Linda Burnham & Steve Durland*

While each of the contributors to this section provides insightful analyses of the global situation, they also speak about how local initiatives present both promising (and necessary) pathways to needed transformation. They see the confluence of locality and culture as a critical incubator for dealing with such disparate issues as energy conservation and sustainable living, community identity and cohesiveness, conflict resolution, economic injustice and issues of race, ethnicity, and class. All emphasize the importance of artists and arts organizations in realizing these opportunities in joyful, meaningful ways.

Chapter 21
Karin Ringler

"The people who grow the food are now part of my community"

Dr. Karin Ringler is a Clinical Psychologist who works at a university Health Center in Wisconsin. She has been on the Steering Committee of Madison Physicians for Social Responsibility since 1983. She also has been on the National Board of Physicians for Social Responsibility since 1994 and is currently Co-Chair of its Social Justice Committee. Physicians for Social Responsibility works for the abolition of weapons of mass destruction and the elimination of environmental threats to human health, focusing on global warming and environmental toxins. In her spare time, she plays blues harmonica.

PS: In the letter I sent you, I pointed out that many people think that we're at a major turning point in the world today and that the path we are on is about to change, that there are forces in the world which will require a reorientation of the world we live in. Do you think we are some kind of turning point?

KR: If we're not at a turning point, we're doomed. We had better be at a turning point, and I hope we are. Some days I think the human race will wake up in time and other times I think we won't. But, I think we are on the verge of destroying the environment and without the environment, we're not going to be here.

PS: You see the major challenge that we face is in the environment?

KR: There are also the problems of war and peace. These figure into each other, because environmental damage creates forces that lead to war and war damages the environment. So, they are all linked together. It's global warming, it's man-made chemicals everywhere on the face of the earth including Antarctica, it's water scarcity. This is all driven by a lot of people consuming way, way too much, and an economic system that demands, rewards, and praises increased consumption. We do not have a sustainable, steady-state economy. So, we're going to have to go backwards to wind it down and then try to create a steady state. That's going to be very difficult to do even if all of us are committed to doing it. Which we are not. It's very iffy. I have three grandkids. I worry about little kids all over the place. I don't know.

I went to a retreat with Joanna Macy about a year ago. Her view is that it's a waste of time to think about what our chances are. We already have spent too much time thinking about how bad things are, so you just have to decide, "Okay, I, personally, am going to do what I can; what happens is what happens."

PS: You seem to be saying that your idea of how we should be dealing with these issues is one person at a time, each in our own individual lives?

KR: No, I didn't mean that. I think there's a big need to come together. Today (Earth Day, 2007) all sorts of people all over the United States are doing rallies and protests to remind people about things they value in the face of global warming. There are people out in the west coast skiing down the shrinking glaciers, and there are people in Madison (Wisconsin) who are going to remind us of our lakes by paddling their canoes into the center of town. I'm sure that there are musicians and artists involved in this in various places.

Step-it-up,
launched in
April, 2007,
culminated with
a "national day
of action on
climate change,"
Nov. 3, 2007
http://stepitup20
07.org/

PS: That is really interesting. Let me pose another question. In our world today, there is increasing inequality and contending world views between fundamentalism and liberalism. Do you think that the environmental pressure of global warming and resource scarcity will be the impetus for people to overcome those differences?

KR: That's a really good question. I don't know. People do have the capacity to pull together in crises. That happens during wars, certainly, and sometimes in natural disasters; but in other crises, people start saying "Okay, I'm going to take care of myself and to hell with everybody else."

PS: As the world has been going along the last decades, there has been an increasing disparity between those who have educations, money, and power and those who don't. It's been happening here and throughout the world.

KR: I think that everybody has the capacity to be part of this; I don't think it has to be a movement of just educated people. There are attempts to respond throughout the world—stopping dams, preserving forests. It isn't true that just people who read lots of books and are on the internet are going to be concerned about the environment.

PS: That's not what I meant. I was thinking that that force of the disparity between the rich and the poor is another issue which sets itself alongside environmental issues.

KR: Yes. It could be a positive thing if the "haves" start saying "Okay, we have to have less or else nobody's going to be around." I think that would be a great thing altogether.

PS: You would argue that if you could envision a more sustainable global society that there would be less disparity among peoples economically?

KR: Yes. There would have to be, because people living the way we do will have to consume a lot less for sustainability to be possible at all. There's evidence that violence goes up in periods when there are big disparities between the rich and the poor. I think if people would say "Okay, we have to stop driving our gas-guzzling cars, we

have to stop doing this, we have to stop doing that," it would be like the United States saying "We're going to give up our nuclear weapons. We're moving toward that, so we want all you other nations to do the same." But, if we don't do it, why should they? It's the same thing.

PS: I know that the Bush administration has said we can't possibly do something about global warming until the Chinese do or the Indians do.

KR: Well, that's a joke, because we consume more than any of those people.

PS: It is as if you are taking poison and the guy across the street is taking poison also. And you say "Well, I can't stop taking poison until he does." It's really stupid when you think about it. Talk to me a little bit more about how you might see a more sustainable society being organized, beside the fact that we'd be consuming less, polluting less, and wasting less.

KR: This is not something I've given a lot of thought to. Obviously, everything would be more localized, because, just practically speaking, it would have to be if we stop consuming so much fossil fuel. I heard Bill McKibben speak a couple of weeks ago. He pointed out that the food we eat travels an average of 2,000 miles to get to us. Ridiculous!

PS: I know there is a lot of interest in our food system becoming more local. How does that work here in Madison?

KR: There is the farmers' market. It had been started before World War II and stopped functioning for a while until people coming back after the Vietnam War revived it. We have lived here during the revived farmers' market. One interesting thing about it is that many more people are now growing food, making cheese, and so forth than at the beginning.

PS: Do you think there has been a stimulus to local production?

KR: Absolutely. What happened was there was now an outlet, so people started mushroom farms, or raising sheep, or goats to make Feta cheese. There are all sorts of things that didn't exist at the beginning. The market provides visibility, but then the producers start selling to local restaurants and local food stores, so that the farmers' market is not their only outlet. It has created a system of food growing. There are also CSA's (community-supported agriculture) where you can subscribe and get half a box or a box of food each week during the whole summer. It just gets delivered to your door. Bill McKibben said the Madison Farmers' Market is one of the biggest and a particularly good one. I didn't even know that. Anyway, it's great and is certainly a local institution.

One of the points McKibben made about farmers' markets is the contrast between a farmers' market and a grocery store. At the latter, you go and charge around filling your cart with food; maybe

you see one person you know. That takes maybe 45 minutes. But the average person going to a farmers' market takes a couple of hours, and they talk to 10 or 15 people. So, it's a totally different experience.

PS: It's the opposite of using the phone for business and you get the automated response: push one, push two, etc.

KR: Yes, exactly. You see your friends there. And gradually over the years, I have come to know some of the people who grow the food. So, we'll chat about this and that. They're a part of my community, which they weren't before.

PS: So, you're suggesting that in a more sustainable society, the human-to-human connections of community would be strengthened perhaps?

KR: Yes. This farmers' market thing could be extended to other things.

PS: Like what? Let's think about things we have to have: health care, transportation, clothing, housing, church or social services. I mean that's all the things we have in the community.

KR: If we didn't transport ourselves in cars that would change things, because cars create a sense of isolation from each other. We have lived a couple of times for a month in Freiburg (Germany); we went back last summer. They have great street cars, and at the end of the street car lines are bus lines that service less populous places. They have really revamped their street car line so that now hardly anybody drives. The whole center of the town is for pedestrians, a vibrant area of walking and talking and shopping and sitting out and eating. On Saturdays it was just a zoo of people. They have an old city bus that they have converted into a place where you can leave your shopping bags if you buy heavy things. Since you don't have your car to put it in, you can take it and give it to them. It's free. They give you a ticket and when you come back you're ready to go home.

PS: Our American settlements are so disbursed. In a lot of towns, the center of town has almost faded out of existence.

KR: Exactly. In German cities, that is not true. In large part that is because of their transportation system. Downtowns are usually pedestrian malls, full of people. They may have some shopping centers on the edge of town, but the center of the towns are really densely full of people walking around and shopping, having fun and eating, doing all the things that people do in cities.

PS: Do you see Americans being able to get over our obsession with my-own-house-in-the-suburbs-with-my-own-plot-of-grass?

KR: I've read that in big cities more and more people are moving in from the suburbs into the center of town. So there must be an appeal to it; no long commutes and being close to what's going on. We were in London for the summer. It's always so much fun, because the neighborhoods are adjusted to people who either don't

have cars or don't drive them in the city. You can't park them any-where, and now you have to pay a per-day congestion charge to drive in London. Nobody wants to do that. The city is trying to discourage driving, because of air pollution, global warming, and traffic jams. They've beefed up their transportation system; it is better than it was five or ten years ago. In most neighborhoods there is a corner grocery store, there's a pub on the corner, and a laundromat. You walk three blocks and you're at one of those things. When you have to drag your purchases around, it's not so bad. In most cities in the U.S. things are not organized that way and we'd have to change. Chicago and New York are, but not smaller cities.

PS: Maybe people will find the benefits of that kind of community worth giving up the grass for.

KR: People are moving in from the suburbs, saying, "It's is boring out there."

PS: We live way out in the woods. But we wouldn't be living there if we were still working. We can live there because we're retired. If we were still working and had to drive 20 miles to the nearest town to work every day, that would be a pretty big carbon footprint.

 A shocking thing happened the other day. I bought some compact fluorescents for my house. When I was unpackaging them I saw that they were made in China. I thought, "That is a win-lose." They were brought in container ships from China so I could use less electricity.

KR: To change our way of doing things is going to require going backwards.

PS: Some people have argued that there are very great opportunities for the technological changes we need to make for a sustainable world. There all kinds of different ways of doing things that will replace the old ways, so that we wouldn't necessarily think about being terribly poor.

KR: No I didn't mean go backwards in that sense. I think our idea has been to try to not manufacture anything locally or not do anything locally. That requires energy; everyone thought that was a negligible concern. Iceland has two aluminum smelters and now they're going to build another one, a dubious project environmentally anyway. They transport the bauxite in ships all the way from Australia, and process it using their water power. The power comes from making dams and destroying whole chunks of their very small area of undeveloped land in the middle of the country. Then they send it to Europe or the United States to get rolled. Apparently the cost of moving that stuff in those ships is cheap enough.

PS: The monetary cost is cheaper, but the environmental cost is unac-counted for.

KR: Exactly. There has to be a change, so that companies have to pay for doing that. This would be an incentive not to transport goods and raw materials half way around the globe.

PS: Some people have talked about a carbon tax as something that might be considered. I think some countries, even some states in the U.S., are trying to do that. I've heard that California, for example, is doing something like that.

But let's turn to the arts now. The kind of changes you've been talking about, assuming they happen fast enough to prevent environmental disaster, are going to require the creative energies of many different people. Where is that creative energy going to come from? What are the sources of the transformative energy that is required? What are the sources of progressive ideas, in your view?

KR: I think the ideas are out there already. I went to a conference of the International Physicians for the Prevention of Nuclear War in Finland last fall. Physicians for Social Responsibility is the U.S. section, and I'm on the national board and the board of my local chapter. One speaker was Hans Joseph Fell, a Green member of the German Bundestag. He is an authority on alternative technology, both for producing electricity and for automobiles. He gave this amazing presentation about the many green ways of producing electricity. First of all, he demolished the idea of using nuclear power. Not even considering nuclear waste, the method is not practical for all sorts of other reasons. If the waste problem were solved, the available fuel is inadequate, the number you'd have to build is large, they have a short life span, and it takes to a lot of energy to build and operate them.

PS: I have heard people say that nuclear energy is an "alternative energy."

KR: But Fell's argument was powerful because he said, "Forget about that. It's not going to work economically and practically." Then he went through several other methods that are out there and already operating in various places, such as tide-powered electrical plants. There were more than just wind and solar collectors. His presentation showed how much of this is already in place, how much is it going to be in place in a decade, and in 20 years, and what proportion of Germany's electrical needs each technology can provide. I had the mistaken impression that many Americans have, I think, that these solutions are way in the future. So we ask, "What are we going to do in the meantime, but keep on doing what we're doing?" He was saying, "No, that's not true at all." He also presented different methods of conservation, such as using heat from one source to power something else. My thought is that a lot of those ideas are already out there, but they're not in front of the public and they're certainly not in front of the people in Congress for the most part. But they need to be.

PS: So you see that in, at least, the scientific community, there are many creative ideas which can soon be put into practice.

KR: At the moment, a lot of these ideas are off to the side, not in front of people's awareness yet. So, I think there's a need for that to happen.

PS: What I want you to do now is tell me what you think the role artists and arts organizations might play in response to these challenges we see ahead of us. What relevance might the arts have to this, or is this primarily a political, economic, and scientific problem?

KR: The arts—music, painting, poetry, plays—played a really important role in ending the Vietnam War. This was something that happened during my adult life so I remember that as being really important.

PS: Why do you think that was the case? You said they helped end the Vietnam War.

KR: Part of the movement to end the war involved a lot of singers and poets and graphic artists who made these things the subject of their work. At certain points, those were really important parts of the movement.

PS: That artistic expression gave impetus to the movement?

KR: Yes, because the arts helped make this a part of people's everyday awareness. Of course, the media weren't such a big factor then, but they sure are now. But in addition, there is the music you listen to, the pictures and posters you see, etc. All of that helped keep the issue on the front burner. It just became part of the whole thing, like "We shall overcome," to use a different example.

PS: When you think about the Civil Rights Movement, you think about Martin Luther King's "I Have a Dream" speech and the song "We Shall Overcome." You don't think about somebody lobbying Congress for the Voting Rights Act.

KR: Exactly. I think that could be part of this. I'm really glad that Step It Up is happening; the people who are putting it together decided that it needed to happen because there have been no marches and nothing publicly happening. I think that's partly because of the nature of the thing: it's not just them, it's us.

PS: Are you suggesting that if artists and arts organizations were to take on the issue of global warming, they would provide spiritual and emotional motivation?

KR: Yes. Information and lectures are important, but then you see a picture of a polar bear and it just brings it back to you.

PS: Like the earth from space photo is really powerful. The polar bear in *Time* Magazine, and the poor penguin looking over the edge of the floating glacier. Those were very powerful photos.

KR: People could be making films that would make you notice. I mean films that are not educational *per se*. People could be making pro-

fessional films; blockbusters about global warming, even if they're dumb, might make people think about it.

PS: The arts seem to have done two things traditionally: one, they raise our consciousness about the problems, and two, they give us inspiration or hope that things could be different. I think I hear you saying that arts and artists might be doing both those things.

KR: An example would be a book put together by artists in the Upper Midwest called *Paradise Lost, Climate Change in the North Woods*. It is a catalog of an exhibit. I think there was music that went with it. These sorts of things just remind people, "It's still there, it's still there. You've still got to do something about it. It hasn't gone away." Everybody has got so much to think about: organization that has to be done and the political work that has to be done. And then there are personal decisions to be made: the compact fluorescents or, "Do I really need to take this plane trip." It's all part of the scene.

PS: That's where the artists keep us reminded? You hear a song or something?

KR: It is useful in protests for connecting people with each other, and also for the power to move people emotionally.

PS: So, you would argue the unique capability of the arts is to create inspiration or a goad to action.

KR: To get people motivated, concerned, sad about the situation, all of that.

PS: I know you're not in the arts community in your position, but would you have any recommendations for what artists or what arts organizations might or should be doing to move us along?

KR: One of the things I've been complaining about is that the work I do environmentally is not enough fun. I think there needs to be more fun in it. I play the blues harmonica and I have thought about ways that I could get the musicians I know to do something about global warming at some point.

PS: You mean have a jam session at which those issues were brought up?

KR: Or just to benefit some local organization, because I think that the point would not be to raise a lot of money. The point would be to raise awareness. You say, "Okay, this is an issue, this is a way that you can contribute to it," and that might get them thinking that they need to do something about it.

PS: And it would be more fun.

KR: Yes, it's more fun. Some of our work needs to be a little more light-hearted, because a lot of the stuff you read and hear is terrifying, grim. It gets to be too much and too scary.

PS: It's much easier to do the ostrich thing and say, "Oh I can't do a thing about it."

KR: And feel like your life is too much about organization and not having any fun while you're doing it.

PS: You've mentioned something really important here about what artists could be doing. Not just to have scary pictures, but to make it hopeful.

KR: And talk about the things that could be fun. One of the things that Bill McKibben talked about was that music used to be more local. He said that there were once 1,300 little opera houses and music halls in Iowa. And those have all disappeared; instead you've got these national acts touring all over.

PS: Up where I live, I see some of that coming back; people get together and sing.

KR: It exists here, too, but I think that another part of talking about all this would be to say entertainment doesn't have to come from FOX or CNN. Or from New York, or on an airplane or on a bus. It could just be local people entertaining each other. We can have our own fun. Nobody has to give it to us.

Chapter 22
Erik Takeshita

"The craving for local connection"

Erik Takeshita is pursuing and promoting the use of art and culture to empower communities of color and develop stronger communities. He has over 18 years of experience in the non-profit and public sectors providing strategic planning, program development, project management and leadership development to a wide-range of organizations. He directed an art center in Honolulu, HI focused on using the arts to help revitalize downtown Chinatown and was a Lecturer at the University of Hawaii in the Urban and Regional Planning Department. Previously, Takeshita served as a Senior Policy Aide to the Mayor of Minneapolis where he championed the development of a 10-year Strategic Plan for Arts and Culture and the creation of an Affordable Housing Trust Fund. Mr. Takeshita earned a Masters of Public Administration from the Harvard Kennedy School, and a Masters in Management from St. Mary's University of Minnesota. He is currently a Senior Program Officer for Twin Cities LISC, an Instructor at the University of Minnesota Urban Studies Department and a private consultant.

ET: Before we start I need to know what you mean by culture.

WC: I'm referring to community cultural resources meaning artists, arts institutions and all the structures that support artistic development and production. But it also bleeds over into questions of design and community cultural development.

ET: But it's not culture in a sense of language and mores etc.

WC: Right. So my first question is if you've given much thought about whether we are at a significant historical moment in the U.S. and world, a point of departure when a significant shift is occurring.

ET: I wouldn't characterize it that way. I think human society has evolved over time and we are in a continuation of that evolution. I think we have a tendency to be somewhat narcissistic in our view of the world, thinking that this is the most important time that has ever occurred. I personally don't agree with that. I think that over the course of human history, lots of things have changed and that in the grand scheme of things, this is probably not a major shift as much as a minor moment in evolution. But, I do think that as a society we are continuing to evolve, or in some ways perhaps revert to a more whole-brain approach to problem-solving and creation.

WC: Some of the people we are talking to are saying that the patterns of human development that have gotten us to this point no longer work. They cite various reasons: finite resources, human impact on natural systems, unsustainable growth, assumptions about the nature and inevitability of conflict etc. They say that because of these things and the increasingly interdependent nature of economies and web-driven democratization of communication that we are at a critical turning point that poses both great risk and opportunity. Does that fit with your view?

ET: I agree with the part about information exchange and economies. There's a higher degree of global interdependence than there has been in the past and less localized economic and cultural activity. It has the potential to be less localized because of this shrinking nature of global technology and information exchange. You also intimated that the means of communication had become more accessible and freer. I'm actually concerned that there continues to be an oligarchic control of our information systems. They may not always be in direct control in that they dictate the outcomes, but they are clearly pulling all the levers and switches. There are examples of that not being the case, but for the most part, I think that there is still a power that is controlling most of those levers and switches. Again, it may not always be correct in their predictions as to the outcomes, but they're still pulling switches. I don't know if that's fundamentally shifted as of yet. There may be opportunities for that to happen in the future. I personally haven't witnessed it. There are one-off examples but it is not widespread.

 I also think that it may be more of a pendulum type of thing

where the more people become connected to and are influenced by the larger world, the more craving people have for local connection. That is, the more impersonal things become through interaction over the internet the greater the necessity for even more human interaction. And so, there's this almost equal and opposite force at play. There is a sense of globalization, but yet there's also a drive to act local. An impulse to build community on a micro-scale, while it's also clearly happening on the global scene. Again, my worldview is not necessarily either/or but rather both/and.

WC: In terms of that, given that the forces that push globalization are largely economic, what forces drive and support localization?

ET: For me, it's the fact that we're human beings and that we have biological and psychological needs to have a connection with other people. It's the social aspect of our biology. We seek connections with other human beings as a part of our self-actualization.

WC: If you thought of the corporation as the self-interested agent that pushes globalization, what is the agent or power source that pushes towards localization? Is there one?

ET: I don't think there's one. I think there's billions. I think its individuals. There's this idea of followership in leadership studies that says, "You can't have leaders unless you have followers and that most of us are actually followers." They say followers have as much of a role in that relationship as the leaders do. I think the same is true in globalization and localization, that the individuals are creating those local connections.

WC: If certain systems, laws, rules, technologies are being created to facilitate globalization, are there countervailing systems or forces in the world facilitating localization?

ET: First, for me the push for localization is being driven by people searching for meaning. As we become more globalized, people are searching for things they can actually get their arms around and understand. It's like the city council having a billion-dollar budget but focusing on a $50,000 line item. You can't get your arms around the billion-dollar budget, so you focus on what's real to you. I think that happens a lot with individuals. Number two, I think the manifestation of that search for meaning is in unique places. I think it's in book clubs of the world. It's in play dates. It's in those kinds of connections and I don't think it's new. I think it was previously in the bowling leagues, as Putnum suggests, or in the health clubs, or in the craftsman guilds. Self-organizing has occurred throughout history. People have always self-organized around certain affinities. I don't know that it's new. And I don't think globalization is new either. I think it's just the pace of its acceleration lately. The same could be said of the 1500's.

WC: Do you see localization and globalization as being in competition?

ET: Look, I'm a Buddhist. It's like the yin and yang. You need dark to have light. You need up to have down.

WC: Do you think they're in balance?

ET: I don't think it is ever in balance. I think like a pendulum with this kind of reaction-action, action and reaction.

WC: Do you have a sense of where the pendulum is now?

ET: My sense is that the pendulum is currently more towards the left brain logical, economic models, but that search for meaning is indicative of how that pendulum may be swinging back. There has hopefully been a reaction to the industrialization, assembly-line focus on the bottom line, and the disregard for some core human values that is beginning to help the pendulum to start to swing back. I think that you see it manifest itself in its rawest form in the rhetoric of politics in the United States. The sound bite politics that we see is an appeal to that kind of search for meaning and values. Personally, I think it lacks the depth that it needs, but it's the first wave of that.

WC: Do you see fundamentalism as some aspect of the local?

ET: It could perhaps be seen as that, as a very basic manifestation of the search for meaning. Perhaps because it is the most common denominator, the easiest thing for people to grab on to.

WC: Over the next 50 years, as this pendulum starts to move, what do you see happening?

ET: I don't know the exact statistic, but there have been more new countries created in the last 50 years than for however long. I think that is a symbol of that localization phenomenon. I don't know that it's healthy, because it starts to create tribalism. I think that this reactive localization could have very negative consequences. In my opinion, it's not enough to co-exist. We have to find ways to interact with one another and find ways of getting along without losing our unique characteristics and identities. It's the model of the United States as the tossed salad, not the melting pot. Which translates as, "I don't want to lose who I am and I want to be respected for who I am. I also want to contribute to the greater whole." In the absence of being able to do that, what I'm seeing on the global scale is this need to assert independence separately rather than collectively. There's not enough space provided for us to just co-exist in this way. We need be able to actually work together to have some kind of a common identity.

WC: So, you are talking about the declaration of the shadow; is "Now it's my tribe versus your tribe" a symptom of this?

ET: Yes, but it's not only declaring my tribe to be separate from your tribe, there's also "I'm superior to your tribe." That's what's scarier to me. Or even worse, "That your tribe's existence is a threat to my existence," or "That your tribe doesn't have anything that my tribe

could learn from, or value." That, to me, is very dangerous. I would suggest that all tribes have something to learn from other tribes.

WC: Are there places were you see this need to find meaning and the need to be comforted by the local, safe, and familiar manifesting in a positive way?

ET: I think it is a question of scale. The positive value of these tendencies is seen more at the micro-level. The value is of the individual to the community, to that localized environment. But when you put the question in the context of the global scale, I think it can have negative consequences. On the local scale it has very positive consequences.

WC: In what ways have you seen this?

ET: At the local level you see a greater sense of cohesiveness, a greater sense of meaning to the individual, a greater sense of connection to others. It is healthy to be a part of a larger whole that has some meaning to it. It gives relevancy. I think the challenge is when these connections are made over and against others, at the expense of others—e.g., coming together because "we are better than you are".

WC: A friend recently shared a story of the creation of what might be called a healing tribe, as opposed to an oppositional tribe. It happened in a level 4 prison yard, at Folsom Prison, with a group of very violent and very segregated prisoners. Inspired by Victor Frankel's work this one guy decided to use poetry and Frankel's ideas to change the culture of the prison yard, which was for all intents and purposes a war zone, where men were used to killing each other.

ET: Was he successful?

WC: He was successful in doing it and spreading it. The new culture offered a way out of a zero-sum game for some of the men.

ET: Although it is violent and segregated within the prison there are also a lot of commonalities: same situation, living in the same place, same guards, the same walls, the same inescapable routine. In the community context it's a bit different. In that context I have to have a clear sense of who I am and a clear enough sense of the definition of my tribe before I can be confident enough to dispose myself to learning from your tribe. I think particularly from the perspective of a person of color growing up in the continental United States that's not something that has been engendered. In the U.S. you have not been encouraged to think about a non-Western identity. It's important for me to have a clear sense of who I am as an Asian-American and what assets I have to offer others as an Asian-American to be open to building a new common identity, particularly because I'm so used to having my identity lost in the mainstream.

WC: So, bridges between tribes can't be built without a firm foundation. It sounds like you see that as basic. It also sounds like you feel the

way in which human beings evolve is not changing, but that the ve-
locity of current events makes it appear that the rules of engage-
ment are changing. But, from your perspective the rules are the
same.

ET: To me, it's evolutionary and not revolutionary.

WC: Do you see this as a particularly intensified moment in that evolu-
tion? Do you, agree with others who say that the moment will re-
quire significant shifts in the way we do business to both avoid ma-
jor problems and take advantage of new opportunities?

ET: I actually don't think there will be a fundamental change in the way
we do business. And when you say take advantage of opportunities
the question for me is opportunities for advantage to whom, which
goes back to the power elite question.

WC: So, one person's opportunity can well be another's danger. Given
that, what dangers and opportunities to you see?

ET: I guess if we're looking at the 50-year timeline, I don't know that
there's going to be a fundamental shift in humanity in the next 50
years—how we do business, who benefits, what have you. I think
that there will be incremental shifts and there will be very signific-
ant shifts for individuals. But, as humankind, I don't have a huge
degree of confidence that we're going to find new ways of doing
business and operating. I think we will continue to see a limited
number of people control the majority of the wealth, continuing
again to push and pull those levers. In terms of economics, those
people will continue to reap the most benefit from those oppor-
tunities. And to the extent that there are challenges, it's more at
the micro-scale and the creation of more tribal warfare, going back
the metaphor of the tribe, in that the more we focus on the cre-
ation of localization, and finding meaning at the local level, there's
more potential for conflict there. Which I think actually, in some
ways, behooves an overseer. I'll use the example of Hawaii, where
plantation owners were very intentional about bringing different
populations to Hawaii and having them fight with one another. So,
you have the Japanese workers and the Chinese workers and the
Filipino workers—and the intention was to create competition.
And, they said, "OK, if you don't work hard enough then we will
just bring in these other workers. Let's have you all fight amongst
yourselves and see what happens."

So to reiterate. First, I don't think there will be fundamental
shifts in the way humankind operates. Number two, I think there
are challenges and I think there are also opportunities. The ques-
tion is more for whom. I think that the challenge at a micro-level,
as somebody who's not part of that power elite that is pushing
levers, the challenge for me is how do I keep from falling into that
conflict that could come up through localization. And then, how do
I change the system? Or alternatively, do I just try to become part

of the system, and try to move my way up the system rather than fundamentally shift it? But rather, try to move myself from one part of the system to the controlling part of the system. I think that's the challenge. I think we need people that are going to be willing to fundamentally change the system rather than move their way up the food chain and be in control and maintain the status quo. The challenge, of course, is once you have "paid your dues" and worked your way up "the system" you have an inherent self-interest in protecting your hard work—maintaining your place. There is almost a natural tendency to "pull up the ladder" from behind you.

WC: Are you also saying that if one starts with the intention of changing the system and takes the strategy of insinuating oneself into the system, that there is an inherent danger that their investment in gaining power within the system will compromise their ability change it?

ET: I don't think it's inherent. I think it's, there's a high degree of probability that they will become part of the system and will lose their own focus and ability to change. I also think that it is difficult for one to change the system. I think it goes back to followership/leadership. I actually think that it's going to take an increased consciousness on the part of a greater number of people to demand change, particularly here in the United States. Looking just at the United States, and our system of representative democracy, I think for us to fundamentally change the politics of our country is going to require a groundswell of people rather than any individual.

WC: Are you also saying that you think we still retain some capacity to respond democratically in a way that could shift things?

ET: In the United States, yes, absolutely. Part of why I don't believe the levers are so corroded as to be unmovable is because of globalization and the acceleration of the sharing of information through technology. For example blogging and text/ instant messaging can create more representative democracy. I don't think it necessarily has, but it could. The advent of YouTube in some ways has made things a bit more dangerous. It's fraught with challenges and abuses. But it's also a way of getting unedited content to a broader audience in real time. If people are paying attention, they can create that energy and change. I think the Orange Revolution [Ukraine, 2004] is a good example. How do you get masses of people to come out and protest a presidential election? Well, with text messages. That's an interesting way in which technology and the acceleration and exchange of information can be used as a form of followership.

WC: Very simple and basic, not overly-complicated.

ET: Exactly, or even in the most recent mid-term elections with George Allen in Virginia getting caught on video tape. That's a way in which representative democracy can still work.

WC: Given your recent experience in arts-based community develop-
 ment at the local level in Honolulu, what role do you see arts and
 culture playing in the near future in these challenges and opportun-
 ities?

ET: Part of what drives my passion for the arts and my interest in work-
 ing with the arts is its ability to transcend that tribal warfare that
 we talked about. It's a way of giving meaning which can transcend
 traditional definitions of tribal distinction, be it race or class or a
 language or geography or whatever. This is because art, in my mind,
 is fundamental to humanity and our common search for meaning.
 Art is an artifact of that search for meaning that cuts across all of
 those tribal lines. So, for me, it's a way of finding that both/and. It's,
 "How do I have my own identity and how can I share my identity
 with you and how can I understand your identity better?" That's
 what feeds my passion.

WC: It also sounds like it feeds your optimism.

ET: Exactly.

WC: Can you talk about specific ways in which you have seen that hap-
 pen?

ET: Sure. As an Asian-American in a primarily white culture, seeing per-
 formances at Theater Mu helped me understand what it meant to
 be an Asian-American in Minnesota. That theater company and
 Asian American Renaissance through their plays, performances
 and spoken word events, and their writing helped formulate for me
 a sense it was okay to be both Asian and Minnesotan. This put me
 on a very different footing with my comfort level with my own eth-
 nicity, which in turn allowed me to be more open to others while
 not creating a response of over and against. That's very, very per-
 sonal and that's part of what feeds my passion and belief in the arts.
 I've seen it happen for myself where it helped me grow this identity
 and increase my confidence and willingness to try to understand
 others.

WC: Bell Hooks talks about the importance of theory or having a the-
 oretical framework for the making of meaning and identity. Did
 Theater Mu and other arts experiences help you construct your
 own vocabulary and theory of being an Asian-American in Min-
 nesota?

ET: I don't think it was a theoretical structure. It was an experiential
 structure. It was that visceral experience of being amongst other
 people. It was about being with other people in the audience that
 looked like me and were like me, not just visually, but their life ex-
 periences, watching productions about those experiences. It may
 not have been exactly parallel. It clearly wasn't exactly my experi-
 ence, but it was people like me.
 For example, there was a production called *Walleye Kid* about a
 Korean adoptee in Northern Minnesota. It was a variation on an

old Asian fairy tale where the kid came out of a walleye (the official Minnesota state fish) and was given to this Norwegian family. It was a creation story. It was about that kid's search for what that meant. Although I'm not adopted and I have Asian parents, there was enough of that story that resonated with me that it helped me understand more about my own journey. It wasn't necessarily a theoretical framework as much as an experiential awakening.

WC: I'm assuming that the fact that it was local made a difference too. It was a production that took place in your community, based on stories that came from your community that was delivered by members of your community.

ET: Exactly. That's what's so powerful about it. Again, that's the localization piece. I don't think this would have been possible if they had been from southern California or New York, because the cultural experience is so fundamentally different.

WC: So what was the meaning that came to you through this?

ET: It validated me. I was born in 1968. In the 70's and 80's in Minnesota you were either black or white, and I grew up white. I was one of the few Asians. Five, ten years later we started seeing an influx of Vietnamese, Hmong, Lao, Cambodians and others, but, at the time there weren't many Japanese-Americans. So, I grew up white. I went to school in southern California in search of that sense of identity. I thought, "I'll go to the West Coast, I'll be with other Asian-Americans, no problem." But in Southern California I ended up hanging out with people from the Midwest and I realized that culturally I was a Midwesterner. So, I came back from college and I said, "What the hell do I do with this. I'm Asian, clearly, because people see me as Asian." They say, "Where did you learn how to speak English so well? Where are you from?" All this stuff. My family's been in this country since the 1880's. Most of my white counterparts came after that, but I'm the one that gets asked, "Where did you learn English?" Clearly, I am seen as Asian, but culturally Midwestern and so, once again the experiences I had at Theater Mu and Asian American Renaissance help me understand that it was okay to be both.

Another piece that was important was that I also began to find role models and mentors within that community that helped give me a strong sense of identity. And then I went to a conference at Hamline University where a speaker said, "As somebody who has been given privilege, as somebody who has been given access to education, connections, or language skills you have an obligation to pave the way for those who come behind you." Up until that point, I'd always tried to disassociate myself from other Asians. I was Japanese-American. I wasn't Hmong, or Vietnamese, so, don't lump me in with "those" people. My family's been here forever, so don't lump me with the Hmong people because I'm no refugee.

From that point on, I recognized that I could not do this, that I had to fight my own tribal tendencies, and I had an obligation to try to extend the ladder down. I had this obligation because my grandmother lost her citizenship when she married my grandfather because of racist laws passed in this country. Because my father wasn't able to get a job because he was Japanese-American in Iowa in 1964. And, because I'm educated in private schools, because I have access to power, I have an obligation to do what I can to minimize this kind of thing for others.

WC: Given that you moved to a place (Hawai'i) that's very different in this context, how did that manifest, in terms of your work and your new community?

ET: It's a good question. In Minneapolis, when I was working for the Mayor, my work there was about those who were otherwise disenfranchised. I'm finding that I'm still a champion for the voiceless, those who are not otherwise represented in the mainstream. So, for example, we were doing a show at the Arts at Marks Garage (in Honolulu) on shelter. We started with a call for practicing professional artists to submit work to show in the gallery. But we also took it two or three steps further. We also commissioned artists to work in affordable housing in the neighborhood to help residents develop their own work through photography and visual arts. Then we actually commissioned artists to work with the homeless population who are also "residents" who may not be housed, but are clearly residing in the neighborhood.

WC: Given that the mission of your organization is to make a difference in the community and that you were new there, where did you want to see it go?

ET: The Arts at Marks Garage, as a community project of the Hawaii Arts Alliance, has only existed for five years. We initially started with the idea of using arts to help revitalize downtown Chinatown. Over 18 months we also began asking, "How do you insure that the people who live in Chinatown have a voice in how that revitalization occurs? How do you insure that the people that are there now have a place in the future? How do we make sure that, again, this idea of coexistence is not enough; that it's not enough to have Chinatown just co-exist with the Honolulu cultural arts district. How do you actually increase the amount of overlap and interaction between the two?" That's the next stage.

For example, having the Chinese Chamber of Commerce host their monthly meeting at the Arts Garage; having Chinese artists from the neighborhood show in our gallery, having homeless people show in our gallery, having performances and community discussions in our space that are relevant to the community's issues. To me, that's the next evolution. It's not so much a fundamental change as much as how do we evolve our thinking about what

we're doing. Again, it has to do with our level of confidence. We have been successful in catalyzing revitalization in downtown Chinatown. It's only the fact that we had some modicum of success, that we can now say, "Okay, what's the next level." And, in our case it's asking, "What are the unintended consequences of our work? How do you mitigate those?" We still have to be focused on using art as a way of revitalizing the neighborhood because if we fail to do that, this other work in the community doesn't mean anything. That's core, but the next layer out, the next rung is, "How do we infuse the voice of the community into that work?"

WC: In the community arts training program that we worked on together in Minneapolis there were four characteristics that we identify as key to success in arts-based community development: respect, accountability, sustainability, and excellence. Do these still hold true in your environment?

ET: I think I would add, "authenticity." The thing that we are really focused on is making the experience authentic. This is not about facades. Maybe authenticity is a way of framing those qualities in a different way. Authenticity ties with all four. In some ways it's an overarching idea for us. It's about saying, "If we're going to work with the Chinese community, this is not a one-off transaction. This is a relationship." If we're going to present art in the gallery, it's because it's good art, it's not because it's politically correct or art just to be provocative. It's about artistic excellence that's authentic. It's coming from a voice that has meaning to the community. It may not be the geographic community as much as the broader community. For us, authenticity is really essential.

WC: You said you were beginning to ask about unintended consequences. What are the unintended consequences, of not being authentic?

ET: I hesitate to even think about the consequences because they are so dire. It would be disrespectful to our constituency, our stakeholders, our partners and our friends. Not being authentic is not sustainable because over time the falsehood will be discovered and you will lose the support of the community and funders. I think not being authentic means we are not only compromising our artistic excellence, but also the excellence of our relationships which again ties in directly with sustainability. I think that if we're not authentic, we're not accountable.

WC: Going back to my earlier questions about shifting worldviews, do you think that defining authenticity as the foundation for your work is an example of a dramatically different way of doing business in a world dominated by bottom line self-interest.

ET: I don't know if it's dramatically different. I think it's different because it has to do with how we define our success over a very long haul. It's not transactional. It's about transformation. It's about

building long-term relationships in Chinatown. It's about monitoring long-term relationships with artists in Hawai'i. It's about changing the cultural landscape of Honolulu and thus Hawai'i and placing it on the international map. That's a long-term big play. So, if we're going to be in it for the long haul, we have to be authentic. We would never be able to do that otherwise.

WC: In the long haul, are you hoping that this way of defining success could influence the way others in the community do business?

ET: First of all, I don't know that we are that unique. I think there are a number of cultural organizations and other non-profits and businesses that do value authenticity which in turn may be a part of a larger shift in values. I was reading the other day in Barack Obama's book about a conversation he had with Warren Buffet about the estate tax, where Buffet said it should be continued as a way to ensure meritocracy over aristocracy and, "Of course, we should pay for health care as a company." So, I think there are individuals and there are businesses out there that clearly get this idea of corporate and social responsibility. It's a whole new impulse inside the corporate world, beyond the foundation giving, where companies are actually engaging in the societal aspects of doing business.

WC: So you're saying that some organizations are becoming more aware that their self-interest is broader than they thought it was, that operating tribally, in a silo is probably not good business.

ET: Right, there seems to be more awareness of that. I also think it's important to acknowledge that some enterprises have always had that perspective. At the same time, there are other businesses that are clearly going in the other direction. But I think that one of the things that can mitigate tribal tendencies and the effects of globalization is catastrophe. So, things like global warming will force you out of your silo and into recognition that we are part of a larger ecosystem. If the global temperature goes up by a degree, or five degrees, that's a fundamental shift in humankind's interaction in our environment that will necessitate those really fundamental changes in our economic systems and our relations with each other. To the degree that these things are recognized as a real threat, I think this offers opportunity for coming together around a common cause.

WC: Do you think we need to practice the "coming together" part rather than just waiting for a knock on the door?

ET: I think it's practiced all the time. I think we should practice the next steps. It's not enough to just come together with like-minded people. A next step is coming together with like-minded people to gain the confidence you need to interact with others. Perhaps, we need to develop different rules of engagement so we have a more productive way of interacting with the "other."

WC: Do you think cultural resources provide unique tools for that?

ET: Yes, absolutely. At the micro level, that was my story with Theater Mu, dealing with my ethnicity and identity and giving me strength to engage with the "other". I see no reason why that can't be scaled to a community, a religious group, an ethnic population, where they can develop a level of confidence in their own values and identity so that they can start to question those and engage others.

WC: So using theater or poetry as a way of questioning the assumptions that underline your own tribe's way of seeing the world might also strengthen the tribe's capacity to listen to and connect with the "other."

ET: The Catch-22 is that you have to have enough confidence to be able to question. I think that's where we are not. From my experience, I see the ones that are speaking the loudest are the ones who are trying to convince themselves. I think that is where we are getting hung up. We all need to be able to question our basic assumptions. It's not enough for us to have a debate about same-sex marriage that ends in "It's just wrong!" I don't think that's going to help us get there. We need to be able to unpack that, and that means a lot of soul searching on the part of individuals and tribes. I don't know that people are comfortable doing that. We don't have those rules for engagement within our own tribes, much less the tools we need to bridge to the next tribe.

WC: It occurs to me this process of gaining the strength through listening, voicing and questioning, is similar to the intentional exploration inherent to the creative process, and very different from the typical win/lose debate. Does that make sense?

ET: I think so. I think it is fundamentally different than the debate process, win-lose, arguments, other side, agree, disagree. It's also fundamentally different from the scientific process in which you say, "here's my thesis" and I'm going to go on to prove or disprove it. It is about the process of engagement. So, in that respect, I guess it is a creative process.

WC: If that engagement is arts-based, would it be accurate to say that because an artist works by using existing material to make something different, that this can change the playing field from win-lose to yes-and?

ET: Yes.

WC: Win-lose is just that. One ascends, the other one drops. The creative process is generative; one thing is always building on another. It's like the concept of Ubuntu that I encountered in South Africa which means, "I am because you are." Nothing is disconnected, everything affects everything else.

ET: We're social beings. So, we're necessarily dependent by definition on others for meaning, for procreation. This is something that exists in every culture and every history. You're asking about whether we are experiencing a significant historical shift. To me, things like

a rise in the printing press are titanic shifts in how humankind interacted. Because, suddenly, there's mass literacy and mass ability to transfer knowledge. So, people begin reading and thinking and questioning the laws of the church. That's a big deal. The industrial revolution and automation of processes, that's a huge deal. Land reform, too, is a big deal. These are titanic shifts in the way humankind interacts. Through that progression in Western society in particular, there has been a divorcing of the economic structure and the human need structure. When we talk about left brain-right brain, that to me is the pendulum. I'm not suggesting that the printing press or industrialization were bad, but, these advances contributed to the bifurcation where man becomes the means for the creation of industrial capital rather than a whole person. It also creates a society where comfort and health can be perceived as synonymous.

WC: So, you can have a world where you can have a healthy industry and an unhealthy community. Do you see the comfort level that has emerged in the western world as a potential form of tyranny?

ET: Yes, absolutely. The more comfortable we are, the harder it is for us to engage the hard questions that might threaten our comfort. I think it is human nature to want to be comfortable. Ironically, this comfort also provides us the opportunity to engage these questions; it is in some ways the precursor needed for us to engage the hard questions. If I don't have that level of comfort and security, I can't engage the question. I will not question my own values until I have self-confidence. So, if I'm worried about survival, I can't engage these hard questions. Yes, it can become a tyranny, but it is also necessary. It is Maslow's hierarchy of needs. If I am still down here in subsistence, there's no way I can engage the stuff I need for self-actualization. But then again, if I am obsessed on material things this is also a barrier to self-actualization.

Chapter 23
Sharon Rodning Bash

"New senses of rootedness"

Sharon Rodning Bash is the program director for ArtsLab, a three year capacity-building program dedicated to nurturing a thriving regional arts ecosystem by developing the core leadership skills and management capabilities of smaller, visionary arts organizations. The project is a $1.85 million investment by a consortium of Minnesota funders: Bush, The McKnight, The Saint Paul, Mardag and Bigelow Foundations. In addition to her work with ArtsLab, Sharon teaches in the St. Mary's graduate program in Arts Administration, in the areas of nonprofit management and program planning and evaluation.

Prior to her appointment with ArtsLab, Sharon was the program director for organizational development and training at the Metropolitan Regional Arts Council. In that capacity she developed and frequently led numerous workshops on a range of capacity-building topics, as well as managed organizational development granting programs. She has facilitated workshops regionally and nationally around her work in building arts participation and community engagement. In addition, she has been a consultant to nonprofit arts and human service organizations for many years, providing support and training in the areas of strategic planning, change management, creative problem solving, and major project implementation. She holds an MPH in community health administration and an MSW in human services administration, both from the University of Minnesota.

PS: Perhaps as we begin, I might give you a brief synopsis of what we wish to discuss today. Some have argued that the world is changing rapidly and we're on the verge of a major turning point. Others argue that the fundamental character of the modern world which we've been in for over two centuries is stable and will continue. Have you given any thought to this question about turning points or fundamental changes versus a linear view of the basic value system under which we operate here in the western world?

SRB: Yes, I think we're at a point of a fundamental shift. Although I would not characterize the shift as related to the "fundamental character of the past two hundred years," I do believe we are poised for another major change. A futurist I heard about three years ago spoke eloquently about the shifts we have already experienced from the agrarian era, to the industrial era, and now to the communications (information technology) era. This has radically shifted us to a much more global world. But the result of this unfolding globalization is the isolation of people and a starvation for social connection. The futurist projects that we are now entering "the age of community." (see Christoper Leo, University of Winnipeg)

 This view says that we are on the verge of a radical shift to a kind of world in which we may be globally linked, but we're much more organized at the small social group level. In some ways, this Age of Community will be very different from and yet parallel to the old agrarian world; people again identified with small groups. As global market competition intensified and as issues of global warming intensify, we increasingly seek to consider strengths and design solutions at the local level. For instance, contemplate the myriad of local economic development cross-sector councils emerging, the "100 mile diet" movement, the "buy local" movement, etc.

PS: So, the course society is likely to take the next few decades is toward this two-tier global-local structure? How will these levels be integrated?

SRB: The struggle for integration is, of course, an enormously challenging question—one for which I cannot presume to have the answer. However, I look to models emerging that are most relevant in terms of fair trade economics, including humane distribution of goods and services. In many ways, the United Nations' four principles for a sustainable future bridge this global/local integration:

 1. environmental sustainability
 2. economically competitive for all (implication is local markets)
 3. socially inclusive (social justice)
 4. culturally vibrant

The way I make decisions about my day-to-day existence is not at the nation state level so much as it is at the local level informed by the global. Both local and global, encompassing values of fair trade and "neighborliness."

PS: So, the nation state is becoming, if not irrelevant, at least not so much the center of power?

SRB: One might hope so. I found it very significant, in 2005, when a headline announced "In an unprecedented move for local officials, over 100 mayors across the country have agreed to abide by the terms of an international environmental treaty that President Bush rejected." In a recent news article it was announced that the demand for local farmers markets is currently outstripping the supply of farmers! And of course the organic movement is outpacing the FDA. We're not nearly as driven from the top down as we used to be.

PS: What kind of changes would this entail in terms of the various institutions in society, religion, education, politics, economics? What kinds of changes do you foresee?

SRB: I can't answer in that depth. I have named local government moving ahead of the national decision-makers, local economic development, and movement toward cultural pluralism. Another that is very apparent to me is how we organize religiously: mainstream, Protestant denominations in the U.S. are moving rapidly towards extinction. The faith communities that are thriving in this metropolitan area (Minneapolis-St. Paul) are those that are interdenominational, that are unitarian [not "Unitarian" as in the denomination] in thinking, that are as welcoming of those that share any number of beliefs from other world religions as much as Christian tenets. The spiritual faith groups that are growing invite spiritual expression without denominational dogmatism. I recently visited a Methodist-identified church that included spiritual practices from the Buddhist and Native-American as well as Christian traditions.

In terms of political structures, I don't have a clear idea of how these will change. While I've been in the DFL (Democrat Farmer-Labor Party) here in Minnesota for a long time, I'm extraordinarily impatient with the party and its seeming inability to focus itself on fundamental values rather than specific issues. To cite an example from our current political environment, the conservative right has done an excellent job of rallying voters around the honoring of "family values," yet that values-laden banner has then granted power which routinely dishonors family values in legislative platform. At the same time, the liberal left remains focused on fixing problems—and failing to gain political traction.

There's more and more disenchantment with our two-party structure. Ted Halstead, of the New America Foundation, has posited in his book *The Radical Center* that our two-party system is ri-

gid and a relic of an earlier era; that it is only a matter of time until the political system undergoes change of a dramatic sort toward a system more responsive to our pluralistic society.

PS: What are the events that you think are causing this tipping, or to use David Korten's words, Great Turning. What are the specific sources of this change?

SRB: For one, we have the largest wave of immigration that we've had in the last hundred years. While that wave of immigration is going on, those that wish to continue to think conservatively are pushing themselves ever the more into a very small echo chamber of only associating and communicating with those that share their belief systems (on both the right and the left). But for the more progressive population, open to differences, it's an enormous, fundamental source of change in worldview, simply because of the "mixing of the pot." That, coupled with the internet, and suddenly I can get my information from anywhere in any language I'm interested in.

PS: You are saying that change comes primarily from the mixing of populations and the technological ability to communicate across barriers?

SRB: Yes, those would be two. There is a third that might be related to that: young people have just grown up in a world that is very different. So, those premises that I use to define the way things operate, they not only call into question, but these ideas are not even in their thinking.

PS: For example?

SRB: A book I read recently, *When Generations Collide*, identifies differences among four generations, which are currently, for the first time in history, working together in the workplace:

- The traditionalists, defined by the depression and world wars. Traditionalists will "stay put" in a job, a lifestyle, for life.
- The boomers, defined by the civil rights movement and Vietnam. Boomers are passionate about social change, and extremely issues-oriented.
- The generation X-ers, defined by latch-key independence and the burst of TV/video. This is the "me" generation.
- The millennials, defined by Columbine, global strife and insecurity. The millennials in some ways identify as the boomers, but are not tied to nationalism or even necessarily traditional family and traditional localism.

What intrigued me most was the description of the millennial generation. This generation organizes at both the local and the virtual levels, but not at the nation state level. Their lives will follow their interests, without regard to national boundary, yet their lives will be very interconnected. They will place great value on a self-identified local place. This articulation of a generation, just now emer-

ging into adulthood, is absolutely true for my own millennial off-spring.

> **5 fundamental shifts – the defining "epic" changes of our time**
> 1. Climate change and the radical impact on our assumptions of "living without limits"
> 2. Urbanization and massive migrations of people and the radical impact on our assumptions about how we build community
> 3. Generational differences with four generations in the workplace, and the radical impact on our assumptions about how work is accomplished
> 4. Digital technology and the radical impact of the information age on how we access information and access the marketplace—the global economy
> 5. Political instability and the radical impact of worn-out political practices and systems on our ability to build the civil society of the future.

PS: What are the major challenges you see to this change in worldview; what would hold it back and prevent it from coming into fruition? Or will nothing stop it?

SRB: I think nothing will stop it. While it is easy to look in the present moment and see that we have a very reactionary conservative government, it is important to remember that this is just in the moment. I don't think the big changes are going to stop. The current political situation is, if anything, a reaction to these trends. It will be reactive for a short term.

PS: Horribly reactive.

SRB: Horribly reactive and maybe even so reactive that it's gone in a moment. I think changes at this level in society are unstoppable. Unstoppable because the change will continue to unfold at the grassroots level, as personal beliefs and needs for community, for security, for "sustainability to the seventh generation" become increasingly paramount.

PS: Of course, the big issues we face besides acceptance of diversity have to do with inequality, safety, environmental scarcity, those

kinds of things. How should or might we be dealing with those problems?

SRB: I have been pondering the question of "rootedness" lately. How do we find new senses of rootedness and valuing of place? The environmental movement is interesting in this regard because it's causing us to start thinking about being rooted in a place at the global level. We clearly need to act locally and think globally when it comes to the environment. We need to feel bound to the earth beneath our feet and need to be bound to our common global environment, focusing on keeping it in good health "to the seventh generation." As an old American Indian proverb states, we need to "keep our head in the clouds and our feet muddy."

PS: Don't you think the fact that Mr. Gore's movie won an Academy Award is an important symbol of increasing awareness of our environmental situation?

SRB: Absolutely.

PS: What about the inequality issue? Because, of course, over the last 30 years we've had an increasing level of disparity between rich and poor, both in our society and world wide.

SRB: That is also being called into question in the environmental movement as we confront global issues of climate change. We're not going to convince the Hummer drivers to change their lifestyle, but I am of the belief, long term, that the amount of global travel, the amount of immigration and emigration, and the amount of broadening awareness of environmental issues will begin to have an impact. It's much harder to ignore global disparities when the "other" becomes your neighbor.

PS: So that people, or least such a vast number of people, won't think it's okay to drive a Hummer and live in a huge house?

SRB: No, not necessarily that. But on a broader level, let's consider an example. Cargill's been getting bad press about how it deals with agriculture in India; as a result Cargill is beginning to change. The more we understand our world on a global level, the more we understand, for instance, that diversity of seed stock is critical to responsiveness to fluctuations in not only weather from year to year, but climate over time. The more our information age and the mixing of peoples bring awareness, the more there'll be demand for change. Again, it is within the realm of a groundswell—a grassroots movement. Is that too idealistic?

PS: No, it's not possible to be too idealistic in this world. I think we've suffered from a lack of idealism for a while. If we're going to deal with a more just and environmentally secure world, it's fair to assume that these kinds of changes will require engagement of the creative energies of many people. In particular, have you given any thought to what role the arts might play in this kind of society?

SRB: Yes, of course. To understand the place of the arts we need to go much more deeply than simply taking the Florida work of the creative class and applying it to the arts, because that's just one piece of the equation (Richard Florida, The Rise of the Creative Class). The recent research that you and I did together ("Thriving Arts, Thriving Small Communities," www.mrac.org/resources/pdf/ThrivingArts.pdf) highlights the importance of valuing the arts in giving people, first of all, the opportunity to get in touch with what I think is fundamental to who we are as human beings: the need to express ourselves emotionally. Secondly, the arts give us tools and ways to experience and redefine rootedness. So, the creative economy is not nearly as critical to me as what the arts can do intrinsically in terms of helping this newly confused humanity reconnect with itself spiritually and reconnect with itself in terms of ties to the earth and sense of place.

A delightful example is The Art Shanty Project. This project initially grew out of a fascination and interest in the traditional uses of frozen lakes in Minnesota, namely ice fishing and the use of ice fishing shanties. The project has grown to an annual temporary community of artists, scientists, ice fishing connoisseurs, and curious community members who gather over five frozen weeks to celebrate ideas of shelter, community, nature and the environment, and an ever-expanding definition of "art." Not to mention fun and fellowship. The Art Shanty Project offers part gallery, part residency and part social experiment, inspired by the tradition of ice fishing and ice fishing houses used in the Minnesota winter. (see www.artshantyprojects.org)

PS: So, we're not talking about how much money the arts generate into the economy. We're talking about the intrinsic value of the arts to the individuals and groups who participate. In particular, how can the arts and culture play this role?

SRB: One really fun example for me, which is national although I experience it locally, is the spoken word movement. The hip-hop generation has had all kinds of nasty press for what the major recording labels have done in terms of selecting hip-hop music that sends violent messages, sex, and all of that. This is most unfortunate because most of the hip-hop music that is created is just exactly the opposite. It gives teenagers—a population that is at the very crucial point of social and emotional development, needing to liberate itself from family and figuring out its place in the world—the opportunity to express this emotional confusion in a way that's extremely positive and extremely "now," extremely fun for that group. The number of spoken word, open mike nights, the number of contests: it's amazing! One local group, Teens Rock the Mike, have won national awards, gaining national prominence for the work they have done in spoken word. I spoke with their executive director, regard-

ing my interest in arts and environment. "So, Melissa, do any of your kids have an interest in and concerns about the environment and do you see spoken word that expresses concerns for the environment?" She said, "You know, I really haven't thought about that." However, it wasn't but about six months later that she e-mailed me and said, "Sharon, you'd be stunned how much I'm hearing in spoken word and poetry expressing the concerns of the environment." Of course, the teens are doing this on open mike nights. So, they're spreading the word. What a fun example of an unfolding movement! The millennial generation hard at work for change.

PS: Yes, that is a fun example. What are the specific arenas where you think the cultural resources that we have or might encourage would be of particular value or relevance in creating local rootedness? How might artists and arts organizations go about doing that?

SRB: The examples are just so myriad, they're so variable. I'll just offer two local examples. One is the White Bear Center for the Arts doing their iron pour. Are you familiar with that project?

PS: No, I'm not.

SRB: An iron pour is like a bronze pour. The difference is that iron is something that is a lot cheaper than bronze. It's basically melting all those old radiators. It's melting junk. And you can do beautiful, first-class, high art with a capital A work in iron. However, you can also do participatory arts projects. White Bear Center for the Arts did an Earth Day iron pour. They created molds that were 10" or maybe 12" squares of dense sand. Interested community members bought a mold and went to one of three workshops where sculptors taught you how to carve out your relief pattern, which you basically can do with kitchen tools. Then they sent you home and you had a month to create something in your mold to bring to the iron pour. What makes this a story significant to the topic at hand is that the entire city of White Bear became involved. The project culminated in an evening in a downtown parking lot where the smelter was set up and the flames shot to the sky. Community centers, a homeless shelter, a Somali group, businesses and civic leadership were all involved. Any interested individual had the opportunity to create a design in their mold and then have it poured.

PS: It wasn't the usual suspects.

SRB: It absolutely was not the usual suspects. They ran out of molds. They could have sold more molds. All the local businesses contributed and were open till midnight. It was a street party *par excellence*. Some people took the final products home. I have two iron pour products in my backyard. Most of them went into a mural that is on the outside of the community center. The event brought people together than never would have come together for any other reason. It gave them something really, really fun to do together, to bond with one another in a way that probably wouldn't have otherwise

happened. They wouldn't have come to a lecture series together. They wouldn't have come together to talk about strategic planning for the city. It bridged the Somali community with the homeless community, with the well-to-do that are the usual members of the arts center.

The arts center had been looking to relocate, because it didn't have enough space and it wasn't getting much city support. The final result of the iron pour is that, all of a sudden, the city is realizing they don't want the arts center to move. The arts center is an important hub and anchor for downtown. The city is now on board helping the art center resolve its space problems.

PS: Wow. That's terrific. From Robert Putnam's point of view it created both bridging and bonding social capital.

SRB: It created community.

PS: Okay, give me another example.

SRB: Let me offer another example within a completely different realm. I want to get away from the arts center mode. There are lots of examples of public art projects that have become focal points. One that comes to mind right away is that Metropolitan Regional Arts Council funded the creation of the mural on the wall of the Resource Center of the Americas, which is a political organization for the Latin American community. Their mural brought artists from Mexico together with residents of the south Minneapolis community who helped design and actually embed the tiles into the side of the building. There are a lot of stories in that mural and these stories are constantly used as examples in discussions of a variety of things that go on in the community.

PS: Like the Great Wall of Los Angeles?

SRB: Yes, absolutely. It's become an anchor in the community as well as a thing of beauty. So many public arts projects are capable of doing that. Of course, if you want regional arts council examples, we're full of community choirs and community bands and community orchestras and many ways in which communities bond and bridge through the arts.

PS: The unique qualities of the arts to create both bridging and bonding social capital, is, I think you implied, that it's not as scary to do art as it is to talk about prejudice? Let's summarize that. What are the unique qualities of the arts that do this?

SRB: I think that the arts are less threatening ways to gather. More importantly, the arts become a way that we celebrate our strengths and find ways to work together and build positive connections, celebrate common values, rather than focusing on fixing problems. That's a short answer.

PS: Is this a one community, one neighborhood at a time proposition? Or is there a way to make the arts and the unique strengths of the

arts move into the corporate arena to create this wider change? You know, connecting-the-dots?

SRB: Well, you do fill orchestra hall one ticket at a time. I think that, obviously, projects happen one at a time. I think you create the buzz. You create the excitement and you start the prairie fire. I think that our "Thriving Arts" work is one piece that is doing that in the state of Minnesota, along with Ann Markesen's art center work. You create an understanding of the value that something has.

PS: I think it is also true that you create a recognition that you are not alone here. There are all these other folks out there doing the same thing or thinking the same way or having the same goals.

SRB: Unfortunately, we do live in the world of the one-page memo. People are looking for sound bytes more than they're looking for large complicated arenas of information that they need to distill. That's one of the sad truths of our age. We're not going to read *War and Peace* and figure it out for ourselves. It brings me to a suggestion and a thought. I spoke on Monday night to the Shakopee (a Minnesota community) strategic planning team that's putting together the comprehensive plan for the park and recreation system for the coming decade.

When I was done with my presentation, I debriefed it a little bit. They said what they really, really appreciated in the presentation was the articulation of values. Prior to my presentation I had listened to an hour and a half of all the "sports people" arguing over the need for more hockey equipment . . . the need for more gyms timed for volley ball . . . the need for more tennis courts . . . the need for more of this and the need for more of that. Problems to fix. Issues-based presentations. When I spoke, I took all of the concepts in "Thriving Arts" and all of the concepts out of the RAND model (*Gifts of the Muse: Reframing the Debate About the Benefits of the Arts*, RAND, 2004) which articulate the value of the arts and articulated those values while making parallel comments to sports.

PS: Good for you.

SRB: What they walked away with was an understanding gained from hearing the articulation of those commonly-held values. For we all want life-long learning, we all want life-long health for individuals. We all want healthy communities. We all want participation and participatory opportunities. We all want rootedness. I spelled out the values and talked about the role of the arts and then told stories. I went through the values (from "Thriving Arts"). I had taken the time to find two park-and-rec programs in the metro area that were working in each of the value areas. So, I could tie it to their specific park-and-rec program. I think in the era of the one-minute memo, we need to help people articulate their values.

PS: I think you're right. I think a lot of changes are happening, but they're not on the major media.

SRB: Absolutely not.

PS: And insofar as people think that what the major networks provide is reality, then it's going to be difficult for new ideas regarding how we act out our values to take hold. But I think people are realizing that there are other ways to learn and connect. I don't know. Maybe that's just my sort of cock-eyed optimism.

SRB: No, I think it's really true. Have you read *Don't Think of an Elephant?* It's a political piece. The point that it makes is don't give people messages as riposte to something else. In other words, don't be reactionary. The other point it makes is not to talk about issues, but rather talk about the values. Find common ground on commonly held values. Work from common ground. I'm going to put this in political terms because the Republicans have done a good job of figuring out what some fundamental values are and then usurping them for political gain, family values.

PS: And co-opting groups who share those values.

SRB: Right. Yes, and the Democrats respond with issues.

PS: Good point. This is similar to a piece of work that my colleague up north showed me of studies of the environmental movement. The point was that environmentalists tend to talk in terms of issues instead of values. But it would be more effective to talk about values.

SRB: Yes. For instance, there is the Seventh Generation Fund; they named their organization in terms of a value. The environmental movement is another really excellent place in which the arts can be very useful in terms of reaching people at the emotional level, at the level of the soul rather than at the level of guilt, of fixing problems. Another area comes from my public health background. Public health has studied how you change adult behavior: smoking cessation, weight loss, etc. It is very clear that adults do not change their behavior based on being talked to, on lectures alone. Adults do not change their behavior based on reading something, on didactic study alone. Adults change their behavior when it reaches them on an emotional level.

That's a very shorthand synopsis. But, there's so much literature out there about best methodology to change adult behavior and the environmental movement could learn a lot from that literature. The arts become a particularly important tool because the arts are an area in which we bypass rational thinking and express our soul, our passions.

PS: True. So, it's not a matter of argumentation? It's a matter of expression. Are there specific strategies that arts organizations, artists, and creative people ought to be using to reach out to environmental movement, the political process, or community development? Are there specific strategies, or is it just like a wave that these things will all come together by themselves?

SRB: The first is to be at the table. The arts, just as much as other forms of organizations and other sectors, need to get out of their silos and be at the table. We're doing just so much work trying to help the arts community articulate their values, articulate the public value of what they do, and understand the public value of what they do. I do a significant amount of work in strategic planning with arts organizations. I'm making sure that every single organization I work with, first of all, articulates their own values and then articulates the public value of what they do. That each organization thinks through how they are a part of the community.

PS: In your work, do you get them to think in logic model terms of change? That is, if we do this then that's going to happen? I think that is necessary. It's hard work. I don't know if it's any harder for arts groups to do that then anybody else, but it is hard.

SRB: I've done two workshops now that have gone significantly beyond the hour of adjournment, when I was ready to go home and participants were not. This was because we skipped organizational introductions at the beginning of the day. I facilitated conversations in small groups: "this is about arts participation, and we are working on knowing yourself and then knowing who you want to reach. You are preparing to introduce yourselves at the end of the day." In the last hour of the workshop (which turned into an hour and a half plus), each group introduced themselves, named their values, named their target audiences in their community, and named how they were going to reach that target. Then the group gave them feedback. Yes, we were doing a bit of a logic model development, although not formally. We were publicly reinforcing our commitment by having to stand up in front of the group at the end of the day and share ideas and get feedback. Everyone loved the peer feedback. No, it isn't going to happen passively. It's going to happen because there's hard work.

PS: I gather you think there are enough light bulbs on around the country or even around the world, that this movement to re-invent our ties to each other and to the earth is going to self-perpetuate and move forward. And that the arts will be one element central to this movement.

SRB: Yes, idealist that I am. I've been looking at state arts boards strategic plans; I've been looking at them in order to understand, "what is a strategy, what is strategic thinking?" A strategy to me, in a business-planning sense, is not how you're going to figure out how an objective is to be met, but strategy is at the largest, grand scale. It is: what are you going to do to have an impact? In the logic model sense, your strategy is what you're going to do to have your desired impact in your community. The state arts boards get varying marks from me in terms of their ability to think strategically, and to think through the role of the arts in change. One of them that

I thought was nicely articulated is the Montana State Arts Board, which has three strategic directions. The first is arts education, because they know that unless you are building arts literacy and arts participation from pre-K on up, you're not building tomorrow's arts community. The second is arts and economic development because they feel that unless the arts are always engaged in being a part of the all Montana rural communities at the level of civic participation, they're not going to be valued. The third was fund the state arts board. But, they acknowledge that the last one is in service to the other two.

PS: In Montana, they're anxious to make sure that the arts are at the table?

SRB: Yes, absolutely. With those two strategic directions, the Montana Arts Board has thought through how to be intentional about being engaged in this change. This is something that all of us in the arts community need to do.

Chapter 24
Gregorio Luke

"Providing a community plaza"

Gregorio Luke is the Director of the Museum of Latin American Art in Long Beach, California. He is the former Consul for the Cultural Institute of Mexico in Los Angeles, Deputy Director of the Mexican Cultural Institute of Washington D.C., and First Secretary of the Embassy of Mexico in Washington D.C. He has organized exhibits, concerts, lectures, book and film festivals, and seminars. He's also lectured extensively on Mexican art in museums and universities in Mexico, Europe, and the United States. Since coming to MoLAA in 1999, Mr. Luke has continued to apply his wealth of experience to lead and administer the cultural programming of the museum. At MoLAA, Mr. Luke also regularly lectures on Latin American cultural subjects and personalities such as: the Series on Mexican Culture: History, Cuisine, and Dance; Diego Rivera, Frida Khalo, David Siqueros, Earnest Hemingway, and Octavio Paz.

WC: From your perspective where are we in the human historical journey?

GL: When he received the Nobel Prize for literature the great Mexican poet Octavio Paz said, "We're looking at the emergence of the age of fraternity." What he meant was that during the 20^{th} century, half of the world, meaning the capitalist countries had focused on the idea of liberty. He said if you only focus on liberty, you end up in a very unequal society. The other half of the world focused on equality, meaning the Communist countries. But if you try to force equality, you end up with a society that ends up curtailing liberty. Now, he said, we have forgotten that modern democracy is not built on two concepts, but on three: liberty, equality, and fraternity. According to Paz, the only way to reconcile liberty and equality is through fraternity. If you read Octavio Paz, it's surprising how he saw so many of the things that are now happening. He says he believes in the resurgence of poetry because poetry is the language of fraternity. When I look at what's happening today with the rappers and I look at this whole resurgence of the word, of the need for not just music and rhythm, but also meaning, communication and understanding, I think that we're seeing a deep need to express what is happening, of reconnecting, of rethreading, so to speak.

WC: Do you think that the modern world that we live in is becoming less understandable, maybe more mysterious, and that this causes people to look a little deeper for those moments of meaning?

GL: I think we have seen the collapse of ideologies and the collapse of simple answers to things. For many years, the idea of society was quite mechanistic. People thought the problem was with the system. So, if we change the system then things will automatically fall into place. The problem of injustice and the problem of inequality were seen as mechanical and systemic. But then, we have seen that the change of systems alone does not solve the problems. The solutions have to be found in ways that do not preclude the possibility of individual responsibilities, of the creative solution and the asking of new questions. I think that right now what we're looking at is the multiplicity of responses that people are giving to try to address the issues of meaning. Some of them have found them in the resurgence of religious beliefs, religious philosophies, the idea that maybe what you need to do is go back to the certainty of faith. Others are looking at ethnicity as a common thread.

We are witnessing debates that are no longer only economic. See, when we lived in the cold war scenario, the fundamental debate was an economic debate, over who should own the means of production. Should it be the individual? Should it be the state, or should it be a combination of the two? But, now, the answers are much broader than this. When you look at the resurgence of fundamentalism, the new jihads of this world, the whole resurgence of

nationalistic forces of ethnic tensions, of religious wars—all these things are no longer based exclusively on economic terms. These debates are not even within the Western society or within the cultural parameters of the West. To some extent, they are not even debates that are occurring in the same historical cycle. I wonder if George Bush were to speak with one of the Ayatollahs that they would even be speaking in the same time, historically. If they could even make sense to each other. I doubt it.

WC: This reminds me of another book I am researching where there's a description of a first encounter between Australian whites and Aborigines. Although they were all *Homo sapiens* they had almost nothing in common, not a conception of time, or of space, common language, nothing.

GL: I was recently in Australia and I went to Uluru. It was an interesting thing because we were all looking at it, and we were all saying, "that looks like a wolf, or no it looks a this or that." At some point this Aborigine guy said, "You see the main difference between us is that for you, this is a rock that looks like a wolf and for me it is a wolf that looks like a rock."

WC: Yes, I was talking earlier today to Judy Baca. One of the points she made is that we are at a time of extreme contradiction where you have greater mysteries and a desire for greater surety that are coming in conflict. Does that ring true?

GL: Absolutely, what you're looking at is the orphanhood of reason. I mean, if you are a communist or a fascist or you are deeply religious, you can fall back into a series of certainties that reduce your existential agony, because you have clarity. You can back up in tradition. I think that part of this is that we are living in a very uncertain age. We are in the moment where there are no longer universal certainties and where it is not clear what the future is going to look like or even what it should look like. After the fall of communism, the idea was that maybe the response will be democracy and free-market systems. But, the problem is that markets and democracy are only a method. They are not an answer in itself.

Mexico is a perfect example. For 70 years, we had the rule of a single party. It was a universal conviction that what needed to change was to defeat the party and to have democracy and that that would automatically solve the problems. What happened is that we had democracy, we had participation, we had elections. An opposition party won in the case of Vicente Fox and then nothing changed. We opened the markets; all of these things that supposedly were going to lead us to greater prosperity and to greater equality did not occur. As a matter of fact, Latin America as a region embraced a lot of these free-market policies, and these democratic reforms; from a region that was largely dominated by dictatorships, now most of the countries in Latin American have what

you could describe in general terms as more democratic institutions. But, sadly, these did not solve the problems. The misery is just as bad. The inequality is just as bad.

WC: So this is an example of that mechanistic approach which assumes that if we change the system or change the leader, somehow everything will turn out better. But, you're saying it's a lot deeper than that.

GL: Exactly. I think of all the artistic figures in Mexico, perhaps the one that has responded better to my present concern would certainly be Octavio Paz. But also, Jose Clemente Orozco. Diego Riviera and Sequieros were militants; both were absolutely convinced that the future lay in socialism. But, Orozco, who had started his career as a journalist, was the deeply distrustful of any form of ideology. He does these murals in which he puts on the same trash can the communist hammer and sickle with a Nazi swastika, even the Christian cross—all on the same can. In his paintings, he savages not only the upper classes, but also the submissive, ignorant, vociferant mobs. Whereas Sequieros believed in the mob, the proletarian masses marching towards the barricades, Orozco paints mobs that are only teeth and machetes, or he paints the new tyranny of the union bosses. He does these corrupt judges. He does all these absolutely intense criticisms of society. Then in the University of Guadalajara, in one of the domes there, he created a fascinating image of a man that has five faces, which is the inquisitive mind, the creative mind, the architect, the builders.

At the time, people accused Orozco of being anarchic or chaotic in his ideology, of not having a faith in the proletariat. I think that Orozco was anticipating the future in the sense that these automatic solutions have not worked: dogma has not worked, systems have not worked. And what we have is questions, the need for creativity, the searching for original solutions for the different places and times we live in. We need a combination of new methods and new responses that are relevant to these places and times. I think that this is the challenge.

WC: It sounds like these five faces could be the multivalent man or the essence of "fraternity."

GL: Exactly. Also I think the U.S. is a very good example of finding original solutions. I have been rereading John Steinbeck. I've been reading him ferociously. I just finished *Grapes of Wrath*. It amazes me the country Steinbeck portrays in the 30's. The U.S. was a country that had every symptom of a third world disaster in the making. I mean here you had workers from the dust bowl going to California with wages getting worse everyday and a system of political oppression, with lack of opportunity, with lack of political expression, with a system in which everything is owned by banks, where it seems to be heading towards a violent revolution. You read Stein-

beck and you say what is going to happen with this society?

How is it possible that we went from that period of the Great Depression with people owning nothing, with no land, with no hope, to the current reality? A current reality where, of course, there is poverty and immense problems, but a place where somehow the institutions were able to change. A place where there were creative responses. You find the New Deal. You find F.D.R. You find systems of redistribution of wealth, the fortification of social mechanisms to alleviate poverty. There were many solutions that were originally designed then that made it possible for this society to renovate itself. That, unfortunately, has not happened in many third world countries in which, many times, what we try to do is to adapt what has been done here or there.

WC: Yes, through the World Bank or IMF.

GL: With very negative results, because once more, solutions cannot be just be mechanically adapted from one society to another. There has to be a point where you introduce the man of five faces. A point where you question and you find within yourself solutions that at the time might seem impossible. Such as the idea to use massive public spending in a capitalistic society to raise people from the depth of the depression. So, in general, I think the mechanical application of other models to other places is not viable and that we need to find new solutions and new ways that are relevant.

WC: Where does human creativity, particularly individuals whose lifework is artistic, fit into that new script?

GL: The biggest challenge facing artists is to resist the forces of the market. The greatest danger that artists are facing today is to become a commodity. Because what happens is that nowadays we are looking at a patron that is nameless. Today, it is possible to create something in an arbitrary way that becomes recognized as a work of art, not because of its relevance, but simply because of its position in the market. Because the boundaries are no longer technical or even expressive. What do I mean? Well, if you went to a traditional museum and you saw a work of art by Rodan or Michelangelo or Rembrandt and you went out and tried to do exactly what you had seen in the museum, you would immediately discover the distance between you and Michelangelo. You would immediately see in a very objective manner why that piece is hanging in the museum and your piece is hanging in your bedroom.

But, nowadays, there are many instances in which I go to exhibits and look at things that are hanging in the walls that are canonized and they're no different from anything that I could do. Sometimes they're not even original ideas. The things that Duchamp thought about 80 years ago. Those pieces are worth millions of dollars and what I do is worth nothing. Why is that? Well, because it happens that that piece was canonized by some critic that claimed

it a masterpiece. Then some collector bought it for a couple of million dollars and then, because museums are increasingly dependent on philanthropy, once that becomes part of the collection of an Eli Broad or whomever you want, then you exhibit it and you recreate the review and pretty soon, arbitrarily, that becomes a masterpiece, even though nobody connects to it or understands it. This has always been the case, but I think it never has been so arbitrary. It has never been so capricious.

Yes, obviously, politics have always been involved in the arts and, obviously, if an artist is a good politician and networks correctly and is related to the Pope or whatever, obviously, it will make a difference in how he's perceived. There always had to be certain thresholds. You could not just take a piece of wood, stick a neon sign on it and make it a masterpiece just because you say so. But, today the strange combination of market mechanisms and the broad ignorance of the general audience makes it possible that you can basically proclaim anything a masterpiece.

WC: Is there another path? If I'm a young creative person who has an incredible facility with painting or rap music or with my computer and the market is beckoning me. How do I protect my soul or my creativity?

GL: You must not create for the market. You must create for yourself. But you have to be careful. What I just described is just one of the processes out there. Another process that happens is artists come up with a certain type of imagery and then become known for that. They become marketable and they have a gallery that represents them and then people expect them to continue doing exactly the same type of imagery.

WC: So they're stuck.

GL: And they're stuck because if they change too much it's a problem. I mean some gently evolve, but if this guy that is known for his big abstract color now suddenly starts doing something that is totally different, the galleries will not touch him. Even though it might be great work, they won't touch it because he is not considered reliable and because his work has become a commodity. If you're producing a Mercedes Benz, you expect that. But now we are applying the same idea to art work, sculptor or whatever.

I think that all these market mechanisms that have been applied to the art are essentially teaching people the wrong lesson. If a critic has the power to determine value then we're looking at a true alchemy, no? When certain people can look at anything and transform it into gold, it's the age of alchemy. Then, if you say "that's a piece of trash," well then, you are a conservative retrograde that is stuck in the 19th century. This is more about being strategic than about art. So, you learn what is important, you find a niche and you negotiate the market. But, you are not being called upon to

improve your technique or deepen what you wanted to say. Quite the contrary. Sometimes, those things do not get you closer to the goal. I think that artists need to be selfish in the best sense of the word—to not worry about the market and not worry about the future and not worry about sales and to focus inward to look for something that satisfies them. Then if it sells or it doesn't, that's another problem.

WC: You mentioned Orozco and Sequieros, artists whose connection to the social and political events surrounding them manifested through their art. There are artists who are responding in similar ways now. The Continental Harmony composer residency project that your museum participated in brought artists in to meld their own creativity with questions rising up from the community. Do you think this a fruitful partnership for artists or do they need to be isolated and separate?

GL: I think that artists have to become political. When I say political, I don't necessarily mean in the nature of the art itself. I'm not proposing going back to the clenched, enraged fist of posterism. What I mean is that artists have to fight for being included in the budget. I'm amazed that the L.A. Unified School District is engaged right now in the largest construction of schools in the history of the world and have not allocated one penny for artistic projects. That is amazing, but what is more amazing is that nobody's making a fuss about it. Why aren't all the artists of L.A. picketing out there and screaming and making a big noise about it?

WC: Or the parents, because it's their kids and schools should be more than walls and chairs and tables, but rather a place of beauty and provocation and inspiration.

GL: Why aren't people banging the walls of the Mayor's office? How is it possible that they eliminate art education and the music in schools and nothing happens? Artists have to go in there. They have to fight. Museums have to be militant. They have to go out there and insist on public funding. I don't believe that this model of leaving it all to the private sector is viable. As a matter of fact, I think it's a death sentence to the arts. As long as there isn't a steady and growing subsidy for the arts, like in Europe, it's not possible to have affordable prices. It's as simple as that. Yes, maybe you can do a concert or two and have a kid go once every three years to hear the Ninth of Beethoven, but that's not going to make an audience for the future.

What needs to happen are two things. First, arts events have to be offered on a regular basis and families have to be able to attend on a regular basis. In other words, there has to be a marketing effort, and there has to be the possibility that you can go to the concert with your wife and your two kids on Sunday like you used to in New York in the 50's. Back then, when we were a much poorer

nation, people could go to the New York City Ballet and the symphony for only a little more than if they went to the movies. Try doing that now. How many people can regularly go to a show that costs $120? I can't. Can you? It's impossible. If you have a wife and two kids, going to the symphony costs you $500. You cannot develop an audience that way. To develop an audience, to get people hooked, you need to be able to go many times. Ballet, music, opera have to become affordable again. You can only do that through public subsidies that come from the conviction that the arts are important. Museums are the last bastion of popular culture, the last places and even that is under threat. We're looking now at museums that are beginning to charge $20 or $30 to enter. Art has to be affordable. It has to be available and it is critical that art and education be linked.

There is a Mexican philosopher, Jose Vasconcellos, who believed that to be effective education needs to be linked with the artistic element. This is why he promoted the muralist campaign. The muralist effort in Mexico is not a fine arts project. It is an education project. It was based on the idea that art, literature, music, and dance provide the inspiration that sets history in motion and provide the inspiration and the impetus to allow a young boy or girl to imagine, to unleash the force of their imaginations. That's where creativity and productivity are, not in the dry memorization of facts and numbers.

Now with all the emphasis on testing I think we are forcing the education establishment to become less creative. As a result we are dramatically restricting the liberty of the teacher to attend to real learning and expression. At the same time with reduction in creative outlets for performances and exhibitions we're looking at an artless society. We're looking at a generation of young men and women who have never been exposed in any meaningful way to the artistic canon that has sustained the West for 500 years or more.

WC: It sounds like you're describing an education of one face rather than five.

GL: Exactly. There you go, and at the same time, a very limited historical consciousness, a very limited humanistic consciousness. We're looking at a process of almost de-civilization, a devolution of consciousness. We're looking at the resurgence of tribal conduct. We're looking at codes of behavior that are more primal and a dramatic disconnection with history, which is even more frightening. I mean, why are the arts so important? Why is it that they are not just an ornate element? Well, if you think of it, art is the historical glue of society. If you want to know more or less what it must have been like to live in the U.S. in the 1860's, read *Uncle Tom's Cabin*. Art embodies the possibility of understanding other societies and other people and of connecting. Art, as Ernst Fisher says in his beau-

tiful *The Infinity of Art*, is the magic that works. In other words, the manifestation of art is very connected to the necessity for magic. Humans gained power when we discovered tools because tools gave the primitive human power over nature. With a club, a human could be as strong as a bear. With an arrow, you can be as fast as a deer. When you apply this idea to other forces of nature you dance as a way of making it rain. You paint the cave wall as a way of producing an abundance of game.

The fascinating thing is that this magical process of dancing or painting or singing works. It works not because of the effect it has on the external universe, but in the cohesive element that it awakens in those who participate in them. In other words, those who dance together do become stronger. Those who paint the animals do gain power over the animals. Why does it do it? It does it because it increases communication within society and because it allows you, later on as society evolves, to establish communication and understanding with generations of the past. What will happen when we end up with generations of people that no longer have that element?

WC: It carries the story forward. So, if we are at a time that is desperate for the five faces, a time that is desperate for fertile imaginations, what role does an institution like yours need to play?

GL: I always tell people that my goal is to be able to create a fusion of a gallery, a classroom, and a nightclub. The museum thinks of itself as part of the entertainment business, not necessarily as part of the cultural business. Our competitors are not the Long Beach Art Museum or the L.A. County Museum of Art. Our competitors are television, the film industry, surfing on the internet, and the beaches. We have to be able to find ways of attracting people. Our case has been particularly dramatic because we have never had at our disposal the traditional marketing tools of museums. What do I mean by that? Most museums rely on the so-called blockbusters, which are pretty predictable. They're codified. Certain artists become golden for some reason or another—Van Gogh, Picasso, the Impressionists, King Tut, things like that.

WC: The Titanics of the art world.

GL: So, 15 years or 30 years later, we're basically recycling ideas from the past; it's pretty predictable. In the case of a contemporary Latin American art museum, maybe if you're lucky, you could end up with a Frieda Kahlo show, maybe a Tamayo or Botero show, but that's pretty much it. In other words, the possibility of coming up with a name that is universally recognized in and of itself that can fill your museum is inaccessible to us. We don't have Latin American Andy Warhols or Picassos. Most of the artists that we feature are unknown in the U.S. Finally we have an exhibit of Guillermo Trujillo or César Menéndez and so on. So, you know normally what

museums do: you have your Impressionist exhibit and you have a series of lectures and workshops where you talk about Impressionism. Everything is subordinated to this big name that sells. But, if you have an artist that's completely unknown, even if you had the money to put banners all over the world about it, nobody will come. Then if you organize all kinds of educational workshops on the work of Menendez and his contributions to the culture of El Salvador, nobody will come either. So, we faced this challenge that was, for us, very dramatic, because we needed to bring the crowds to the Museum of Latin American Art. What we did was create a different structure for the museum in which the curatorial department would, of course, be a wheel, but would not be the main or the only wheel. Simultaneously, we created a special events department and an education department. So every exhibit we develop has a series of programs and support activities. But overall we tried to articulate the activities of these three engines with the mission of the museum and not necessarily with the exhibit at hand.

For instance, we have an exhibit of Cuban contemporary art. I sit with my people here and I say, "Okay, how are we going to bring the people here? What do you think?" Of course, I have a talk about Cuban artists, but what else can we do? Well, why don't we do a Hemingway presentation? Hemingway loved Cuba. Good, that way we bring a lot of people that would never come to a Cuban show and come to a Latin American museum, but love Papa. We are able to get all those people who have read *The Old Man and the Sea*, all those people who love his hard-boiled character, all the English professors. Then we say, "Well, why don't we do a night in Havana and bring in a Cuban band and serve the best mojitos and daiquiris." We can get some of the exotic Cuban dancers and we create a whole ambience, like a nightclub with drinks and food, and promote it everywhere. Then we get all the Las Vegas crowd. All these people that love this exotic ambience but would never, ever, ever go to a museum.

WC: So the museum is a cultural center?

GL: Yes. Then we say "Che Guevara" and we get the hard left; they come and see the exhibit and we do a whole presentation. Tomorrow, we're doing a night in Argentina. It has nothing to do with the Cuban show, but Che was from Argentina. All these events are not free. We charge as much as we can. A ticket is going to cost you 60 bucks. So at these events you have people who were having a good time, talking loud, ordering drinks, looking at this or clapping—they could have been in a bar.

WC: In Cuba.

GL: Yes. The television station is coming today and we are thinking we will not only sell out, we were going to leave 200 people outside the door. And then we do things for the children: we do summer art

camps and we have dance classes. We bring in all these different groups that come here to learn about art, the conventional museum public that would never go to a nightclub, that would never go to watch a Tropicana show, but they trust the museum and so they come too. So you get this incredible mix. And that mix is what we want, too, because these people never see each other, anywhere.

WC: So this is more than a party.

GL: Yes, these people are separated in our community. In a small way we are providing a common ground, a community plaza, a safe place for them to see and experience each other as flesh-and-blood people. You know the precondition for any kind of genocide begins by making an abstraction of the human being. In other words what did the Nazis do before the Holocaust? They basically separated the Jewish community from the German community. Then the Jews became an abstraction. People were not allowed to contact the other person. But here we are doing it to ourselves. You have the blacks and the Latinos and the whites and everybody's separated; our society is resegregating itself. So, when you bring them together and people dance and see the Mexican and the guy there poking his nose and the white guy over there enjoying the tequila and the Asian couple dancing, you get a chance be in the same place, have fun, and even learn something. Museums are ideal plazas for this. Museums are wonderful venues to bring people together, to let people know each other.

 In order for museums to become this kind of a place for a community they need to transform themselves. They cannot continue to be the passive curators of exhibits that are already codified. They have to transform themselves and become a true museum. I always say the word "museum" refers to the home of the muses and the muses are not just painting and art. But some people say to me, "Oh, you're not a museum, you're a culture center. I say, "No, we are a museum. It's the others that are not museums." Museums are the unity of the muses. The muses are literature, poetry, music, dance, painting—all of these things. This idea of museums as essentially visual art institutions is a wrong idea, because a lot of the other artistic forms have become inaccessible for the great majority of the population.

WC: They're segregated.

GL: A museum needs to be a place where people can still connect with each other and with other artistic forms of expression.

Chapter 25
Linda Burnham & Steve Durland

"Community arts –– the cutting edge"

Editor's note: The interview with Linda and Steve was, as might be expected, wide-ranging. Accordingly, we have divided their contributions to the project into 3 parts. The first portion was included in Part 2 as Chapter 11 along with their respective biographies. In this section, they bring their considerable community arts expertise directly to bear on the need for local action. Their remaining contribution will be found in Part 6 as Chapter 28.

LB: I have something to say about the arts, about artists. About ten years ago, I went to a conference in Liverpool, England. We had a speaker, Burt Mulder (see the final section, Chapter 26). He said: "I know that you people are all suffering for lack of funding and your organizations are on the ropes, but don't worry. At the turn of this century, artists are going to be absolutely necessary, because the only way we are going to get out of all the problems we're facing is creative thinking; we will need to take everything we have—technology, raw materials, and our stories—and use them creatively to solve the problems." We have talked a lot about this since then and I do think it is happening.

Recently in England, I met people from group called Creative Clusters, a practicing group of artists, technologists, and industrial designers. They are trying to get people interested in artists as problem-solvers. Steve has always said that our assignment as artists is to solve problems.

PS: That's interesting. Another person I interviewed made the same point, when I asked her what artists might be doing. She said artists are just basically problem-solvers. They have to figure out how to phrase that set of notes or what to put in this corner of the canvas.

LB: Problems inspire artists. They love them. They just love them.

SD: What goes hand-in-hand with that is we artists are taught to look beyond past solutions and to not be afraid of something that hasn't been done before. Most people, especially politicians, are afraid and understandably so. You raise the capital gains tax or you lower the capital gains tax; you do something that's been done before, not something that nobody's ever done before.

LB: That's all artists will ever do.

SD: People live their lives like that, too. That's why it's so hard to change anything, even when it makes sense. Artists are the one group of people who are trained to make that leap and hope that it works.

LB: They're actually born like that, I think. There is another interesting thing about this moment in time. A lot of us came swarming out of art schools in the 1960's and 1970's. It was a huge bumper crop of artists. Now here we are, and everybody behind us had art cut out of their school programs. Plus, we're the people who were brought up on the Whole Earth Catalog, so we are that kind of problem-solver. We are very motivated to get out there and solve these problems. And our generation of artists evolved into the community arts setting, which is, I really believe, the cutting edge of what is needed. Our whole group evolved into community artists with the idea of making things manifest in everyday life. So artists are going to bring issues out into the open, help foster change, and create the paths to get us out of these messes. They're going to see that it's their job. I heard on the radio that there's a big event in

Raleigh [NC] today for Earth Day where dozens of people are out-
doors painting. "Here I am. I'm not pulling a gun on you. I'm paint-
ing." I think there is that impulse to not stay in the studio, but to
manifest creativity as broadly as possible. That's why Community
Arts Network is on the web.

When I turned from performance art to community art in the
middle of the 80's, I saw artists trying to confront social problems
as artists because they couldn't do anything else. For example, John
Malpede started the Los Angeles Poverty Department, a theater
company of homeless people in 1985. He was the first artist I knew
well to do that kind of work, dealing with a population of people
we had to step over every morning when we left our studios. He got
a part-time job with a free law center as a homeless advocate. But
he didn't know how to do anything else except start a theater com-
pany. That's what I wanted to find out about: who these weirdos
were and what they were finding within themselves to actually
change the world. They had to do it as artists because it was prob-
ably too late for them to do anything else.

PS: Are you suggesting that there's a certain generation for whom the
arts as a transformative power is particularly germane?

LB: Yes. There was a very strong spirit of activism in our generation,
but I think activism is attracting more and more artists to it now.
Older activist artists will pass their lessons on and say, "Well, here
are some of the things you can do." I just think that something is
flowering now which will really come to the rescue in terms of all
these crises. It will happen. I don't think that these are people who
can do something else, and they will do it through their art work.
Whether it's going to save the planet or not, I don't know.

SD: When I think back to when I was in graduate school, we were act-
ivists in our vocabulary and our thinking. But it was so simple; you
know this idea of "I'd like to teach the world to sing" or something.
We were all very naïve; we talked about Marx then. We were going
to break down the capitalist system by creating unlimited multiples
of Xeroxed books, take out Rockefeller, do performances in the
street for the people. We didn't know very much. We thought
about things a lot, but we had no real sense of where that was going.
What I've seen in the last 30 years is my generation of people get-
ting more and more sophisticated and understanding things. We
started from a very loud activist art that named the problems, but
never really did anything about them.

PS: Sort of confrontational art?

SD: Yes, preaching to the converted sort of thing. Here's my art that
says "I don't like AIDS" and here's my art that says "I don't like
apartheid." Eventually, what people realized is that you had to be-
come invested in something; community art ideas came from that,

because artists realized that they couldn't accomplish anything on the outside.

PS: So they needed to be embedded in a community?

SD: You had to get actively involved in the issues that you wanted to address.

PS: It wasn't enough to do sloganeering?

SD: Right. The visual arts had an interesting vocabulary that developed in a way that didn't happen in the other arts. Back in the 60's, conceptual artists were talking about systems aesthetics. They were doing things that were about social manipulation. At the time, it wasn't political, but it was social. That laid the groundwork for artists to give themselves permission to take that same construct, add some content to it, and still stay in and of the real art world. But the people who really take to it are the performers. They had the feeling that going off in this direction meant that they were no longer to be taken seriously as artists, and so they struggled with that.

PS: It wasn't real art any more?

SD: Yes. One of the things I've tried to do is point out that you're still part of that great tradition of Western art. As limiting as it might be, there's still a part of you that wants to be that, because that's where your thinking is. That's what you learn when you're going to school; you never felt like you abandoned it. Why did everybody decide that you had? My argument is that, well you haven't. Sometimes we need to share vocabularies across disciplines in order to make sense of the new.

LB: I have a great quote from Matt Schwarzman. He said we need to articulate the difference between art that is about politics and art that is political. It is not enough for art to represent a political event for others to observe; it must also provide a context within which others can take action. So that if you have a project that results in people changing, that is true social change as opposed to something which happens at the policy level.

PS: You're suggesting that the character of the arts which make it possible to be a positive force in the future, if the world doesn't fall apart and if the worse doesn't happen, is because of this problem-solving character and because of the activist nature of at least your own generation of artists?

LB: Yes, and I also think women have a huge amount to do with that. One of the reasons I came to the art world in the 70's was because of the feminist art movement. I saw some things on TV that made me want to get involved with feminist artists and it was the first time art, spelled A R T, ever had anything to do with my life. They were making art about what a woman's life was like, and with communities of women who weren't artists. I think that the fact that women have finally penetrated the art world and are in fact running

it, brings in a lot of feminine values. Women care about their families and their children in a really primal way. So, there is a caretaker element that's part of the art world now. Unless they figure out how to jam us all back into the bottle, I don't see that it will go away. There is a real human element to things now.

There are a lot of really powerful women artists of color who are running programs, for example, in California and New York. There's a woman named Marta Vega who helped start the Musee da Barrio with a bunch of Puerto Rican parents in the Bronx. The parents came to her and said we really need a place for our culture to come together because what we see around us doesn't chime with how we grew up. Now, she runs something called a Caribbean Cultural Center/African Diaspora Institute. I met her and two other women from California at a conference last fall. They were the three keynote speakers, so generous and so brilliant about what culture is. I wrote an article for the catalog from that conference, called "Listening for the Lexicon of Cultural Shift." People are talking about art in a new way or in a different way than I'm used to hearing about it. So, I took my notes and created a whole lexicon out of how they talk about ways that artists and art work in communities. They have gone beyond the "Screw Whitie" period to: "we want to make family with all of you and we want to help this movement grow and become really effective."

PS: You said something about the generations coming up behind you who had art cut out of the curriculum. Was the implication that they are less on this path than your generation and that your generation has some kind of peculiar responsibility or opportunity?

LB: We're the teachers. We're the leaders who founded a whole alternative art world. Most of the young activist artists that I meet in community arts had parents with the same kind of values; they either steered or allowed them to move into the arts, carrying those values with them. I think CAN (Community Arts Network) is making a difference by pointing people to training programs that are valuable in all the ways we've been talking about. We're trying as hard as we can to get people to set an example and to teach and to pass things along.

I have great hope, because I've met a lot of young people that are totally into it. We hear a lot about how materialistic everybody is, but in the country around here (Chapel Hill, NC), I meet a lot of young kids in their 20's that are recycling like crazy, growing their own food, strumming their guitars. Maybe things are different in the inner city.

I found a wonderful quote on the web by Pepon Osorio, a Puerto Rican, or NY-rican artist, who works at Temple at the Tyler School of the Arts. He said that we need artists to address the issues of identity, class, race and inter-group conflict that are

really affecting our neighborhoods right now. Artists working to-
gether on these issues can be incredibly useful in the neighborhood.
Because if we don't solve those issues, we'll just keep replicating the
same problems that we continue to have.

PS: Working at the local bedrock level?

LB: Yes. Artists that come to work, say, in an elementary school of dis-
advantaged black kids, bringing everything they know about iden-
tity, race, conflict in their work with the kids on their issues. He's
saying there is actually real spade work, to do right there and that
artists are equipped to do it. Artists from that world of color have
created spaces for immigrant and marginalized groups to come to-
gether where they hear the sounds, see the colors, and hear the
words that they're familiar with.

There's a really great line in one of our studies we did of an
ensemble theater in the Bronx. We had people go out and inter-
view people from the audience and people in businesses surround-
ing the theater, asking "What has it been like to have these people
in your midst?" One person said, "I trust Pregones because they
speak my language, because I know they like to eat their tostones
con mojito. That's why I think people will come in here with their
guards down—it's safe." I think that if Pepon Osorio says we need
artists in his neighborhood, then we do.

PS: Certainly there are artists all over doing that kind of work. I
worked with the Institute for Community Cultural Development
at Intermedia Arts in Minneapolis this last winter, and we met
around town at the various art centers who are doing important
community work, like Juxtaposition Arts and other places.

LB: Steve and I did an article about three weeks ago, called "Help
Wanted, Communities Reach Out." We said that most
community-based art projects are actually artist-initiated. But if
this work is so great and so important and so successful, we
wondered if more communities are beginning to ask for it. So, I just
sent out an e-mail to a whole bunch of people and said" "tell me if
you've been hired out of the blue by somebody, why do you think
that happened, and what was the circumstance?" The article tells
probably 14 or 15 stories about community-originated arts practice.
Some community agency came to an artist because they heard that
they were good at something to do a project.

SD: My first involvement with work like this was when I graduated
from college in '74. I got a job with the state arts council in South
Dakota doing ceramics as part of their arts in communities pro-
gram. Your workshop is in the back of the van and you go around
and do a dog-and-pony show all over the state. One of the towns
I went into for two weeks was Madison, South Dakota, a town of
about 8,000 people. A core group of people got really excited, went
out and found a CETA (a U.S. Dept. of Labor jobs program) grant,

and hired me for a year as their artist. They gave me an old abandoned jewelry store on Main Street. My job was to be working in the studio 20 hours a week and to be working in the community 20 hours a week, going into schools or working with elderly groups. It was the most amazing job I've ever had. I would just be there on Main Street working. Going out into the community was fine because you had a context. But sitting there on Main Street doing art was incredibly unnerving. Eventually, people started figuring out, "this is our artist; we're paying him." So, they'd start coming in the shop. I'd sit there and talk to them about it and then they'd come back with their artist questions, like "what color should we paint the walls?" There was a sense that "That's what you're here for. That's what we pay you for." I started to get this sense of the artist who's part of the community. I use the analogy of a plumber. It doesn't mean you're going to get rich and famous, but you have a function that everybody understands and they call on you when they need you. It was an amazing time.

LB: At CAN, we can tell those stories, the stories that I think are going to save the world. That's why I'm doing what I'm doing.

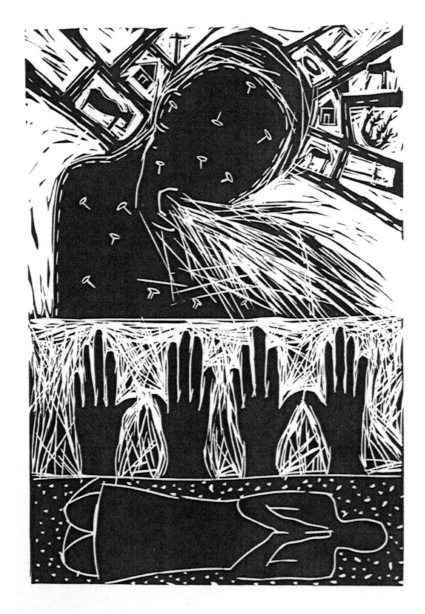

Gabisile Nkosi: *Uxolo* (Peace), Linocut, Gabisile Nkosi, 2007 from the Healing Portfolio commemorating the 200th Anniversary of the Abolition of Slavery in the United Kingdom.

Part VI

Between Grace and Fear

The Responsibility of the Arts in a Time of Change

Between Grace and Fear

The Responsibility of the Arts in a Time of Change

Bert Mulder, David O'Fallon, Linda Burnham &
Steve Durland, Milenko Matanovic

This final set of interviews looks, in depth, at the need for creativity to meet the pressing issues of our time. They also speculate on the responsibility of artists in the task. All agree that it is essential that artists continue to do what they do best: create work of the very highest quality and to inspire others to do the same. They also concur that engaging community issues through culture can have progressive effects, leading to common vision, enhanced democracy, and the creation of beauty. Despite the impediments thrown up by modern systems these commentators all believe that there are enough cracks in the bureaucratic cement to allow the growth of new stories. They also advance the notion that the interdependence of all living things and the astounding rate of change makes imperative increased communication and cooperation for the common good, and that this work needs to exhibit a positive and joyful vision of the future. Otherwise, as Matanovic notes, fear will suck our creativity dry.

Chapter 26

Bert Mulder

"The architecture of inspiration"

Bert Mulder's background is in psychology, futurology and informatics. Mulder was head of the information department of Veronica Broadcasting (1984-1992) before he became the information advisor of the Dutch Parliament. He is also engaged as a Consultant at the Institute of Strategic Management Europe and works with the VITAL Consultancy Network. He is on the advisory board of the University of Art and Design in Helsinki Finland. His recent projects are: Strategies for teleworking and hospital information services, workgroup system for newsrooms, information architecture for the multi-media research institute, future information system architectures for local government, and redesign and implementation of parliamentary information systems.

In September, 2006, Heads Together, a community arts organization, (www.headstogether.org) in Huddersfield, Yorkshire, United Kingdom, invited Bert Mulder from De InformatieWerkPlaats in The Hague for a week of interaction designed to get people thinking. This culminated in a public seminar on Friday, September 22nd. The following is from the address Mr. Mulder gave to the group. Used by permission.

One of the advantages I have is that I don't come from the arts sector and I come from another country so I have innocent eyes. I have my own frame of reference. So, when I look at your sector here in England, I just see these things that really amaze me. I think that it's time for a change and I think that you should be part of that change.

Adrian [Sinclair, Director of Heads Together] said he wanted to have a time for his company to think. Thinking is not just getting up in the morning. There's a difference between getting up in the morning and deep reflection. I have worked with people in the cultural sector in Holland; real deep reflection is not a common thing for them. But you're not the only sector that doesn't reflect; the medical and care sectors don't do that, as well. The reason is that, when you are in a creative sector or in a sector that deals with people, every person is an individual and every contact and every situation is unique. Because you know that, all your skills are geared to recreate anything that you know in each individual instance. That takes you away from universal models or any large-scale thinking, because you know that the intensity that you create can not easily be replicated. But then you forget that you actually need reflection to develop yourself, maybe not to develop your practice, but to develop yourself. So, reflection is actually a skill that you can learn. But, you have to practice it just like the other artistic skills that you are much better at than I. And it also requires time.

Part of my work is that I teach. Once I taught a course called "Reflection and Transformation" to a group of high level Dutch civil servants for four Fridays where we talked about philosophy and transformation. After a couple of Fridays we asked them whether they thought this kind of reflection was important in any way. They said, "Well, yes it was very important." I asked, "Could you do without it?" They said, "No, you cannot do without it." Then I asked, "But do you do it in your work?" They answered, "No, we don't do it." Finally I asked, "Could you do it in your work? And they said, "No, we don't think we could."

So, you're looking at the top civil servants in a country that don't reflect, who say that it is important, they cannot do without it, but they would and could not organize it in the future. How, then, is this country run? How can you run a country when the top civil servants don't reflect in general? Like you, they just work in their day-to-day business. It's kind of unnerving. It's not unnerving when everything stays the same and the whole world is rosy and we don't need any extra investment. But the world maybe is not that rosy and we're living in a different period.

Art makes people think, but do we think ourselves? Do we use our own practices to make ourselves think? As members of the culture sector, I think it is very, very, important that we learn to think beyond case studies. It's so embedded that you teach by example but I say, "What's the model, the reason? Where are the causal relationships?" You don't make models, but just teach with examples. Of course, I'm impressed with the quality of the examples.

We were talking to six-year old kids yesterday morning about a difference between Holland and Yorkshire. I said, "In Holland, we have no hills."

They gasped. It's been a long time since I have seen people do that, you know, gasp. Sitting in front of a group of 30 children is great fun. I immediately understand the energy and have a feeling that working in education would be great. But, it isn't. A single case is beautiful, but working in education is hell. It drains you of all the energy, it's actually deadening. But, with each and every individual instance of contact that you all have with a young person, you immediately get energized and inspired.

Why is it that we can actually do these things in the individual instance and create horrible systems? That's interesting. We're all smart, we're actually quite effective; we're good, motivated, authentic, and intrinsic. We do all these things and then we create these large-scale systems. But we missed going beyond the individual case studies. To take the intensity and the inspiration in the individual case studies and actually create something that allows many, many people to recreate it without losing that individual inspiration—its almost impossible. But, it's really important to do so. I think we have an opportunity to rethink what it is we're doing in such a way that we might solve this problem.

I was in a couple of meetings with people from participatory arts organizations. There was a lot of talk about the frustrations of today: you know, nothing works or funding doesn't work or disorganization of the council or something. But, that doesn't really help you, because while the cultural sector is determined by all these forces that are not under your control, I don't think that's really where you are. But, the current rhetoric, the mode of talking with each other in meetings is that you're stuck and at the whim of funding schemes or London policies or local policies or organizational things or people that are incapable.

One question I thought would be very important to explore is: Can we not envision where we would be in 10 or 15 years? Where will you be as a cultural sector? Can you ask, "Where should I be in 10 or 15 years' time?"

I'll just give you a couple of examples. In Japan quality control circles were introduced in companies a long time ago. One of the reasons why Japanese industry was so effective is that the managers had to come up with really simple statements to get people to think. They actually introduced reflection as part of the production system. One manager did it by asking, "I'm not interested in what you did today, but what you did different today." The interesting thing about the culture sector, you always do different things because each and every project is different, the only thing you do is different things. I'm not interested in that kind of difference; I'm interested in difference at another level.

Another guy in Japanese business told his employees, "If something goes wrong, ask five times why." So, if something falls on the floor he says, "Why does it fall on the floor? Because it was on the edge of the table. Why was it at the edge of the table? Because I don't have any room for it here. Why don't you have any room here? Because this is here. Why is this here? Because I don't have any place else. Why don't you have any place else? Which is not a right answer. It falls on the floor. Why did it fall on the floor? Because my hands were full. Why are your hands full? I don't have any clothes.

Where are your clothes? My clothes are in the locker. Why are they in the locker? Because I thought I didn't need them. Why did you?" So, asking five times why doesn't mean that you aim for a right kind of answer. It just deepens the question. It's a very, very simple way to actually teach people how to reflect. You don't say "Go reflect," but rather, "Just ask five times why." So, maybe, we should ask five times why when we wonder how to develop this sector.

Given where we are in the world in terms of human development, I think that the culture sector is very, very important. The participatory arts, in particular, are a crucial element at this moment in time. I have a certain sense of urgency and I'll explain to you why.

One reason for this is that the information society is not about information. It's about meaning, about making sense. One of the main problems of the information society is organizing quality. All the quality newspapers have problems retaining their readers. We have lots of metros, those free newspapers on the small tabloid format. But the quality newspapers go down. We have more TV programs than ever, but their quality goes down. We have more information on the internet than ever, but the general quality goes down. Organizing quality is an essential problem in the information society. The organization of excellence and making people aware that you can actually grow and strive to make something better is very difficult.

So, how do you deal with this slowly-declining quality? How do you make sense of all this information? This is why I say that culture has an important role to play. It is at the heart of the information society, because it creates meaning. It connects me to my own ability to create meaning, to be creative, to find my inspiration, but it does it in such a way that I then create something that is meaningful for me and for somebody else. It is a very, very basic requirement for living in the information society. So now, who owns that area? Who is professional in that area? You are. You are. And then I come here and I ask you, "Where is your sense of purpose?"

Five or 10 years ago, there was a creative city initiative in Huddersfield (a European Union economic development initiative). You were all going to change the future. Now, I come here and it looks like it is gone. People are saying, "We're out in the rain; yes, it's gone but we don't really know why. Why and how did we lose it? How is it that we actually think that it's kind of okay?" People were saying, "The way that came forward was because there were 20 mavericks around here." So I asked, "Where are they?" They said, "I don't know. They do different things." Nobody said, "Well, I'm going to be the new maverick or "Yes, we're sorry they're gone." What this means is that when innovation and creativity are at the heart of society, there is also a certain kind of responsibility, a certain kind of ownership that is necessary for it to thrive.

So, you see yourselves at the edges of society. But I was in the Welford School yesterday talking to a teacher and she said, "Well, we had the national curriculum and we were all dying from it. It was horrible. So, we said we can't go on like this any more. Then we had a couple of artists coming in and all of a sudden, the artists said, 'We will just start and ask the kids what they

want to do.'" The kids came up with ideas, which actually deeply changed her view on what a child is. For the first time, she noticed that kids can do much more then she ever envisioned. It actually transformed her notion, as an educator, of what a child is.

How is it that you have to bring artists into the educational system to bring about that kind of transformation? And when artists bring about that kind of transformation in education, in business, in the care sector, and in democracy in the larger civil society, how are you dealing with it? Is that a responsibility or do you still think that you're at the edges of society? Why is this? I feel this kind of tension. Maybe I'm projecting into you more than you want or more then you're able to respond to. That could be a problem, because this need in society will be filled in. If you don't fill it in, somebody else will fill it in, but not with the same kind of quality.

So we now have the Rijksmuseum in Holland building a small museum in Schiphol Airport. It's kind of nice, but is it the right thing to do? Some of you look at other projects and say, "Yes, that is doing what I did, but they are just doing it for the form. They don't understand what it is that I really did, that I actually aim for transformation." So you know it is of a lower quality. But, they don't know. They think it's all the craze. One idea I am sharing is that other sectors in society are taking what they think are cultural practices, and trying stuff out. They will be doing this more and more, but, they're not cultural professionals. Actually, they don't even understand what the difference is between a cultural professional and what they do. Adrian came up with the example of turfing the street (laying sod) in Methleys. Yes, anybody can turf the street, but just turfing the street was not the point, as a cultural person understands. An alderman or a policy-maker doesn't understand. He says, "Okay, we can turf the streets by the truckload," They're really amazed when nothing happens, but they don't know why.

So, I'm actually trying to talk you into the idea that you have a bigger importance than you envision yourself having. The problem is whether we can afford to not think about it. Here is the reason that I think we cannot afford to do that. It's a piece of research from two guys, Straus and Howe (William Straus and Neil Howe, *The Fourth Turning: An American Prophecy*. Broadway Books, 1997, www.fourthturning.com.). They looked at how society developed, specifically in English and American society and concluded that society develops in blocks of four generations, each one lasting between 21 and 24 years. They looked backwards very carefully to find this pattern throughout history. They found that this pattern has been active in English society first and then in American society ever since 1433. So, for ages and ages, for centuries and centuries, we have evolved in cultural cycles that were determined by four generations. When we hear about cyclical models, you feel kind of cramped in because we're from "free societies." We're all for linear models where there's no end to development. That's really what we do in western scientific thinking. But, of course, nature works in cyclical models—we have summers, and winters and again summer and winter. Nobody feels constrained by this. These guys point out that in social development, there are also summers and winters.

Now, it would really be interesting to know where you are in these cycles, particularly when you want to add to society or change. One generation that they call the "high" is very expansive with loads of ideas and renewed concepts. It lasts about 20 years. These people build a society, civic institutions, new ways of working, new schemes of funding, new politics, new regulations, and that lasts another 20 years. At the end of that, throughout a period that they call unraveling, you start to miss the point a little bit. The society is there, but it's not really your society any longer. So, in this period of "unraveling", you get increasing individualization and civic institutions lose their self-evident meaning. We lose trust in politics, we lose trust in the police, like this period that we just had, I think. Then there's a period of "crises" where this deepens, and which usually ends with a period of deep transformation—like for instance, the Second World War.

So since Straus and Howe actually came up with this idea of the cyclical nature of cultural development in 1997, we should actually be able to predict what will happen in the next couple of years. So they predicted a couple of years after 1997, there should be a cataclysmic event, because the crisis period always has started, every 80 years, with a cataclysmic event. They say the cataclysmic event serves as evidence for this general feeling of uneasiness, where people feel that society isn't what it used to be and that something is deeply wrong. There is a period of a deepening sense that things are not working and that we can't go on like this. What they predict is that after the cataclysmic event there will be a major crisis and transformation.

The interesting thing is that the nature of this deep transformation depends on how we handle the period. It's certain that we will create and engage ourselves in a deep transformation, but the form is not really certain. I'll give you a metaphor as an example. Many of you have children. So, there is a day when your children go out the door to a party and you say, "You're supposed to be home at 12 o'clock as usual." and they say, "I don't think so." Then you are amazed and you say, "I think so," and they say, "I don't think so." You notice that there's a new energy in the voice there. You may win the argument, but it continues, lets say three or four times, and finally you realize, "There's a pattern here." At that point, you have two possibilities. Either you're going to severely enforce the "I think so" bit and suffer four or five years of deep trouble. Or you realize, "It's the onset of puberty! It's a completely new phase here. We're going to have a new rhetoric and build a completely different kind of dialogue." If you do this well, the same transformation will happen—building up the identity, separating from your parents, doing your own thing, whatever, the same needed things will happen, but in a completely different way.

The only thing that distinguishes us from all the generations before us is, because in this last century we've had so much research in history, we can see this happen. This is actually the first time that we can say, "Aha, it's winter. Maybe I should put a coat on." You could say, "It's cold, it's your fault." We have all these problems and then we say, "It's this politician and it's his fault." That's what we do right now because we don't have a clue. It's like when your kids tell you, "Yes, I don't think so." And you go,

"What!!" When you do that you increase opposition. As somebody in Holland said, "Always ride in the direction of the horse." But when we don't have a notion that we're going in a particular direction, when we're riding all over the place, we end up very confused. And it's because we don't have this idea, this way of seeing where we are.

Here is my sense of urgency. How do you go about being professional in these different cycles? What would my cultural strategy be in the winter? Actually, what is a coat in a period of winter? Should I take more responsibility? Does this increase my responsibility, or am I still at the edges of society doing my own thing saying, "Society goes as it goes and I'm doing art, way out there." So when people have time, they say, "Oh yeah, I'm going to do a fun thing, that's arts. I'll also give them a little money." Arts funding is a pathetic percentage of economic funding, pathetic. It's almost unbelievable, but you live with it because we have this notion that you don't need art to sustain a vital society. The prevailing attitude is, "We have a vital society and then there is art." My argument is, we don't have a vital society and we need art. That's a deeply different position. But it also requires a completely different attitude of you.

Five or six years ago I hosted a workshop for the civil servants of the largest cities in Europe for EuroCities, the 100 largest cities above half a million. It was the urban development people together with the heads of the cultural departments of the larger cities. The first question was to the urban development people. "What is the importance of culture in your area of work?" They said, "That's an obvious question. In order to increase the vitality of our urban society, we know that the first thing we need to do is invest in culture. It's not even a question for us." I was really amazed. I also had a programming problem because I was the chairman and I thought we were going to talk about this for 45 minutes. But it wasn't even a question. Then the cultural people said, "Wow, they never said that before." But then I thought, "Yeah, you never asked the question before either."

The unnerving thing was that then the urban development people said "Well, let's say I have 100 million euros. Just tell me, should we build a theater or start a female choir?" Then the culture people became uneasy. They said, "No you don't talk about culture like that." So the guy goes, "Yeah, but I have 100 million euros and I need to vitalize the city. I don't care how, give me anything." Again, "No, no, you don't talk about culture like that." In the end there was no conversation. The economics people, of course, have to measure in economics, which is a big problem with culture. They said, "Let's do a piece of research on the contribution of culture." All the culture guys go, "Aah, we do that so often. We know what the contribution of culture is, its so many people in the theaters. But, that's really useless. What we should do is, actually, come up with a completely different way of measuring the intrinsic value of what a theater adds to a city." Then, the economics people said, "Yeah, all right, whatever you want." Then the culture people just went dead because it's a hard question. They didn't come up with a method, they were kind of slow, and these economics types are impatient. So they did an old piece of research and got away with it.

There was no real answer from the cultural sector, but the fact that it was deeply-valued was there. So there's this potential dialogue between culture and society that could really deepen. What would your cultural strategy be in this period of time, vis-à-vis this order of people that will actually take culture on but maybe misuse it?

One of the interesting things that came up in this week is that everybody now senses that this is a time of opportunity. In each of the meetings that we had, people said, "We're actually thinking about really changing what we're doing, reorganizing," or "We have the idea that here there's a real opportunity." They not only voiced this notion of opportunity for each of the individual organizations, but also for this time period when people are saying, "I don't know what it is, but it's in the air." So then my question is, "What are you going to do in the next couple of years?" Considering the fact that now I'm talking about Huddersfield and how very, very easy it is to lose this kind of purpose.

The problem is that there is a very, very deep challenge here. Culture as a resource is well accepted. Everybody will use and reuse it. Can culture be used up? Can I misuse culture? If I use classical paintings to actually jazz up any product, am I then misusing culture? If we use artists to create campaigns for Beneton, is it a misuse of culture? Is it pornographic? Does it degrade the value that I attach to images? This is the challenge. What does it mean when education uses artists? Is it a good thing or a bad thing? Well, it's a good thing for education. But don't we neglect culture?

So, in Holland, culture has to solve everything. The last cultural minister we had said, "We'd like to use culture for integration, so you get paid by the number of non-native Dutch people in your theater." Okay, if you're the Minister of Culture, are you also the minister of social integration, what are you trying to do here? For many theaters, this was a complete disaster, because they couldn't come up with real good productions. They had to come up with these mainstream productions because, otherwise, they wouldn't get any money. I understand that social integration is very vital in society. But should you then create policy that, at the same time, deadens any initiative in the cultural sector? This is what's going on. You know that much better than I do. Every four or five years, you get policies that just are destructive for the culture sector, but they seem very, very in tune with vitalizing society. I'm not saying this should never be done. We need both, but how do you create a vital balance? Who draws me a picture of the landscape?

For this couple of years, I'm a member of the European Cultural Parliament. It's not a real parliament, just a bunch of people from 30 countries that call themselves the European Cultural Parliament. We get together once a year and have great fun. But we were asked by Jose Barroso, the president of the European Commission, to come up with a proposal how culture could add to the European identity. They asked me to write it up because I'm not from the culture sector and I said yes. I sat around the table with these cultural people who gave me loads of case studies, which are good stories, but not comparable and can't really show patterns. They said,"What do

you mean they are not comparable" and I said, "But I have to write a paper." People got really adamant because it's their stuff. So, I can't get rid of these case studies, nothing builds up, there's no overall picture. I hope you get my drift here.

What we did in the end, actually, was to distinguish among three different uses of culture, and because the case studies were really interesting we incorporated them. For example: the Stockholm School of Economics has had a ten-year program for aesthetics in business. They are now creating all kinds of different programs based on this that are being taken up by the Copenhagen and Helsinki Schools of Economics. It's not about the cost of art or the art market, but rather "when I think about aesthetic principles, philosophy, practice, how can I project that onto running a business?" This is real deep thinking. They've been trying to find new inspirations for running businesses on a large scale, by looking deeply at aesthetic practices.

In the *Harvard Business Review* a couple of months ago, there was a small article that said that large companies are now no longer looking at MBA graduates, but they are looking at art academy graduates—people with MFA's. Many of these people get hired by very large businesses. So, business realizes that when you want to create value, you need people that are professionally, deeply creative, not just people that generate ideas. Because to sell something means creating an experience. Nike doesn't make shoe stores, they make Nike Towns. It's a large experience, which actually sells goods. But how can you distinguish a good story from a bad story? How can you distinguish a good painting from a bad painting? You have to have this artistic professionalism. So, there's a deep shift in business. What you are doing is actually parallel to this deep shift in business. It is people trying to create meaning. I mean really seriously grapple with how to do that and come up with new strategic uses of culture.

There's a big program in Sweden called the Design of Prosperity, a conference for business people, artists, and designers to all come together. In Holland, we have a program where we start to merge design and government because government isn't coming up with any vital practices for the next 15 or 20 years, but designers can. Design is completely different attitude, a completely different way of thinking. I'm saying that we need that at the government level but, like with EuroCities, they can't even speak to each other. So, you see that the idea that the place that you have in society might be changing comes from many, many different directions.

There are three different uses of culture. The operational way of dealing with culture is to stimulate arts culture and heritage. That means that I give more money to a museum to be a museum. I give more money to a library to be a library. I stimulate an artist to be an artist. We also need this because we were talking about the use of culture to further society and this is part of it—the operational use of culture. Then, like Heads Together and many of you, there is the application of the arts and culture in other fields. You do deeply artistic practices in education or in social services. Then the presence of the arts changes the practices in those fields.

The third one, the really strategic one, is systematic. We actually come up with a completely different educational system, a completely different system of government, or a very different way to define prosperity that leads to new regulations in the economy. This is a cultural prospective, a humanistic, cultural prospective, that actually leads to transformation. For those of you who choose to participate, you will also be playing all these levels in the next 10 to 15 years, because society already shows these trends.

As I said at the European Cultural Parliament when we sat around the table talking they came up with loads of examples, loads of case studies. I just wrote up a paper and said, "These are the uses of culture and here are 50 examples." The examples came from business schools, large businesses, hospitals that are being transformed. They came from educational practices that are being transformed. Heads Together was an example, Next Start was an example, the South Bank Unit in London was an example. We used all these deeply transformative practices as examples. For this report we felt that that proof from practice would suffice. But, it won't suffice in 10 years.

We also said it needs professionals, active skills, and experience. Any policy maker who creates new policy thinks, "Well, it's just a painting. My kid can do that. I can just turf the street. Anybody can turf the street. So, hey, I can take any organization, set up a large program, fund it. Anybody can run this program." But you know it doesn't work that way. It actually requires professionalism, but what kind of professionalism? Well, when we talk about participatory arts, we are into a very strange form of multi-disciplinarity. The problem is that once you recognize it, you also recognize that it's not easily available and we have to develop it.

It's a different way of working. You connect with the people and their capacities. All current policies on social development actually focus on what's missing. What you do is a completely different way of looking at things. We're currently working together with the European Union on changing their inclusion policy, focused on the blind, the handicapped, the unemployed, etc. As a part of this I said, "To do this right you have to shift your focus and connect with their capacities and the strengths of society in general. And then all these people will slowly be integrated through that." That's actually the same kind of stuff that's happening with participatory arts. You attend to the potentials in society or a community instead of focusing on what is missing. That's a completely different way. In Holland, we find that we have to retrain the professionals that work with us, because they always want to look at what's missing. With that perspective they are only going respond with something that caters to what is missing. We say, "Hey you can do that, but it's meaningless." So, we have to retrain them.

Assessment is a real big problem. How are you going to prove that you're contributing something? All throughout Europe there is difficulty trying to define what social equality is, since it is scientifically unclear what social equality is. Measuring learning outcomes can also be problematic. When I was talking yesterday to the teacher, she said, "Well, we have kids and we do these things with pictures," and I said, "Yes, but what does that mean to

the curriculum?" She said, "Well we also have the curriculum." So I asked, "Yes, but when the kids spend time doing the pictures, what do you think they learn?" She said, "They learn real, important skills, critical skills for life" I said, "So, you have the National Curriculum and you have your own curriculum that prepares them for life." She said, "Yes, the National Curriculum contains some of the things that are necessary, but here I do other things that prepare kids for life—a sense of aesthetics, of creativity, a sense that I can grasp hold of my own life." But the problem is that when you then assess what you contributed to education, in which scheme are you assessing it? What measurement scale are you using? Well, if it's the National Curriculum scale, your arts contribution will be utterly useless.

So, as artists doing this work you have a double problem. You're not only in an identity crisis, but also your practice, your curriculum is useless. Well, I know you're having fun with it, but, unfortunately you can't prove what you do. If you look at the British Arts Council budget, or a city budget, the cost of a theater is there. Then there's this pathetic number of tickets that you sell; we can add on that the people also drank something in a bar. These are the "really important things" that you measure and they're completely useless. How can I come to grasp your real added value to society? When we cannot measure it, your work will be useless. It will have no meaning.

So, we have to do something about it. The same goes for democracy and participation. Okay, this is a nice story, but, of course, real life isn't like that, because funding is declining. I'm saying society on a large scale is moving towards cultural practices inevitably, because people just take them up. They do whatever they can to actually make life more interesting. If you look at it from a cultural or artistic perspective, cultural practices are increasing but the funding for culture is declining in almost all countries. But, at the same time, we are having these grand ideas. What's the tension in there? If a vital society needs culture, how does that translate to this declining funding for culture itself?

One reason is that it's a risk. Look at Huddersfield. You had this amazing group of people with amazing energy and not even a decade later, there's nothing left. And why did it happen? It's hard to describe, but it happened. But what are we going to do now? Imagine being faced with a new idea, a new five-year vitality plan. Are you going to go through the same cycles again, like Huddersfield? Assume people you know are gathering to develop a creative city. Will it die like before? Are you creative professionals or not? It's really strange for those who are part of the creative sector to just let the creative energy of society disappear. I wonder, considering the period we are in, whether we can afford to be like that? Shouldn't we be taking this challenge up with a different sense of urgency, with a different strategic purpose, with a different intention, with a more definite goal and not let our sense of purpose just dwindle away?

To do this of course, one has to have an explanation of policy and programs, so that everybody knows what we're talking about. Then we have to connect vital practices with vital policies. Vital policies need to translate in-

to vital programs. I'm leaving you with many, many different questions because I think they need to be considered.

One of the things I find really exciting here with Heads Together is that they have found a way to suss out what a vital society is. They come into a classroom and when they leave, it's more vital than before. They go into a neighborhood and when they leave, the neighborhood is more vital than before. The neighborhood doesn't say Heads Together actually did it. The neighborhood says we did it and Heads Together was also there. When you ask Heads Together what is important in their work, they can come up with specific lists of what's important. They never do that on their own because they're not into making models. But, when pressed, they can actually come out with what you need to do this work well. So it would be quite simple, actually, to come up with a piece of text or a model on how to do these things.

So here is the big question. If the participatory arts sector has found a way to vitalize society and if we're in a period of winter where that vitality is declining, am I not looking at an important strategic resource? If that is so, shouldn't we be studying it all over the place and try to figure out how to disperse it?

If this is all true then what I am looking for is the architecture of inspiration. What is the architecture of inspiration? How can I create sustainable inspired societies? That's your challenge here in the participatory arts, maybe also in other arts areas. You have projects, but you need to create methods, reflect a little bit, and then build strategy. But, one of the challenges is to connect all these. You cannot create strategy when you don't know how it works in the neighborhood. So, in order to do this, where should our attention be? Well, we should actually deepen this practice and at the same time, create working networks. You need networks of cooperating organizations that are not competing for territory. A creation society requires a special kind of network.

When you do research, it's important to make it useful. Academia researches this kind of thing to understand it, but I'm not interested in theoretical understanding. I'm interested in understanding only to the degree that other people can to do it, too—in practical understanding. That's a completely different kind of reflection. Now, all throughout Europe, people are in the process of developing a pragmatic reflection on practice. When you create strategies, they can only be created by people that deeply understand what is happening here. Any strategy that is created should involve the people that live these practices here and now.

I think that arts and culture are strategic, but not as a theoretical concept, or a piece of niceness, or something to share over a beer or a scone. I think arts and culture are strategically critical to the quality of society in the coming years. Participatory arts, because it combines all these different things, is a big source of inspiration. So, it is important that you identify the architecture of inspiration, and with that, try to find ways to develop a society that is characterized by vitality and inspiration in a phase of cultural development that might well be winter.

Chapter 27
David O'Fallon

"The arts have a new responsibility"

Dr. David O'Fallon is an experienced educator and leader who works at international, national, state, and local levels to develop innovative programs to strengthen arts organizations and systems, improve education and link learning with the arts. He is currently the president of MacPhail Center for Music, one of the largest community music education centers in the nation. MacPhail's mission is *to transform lives and enrich our community through music education.* MacPhail has recently moved into a new facility located in downtown Minneapolis on the Mississippi River. The new James Dayton-designed flagship building is the center of a network of 7500 students, 165 faculty, 50 community partnerships and multiple expansion sites.

Prior to joining MacPhail in March of 2002, Dr. O'Fallon was the Executive Director of The Perpich Center for Education in the Arts in Golden Valley MN. He served the National Endowment for the Arts as director of the Arts-in-Education program and directed the Arts Education Partnership Working Group at the John F. Kennedy Center for the Performing Arts. He has been on the boards of the American Composers Forum, The Benedictine Center for Lifelong Learning, the National Scholastic Art and Writing Awards, the steering committee of the National Arts Education Partnership. He recently received an honorary doctorate from St John's University for his national impact on arts education.

PS: Do you think our culture is on the verge of a major change in world-view?

DOF: There is some great change underway. How you think about that, I'm not absolutely sure. I've been influenced a little bit by Ken Wilber and his approach. His challenge is to come up with an integral vision so that different elements: psychology, economics, technology, and so on could all be mapped out together, because they're not all separate units anymore, although we attempt to think about them as all separate. Economy is separated from ecology which is separated from the arts; health care is over here and transportation is over there, and so on. I think one of the big changes that is definitely underway is a rapidly growing understanding that, gee, all these things are interconnected somehow. We're not sure how, but we're beginning to appreciate that they are. It is systems theory written very large, not closed systems, but literally a sense of the interconnectedness of everything we're doing, body-mind, individual with community, small communities with larger networks, ecology with economy, with transportation, with health care. It's all interconnected; you tweak one part and something else moves.

PS: We can't do just one thing.

DOF: No, you cannot. You can pick almost any working example. You can't treat homelessness as the problem of this individual on the streets. You can't treat health care as simply have I joined the gym and am I watching my diet. All these things have multiple layers and interconnections. The short answer, is some big change underway? Yes, I think it is. I think that change has to do with this appreciation of connectedness.

PS: A more integral way of looking at the world?

DOF: I think that is becoming somewhat more understood and appreciated. I think the Kyoto Protocol was a step in that direction. I think within the last week of the time you and I are sitting here talking, the stock market in China had a little hiccup and the entire world hurrumph-ed. Okay, that's just on the economic sector, but there are others. You could pick a hundred examples, but I do think that is part of the transition that's underway.

 Let me put it a different way for a minute. I've been talking for awhile about the concept that I call the totally-designed world, TDW, which is the world that each of us individually lives in every day. This is true for almost everybody on earth and it's certainly true for people in industrialized or developed societies. We're spending every minute in an environment that we've shaped. So, we are almost never in our lives anymore in an environment that you could call natural. You're in a built environment or you're in your car or you're on a road. Even if you're hiking, you're covered with gear. You're on a trail. You look up and you see contrails and you may have a GPS thing with you. The fact is that we have now

pretty much come to the point where we're living in a totally-designed environment. There are vast reaches of the globe where you can get lost and die. That's all true. But, as a gross generalization, I think the concept of TDW holds up. That leads me to the sense that we have crossed a threshold. I think we have a new level of responsibility because we've seen how our various technologies can impact everything. We're cleaning up oxygen canisters from the top of Mt. Everest because so many people have been up there and abandoned them. They're like junk. They're like fast food wrappers. It's a problem getting them down. Or you go to the depths of the ocean and there's human residue, chemical this, particle that, plastic this. We are actually now everywhere. Because we are everywhere and have left our human mark on nearly all the planet, we must accept a new responsibility for our actions—and that includes artists.

Then the second part of your question is what role will the arts play in this? I have given a lot of thought to that area. I think we may be coming out of an era in which the arts were mostly responsive. For example, another one of the thresholds we're crossing is we know now that you can have your imaginative image, your story, your perceptual framework, extended through technology almost instantly. It can be out there in the world very quickly, for good or ill.

I think we now have a new responsibility because we're shaping the world as we never have before and we're hardly aware that we're doing it, although I think the awareness is growing.

PS: I think we are just becoming aware that we can actually transform the climate of the entire planet.

DOF: And we didn't know we were doing it for a long time and there are still skeptics. It's not universal because you have some countries who are saying it would be too expensive to change our technology to make it greener, and India and China, of course, with their massive and rapid industrialization, which green concerns find difficult to restrain. But, even granting exceptions, I do think we are crossing a threshold of awareness and responsibility and it will not be one we can turn back from. Since we are connected in new ways, we are, I believe, responsible in new ways. Therefore, I think the role of the artist is shifting from responder or reactor to someone who might be a shaper, creator, maker. This, for me, is a big difference. If you go from the old story to a new story, the old story of the artist would be, "hey, I just do my work and whatever you make of it, you make of it. I'm not responsible for it." The new story would be: actually, you are responsible for it. If you put out there some destructive, distorted horrible image or narrative and people use it and respond to it, you do have some responsibility for that. If I tell a story, I can't control what you make of that story, but I do have

some responsibility for the way I tell and shape my story. I do. I believe that's true. An example for me, a turning point actually, was when I was at the Endowment (National Endowment for the Arts). Remember Andres Serrano's photograph "Piss Christ"? He was basically saying "well, geez, it wasn't my intention to irritate any of the Christians who were looking at this crucifix immersed in urine. My intention was to bring out the awareness that the image of Christ is being abused." I said, "Well, you failed. You just absolutely flat out failed. No one got that."

PS: I never realized that was what he was doing.

DOF: We don't take away the right to tell a story, make an image or do whatever you want to do. But, then, we also have to think about how someone else might respond or take this. It's not enough to say, "I've done my work. I now wash my hands of it." That's a change in the arts world to some degree.

PS: You mentioned an increasing awareness of our interconnectedness. I'd like to go back to that for a minute. What is causing this awareness?

DOF: Well, just look at the way people live. Nobody is living naked in the wilderness, any more anywhere. So, that's an on-the-ground fact. We are at a level of interconnectedness that we don't even understand right now. Look at the struggle over the internet. I read something the other day about China and Iran trying to restrict access to points on the web. It's still early on, in some ways, but clearly, the internet is part of the change.

PS: You seem to be suggesting that the ability of the nation state to govern or rule what people see and do is less possible now.

DOF: I am. Ten or 15 years ago I remember reading the idea that the nation state is just at the wrong level; it's not big enough to be global—to take on global warming, for example—and it's too big to be local.

PS: Right. The globe seems like the level requiring attention. Unfortunately, the nation state can still do a lot of mischief.

DOF: It has enormous military power. No one else has that kind of military power. No state in the U.S.A. or no global corporation has that kind of power.

PS: And military power is often used to serve a small group of powerful people's perception of the national interest rather than the common good.

DOF: Apparently, so far. But, we could see a huge change in the American nation state, because we've gone from a creditor to a debtor nation, the world's largest debtor. Somebody may look over at the Euro at some point and say that's a much better investment than the dollar. If that happens, we'll be sucking wind. We really, really will.

But to come back to communities of artists and arts work for a while, my experience now is that there is a bi-polar dimension to a

lot of this work. A lot of these folks think of themselves as global citizens and local citizens.

PS: Not national citizens.

DOF: Not national, global or local or both. There's a sense of needing to belong and be grounded someplace; at the same time you're not owned by the nation state. You belong to humanity. Those aren't new ideas, obviously. They've been kicking around in the world for a while. But I think they're taking on some new dimensions.

PS: For example?

DOF: There is a local dance theater company, called Off Leash Area, for example, which exemplifies both levels. On the one hand they are embedded in local issues. They just did a very powerful play on schizophrenia. On the other hand, they're doing another one on border crossings from Mexico into the U.S. So, they think of themselves as a Minneapolis regional group here at home, but they also work on much broader things like people crossing borders of all kinds. Their work is interdisciplinary, another example of interconnectedness in the arts. A lot of the issues that I see people working on aren't owned by a nation state or a locality. The arts have often thought of themselves as being universal, although I don't know if I buy that universal stuff any more.

PS: What do you mean? Music is the universal language, that kind of a cliché?

DOF: By universal I mean a single definition of music, or excellence in visual art, a single standard for judgment and appreciation. Imagine that you take somebody who was raised in Hmong music to listen to the orchestra; or, more to the point, imagine the orchestra inviting the Hmong community in and having their musicians play on the orchestral stage. Suddenly, how universal is this norm, this language of music?

PS: Do you think that kind of experiment appears ill-formed or ill-conceived?

DOF: Well, it's hardly ever done. I can't think of an actual concrete circumstance where that has been done. There is the evolution of world music, fusion; a lot of that is going on and is really interesting. Musical languages and traditions influence each other now in ways and with a speed not possible before. And as do all the forms of arts.

But let's come back to this bi-polar concept, the notion that there is local specificity that is absolutely essential, but at the same time you recognize, because of the internet and multiple other connections and travels, that anybody on earth could actually respond or listen to it. I use an agricultural metaphor sometimes. I'm not sure if it is still true, but maybe 15 or more years ago the genetic structure of the corn crop in the U.S.A. was virtually the same throughout the entire center of the country.

PS: I'm sure that's true.

DOF: So, because of this monoculture, a single blight could take the whole crop out. Then you get to the benefits of diversity. Diversity protects us against the weakness of a monoculture. I think one of the things the arts do, at the opposite pole of universal, is to create something specific, odd, local, unique, and keep it alive against whatever future may occur. This might be anything: maybe folklore, maybe something brand new that Off Leash Area just created the other day, and not part of any folk tradition. An image, a form, a thought, an idea, concept, a movement, a few bars of music, a line of poetry, a story, something that preserves us against monoculture. I think that is one of the essential works of the artists.

PS: It seems to me that one of the major issues facing us as a globe, a nation, or even a local community, is this issue of diversity and inequality. And, it seems to me that the pulling apart of society that we've seen over the past few years can't be let to continue without serious consequences.

DOF: You think the arts have some role to play in healing that?

PS: I would hope. Do you?

DOF: I'd say there are six different windows through which to look at the arts. One would be the window which you just mentioned: the arts should have something to say or do with issues of social justice, imbalances of power and equality. There's a long tradition of that. There's another window which says, what the arts really do is simply celebrate life. We celebrate the fact that we're born, that we're alive, that we are birthed, that we get married. We celebrate the richness of life and leave that power struggle over there someplace else, to other forms of public action and discourse. The arts can maybe talk about that, but it's not really what the arts do. That, too, is tradition in the arts.

 We might think of these windows as stories also. The third window or story is that there is the journey of life and what the arts do is simply mark along the way the great moments of life, birth, transition from childhood to adulthood: transition into married life, divorce, death, separation. All the way along the arts have their role to play to help you deepen and appreciate whatever stage of your life you're in. The arts allow us to recognize and vocalize the emotional and spiritual aspects of life. That's three different stories. They're all valid.

 A fourth story is that while all of that may be true, the fact is that what is called "the arts" are really only the stories, images, dances, music, and so on created by a very few talented people and it's really left to history and the specialists to decide whether this is a work of art or not. So, the specialists, the museums, the curators, the historians, the very deeply-educated people finally make that judgment. The orchestra doesn't play every kind of music in the world. It plays a select repertoire. Not everything makes it into

the Walker or MOMA. People select what goes into these things. There is a sifting out of the best, the most important. Those things are what ultimately come to be called the arts.

But the fifth story follows after that new responsibility I alluded to earlier. It says, "Wow, here we are. We're co-creators of the world. We have a new responsibility. We have the power of story, the power of creation of images. We're designing every space, every vehicle, garment. We're affecting the earth and the water for good or for ill. Our impact is no longer a question. We have a new awareness and, therefore, a new responsibility. So, we have to be the artists of our life, co-creators of this world because we are shaping it."

PS: Who is the "we" in that?

DOF: All of us, humanity.

PS: You meant not just the arts with a capital A.

DOF: No. Actually, artists with a capital A have a role to play in this, but everybody has a new responsibility. But artists, those people who specialize in creating a new story or creating the new music or the new images, have a new level of responsibility, because their work now affects a much wider range of people than ever before.

The sixth story is a variant on the previous two ideas. The headline for this one is Life is a Body and We're All Connected in the Body. So, for example, the Christian mystical body of Christ, the Gaia concept of earth as alive. One of the implications of life as a body is that the body has special roles for the different body parts. Your eyes don't do the job that your feet do. Your liver is not your lung and so on. In this window on the world, the arts have a special role to play, but not everybody is an artist. I mean, some people are better storytellers than others. In this view, the function of artists is to be an original creator. In the co-creator model, everybody is a creator, everybody is. You are, at the very least, creating your own life; you are the author of your own life. This implies agency rather than passiveness. But in this story, however, only a few are creators.

PS: Am I putting words in your mouth to suggest that the artist with capital A is kind of a mediator for the creative energy of the rest of us? And is this heightened sense of responsibility for co-creation something you see happening?

DOF: I think it is happening, to a certain degree, but I wonder if it will continue to happen, because none of these things are givens. Things could go a lot of different directions.

PS: What do you mean things might go different directions?

DOF: Arts Institutions, especially larger ones, could be so concerned about their role in defining what art is and presenting it in certain limited ways that they miss the wilder and wider dimensions of the arts and the multiple ways in which people can engage the arts and for multiple purposes. The orchestra could keep playing the kind

of music that it plays and wonder where the audience went. For example, I had breakfast with two members of the orchestra recently. One said to me, "the orchestra is not a giving organization. I need to do other things with my life." She's not going to leave the orchestra because it's too good a deal. But she wants to do other things. She said, "We play music at a high level, but at some point, that's not enough. Where are all the other things?" And I think by "other things" she means that wider engagement with the world we are living in, our concern for how we affect it and shape it, that sense of responsibility we have for people and issues that seem not be about the arts—but everything is connected. The way things are is a hard pattern to change. I don't see it changing very soon, at least for orchestras and other large institutions.

PS: If patterns are hard to change, it could be because of bureaucratic rigidity. Or maybe it is because there aren't sufficient crises or opportunities to make change happen. Or is it both?

DOF: Maybe both. When I did some work with Lincoln Center, we convened what we call Conversations on the Imagination. A person (who had been a commissioner of a state agency, head of a major foundation, and now the president of a college) said that historically we're at one of these turning points, because although we know an awful lot now about human development, learning, growth, change and so forth, most institutions can't actually support people doing that. Most organizational structures don't really allow that individual capacity to develop.

PS: And presumably that is what we need for the development of people's creative potential?

DOF: Yes. For example, I think K-12 educational system is a good example of that: so many rules and regulations and different people pulling in different directions. No Child Left Behind and testing this and that. And, at some point, a new administration will come in and they'll change things again. It makes it harder. That's true of lots of state agencies too, and I have some experience with them. There are just piles now of rules and regulations and statutes and policies that make it really hard to change anything. It is like trying to change an ocean liner a few degrees to the left or the right. On the other hand, to go back to the orchestra, you've got 80-some musicians over there who find other venues and do different things as individuals and in smaller groups and are creative in different places. That's interesting.

How do we take our new knowledge of humans and learning and growth and the power of the imagination in story and so on and give it support and latitude?

PS: Do you think that more and more people are, either completely or in their "spare time" like the musician you mentioned, opting out

of the hierarchal, bureaucratic juggernaut that we have learned to live with?

DOF: I think a lot of people are looking for ways to fully, truly realize themselves and to bring their best into the world, maybe within the structure that they're in or to find some other way to do it. I know people have bills to pay and families to feed and so do I. That's a powerful incentive to keep doing what you do. But, for example, there's an enormous energy and surge in the business world to have spiritual values at work. I don't mean Christian prayer groups only; I mean to really bring your full humanity, your deepest values into the workplace. To understand that leadership isn't always top down. In fact, in a lot of institutions that hasn't worked very well. So, there's a lot of stirring and urging going on. The hope is that all this could be transformative.

PS: Well, yes, if enough people say I have to do X, or Y, or Z in order to fulfill my life, my responsibility to the earth, or to my fellow humans, it could have a transformative impact.

DOF: I think that is actually the hope: not just to reorganize things from the top down by making proclamations, or passing laws or new statutes for this and that. I think an essential role of the arts is to keep alive the smaller stories, powerful images, and so on in smaller pods and groups, with the hope that at some point, enough of these will connect, like kudzu or creeping charlie in the yard, and take over. The new story would be that wherever you live on earth, we are all connected with each other and we are not that different from each other. So I shouldn't actually kill you because you believe something differently than I believe. That's a powerful story. Obviously, it's got a few problems at the moment, but people are keeping it alive.

PS: I agree with you, absolutely. There's been a lot of effort to try to convince us that's not a good story. We have had quite a taste lately of the old story: that me and mine are the only true and pure and good people. I don't know if that kind of divisiveness can hold.

DOF: I don't know either. I think that's a really good question. Do you remember Frances Moore Lappé, who wrote *Diet for a Small Planet*? She wrote another book, *You Have the Power*. It addresses the point that you just raised, tribal boundaries set by fear of the other. Her theme fits right into our conversation. She argues, which almost goes into brain stem science, that basically we are born with the story that if you're not of my tribe, my gender, my community, or whatever, then you are "Other." That served humanity well for a while because you did have to protect your group from various predators, sometimes human, and keep people alive. Now, it doesn't serve as well. But, it takes an enormous amount of courage to overcome the fear that goes with actually encountering the "Other." This small book is another little piece of a new story. It

has got a little pod of people here, another one over there who have been influenced by it.

PS: I think there's another part to the new story and that's that we humans are not different from the rest of the creatures.

DOF: Yes, that's part of the inter-connectivity story. It's not just us humans.

PS: As a person, I am greatly concerned by the fact that there are so many billions of us and we have created this tremendous juggernaut of impact on the planet as a whole. What role might the arts have to play in ameliorating that? By the arts, I was thinking broadly about the creative impulse which we all have to some degree. But, also I was thinking about artists with a capital A and arts organizations and institutions. What role might they have in birthing a new world?

DOF: Let's cut this into two or three pieces then. I think one place you can start from, and this has been substantiated in the last 10 or 15 years, is everybody is wired up neurologically to do the half a dozen things that we claim are the arts. So, we all tell stories to make meaning out of the world. Every single person does. You can't stop it. We all create narratives to hold ourselves together. We all move; every little kid enjoys movement until somebody switches them down. We're wired up to make and enjoy of music. Even people who are deaf-mute respond to and enjoy rhythm and the vibrations in music. So, we're all doing that. We all love certain things visually; there are images and shapes and patterns we respond to and so on. In a sense, everybody has these primary impulses to make, shape, create, and tell stories. It's like everybody has some athletic impulses: throwing, catching running, jumping. Some people do it a lot better and really, really love it. Others, not so much.

PS: The more people are better at it to begin with, the more encouragement they get from others.

DOF: Then they get reinforced and so forth. But, I want to start with this biologically; we're created to do these things, it's in there, we're wired up to do it. Then people get filtered out and reinforced or discouraged along the way.

PS: What happens is that only people who are really good enough to sit on that stage are allowed to do it. Otherwise, it's not "real music."

DOF: That's exactly right. One of the turning points might be to just recognize that everybody has this capacity, this urge, this interest. We have been speaking of stories; I think a few years ago, we would have said, "stories are just stories, fiction." Now we understand their power. For example, President Reagan was an incredible storyteller, although the facts never bothered him. But his stories still have weight; people still refer to them.

But to think about the role of the arts, we have to consider what happens in the conservatories and schools—the places that exist to

educate those who want to be artists. I think many of them are so far out of it, it's hard to understand. They are still preparing people to enter a world that is actually disappearing. My on-the-ground example is out of 165 musicians teaching at MacPhail (School of Music), almost none of them were prepared for this job by their schools of music or their conservatories. The same is true of the visual arts world. So, how do you help artists understand that this training in the art form can actually be used in many other ways? A couple of Saturdays ago, I spent an entire day with the poet David Whyte. He wrote a little book called *The Heart Aroused*. He got into corporate consulting because he kept saying, "poetry is the doorway through which you ask yourself the serious questions about your life." And the corporate world said, "We're really interested in that. Would you help us ask these questions?" He makes a living all over the globe using poetry—some of his own and some from others—to take people deeply into the "why am I here, what am I doing with my life" kinds of questions. There are other examples of this and they are hopeful signs of the arts coming out of the narrow art world and into the broader society, saying, "This is a body of knowledge, a way of being in the world that you need to know. Art helps with the work in the world that really needs to be done." We know we're interconnected and that we're responsible for shaping the world. We have a new level of ethics that we need to aspire to, and the arts help us do this. Do you know Daniel Pink's book, *A Whole New Mind?* He lists the skills we need today: Story is one. Symphony, play, design, empathy, meaning—those are the others.

PS: Yes, I've been impressed with Pink's ideas. I've also been reading a book by Thomas Berry, *The Great Work*; he argues that solving our environmental crisis is more a question of the arts and religion than it is of politics and economics. He's talking about a new ethic of being in the world and relating to the world. His artistic imagery is that the world is a symphony, not a spreadsheet.

DOF: Exactly. That's one of the ways you begin to change the story or the mental map of: "gee, what's going on and how do we all connect to it?" But the arts world itself is not preparing people to do this at this point. Is there any way that could be changed or encouraged to change? This goes back to our earlier question; can you change institutions enough to help them prepare people for this world? I think there are so many things that are happening at the edges and the fringes that are interesting. All kinds of crossover work: the Heartland Institute and thought leaders gathering there, the work that David Whyte and others are doing. I don't see any one institution right now being able to move fast enough. But, there are hundreds of little places around the U.S. like the Continuum Center here in Minneapolis, for example, that keep bringing in people who may seem far out. But, maybe all of this pulls us a little bit

in the right direction. There is the development of holistic medicine at the University of Minnesota and Saint Catherine's and other places. There are things happening. There's no question about it.

PS: What we might hope for is that gradually this grassroots activity would infect the other institutions which would either become transformed or become irrelevant.

DOF: I think if you accept that we're in some kind of turning point, things could go any direction. It could go bad or it could go good.

PS: What would bad look like?

DOF: More protectionism, isolationism, more fear, more tribalism. Tribalism at a very large level. Nationalism. Things like a 700-mile fence to seal our border off from Mexico. Shit like that. There's plenty of fear around. Fear is interesting because it goes to the sort of lowest part of the brain stem.

PAT: The arts don't operate that way?

DOF: Sure they do. Of course, they can. When the arts arouse very powerful emotions, then they are the most effective. It may stick with you longer. I think one of the things we've come to learn, and I will now refer to the 1924 K-8 teachers' guide for the state of Minnesota. It was my mother's. She was a public school teacher in Chicago and then here. I found this manual when she moved out of her home of many years. In the section on history it said we know that if you teach history using plays and stories, people remember much longer, because a fact by itself is soon forgotten.

PS: Oh my goodness, over 80 years ago!

DOF: People have known this for a long time. So, we know that information connected with the power of emotion is what you remember. Howard Gardner's done a lot of work on this. That's where the arts come in: to help us make sense out of all this crap. We need stories to do that and we need to be emotionally engaged. It's not a fault to be emotionally engaged. It's a powerful resource to be emotionally engaged, to help us go on, to be motivated, to have energy, to care, just to care.

PS: I was reading something somewhere that one impact of our last few decades is that our caring is very much about me and mine, my family. But, we've also learned to care about the people in Darfur. When there's a tsunami in Asia, we care about that. That's what you were talking about before: the global and local kinds of connection.

DOF: Yes, both at the same time. Then I think what frustrates people is that they don't know what mechanism to use to really affect something like getting aid to somebody after the tsunami or in Darfur. We do some of that. So, people volunteer, they write checks, they do things. But there's a certain level of frustration, because the official institutions don't work very well.

PS: Well, we know how they screwed up Katrina. People want to be involved.

DOF: They do. Look at all the churches that have sent busloads of people down to the Louisiana, Mississippi areas to build a home or clear trash or whatever. Hundreds, thousands, thousands have gone down to be helpful. Absolutely. Then you look at the institutional response and you say "Well, that sucks. Why can't they figure that out?" That's what I mean by the bi-polar experience. While we're looking at Darfur and we're saying it is genocide, hundreds of thousands of people are suffering and dying. People care, it's not about not caring; how do we have any impact? Kick the U.N. out or it goes in and it gets kicked out again. Stuff happens. That's when I come back to we don't have the institutions right now that can do these things in the way they need to be done. I don't know if we ever will. I really don't know.

PS: And if we don't get them, what happens?

DOF: I don't know. But I do know that people have been and are inventive, creative, courageous. Our capacity to exercise our imagination is greater than we credit ourselves for—and now we face the most complex interconnected challenges ever faced.

PS: My final question has to do with the possible ways our cultural resources, whether we think of the arts world or the broader creative potential of folks, might be integrated into positive change? You were saying that's what might or should or is happening. How might that be encouraged?

DOF: It could be encouraged by a shift in funding priorities, a shift in concepts. I'm glad to be at MacPhail right now because we're so flexible that we can shift and respond and talk and change our story. That's exactly what we're doing and we don't need anybody's permission. That's fun. I'm there, I think in part, because we can do this. If I were part of a state agency or a school system, I'd have too many people who would say, "Oh, an interesting idea, but we can't do that."

PS: We don't have the funds.

DOF: And we have to test kids until they practically die or something like that. I'm very cynical about changes at some of those levels, even at the university level. I think the university keeps preparing people to teach at the university. None of that is bad by itself, but it's not transformative. Again, there are a thousand exceptions; you can find places where things are very different.

PS: You're right. But, the differences are often found in the interstices between the institutional silos.

DOF: I think the DNA of an organization like a state agency, a university, an orchestra, whatever is too often to keep itself in stasis. And still, in the interstices, as you say, there at the margins, transformation is taking place.

PS: For years, for hundreds of years, we've known that bureaucracy tends to perpetuate itself, even if it's not doing what it was originally designed to do.

DOF: Then you ask, "How do you hold that group of people accountable?" People have been struggling with that for hundred of years too.

PS: David, thank you so much so sharing your thoughts with me. It's been great to talk to you again.

Chapter 28
Linda Burnham & Steve Durland

"A culture needs art to be whole"

This is the third and final part of our interview with Steve Durland and Linda Burnham, the founders of the Community Arts Network. The conversation continued with reflections about how the arts should function in the world as we know it.

SD: I've been thinking a lot lately that we have to do more in terms of how we frame these ideas, because that affects how we understand them. A couple of months ago, somebody wanted me be on some panel; the topic was basically about this new movement called community art. But this set me thinking that we're talking about it wrong because it's not a movement and it's not a discipline. Rather, it is simply the basic way of looking at the relationship between artists and the larger public. This could take various forms: it might be activist, it might not, it might be performance art, it might not. It is artists in the community responding to the problems of the community. That's not something you are adding on. That's something that's totally natural.

LB: Art is part of the assets in your community.

SD: Yes, that's what any artist would make art about. The second issue that I keep dwelling on is we keep framing art as a tool for addressing issues. I think that sells art short and it leads to misperceptions where we end up with these Richard Florida, cultural tourism ideas. Artists realize those things aren't about art. Those things are about somebody making money and as soon as that's done, then the art is gone. It's because we think that art is a value-added sort of thing, like they tore the last chapter out of a book. Putting the chapter back doesn't make it a better book. It makes the book whole.

A culture without art isn't a culture that needs art to be better; it's a culture that needs art to be whole again. A whole culture then has what it needs to respond to these kinds of crises inside itself. When you marginalize the arts in your community or in your culture, it is like a chemical imbalance. Part of the way that we do that is to think that we are having art when we watch television or we watch movies. If that's all the art a community has, then we all live in New York and Los Angeles. People lose their sense of self worth then, because there's nothing about me. My life is represented by somebody who lives in the upper west side in Manhattan, because that is what my art is about.

PS: I was talking to David O'Fallon about the place of the arts in culture in general. On one hand, he said, the artist expresses the dreams, visions, and needs of the community. On the other, the artist provides the channel by which everybody's creativity gets developed. On one hand, the artist is the creator who takes the raw material from the community and on the other, the artist infects the community with creativity and brings forth the creative impulses of the community at large.

SD: It can be both. The arts work in two ways. First, there is what the arts do for the people who are doing them. Even if you never do anything great, just the process of painting is a physically healthy thing to do just as the process of dancing or playing the piano. Then there's the process of listening, of hearing great art being done or

seeing it or watching it or being inspired by it. These two aspects are not necessarily mutually exclusive.

Take the example of community theater. People say, "Well, did you see that, it was so bad." But maybe that wasn't where things were supposed to work. I like the baseball metaphor; forty year-old men with beer guts go out and play baseball and little kids play baseball; nobody says baseball's bad, even though the quality of the game is terrible in those cases. There are a few people who are actually good enough so that somebody will pay them and other people will pay to go watch them. There's no reason we can't look at the arts as having that kind of hierarchy; art-making is totally infused in the community and you've still got museums. There is no reason that kind of hierarchy can't be part of this world that we're looking at.

LB: The Ford Foundation has something called the Leadership for a Changing World Program, which has included a few artists. Their published study (*Quantum Leadership, the Power of Community in Motion*, written by Jennifer Malenski) of interviews with the recipients of the award says that the United States is in the midst of a leadership revolution. The review we have on CAN says: "Positing a revolution driven by the actions of a community instead of an individual, the report defines quantum leaders as not necessarily heroes or born leaders; rather, they know how to tap into the leader in each of us, often giving marginalized community members their first sense of possibility. It outlines seven strategies that quantum leaders use to catalyze and strengthen their communities."

PS: That goes to what I was saying about the artist as the person who infects and who creates the context within which people can recognize their own creativity, and take ownership and responsibility.

Do I hear you saying that artists are doing everything they might or should in this area? Or are there other kinds of foci or targets that artists and arts organizations might attach themselves to?

LB: I think there are some very strong organizations of color rising, for example, Pangea in Minneapolis. They are bringing together all kinds of immigrants and really bringing a voice that's not being heard anywhere else. And they are not going to be shut down. They're still standing up, they're still raising money for their organization. They're still making these outrageously political statements. I think that there are new voices coming out all the time.

PS: So artists are doing what they can?

LB: Despite the fact that there's absolutely no funding and they all have to have jobs. Maybe if artists had more opportunities or more credibility. Steve, what would make artists more effective?

SD: Criticism. We've totally done away with this idea of the critic, and by that I mean somebody who's going to reflect seriously on what artists are doing. I still think back to Mike Kelley's great answer

when someone asked what the problem with art in Los Angeles was; he said "not enough people hate that painting." We used to have this argument all the time when we were talking about activist art, too; just because it was about an important issue doesn't mean it was done well. This whole world we're talking about now is relatively new and it needs to be allowed to grow. But it is also time to introduce some more serious critical reflection on what people are doing if you're talking about what's going to make it all it can be.

PS: That has to come from within the art community itself though, doesn't it?

SD: Traditionally, criticism doesn't. It's its own field whether it comes out of philosophy or sociology or some place like that. I guess if you're talking about visual art, the greatest criticism tended to come from the poets. You know the greatest critical writers in 19th century France were poets and writers. They would write about paintings. Where this comes from could be internal, could be external.

PS: Do you mean criticism of the quality of the art or criticism of the way in which art engages with the community?

SD: I mean criticism of how well the artists accomplish the goals they set for themselves when they started doing their work originally.

LB: I think the kernel of what Steve is saying is the only way art gets better is if somebody challenges the artist about what they were trying to achieve and whether it looks like they did. Here's my point of view on that. I don't think that the critics are going to come from the critic class any more. Rather there is a bottom-up kind of criticism through the internet and so forth.

PS: Do you think the implication of that is that art will be strengthened?

LB: If you were trying to do something and somebody said, "I know what you were trying to do, but you didn't do it." If you're an artist, if you're truly an artist, you're so obsessed that you're going to try it over again and get that better, communicate better about what it is you're trying to do and go straight for the heart of it.

SD: Or, if you're somebody else and you want to do something similar, you're going to say, "okay, so and so tried this, didn't go over very good, or it went over very well."

LB: So many artists claim they're trying to make social change now. They need to be called on that. What changed? What do you think? What was learned here?

PS: Let's go back to the question of social change in general and the place of the arts in it.

SD: The only other thing that I always like to talk about is I just get a little concerned when we start talking about art for social change, because there's a percentage of people in our world for whom the

social change is important as opposed to the art. I'm not saying that social change isn't important.

PS: But there's more to art than that? It transcends?

SD: Yes, art is social change.

PS: Good way of putting it.

LB: It's a manifestation of social change, isn't it? We know people who are well-known award-winning artists, who have said straight up they wouldn't be in the arts if they weren't doing something political. They came out of activism, that's what they're using it for, and it's no good unless it helps them reach their political goals. Dudley Cocke is one of those people and John O'Neil, too, I think.

PS: For them, their artistic inclinations have to be moved toward making the world a better place in some way or other.

LB: Yes, absolutely. They're constantly trying to jerk the whole field in that direction by setting up organizations, conferences, and stuff.

PS: Do you think they're successful in jerking the whole field that direction?

LB: George Bush has probably done more jerking than they have. Dudley Cocke is involved with these people of color centers that I was talking about. They all trust and like him because they see Appalshop as being marginalized, impoverished and under-served. He would just love it if our website was about nothing but social change, leaving out all the people who are going out and doing painting in hospitals with the terminally ill or working in schools. But our umbrella at Community Arts Network has to be bigger than that because we really believe people are just starving for their creative selves.

PS: I guess I would argue that working with terminally ill patients is as important as protesting at the Republican Convention in terms of impact on some real person somewhere.

LB: You put activists and artists in the same room and you're often going to find that edge, that rubbing up against each other. The ones that are full-time activists truly believe that if you really were an activist, you wouldn't be an artist. Making art is a waste of time. You just wasted all that time and energy, all those hours when you're not sleeping, when you could be engaged in political action.

PS: A woman who is an activist in the area of sustainable economy told me that the arts are essential to making change happen. People get tired of being lectured at and being organized. The arts can teach, can inspire, can encourage, can motivate in a better way than simply saying here's what the problem is and here's what you need to do.

LB: Well, there's something in it for you: you get to paint, you get to dance, you get to play music. One of the things that I've come to think, having looked at a lot of theater and performance art, is that the most successful community theater is musical theater. People

really love making music together; they love getting up to sing, having someone else giving them permission to do it, and have it be in a context where the audience is your friends and family. Those kinds of performances where music is involved are the most successful in community theater.

SD: It's an interesting thing to look at the various disciplines. Music and to a slightly lesser extent dance are disciplines that exist in popular culture, so everybody feels empowered to be musical or to dance. You don't call it art. Whereas theater and painting, and to a lesser extent writing, that's when you talk about elitist stuff. People don't feel empowered to just draw and call it art, the way they feel empowered to just dance.

LB: I believe that in community art, the project is only as good as the artist at its core. There has to be an artist there. I believe it's a director's medium in a way, because each artist goes into a group, works with what is there, and makes that into an art work. You see it the clearest when you're dealing with a community-based theater where a director goes in and deals with 100 people who've never danced before and then they're dancing. Whether they can kick high or pirouette or whatever, the director has to figure out how to use each person to best advantage and mix all that together. I really, really believe there has to be an artist for it to be interesting.

PS: That's how American Composers Forum's Continental Harmony program was organized. The composers took a community and studied it and then wrote something for their performers, who may not have been able to sing on key particularly or play very well. The composer wrote something that they could do, that they themselves could do.

LB: We're really committed to the idea of the community being empowered to hire the artists. The Cultural Affairs Department in Seattle created a similar program called Arts Up, where communities would apply with an idea and then the arts commission would match them up from a huge roster of artists from all over the country.

SD: We learned about it because they invited me out there to sit on a panel to create a roster of artists for the communities to choose from. The money goes to the community. This totally short circuits a lot of the problems with community art, where the public getting upset, saying "we could be spending this money on homelessness or we could be spending it on AIDS." So often artists go out and raise the money from foundations that give money to artists, and then they go into the community and have to sell the idea. In that case, the communities can't lose. They think, "Okay, you got the money and you want to do this. Go ahead. We'll sit back and watch and if it fails. . ."

LB: But people say: "If we had that much money, we could put a street light in the center of town."

SD: But when the community gets the grant, then the onus is on them for the work to succeed. If it fails, it's not the artist's fault.

LB: Toward the end of the 80's I came to the South for the first time and met with the artists of Alternate Roots. They really turned my world around. They were working all over the South, often in their own hometowns. Alice Lovelace, a black poet, in Atlanta was literally the writer for her neighborhood. She would write for people who couldn't write, help them with things. Dudley Cocke and Ruby Lerner wrote a manifesto about the artist's place in society and in the town. We have it on the CAN website. It just completely turned my world around, because I was able to see things from that point of view. (www.communityarts.net/readingroom/archivefiles/2003/10/a_call_for_cult.php)

PS: Since some of these issues like climate change have to be dealt with locally, I would think that the artists could be really powerful in helping communities to figure out how to use less energy, grow food, and celebrate their sense of place.

LB: They are creating projects in neighborhoods all over the place that make these values manifest, creating urban gardens and things like that. Especially in northern California, it's a huge deal. What I'm saying is that when artists do a project around recycling, it's going to be really interesting and attract a lot of eyeballs.

PS: Right. It's not going to be the same old boring thing.

LB: The participants who are part of the project, their lives are going to be changed. And possibly even those who just watch. But if you don't get people involved in a project, it's hard for them to change because they're so used to being an audience.

PS: That's true. Participatory projects allow people to take power over their own lives and over their own situation.

LB: Right because they've actually done it. Back when I was interested in performance art, I remember talking to a psychologist who said there are certain ways of moving your body that can actually change the molecules in your body, change your personality, and change your organs. For somebody who has a job where they fix widgets all day long, dance or performance of any kind could do that.

SD: One of the challenges now, I think, is that every place does not have the same big issues. You don't go to Darfur and tell them the biggest issue is global warming. We heard speak a guy from South Africa talk about these community art centers that have been set up all over. But between what happened with apartheid and now this devastation with AIDs, there's no concept of community, no family structure, no community structure. His job is basically a circuit rider to go around to these various community centers. But they can't figure out any way to get people to use them because

people have no vocabulary of getting together, of working on is-
sues, of addressing things, because the world has always happened
to them. Those are just a couple of examples, a segue with Baghdad.
Most people in Baghdad aren't too worried about global warming
right now.

PS: No, but they have their own issues of violence and survival. I don't
know if there are any artists left in Baghdad. I bet if there are,
they're trying to help people cope.

Chapter 29
Milenko Matanovic

"A joyful image"

Milenko Matanovic is a community builder and a visual artist with an international reputation and a professional career of over 40 years. As a member of a Slovenian art group OHO (1968-72) he exhibited in museums and galleries throughout Europe and the Museum of Modern Art in New York. As founding director of Pomegranate Center he has created an arena in which art, public participation and community betterment converge. The non-profit Pomegranate Center facilitates the conception and construction of open-air gathering places, and integrates art into architecture, landscape and streets. His work at Pomegranate Center has brought people and communities together to create and identify cultural, environmental, and social priorities in community development. Mr. Matanovic is a popular public speaker and has made presentations at numerous events and conferences throughout the U.S.A. and Canada. He is an author of three books. The most recent, *Multiple Victories—Pomegranate Center's Art of Creating Community-built Gathering Places*, describes his philosophy and working methods. He was honored for his work linking community betterment and design by the 2005 national Home Shelter Award and a 1997 Evergreen State Leadership Award in Washington state.

WC: Do you think that we are at a point of departure in human history?

MM: We are at a point of acute acceleration. Many of our everyday actions are destructive and the feedback is now so pronounced that we cannot ignore our actions any longer. The reason why I'm thinking about acceleration rather than departure is that I, personally, have heard this talk for the last 45 of my 60 years. This notion that we need to come to terms with how we use our human power, how we relate to the planet, how we either destroy or collaborate with nature, with each other, with other cultures, has been at the forefront of the thinking of many people for a long time. What is new, I think, is that the sum total of those actions is now confronting us with greater urgency. Global warming, our current environmental indicator, is an exclamation point at the end of a long book that tells how we have destructively impacted the environment throughout history. Now it has come to a boiling point. The totality of our individual and collective acts, magnified by population growth and increasingly awesome technological abilities, is creating our modern condition of destabilized nature and deeply confused culture. Determining the difference between destructive creativity and constructive creativity has been a concern for a long time. Answering it now is urgent.

WC: Would you agree that the question of whether humans are having a deleterious effect on the health of the planet has moved from the theoretical to material realm for many more people?

MM: I think it's occurring more but I don't think it's occurring fast enough. We have all the information we need, but are not compelled yet to change our behavior. For example, today's Seattle *Times* had an article about the negative repercussions of an increased demand for cashmere sweaters produced in China. It turns out that the method currently used in China for producing them has led to widespread overgrazing. Focused only on their sweater, I think it would be safe to say that the average cashmere sweater buyer is not aware of the far-reaching consequences of their seemingly benign purchase. I think it will take a lot of storytelling, like the one in the Seattle *Times* today, to drive home the fact that our most automatic acts need to be scrutinized, reevaluated and changed. The routine use of cars, for example, will need to be revisited; as will the purchase of cashmere sweaters. How we construct our homes, how we hop on airplanes, how we eat, how far from home we work, how we inflict injustices in pursuit of conquering economic markets—all that will need to be revisited. This is a very big and uncomfortable challenge for all of us. The great majority will want to postpone change for as long as they can. In the past decades, it's been a very small vanguard leading the conversation about our collective re-visioning. As the consequences of our actions have become more visible, this group has grown enough to

be considered a small minority. That said, we have a long journey ahead of us before the imperative for a deep and profound collective change will be embraced by a majority.

WC: Many people will try very hard not to believe that their behavior has any impact on the world in which they live. Where do you think this denial comes from?

MM: Confronting change is not easy. I remember the struggle that I had to go through to stop smoking. I knew that it was not good for me. But, the cells of my body were yearning for it and contradicted my best judgments. Well, you multiply that small case by a factor of billions and you get the situation we're confronting. There are so many things pushing us back into familiar patterns and comfortable habits. Change is hard work. Only a compelling and shared vision of a better future can create conditions for more rapid societal change. As it stands now, we do not even agree on what the problems are. I see this playing itself out in the communities where we work: initiatives for new gathering places, parks, town centers, bicycle trails and other amenities, promoted by one group are perceived as threats to the privacy and well-being of another. Two divergent images of community are played out. In our country there are wide discrepancies about what future to invest in. In Seattle we go back and forth about what transportation infrastructure to support: mass transit or roads for cars. We end up supporting a little bit of both, never committing enough to either one for it to be truly effective. Then we sit in traffic, with a poor mass transit system, still undecided about what future to invest in. My sense is that much collective conversation needs to occur before we agree to a shared vision.

WC: Do think we live in a culture of deferral? Where more and more people are inclined to take a pass—leaving it for someone else?

MM: Change will happen, whether we want it or not. The choice is between being a constructive and willing participant in the change process or being a victim. Can we adjust, learning and adapting with grace or do we wait until 4 x 4s start falling on our heads, subsequently allowing fear to spur us into action? The trouble is that learning by fear doesn't work because our creativity is constricted, our imagination is compressed, and we become reactionary only. Fear is like a black hole sucking energy, reducing the large field of possibilities to a singular point of view. Human beings have the capacity to be very creative and imaginative under the right conditions. I do not like people who use fearful scenarios on the assumption that this is what you need to wake people up. I think that's a trap. It only suggests a lesser present rather than a greater future. Even though the dark vision might move some people in the right direction it won't get us where we need to go.

When I stopped smoking it was not the fear of dying prematurely that got me to change. It was the fact that I started to bicycle. The cigarette I smoked before I climbed the hill caused me to stop four times gasping for air. I realized if I want to bicycle, I cannot smoke. A more compelling image of me as a bicyclist pulled me away from my image of myself as a smoker. The transition was simple because of this re-identification. I did not suffer through the change. I was easily pulled into something better. Cultural change will happen in a similar way. We need to create an exciting, inspiring and joyful image of the future that pulls us forward. This is more than improving the present. It requires a deep re-imagination of what human existence and culture is about. Being pushed from behind works only to get us started. The long journey requires purpose and courage only made possible by a compelling, living vision of the possible.

WC: Earlier you commented that you thought it would take a lot of storytelling to get people to change their worldview. But you're also saying that if you focus on the scary story you will drive people further into the "I might as well get mine while I've got time" mindset. In order for those stories to resonate don't they have to be authentic? Don't they need to be grounded in truth and hope?

MM: In the fear-based mindset, problem solving is diminished. Creativity is made possible by the tension between the possible and the real. This means looking the world squarely in the eyes and acknowledging all the violence and stupidity that exists, while simultaneously seeing possibilities beyond that reality. Facing both of those poles at the same time is a precondition for creativity. When we are in "the world is ending" scenario, that tension is reduced to one pole only. Within that, you cannot be creative. You can rearrange things within the same mindset, but you can not be creative because there is nothing pulling you beyond the current situation.

WC: You're in the reactive mode.

MM: Absolutely. The polar opposite of this is the kind of a blind idealism where you can't face the reality and you become detached and irrelevant. For obvious reasons, this is as ineffective as its converse. Somewhere in between is this modality of a creative person that can face, Janus-like, in both directions, always nudging the reality towards the possible.

WC: So how do you see this working in the work that you do at Pomegranate Center?

MM: We try to create conditions where collective creativity can flourish and where change can take place. I think that we underestimate collective wisdom. I base my work on the simple idea that together we know more than any one person. We try to create environments where that knowledge can come to the surface to guide projects. I bring artistic methods to my community work. This means that I

am interested in creating specific projects that connect to the ideas
and hopes that reside in a given community. Pomegranate Center
artworks are gathering places envisioned and built with community
involvement in all phases of the work. Some are also plans for town
centers, trails, libraries, parks, all based on community ownership.

Our strategy is to break down this idea of large societal change
and do something that is bigger than individual lives, but still small
enough that we can actually do something about it. We may not be
able to do much about global warming, but we can do a little bit
to improve our community and maybe, as a result of that improve-
ment, people will walk more and drive less. So we take big questions
and find a very doable action to honor them.

WC: It seems to me that, you're giving people a safe place to learn and
experience citizen-centered social change. Kind of like Commu-
nity Change 101?

MM: We break projects into three phases. The first is about imagination
and vision, the second about the design that rises out of that ima-
gination, and the third is about action, construction and fabrica-
tion. During the first phase we try to uncover big ideas that reside
in the community. We try to pull out of the community its own
imagination for what the neighborhood or town should become.
During the second phase we translate these ideas into design con-
cepts. We do this through community design workshops where
members of the community work alongside us offering their ideas
and providing instant feed-back to design proposals. In the third
phase we invite community members to work on appropriate ele-
ments of the project with the Pomegranate Center team. Our suc-
cessful projects benefit from 1500 or more volunteer hours. This
model replicates the artistic process. Our goal is to engage the ima-
ginations, minds, emotions and hands of the people we work with.
Results are better because of this, because we know that ideas and
concepts alone do not make the work.

WC: Some people think of human creativity as a kind of gift that's dis-
tributed around serendipitously to the fortunate few. I don't think
either of us subscribe to that notion. Where does the creative pro-
cess rise in your work, particularly in communities with groups of
people who are in some way connected?

MM: I think that we need to acknowledge that some people are more tal-
ented. Think of Mozart who as a four-year old picked up a violin
and knew how to play it the first time. Let's acknowledge that this
is just a special individual gift. I'm interested in collective creativ-
ity. Can a society be creative? Can a community be gifted? How do
you create ambience that allows that creativity to be more evenly
distributed, so that creativity becomes a way of being for many
people rather than for a few special artists or creators?

We need to learn the difference between cleverness and creativity. I think we know much more about how to be clever than being creative. By cleverness, I mean the ability to do something unusual, even outstanding, regardless of what affect that may have on community, the society or on the planet. An architect can design a brilliant structure in the wrong place, harming the community. Cashmere sweaters are brilliantly produced yet still contribute indirectly to overgrazing. Cleverness is a one-way street, a person acting out unto the world. Creativity, in contrast, is the joining of an act with the context, a two-way street where we allow the world to act on us as we act on it. So, true creativity would have the producer consider goats overgrazing and the resulting dust bowls as much as the design of the sweater. I think this is the challenge facing us now: how do we place our individual brilliance into this much broader context of community and natural vitality? How do we make sense of what we do in that context? I believe the way towards a saner and more sustainable future will follow the pathway provided by peer creativity, team creativity, collective creativity, community creativity, where we use each others' talents and knowledge to ensure that our actions enhance rather than destroy, connect rather than fragment. Of course certain people will be more talented than others, but we will still require a much broader joining of creative talents to start mass-producing even a cashmere sweater properly. In short, to have any chance of solving the many problems facing us, we will need to consult many sources of knowledge, many intelligences, many experiences. We will need to learn how to tap this greater knowledge. Pomegranate Center is a small experiment contributing to this notion.

WC: We live in a culture that often treats the idea that we should work collectively or think about things beyond our own of territorial imperative as restrictive, as impinging on individual rights and individual self expression. Do you confront this in your work?

MM: Absolutely, all the time. I confront a disdain for collective creativity, especially with some designers. Many people believe that group work equals mediocrity. To be fair, they have a good argument, for indeed many community projects are dragged down by the lowest common denominator. I want to make it clear, though, that for me it is not an either/or situation. Collective creativity doesn't mean that individual creativity is not important. The key is to find a way where individual work and teamwork coexist and support each other, like in jazz where individual virtuosity coexists with the collective work.

WC: One of the things that I think is striking about the way that you work is that it's about groups of people taking ownership and taking responsibility for collective endeavors, everything from design to building. But, there is also a strong role for a lead creator or a fa-

cilitating creator in the process. Could you talk about the balance between the two?

MM: In the conversation phase of the work, we propose a set of ground rules to guide the process. These ground rules are quite demanding, created to maximize creativity and surface the best ideas. In that phase, our leadership is in helping with how the conversation is conducted, not with what is being said. When we actually build and make art with people, we urge them to do their best. Many people we work with have never done art work, but we want the end result to be excellent. Some people don't like to be pushed this way. They think that the fact they are volunteering should be enough. Afterwards, however, they're grateful and proud. They say, "Wow, I did that." Pomegranate's role in this work is to nudge the level of expectation as high as possible while still accomplishing the work. Recently, we worked with a group of children with the attention span of a few minutes. We then needed to figure out what could be done with those few precious minutes of focus. In those circumstances we break down a larger project into smaller manageable parts, like a quilt. We ask the children to create something small that we can assemble into a larger work. We adapt with the circumstances. With adults, we can sometimes get them involved in hours upon hours of work and by the end, they not only produce great work, they also master new skills and learn about each other and about their own community. They realize that they are capable of so much more than they thought. For me, those are moments of great satisfaction.

WC: David Korten talks about the stories of empire that have informed modern assumptions about the way the world works. He also says that the only way we can change our worldview and the way we behave towards each other and the planet is by changing these stories. You have mentioned helping people alter their community's story through their collective efforts. Do you see these notions about community story and world story as connected?

MM: I hope so. We are trying to help a community create something very physical that benefits their own community. Because our model is to move swiftly from ideas, design, construction and then to the programming of the space, lots of people can travel with us from the beginning to the end of that journey. Part of what we give them is that, at the end, they become the storytellers of their own journey—a journey that started with a vision and ended with reality. That journey is about spanning the tension between a utopian ideal and a real situation. How that tension is resolved makes a great story. It is the kind of a story we need to tell ourselves for the planet right now. Here we are. Here are the troubles. Here's where we could be. Let's go on a journey to move in that direction and make it happen. For this kind of a planetary story, I think

we are talking about generations of work. So, part of our strategy at Pomegranate Center is to bring that down into a manageable chunk so people can give themselves up to a small journey that, in a small way, mimics the larger global journey we need to undertake. So, coming back to your question, do we give that experience to people? I hope we do, but we do it through the doing and making. When the best happens, at the end, there are a bunch of storytellers that come out saying, "Let me tell you about the incredible thing that we did." It's the energy of that story that has power.

WC: How does this relate to the continuing story of democracy here in the U.S.?

MM: It fits perfectly. In our governing system we elect people who represent us and make decisions on our behalf. In participatory democracy the decision-making responsibility is abdicated less. At Pomegranate Center we try to create an environment where that notion of participatory democracy grabs people so they see their ideas contribute to the excellence of the project. We find that this is especially touching and meaningful when we work with the new Americans, people who moved here recently, who come from a place where their personal power, their voice, meant very little. So we come in and say, "We're going to build something together. What should it be? What do you think?" Sometimes, they turn back to us and say, "You actually want my opinion." We say, "Yes, we do!" and they say, "I have never in my life been asked what I think." So, in small doses we are reinforcing the notion that peoples' ideas contribute to how well their community works. It's a simple but very powerful notion. Ultimately, I think we will all need to elevate the practice of participatory democracy in order to make our representational democracy work better. To do that, we will need to engage more people on many more occasions, in a participatory decision-making process. This will keep the spirit of democracy alive.

WC: In the practice of Open Space Technology we often talk about balancing the relationship between passion and responsibility—taking responsibility for the things you care most about (http://www.open spaceworld.org). How does that play out in Pomegranate Center's work?

MM: You know, for me, it's all context-based. Our individual actions are more likely to be responsible when we understand the context we find ourselves in. When we ignore or don't bother to understand all the issues and aspects of a given setting, our actions are more likely to be counterproductive. So, responsibility, in that sense, is the ability to align the act with the greater field, with wishes and hopes that reside within a community, with the history of people living there, and with the natural setting. We begin designing only after the context is understood. Then we ask for ideas about how

to design something that honors this context. Again, it's like jazz, where the musician constantly seeks opportunities to integrate her unique notes into the larger composition. In jazz individual contributions are essential for the composition to work. So a big part of what we do is help people understand the surrounding issues and then provide an opportunity for them to act with confidence within that context.

WC: So given all the people that have been involved in your projects, how much of this rubs off and is sustained?

MM: I wish I knew better the impact we have made. I know that there are individuals who worked with us 15 years ago who still are friends because of that experience. I know that there are people for whom that involvement impacted them afterward. For example, I know an architect who worked with us who changed his practice. I know of people who, as a result of our work, stayed in the neighborhood they planned to leave. The project made them optimistic. One community had a block party at our park to celebrate the park that compliments their homes. We were told that because of our involvement people take greater care of their neighborhood. I think some people who are planners and politicians value community input a bit more as a result of our work.

WC: You work with many people across community sectors. How do you think the powerful potential of human creativity that you've been talking about becomes more integrated in the rough-and-tumble everyday life? In particular how does it join up with the people who are trying to promote new ways of thinking about creating sustainable, healthy, and just communities?

MM: There are individual artists who love working alone and being accountable to themselves. That's how they perform best. Unfortunately, for many people this one image defines what all artists do. Some see artists as odd creatures. They enjoy the product of the artists' solitary work, but they don't see them as anything particularly useful or relevant in the broader society. I'm not that kind of an artist. My work is to energize the idea that it's a great opportunity for artists to make communities outside their studios into communities and neighborhoods. What excites me is that in this day and age, artists have an opportunity to bring the essence of artistic practice to arenas of social vitality, community identity and character, urban planning, environment, etc. Artists can contribute to sectors of life where artists have not been traditionally found. That's really been my personal journey. Long ago I decided that making art for galleries and museums was not going to serve my notion of making communities and society more meaningful, livable, and beautiful.

WC: Have you found that the folks on the other side of the table, your clients, your collaborators, your community partners are generally receptive to this notion? When they are not, what does it take to open their ears and eyes?

MM: I don't try to open their ears and eyes overtly. That intent, in itself, can make them less receptive. I try to make myself available to the situation and try to understand their work. I see it as my responsibility to honor both the context and the creativity that is called up in that situation. I find that people are quite receptive when their work and identity are respected, and their situation acknowledged. Within that, I explore new ideas and fresh approaches to increase the team's ability to problem solve and increase creativity. I am interested in solutions with multiples uses. Can a neighborhood that a developer is going to plan anyhow also achieve some other victories that were not in the original plan? I find that people I am working with are often happy to do this once they understand the possibilities. My creativity is to be a presence at the table that allows those connections to be made. The title of my last book is *Multiple Victories*, the idea that in a world of dwindling resources it becomes imperative to do more with less. Therefore, doing something for economic gain alone is not acceptable if that means a loss of environment or justice or misuse of local talent.

WC: So, you're being responsive rather than reactive or prescriptive?

MM: Right, I think that goes a long way. Again, I want to go back to the idea of cleverness versus creativity. Creativity is about connecting the act to the context. Cleverness is focusing so much on the act that the context is ignored and often unintentionally violated. I think that creativity, this art of joining the act with a context, is really part of what artists can teach everyone, because that's what they know. They know a lot about how to attach color to a paper. They know a lot about how to attach a tone to the silence and find the right words to fill an empty page. To improve upon the previous state is their core expertise. So, in the final sense, creativity is about improving on the context, adding to it, offering a gift to it, rather than using it for one's own brilliant purposes.

WC: So saying that, when artists are able to allow the world in which they live to somehow influence the mark or the tone or the color, there is a greater likelihood that their work is going to resonate with the people who inhabit that world, their audience.

MM: I would say that all good artists do that. Their work may be done alone and come out as a book or in an exhibition or a movie, but for it to connect, there needs to be this listening, this responsiveness at the beginning. In my case, the distance between the listening and the product is much closer and quicker because I work right there on the spot. These principles are, however, relevant to all good art.

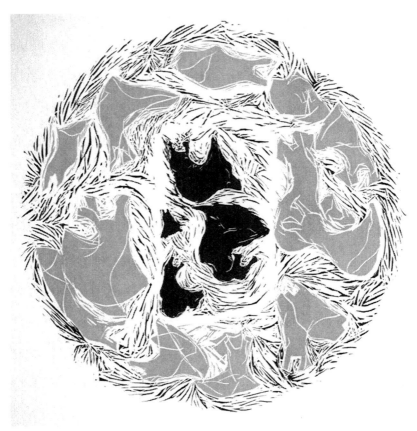

Gabisile Nkosi: *Umbhesiwe* (The Anointed One) Linocut, Gabisile Nkosi, 2007

Part VII

Griot Stories and Shaman Dreams

Visions of the Arts in a Changing World

Griot Stories and Shaman Dreams

Visions of the Arts in a Changing World

Many of the people you have met in this book have shared stories to describe their experiences or elaborate on the ideas and issues being discussed. This is not surprising given that so many of them refer to stories and storytelling as central to their work. As we begin the concluding section of this book, we would like to continue in this vein by inviting you to join in a short imaginative journey of your own.

Our story begins in the meager settlement of a small prehistoric clan gathered around a raging fire.

We are gathered around the ritual fire in preparation for the year's final hunt. The Shaman presides. The fruits of this perilous quest will sustain us through the long and barren winter. The Shaman sings and dances and paints the images of our prey on the cave wall-beseeching the gods on behalf of the tribe.

We know that without this intervention the hunt will fail. What we do here together in this circle is crucial to our survival as a tribe. The Sharman's actions tonight are not an option, an extra, or an entertaining diversion. Our continued existence depends upon the success of this dancer, teacher, poet, singer, storyteller, painter, healer, priest, alchemist--our liaison to the spirit worlds, our spiritual mechanic, working for the community in its essential relationship with the gods.

As we conclude our sacred dance in a whirl of rising dust and ash, we gaze up into the night sky. Sparks and stars mingle in the blackness. To a person, we can feel the presence of the gods. The Shaman nods and smiles. The hunt will be successful. The tribe's song has been heard.

Now fast forward, if you will, to the dawn of the 21st Century. As they say, "Times have changed." Our spears are more powerful, more efficient. We seldom use

them for food as they are far more likely to be used on other humans. For some, the gods are a distant presence, but others believe they are earthly and wear suits or lab coats. We long ago snuffed out the ritual fire and, unfortunately the shaman is a stranger to the village square, which also seems to have been misplaced.

Beyond our borders, which are numerous and in constant dispute, we confront a world in transition, facing enormous challenges---deadly conflicts, widespread injustice, a wounded planet, a loss of imagination. Time, which has become a dominant presence in our lives, also seems to be running out--- for the tribe at least. And so, we are once again on the eve of a crucial, but very different hunt. Our survival depends upon our capacities as innovators, problem solvers, change agents, shape shifters... Our survival depends upon our energy, our tenacity, our morality, our faith and most importantly the vitality of our creative spirit.

One could say that a key question posed in this book is whether we have come to a time in human history when we need to invite the shaman back into our communities as an essential partner for the epochal journey ahead. As we pointed out in our introductory essay, we are not equivocal on this point. We are in agreement with David Korten, Joanna Macy and others who posit that there are fundamental narratives or stories that have shaped both human perceptions about how the world works and our resulting behavior. We further believe that human creativity and cultural practice are essential to the formation and sharing of the new stories needed to achieve a just and sustainable future. We initiated these exploratory conversations to test this thesis with colleagues from many community sectors who have spent their lives working toward that end. The results have been both predictable and surprising.

We feel our colleagues have spoken well enough for themselves, so we are not going use this final section to summarize scope and depth of the conversations contained in this book. But, we would like to explore some of what might be described as the ecology of the conversations. To do this, we are going to experiment a bit by using some alternative methods to investigate the Between Grace and Fear landscape that has emerged in the preceding sections.

The first, *The Community Culture Story,* is the product of an interesting story-based process our colleague David Korten uses to critically examine status quo thinking about the way the world works. This is followed by a section called, *Bridges Translations and Change: The Arts as Infrastructure in a Time of Change* which is our response to what we hope will be a heightened interest in specific examples of an arts animated movement for a just and sustainable future. The final chapter here provides the most extreme departure from our established format. In it, we provide a short prose poem called the Story Story that explores the relationship between stories, the arts, and social change.

Chapter 30
The Community Creativity Story

In his book, The Great Turning, David Korten uses a story-based process to describe and critique the prevailing assumptions and ideas that shape the dominant worldview. The three "Empire Stories," or scenarios he shares in the book are "Prosperity, Security and Meaning.[1] " David believes that change can only occur when we become intentional in our choice of the stories we communicate in our daily lives and through the organizations in which we are involved. As such, he also provides three alternative "Earth Community Stories" for these same subjects. We thought this "reframing the story" exercise might be a good way to animate our discussions about bringing art and creativity into the heart of community life. To that end, we have created two versions of what we are calling the Community Creativity Story

This first piece reflects what might be called conventional wisdom regarding creativity and the arts.

Most people are not very creative. This is because creativity is a gift, like being smart or having a talent. It is also kind of magical, and not particularly well understood. There is no disputing that creative people are valuable, but unfortunately they do not have the discipline necessary for strong leadership. This is because they are often unorthodox and unpredictable. It's good for scientists, engineers, and designers to

1.Go to Korten, *The Big Three Story Matrix,* http://www.davidkorten.com/content/story-matrix

be creative. But learning how to make art or becoming an artist is not very practical or useful. Art can be important, but it's not basic like shelter or food or education. Some artwork can be valuable, beautiful, or inspiring, but it is often so difficult to comprehend that we need some one else to tell us what's going on. All in all, everyday people really don't have much to do with art or creativity.

This second piece provides the alternative that lens that we think is needed to move art and creativity from the margins to the middle of community life.

Humans are essentially creative beings. Our creativity is naturally occurring and massively abundant. It is also the most powerful of human capacities. By the age of four, every child has employed it to learn the language, symbol, and social structures that they will depend on for the rest of their lives. An arts-centered education is necessary for each person's full development. We use the creative process every time we apply our basic skills to solve problems, communicate complex ideas, and envision the future. We need our creativity to help us build caring, capable, and sustainable communities. Art making too is an intrinsic and pervasive human activity. It is one of the most powerful tools we have for engaging the imagination and strengthening our creative capacities. Artists are the athletes and explorers of the imagination. They help us commemorate, celebrate, mediate, communicate, entertain, worship, heal, design, initiate, and learn. This powerful thing that they do, that we all do, helps us make sense and meaning in our complex world. We need the arts to tell our stories, explore the mysteries, and articulate our dreams.

Chapter 31

Bridges, Translations and Change:

The Arts as Infrastructure in a Changing World

William Cleveland

At the time I wrote the first version of this essay for the Winter 1992 issue of High Performance Magazine we were in the midst of what I described as a world "in flux and out of balance." In short order, the dissolution of the Soviet Union and the Persian Gulf War had established the U.S. as the "world's lone superpower." In the summer of that year, an urban uprising in California had resulted in 51 deaths and left the community of Watts a charred ruin. A few months later, a young, relatively obscure, southern governor named Bill Clinton thwarted George Herbert Walker Bush's quest for his second term. It was a time of grave concern and uncertainty, but also, cautious optimism.

The essay was presented as a plea to America's cultural community to get off the sidelines and join the fray. At that time, I (along with many others) asserted that what some were calling a "new world order" was in fact a new world condition--- that the recent spate of tumultuous events was not an unusual spike on the Richter scale of human affairs, but rather, a natural symptom of a globe that was in a perpetual state of accelerating change. This call to action was an attempt to provoke a debate about the assumptions and expectations that had been shaping the contours and trajectory of America's cultural sector in light of that fact. Many others, more eloquent than I, argued that the time had come to dispel the notion that creativity

was an exotic byproduct of the human condition—that, in truth, challenging that notion had far more to do with the survival of the species than it did the future viability of the symphony orchestra.

Looking back, I would say this was an important period in U.S. community cultural development. The country was entering a sustained period when the vital connection between the arts, community development, and social change would be seriously supported beyond the spasmodic vagaries of the public sphere. During this time, large national funders and thousands local supporters in the public and private sectors made significant investments in both community arts programming and infrastructure development. As a result, the field grew appreciably, the Community Arts Network was born and numerous academic programs devoted to community cultural development were launched.

This was also a time when more and more American artists and arts organizations began to realize that their marginal status had as much to do with their own assumptions and behaviors as it did with an unsupportive or indifferent public. For those most invested in working with communities, moving out of the margins meant that their network of partners broadened to include colleagues from other sectors. These collaborations greatly expanded the diversity and complexity of the work and dramatically re-shaped definitions of success or failure. For some, this growth in perspective and partnerships was also accompanied by an increasing awareness that they were a small part of a much broader current of global cultural transformation—a powerful movement of creative community builders and healers with whom they not only held much in common and from whom they also had a lot to learn.

Today, as they say, is a very different time, particularly with regard to America's position at the head of the class and long held assumptions about the global economy. But the themes unfolding on the world stage are also strikingly similar. The threshold issues touched on in the conversations shared in this book closely parallel those that preoccupied us at the close of the last century. Climate change, the gap between rich and poor, the promise and challenge of technology, the clash of tradition and modernity all dominate the daily headlines. If there is a difference, it appears to be in the increasingly obvious intensity and interconnectedness of the issues. Tumult and transformation is the order of the day. Everything is moving at the same time. Everything is speeding up. Change is constant.

In 1992, I said that the changing world would need more than a strong will and a strong arm to come to terms with its problems. Now, as the challenges have become even more sharply defined, our successful navigation of the 21st century will demand the power of the imagination and regeneration. This, of course, is a time of great opportunity for world's artists and cultural institutions. They can bring proven capacities as bridge builders, translators and problem solvers to the daunting task at hand. In the process, they can help to illuminate and expand the language and practice of transformation. To rise to this challenge, though, the world's creative community will need to revitalize and reframe that transformative power and the moral integ-

rity of its work. This was the central point my earlier essay, and I strongly believe that this is still the case. I would also assert that the wide-ranging voices represented in this book are of like mind. My earlier version was directed principally at an American audience. While some of these specifically American references remain, it is hoped that what follows will resonate far beyond our shores.

A WORLD ORDER IN TRANSITION

At the cutting edge of the sciences, a new concept of the world is emerging. In this concept all things in the world are recorded and all things inform one another, This gives us the most encompassing vision we have ever had of nature, life, and consciousness. If (this) information and memory-filled universe is the best insight we have ever had into the nature of reality, we should know it not only with our rational faculties: we should apprehend it also with our creative imagination.

Ervin Laszlo, from "Science and the Akashic Field", 2004

Art can be a shaking, but a very constructive, inspirational experience about many things: the river or the stars or the cosmos or our fellow human beings and community.

Wilson Yates, President Emeritus of United Theological Seminary, Minnesota,

With each passing month, the chaotic dance of world events seems to be intensifying, building momentum. The globe is shifting beneath our feet in ways that would have seemed inconceivable three decades ago. Each morning's headlines leave us shaking our heads. "What's next?" we ask. "World order! What order?"

Early explorers imagined America as an island, a geographic impediment on the way to the Orient. Although they were mistaken in a literal sense, throughout its history the U.S. has maintained an "island-like" attitude about its place in the world. America's evolving power and geography have allowed it the luxury of choosing its connections.

This island status belonged to a world order that no longer exists. Over the course of the past three decades the planet has witnessed change on an unprecedented scale. The collapse of communism, the globalised economy, China's rise, the technology revolution, and the emergence of Moslem fundamentalism have overturned the old global chessboard. In its place is a new world game, or games, that are being designed and played simultaneously in Shanghai, Tokyo, Mexico City, Washington D. C., Moscow, Teheran, Tora Bora, Lagos, and cyberspace.

As its role as "the lone superpower" enters its final season, America must learn to operate in an environment of shifting, toppling, and even flattening hierarchies---a world where information technology, multinational finance, world famine, ethnic conflict and ozone depletion are but a few of the interconnecting threads in the emerging global fabric. In 1776, America declared its independence from the old world. For the second American Revolution

to succeed, it must re-imagine itself not as a separate island, but as one of many components in a complex and fragile ecosystem.

A PERPETUAL REVOLUTION

"Change will happen, whether we want it or not. The choice is between being a constructive and willing participant in the change process or being a victim. Can we adjust, learning and adapting with grace, or do we wait until 2 x 4s start falling on our heads, allowing fear to spur us into action. Fear is like a black hole sucking energy, reducing the large field of possibilities to a singular point of view. Human beings have the capacity to be very creative and imaginative under the right conditions
Milenko Matanovic, Artist, Founder Pomegranate Center

While we were watching the transformation of the world on CNN, the U.S. has undergone a metamorphosis as well. The dramatic migration of population from the north and east to the south and west, the move from an industrial to a service- and information-based economy, the ongoing deterioration of human services, education and public works infrastructures, the country's deep political polarization, its emergence as a truly multicultural society, are but a few indications of the monumental changes taking place. The real revolution in America, though, is rooted in our struggle over changing values. Very little of what was considered the cultural norm during the first half of the 20th Century remains the same. As the U.S. steps gingerly across the border of the new millennium, the debate intensifies over such core issues as: the loss of the nuclear family, the changing roles of men and women, the definition of right and wrong, our relationship to the earth, the distribution of wealth, freedom of expression, the importance of cultural identity, the necessity of war and peace, and much more.

Some see the changes taking place as a disintegration of the basic tenets of the American cultural fabric. Others contend that the U.S. is finally grappling with the gap between our stated ideals and the entrenched self-interest of the established power structure. In some quarters, this questioning of values has precipitated a rekindling of the American spirit of creativity and innovation. In others, the response has been defensive and reactionary.

Regardless of point of view, the movement, the change, the transformation, is inexorable. At home and on the world stage, America is ending its adolescence. As the grip of hierarchy, patrimony, and monoculture slowly fades, there is both jubilation and fear. Conflict is inevitable. But, amidst the chaos of transformation, great opportunity awaits for those who wield the power of the creative process.

A NEW COMMUNITY AESTHETIC

"In our modern world the artist is tempted simply to do stunts in order to attract attention. But the true task of the artist is to discover her or his relationship to a community, a community often in desperate need of the artist's power to see the world anew."

Historian Page Smith, from the forward to *Art in Other Places: Artists at Work in America's Community and Social Institutions*

As we seek to reestablish the vitality of our communities, we must turn our attention to more than bricks and mortar and job programs. We must acknowledge that there is more to a community than geography. Each community has a character, a spirit that rises from its citizens and determines the quality of its life. This essential element does not emerge from the structure of laws or codes or buildings. It comes from humankind's most powerful capacity-the ability to synthesize and innovate and make new-the power of creation. Our creativity mediates the tension between the need both to assert our uniqueness and to link to others. Its power allows each of us to make our own one-of-a-kind mark in the sand, using aspects of past marks, adding new elements, linking ourselves to those who have come before and those who will follow. It is a simple thing, easily called up in the right conditions, easily stifled.

During his presidential campaign Barak Obama put it this way. The "arts teach people to see through each other's eyes, to respect and understand people who are not like us. That makes us better citizens, and makes our democracy work better... imaginations sparked by the arts are more engaged."

Meeting the challenges of this century will require a citizenry with enormous energy and a well-developed capacity for imaginative discipline. Each community will need creative pioneers, adept at risk taking, who will challenge assumptions and question conventional wisdom. This is the domain of the citizen artist --- listening, translating, borrowing and synthesizing; taking the old and new and linking them; celebrating the common threads and the dissonance; reflecting our triumphs, our pain, our folly; creating fresh images and giving new vision.

In the first interview in this book, David Korten makes an impassioned plea for a new set of stories to counter the crises of ecological devastation, unsustainable materialism, growing inequity, and the corruption of democratic institutions. He calls on people to work together to create a new social structure based on cooperative, bottom up, cultural, economic, and political ideals. He also asserts that the only path to this kind of a shift in worldview is to insinuate these new stories into community consciousness.

The point made in many of the interviews that follow is that neither Korten's or Obama's visions can be fulfilled without the active participation of the world's cultural community. This notion is something that numerous communities have already (or have always) embraced. Over the past few dec-

ades, artists, arts organizations, governments and funders around the globe have come to see the fundamental necessity of re-integrating of the arts into all aspects of community life. Along the way, many artists and arts organizations have acquired new skills, learned new languages and established creative partnerships in town squares, factories, prisons, shopping centers, in hospitals, on the internet, at universities, in war zones---you get the picture.

The need for this is palpable. Every day, in communities across the world, we hear from people in search of a new kind of story --a story that navigates the narrow path between the safe and the challenging, opportunity and responsibility. Most of these people also understand that the essential difference between an authentic story and a false narrative is in the making. Another way of saying this is that authentic stories are hand built, by and for the communities that will bear the consequences of their materialization. This, of course, is the cornerstone of effective community building. The inherent and embedded creative wisdom that it represents could also be characterized as "slow culture."

There are many in the global arts community who know and respect the slowness necessary for sustainable community cultural development. They have been working to build caring and capable communities for multiple decades. Now, more than ever, they are ready to gather again with their fellow citizens in the town commons to help weave the fabric of stories that we will need to honor our histories, share our hopes, and manifest our dreams.

THREE ASSERTIONS AND SIX ARGUMENTS IN SUPPORT OF THE ARTS AS INFRASTRUCTURE IN A CHANGING WORLD

Bringing human creativity and the arts back to the community commons will require a dramatic shift in the prevailing view of how the world works. It will require a new paradigm that views the arts and human creativity as central the development of a healthy world in all aspects. I would offer the following three assertions as a foundation for this audacious task.

• Arts-centered learning is necessary for the healthy development and growth of every child.
• Robust and pervasive cultural development is necessary for the creation of healthy, productive and sustainable communities.
• The development of a worldview that supports a sustainable future is not possible without the active participation of society's creators and story makers.

Simple and straightforward as they are, transforming these assertions into widely held assumptions and an unquestioned support for our creative capacities and resources will continue to be a challenge. Many otherwise sensitive and clear thinking people maintain that creativity is a rare and mysterious gift, and that its beneficiary's are exotic and unpredictable outliers. I think it would be safe to say that the thoughtful and committed leadership represented in this book hold a very different view. They see our cultural

development and the attainment of a healthy, just, and sustainable future as intrinsically linked.

There are many, including myself, who believe that knowledge must be annealed by experience to become accepted, embedded wisdom. Nonetheless, making change inevitably involves making a coherent case. To that end, the following are very brief summaries of six arguments and associated strategies in support of the reintroduction of the arts into community infrastructures. For the most part, they are neither new nor groundbreaking. Their newness has more to do with their perspective than with actual content. Rather than advocating from a position of self-interest, this approach ·speaks to the perspective of community members as they inevitably ask the question: "How will the arts contribute to our meeting the social, political and economic challenges facing our community: How can the arts contribute to the development of a caring, capable and sustainable community?"

1. The Arts Are an Essential Resource for Community Development

"Without creative personalities able to think and judge independently, the upward development of society is unthinkable..."

Albert Einstein

Art is fundamental to our common search for meaning. Art is an artifact of that search ...that cuts across all... tribal lines.

Erik Takeshita, community leader, change agent

ECONOMIC IMPACT: Arts-powered economies are slow and green and resilient. They are driven by sole proprietors (artists) and locally engaged small businesses (arts organizations) with small ecological footprints and deep community connections. The many economic impact studies conducted over the past two decades confirm the vital economic spark provided by the cultural sector.[1] More recent research shows a direct connection between cultural engagement, social diversity and community capacity building. In short, arts-rich communities are healthier and more resilient. Most importantly, the data indicates a robust correlation in low-income communities between cultural abundance, population growth and poverty decline.[2] Other studies demonstrate that the arts can be a magnet for both urban and suburban reinvestment and economic regeneration. Rural arts providers, as well, make the case for the arts as a useful stimulus for both economic and social development, particularly in depressed areas.

1. *The Arts and Economic Prosperity, The Economic Impact of Nonprofit Arts and Cultural Organizations and Their Audiences,* Americans for the Arts, 2009, http://www.americansforthearts.org/information_services/research/services/economic_impact/default.asp

2. Mark J. Stern, Susan C. Seifert From *Creative Economy to Society,* Social Impact of the Arts Project, University of Pennsylvania, 2007

Cultural tourism, urban and rural, has become a core marketing strategy in the travel industry. Beyond tourism and community renewal, the arts are big business. In the U.S., the nonprofit cultural sector alone generates $166 billion in economic activity, produces over $30 billion in tax revenues and creates 5.7 million jobs.[3]

COMMUNITY LEADERSHIP: In recent years, public and private leaders have expressed concern about the lack of creativity and problem-solving capacity exhibited by entry-level workers, managers, engineers, and scientists. In response, government and business sectors alike have invested millions of dollars in training programs designed to increase the creativity and teamwork of their work forces.

Given this, it seems ironic that the perpetually poverty stricken community cultural sector has quietly become a hothouse for the development of effective community leadership. For artists and arts organizations, survival in a commodified culture has always meant simultaneously marshaling resources, advocating effectively and producing results. This has produced leadership that is resilient, adaptive and improvisational and that understands that change is a natural feature of the community landscape. It has also created dynamic organizational cultures that recognize that both form and freedom are necessary for integrating creative inquiry and community development.

To be effective, new leaders will need to know how to improvise on a theme while keeping a beat. Lifelong learning, in and through the arts, offers access to the kinds of skills our next generation of workers and leaders will need. These skills include: harnessing and synthesizing the qualities of logic, organization, flexibility and insight; creative teamwork; learning that problems are opportunities not obstacles; learning to discipline the imagination to solve difficult problems; and learning that "failure" is a functional aspect of discovery.

2. The Arts Are a Basic Educational Reform

Of course, the arts are very revolutionary... because the arts expand awareness... (They) give you what you really need to know without clouding over the issues that need to be addressed.

R. Carlos Nakai, musician, composer

The arts have always had systems thinkers, because the artists are always thinking about the whole, the big picture. The whole point of the arts is to give you a context, to understand the significance of something.

Dorthy Lagerroos, writer, musician, activist and teacher

Since the 1983 publication of *A Nation At Risk: The Imperative for Education Reform*, educators, parents, and civic leaders have sought reforms in

3.Americans for the Arts, op. cit.

education. In response, school systems nationwide have placed a greater emphasis on the generally accepted "building blocks" of basic education: reading, writing and math, and instituted a multitude of tests to hold schools and teachers "accountable." Despite efforts to stem the tide, this has resulted in a dramatic reduction in learning opportunities in the arts for students.

The landmark 2001 report from the Arts Education Partnership called *Champions of Change* offers a very different view of the relationship between the arts and learning. The study's researchers found that "learners can attain higher levels of achievement through their engagement with the arts." Moreover, it concludes "learning in and through the arts can help level the playing field for youngsters from disadvantaged circumstances."

The report, which is actually a compendium of five separate studies goes on to conclude that the arts offer a powerful cost-effective alternative for educational success for students who struggle academically. Indications are that the discipline and self-esteem that these students acquire often carries over to their study of academic subjects and provides motivation to stay in school.

The fact of the matter is that education in the arts is a curricular necessity. The creative process is the means we employ to put our basic skills to use. The problem solvers of the future-the explorers, scientists, or engineers who will confront tomorrow's challenges- require more than the basics of math, science and language. They need hands-on experience, manipulating the tools of change-taking chances, challenging convention, taking on the impossible.

Educators are only just beginning to acknowledge the complex mix of human intelligences and learning styles. In this context, arts education is educational reform. The pedagogy of the future should not be just arts inclusive, it should be arts-based. Teachers should know and employ the creative process in everything they do. Arts-based education is the laboratory for harnessing the power of the intellect through the discipline and vision of the creative process. Arts-based education will support the growth of the imagination and creativity as tools students must employ to succeed in a complex society.

3. The Arts Provide a Common Language in a Complex Global Culture

When people make beauty and move to creative action, other things come to life. It's like striking the pilot light. I feel that's what it is to believe in democracy--- the equality of all of us--- we all have that light within us.

Lily Yeh, artist, community organizer

...the iconography of the Great Goddess arose in reflection and veneration of the laws of nature.... The message here is of an age of harmony and peace in accord with the creative energies of nature which, for four thousand prehistoric years, anteceded the (next) five thousand-a period James Joyce has termed the "nightmare" (of con-

tending tribal and national interests) from which it is now certainly time for this planet to wake.
Joseph Campbell, from the Forward to *The Language of the Goddess* by Marija Gimbutas

The iconography to which Joseph Campbell refers is the symbolic vocabulary embodied in European and African Neolithic art. Although the written language we use daily evolved from these symbols, we no longer recognize these shared roots. The marginalization of the arts in this country has separated the American "tribes" from a powerful common language. As change gives rise to protective and reactive responses, we must rediscover the power of the arts to translate cultural difference as a common bond. We must also acknowledge and learn from those artists now working as agents of community change and as builders of bridges.

As these bridges are built, we should focus on the strength inherent in our growing diversity. In her book, *Mixed Blessings: New Art in a Multicultural America*, writer/critic Lucy Lippard describes the changed face of America as an "ajiaco"-the flavorful mix of a Latin American soup in which the ingredients retain their own forms and flavors. She describes this new model as "fresher and healthier; the colors varied; the taste often unfamiliar" that "calls for an undetermined simmering period of social acclimation."

Many artists are beginning to manifest this new global community aesthetic. Their work is the product of a media age, in which, for the first time, cultural interaction, influence and change have not been tied to humankinds' ability to move physically from place to place. These artistic dialogues and collaborations are models for the new ways we will have to interact as global citizens.

4. The Arts Help Us Make Sense and Meaning in a Technological Age

Culture ...is at the heart of the information society. Why? --- Because it creates meaning. ... The key is that it does it in such a way that I when create something that is meaningful---it is for me and for somebody else. This is a very, very basic requirement for living in the information society."
Bert Mulder, Associate Professor, Information, Technology and Society, The Hague University, Former Chief Technology Consultant to the Dutch Parliament

We have the means to gather and manage and act on information in ways we never had before. Artists are poised to become significant actors in these kinds of situations. If we can join with activists in critical ways, it's going to be powerful.
Judy Baca, artist, educator, activist

During the last decade, the arts have been dramatically transformed through the introduction of new technologies. In areas such as film, video, music, design and holography, new technologies adapted by artists for their art have produced innovative applications and opened new markets.

As inventors, art makers are a breed apart. They are unencumbered by the practical constraints experienced by their more product-minded counterparts. Hardware and software in the artist's hands can be merely a technical means to an aesthetic goal. The commercial feasibility of a given solution is often not relevant. But, as has been the case with the artistic exploration of special effects technology and computer graphics, new and unexpected applications emerge. In some ways, the interface of the arts and technology has created an unintended research and development arm for commercial high tech concerns.

The roles of the artist and the technological innovator are often interchangeable. In his book *The Paradox of the Silicon Savior*, Grant Venerable points out "that the very best engineers and technical designers are, nearly without exception, practicing musicians."

We live in a world that will be increasingly influenced, even dominated by modern technology. As with most paradigm shifting innovations this has had its downsides. Social alienation, the loss of community cohesion, the dumbing-down of language, even the epidemic of obesity have been identified as negative effects of the digital revolution. Some warn that the real long-term threat posed by the growth of our technological capacity is having too much of it. Bert Mulder, the Dutch technology futurist thinks the exponential growth and availability of data is one of the great challenges of the century. He also sees artists as uniquely suited to help us deal with this challenge. Mulder feels that the discernment, reflection, synthesizing that are inherent to the creative process will be essential tools for making sense and meaning in the change constant, information saturated environment we are becoming.

5. The Arts are a Proven Strategy for Healing, Prevention and Empowerment

There is a larger music that we have no control over. As humans, we only get snatches of music from this more cosmic level. So, music is beyond us. But it has the power to change us. You can go through all history; music and the other arts have always been there, transforming.

Steve Heitzeg, composer

I was out on the Tonle Sap with a guide one day... and he recounted this harrowing story of watching the Khmer Rouge kill his father... He turned to me after the story and he said, "Do you know anything about the Cambodian dance?" I said, "Are you an artist?" He said, "No, no but everybody in Cambodia loves the arts. The dance is what tells us our myths, our stories of creation, our Gods. They keep us going; that is why we can go on, because of the dance. The dance is the spirit of Cambodia."

Lynn Szwaja, Philanthropist

Art making-the study and practice of the creative process-is inherently empowering. Each day the artist engages the muse, he/she does battle with

the new and unexplored. All artists, student or master, young, old or infirm-
are creative pioneers and adventurers. The challenge is to work honestly,
with self-discipline, owning the success or failure of one's endeavors.

During the last quarter of the twentieth century, a time when traditional
arts education was beginning its decline, many professional artists began
to look to society's neglected corners for a new constituency. The results
of their work with youth at risk, people with physical and mental disabil-
ities, prisoners, patients, seniors and others have shown that the arts make
a significant positive impact in the lives of these largely forgotten citizens.
The establishment of comprehensive arts programming in prisons, hospit-
als, mental health institutions and in numerous youth development pro-
grams is testimony to the effectiveness of these efforts.

The variety of problems being addressed by the increasing numbers of
artists engaged in this work, has valuable implications for educators, social
service providers, and community leaders. Artists working and succeeding
in these "other places" have generated a new technology for problem solv-
ing, communicating, building self-esteem and much more. A significant
body of research in the field shows the practice of the arts is, in itself, a
healing, transformational, therapeutic activity that, in some cases, may be
more effective than traditional approaches. Documentation further shows
the arts to be an effective and cost-beneficial resource for reducing violence,
recidivism, and psychopathology.

6. The Arts Help Us Communicate about Transcendent Values and Is-
sues

*"The artist as shaman becomes a conductor of forces that go far beyond those of his
own person, and is able to bring art back in touch with its sacred sources; (The sham-
an) develops not only new forms of art, but new forms of living."*
Suzi Gablick, *Has Modernism Failed?*

*"If something's being born, then, I think artists have a midwife role... We know
how to sit with people in a circle and get their stories... This thing that all these other
fields are looking for----we know how to do it."*
Arlene Goldbard, Writer and cultural theorist

Today, although the artists have been cast out from the center of com-
munity life, there are many who continue to sustain a vital link to the
transcendent-to provide the imaginative sustenance and vision for the quest
for truth and meaning, beyond the material. The artist, says psychologist
James Hillman, "bears sensate witness to what is fundamentally beyond hu-
man comprehension."

The trivialization of the arts in contemporary society has produced many
negatives. But none has been so damaging as the undermining of this con-
nection between man and the artistic illumination he needs to explore the
transcendent. Losing it, Hillman continues, "diminishes our ability to love
the world." Our alienation from and abuse of what artist Isamu Noguchi

called "our temple," the earth, is but one symptom of this condition. The artist at work in these realms mediates the moral, the rational and the spiritual; the artist sensitizes us to the presence of social and material toxicity.

There is no doubt that a new artistic process has started asserting itself in response to what many feel is a spiritual vacuum. Critic Suzi Gablick sees great hope in the work of artists such as Anselm Keifer and Joseph Beuys, who have "placed primary value on (the artist's) function as a bridge builder between the material and the spiritual worlds. Beuys and Keifer are part of the long but largely ignored history of "artist shamans" working in a time that has been dominated by science and material progress.

As we tire of our fascination with material flash and velocity, the need intensifies for the aesthetic bridge to what Alexis de Tocqueville termed "the mystical forces that govern ordinary events." A connection, he declared, which is "functionally necessary to society." In the Greek cosmology the gods could not appear in the material world without the presence of Aphrodite, the goddess of beauty, love, and fertility. She made manifest the divine mind. In the 21st Century, that presence will be needed as never before, as we continue to lift the veil on the mystery of creation and struggle to stop ourselves from destroying our temple.

STRATEGIES: BRIDGES. TRANSLATIONS AND CHANGE

The following is by no means a definitive list. These strategies are offered rather as a stimulus to further brainstorming, debate and, hopefully, action.

Bridges

1. EXPAND THE ROLE PLAYED BY CULTURAL INSTITUTIONS IN OUR COMMUNITIES. Begin exploring new working relationships with the non-arts service providers in the community. Help funders leverage their investment in the community by enlisting their support for partnerships between the arts and other community sectors. Make the case for the arts as both an essential human resource and a critical human need.

2. LEARN FROM THE INNOVATORS IN OTHER FIELDS. Look beyond the non-profit world for new and efficient models for managing, marketing, communicating, and networking. Pay particular attention to innovative strategies used by entrepreneurs, new media networks and small businesses that have grown despite the recession.

3. FIND THOSE IN OUR COMMUNITIES OUTSIDE OF THE ARTS WORLD WITH WHOM WE HAVE NATURAL AFFINITIES. The arts community should be exploring our common ground with those working in support of ethical business, sustainable community development, environmental justice, and freedom of expression.

4. EXPAND THE CONCEPT OF THE "ARTIST IN RESIDENCE" BEYOND SCHOOLS, AND SOCIAL INSTITUTIONS. Establish true residencies as long-term laboratories for exploring new ways for artists to

interact with their communities and institutions. Recognize that artists are both art makers *and* creative problem solvers. Consider new venues such as factories, condominiums, unemployment offices, neighborhoods, individual homes, cyberspace and the halls of government. Document and publish the results.

5. CONFOUND THE "SPECIAL INTEREST" STEREOTYPE of the arts by building organizing and advocacy alliances across community sectors. Explore the creation of mutually beneficial working relationships with like-minded activists at the local and state level. Join with respected community leaders in other sectors as campaign co-designers. Adopt strategies used by other highly successful political movements to advocate for the arts.

6. IDENTIFY THOSE NATIONAL ISSUES that have a direct bearing on the immediate and long-term health of the field. Join with those who are advocating positions that have an impact on the cultural sector. Take on issues with significant impact on artists and arts organizations. These include: health security, civil rights, immigration rights, education reform, AIDS prevention and many others.

7. CREATE FORUMS FOR DISCOURSE, learning, and problem solving between and among artists and scientists, engineers, politicians, economists, philosophers, etc. Support interdisciplinary collaboration among practitioners working across sectors to advance creative inquiry, expand vision and renew knowledge.

Translations

1. REWRITE THE "DICTIONARIES OF CULTURE." Examine and question the vocabulary and prevailing standards used to represent art and culture. Consider how language reflects and supports the marginal status of artists and the notion of creativity. Use language that reflects the dynamic and interconnected nature of our communities and the world. Recognize that the ongoing process of defining culture is taking place in community conversations that are taking place outside institutionally delimited silos.

2. CONDUCT RESEARCH ABOUT THE STATE OF THE ARTS and artists and the impact they are having on our communities. Use the results to create a regularly published Cultural Almanac.

3. TAKE THE POSITION THAT CREATIVITY IS A BASIC AND POWERFUL HUMAN CAPACITY, that the exercise and expression of our creativity is crucial for the health of individuals and communities, and that the arts are the laboratory for the development and understanding of the creative processes.

4. LEARN FROM OUR ELDERS. Those we consider newcomers to our communities actually bring older, far more inclusive cultural traditions with them. The same is true of those who were here before us. As these traditions take root or are maintained here, they form a new-old aesthetic. Work to protect them from domination, co-option and expropriation.

5. PROVIDE TRAINING FOR ARTISTS AND ARTS EDUCA-
TORS ON THE WIDE RANGE OF ROLES ART CAN ASSUME IN
COMMUNITY LIFE. Quash the notion that true artists are alienated and
aloof and uninvolved.

6. MAP THE CULTURAL ECO-SYSTEM. Acknowledge that our cul-
tural ecosystem is out of balance and that we know very little about its struc-
ture and dynamics. Recognize that a cultural ecosystem in which the finest
artists cannot sustain themselves on their creative work, and few children
have regular access to learning in and through the arts, is in serious decline.

Change

1. MAKE THE CASE FOR THE STUDY AND PRACTICE OF
THE CREATIVE PROCESSES AS A CORNERSTONE OF
EDUCATIONAL REFORM. Collect and disseminate information about
the success of arts-based education as it is successfully practiced in thou-
sands of schools across the globe. Establish local initiatives for arts-based
reform. Pass legislation to provide incentive and support for such local pro-
jects.

2. DEMOCRATIZE CULTURE. Decentralize the controlling forces of
cultural power. Institute policies and investment practices that emphasize
local and regional cultural ownership and accountability (slow culture). Re-
cognize that public attitudes towards the arts are in large part determined
by cultural arbiters who have a self-interest in the market-defined notions
of artistic quality and success. Acknowledge that the status of artists in so-
ciety profoundly affects the quality and content of art.

3. IDENTIFY THE ARTS COMMUNITY AS PART OF THE
PROBLEM. Arts communities must resist the tendency to self-define ac-
cording to the marginal condition in which they find themselves. Arts ad-
vocates should refrain from intramural fights over scarce funding and under-
stand that the real problem is the community's unwillingness to invest in its
cultural resources.

4. TOPPLE THE HIERARCHIES. Replace the notion of cultural hier-
archies with the idea of a cultural continuum. Challenge the market-driven
practice of creating categorical pecking orders. Recognize that distinguish-
ing difference (fine and folk, classical and traditional, monocultural and
multicultural) is not the same as discerning quality. Broaden and enrich the
definition of artistic excellence through inclusion and education.

5. CHALLENGE OUR MISSIONS. Reexamine the missions of artists
and arts organizations in a complex and changing world. Consider how "the
work" contributes to the common good. Consider the arts as an essential
human need as missions are reframed,

6. EXPAND THE DEFINITION OF "PUBLIC ART" beyond the
realm of the public artifact. Adopt the position that citizen/artist collabor-
ation, integration, and activism are necessary components for true commu-
nity ownership of artistic endeavors. Include areas such as urban planning,

ecology, science, and mass communication as new contexts for public cultural expression. Establish artistic strategies and resources as primary assets for re-animating and revitalizing democratic ideals, practices, and institutions.

7. PROMOTE AND SUPPORT THE WELL BEING OF THE INDIVIDUAL ARTIST as a cornerstone of arts policy. Over the last three decades, artists have developed new approaches that deepen learning, cultivate creativity, and build community. This growing constituency of arts workers is an unrecognized asset for community development. It is time to recognize that there is a synergy between artists and creative communities where one fosters and sustains the other.

Epilogue

The Story Story

William Cleveland

In the beginning there was a Word
The Word, a word,
who knows...,
but somewhere along the line
that Word begat
a Story and
that Story was whispered, and sung,
and gestured and proclaimed
until it gave birth to another story---
a brother story
and then, a sister story
that, given the nature of humans and stories
grew to a family, a village, a tribe,
a continent of stories
all alive in time
to the rhythm of all the story hearts
and all the story souls

beating then, and now
and forever in the world

If you sir
here and now
can feel that rhythm
If you can move your feet and sing
and make contact with the memory-filled universe
of all that telling, and listening, and telling
you are tapped into in the crucible of the signifying, sanctifying
transforming power of stories
Yes ma'am, if you are tapped into that
you are holding a beaded parasol in the second line of all those
story births and deaths
and the change, change, change that comes with them
If you are tapped in to that
well it may just be that you on your way to becoming
a link in the chain of the makers and takers of stories
And if that's true,
if you are tapped into that
then you'd better listen up:

Where do I start
Well, I'll begin with a warning
We all know about stories, right
Stories are fun, stories frolic, stories amuse...
Yes, but
stories are also nimble, tricky, malevolent, and ...
well, you fill in the blank.

Some say if you Hold "the story,"
if you own the story
then you hold the power
Others say, Defining "the story" is defining power.

And that subjugation is story killing

What we do know is that every
individual, every family, every community
is defined by their stories,
and, if we don't tell our stories
we lose our dignity,
our humanity,
our souls,
as in East Germany,
as in Chile,
as in Cambodia.

These particular stories teach us that
tyranny is story subjugation driven by fear
Here's how it works:
One-- Keep them from telling the story
Two-- Ignore the story
Three-- Control the story by altering or editing it
Four-- Romanticize the story
Five-- Simplify the story
Six-- Trivialize the story
Seven-- Buy, then sell the story
Eight-- Murder the story

But, you know, stories do not die.
Just like the blackberry canes that
crowd our lanes and clog our fences

And of course you all know the story about neighbors and fences
Good neighbors ---make good fences and
good fences make for good stories
And as those good stories migrate and join
at the hip

at the shoulder
at the third eye intersection of self interest and common ground
those tall tale partners
become democracy zygotes

Yes, democracy is the art of collective story making.
Democracy says:
"Here is the story to this point—let's decide together, what's next."

The arts are the tools humans use to craft stories.
Story making is the reason---for art.

Got a mystery, get a Shaman to
stitch it to the rest
of your cosmology
with a story
If you don't, the mystery, unaddressed,
and out of context,
will literally scare you to death

Untold stories are nascent shadows
The shadow grows as the story is smothered,
and
stifled stories,
unpeeled stories,
unexamined stories,
left to fester---
are very, very dangerous.

If you don't examine and tell your own stories
you can't help others tell theirs.
Stories reveal humanity in all its frailty, power, ugliness,
passion ...
you fill in the blank.

Some stories make sense and meaning,
others lie.

Everything in the world is translated for us,
to us, by us
through some story
For good and for ill
Everything we see, hear, taste and feel
has a story attached.
Meaning makes its presence felt
through the story.

Imagination is cold fusion,
generating more power than it consumes
as it chugs along raising the temperature
in the hot house of stories.

Privilege is the ability to manifest one's story, unabated,
to the exclusion of other's stories.
Dignity is the unfettered capacity
to make and share stories.
If you have great material wealth
you can buy the story you think you need
If your story holds great meaning
you can acquire power
out of proportion
to your material status.

Empathy happens when
I tell you my story
and you tell my story back to me
and I nod my head.

Art contains the story, but only just--- for a while

The artist says, "This is how the story goes at this time and this place."
Sometimes the story sticks around
Sometimes it mutates or migrates.
Sometimes it escapes

Improvisation is fishing for fugitive stories
New stories get born
when improvisation and imagination converge
bending time and space wide enough
for story sperms and the story eggs
to find each other and join.

But of course there are no new stories
and all stories are new

Some artists say,
Have a seat while I tell my story
Some artists say,
Have a seat while I tell someone else's story
Some artists say,
Have a seat while I tell your story
Some artists say,
Stand up we have a story to tell

I say
Once upon a time...

CPSIA information can be obtained at www.ICGtesting.com
Printed in the USA
267120BV00003B/11/P